To J[...]

N[...]

did you help
write this?

Enjoy,

Love,

M. '09

Media, NASA, and America's Quest for the Moon

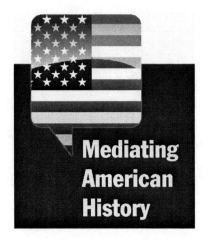

David Copeland
General Editor

Vol. 4

PETER LANG
New York • Washington, D.C./Baltimore • Bern
Frankfurt am Main • Berlin • Brussels • Vienna • Oxford

HARLEN MAKEMSON

MEDIA, NASA, and AMERICA'S QUEST for the MOON

PETER LANG
New York • Washington, D.C./Baltimore • Bern
Frankfurt am Main • Berlin • Brussels • Vienna • Oxford

Library of Congress Cataloging-in-Publication Data

Makemson, Harlen.
Media, NASA, and America's quest for the moon / Harlen Makemson.
p. cm. — (Mediating american history; v. 4)
Includes bibliographical references and index.
1. Space flight to the moon—Press coverage—United States—History—
20th century. 2. Project Apollo (U.S.)—History. 3. Moon—Exploration—
History—20th century. 4. United States. National Aeronautics and
Space Administration. I. Title.
TL799.M6M265 629.45'40973—dc22 2009011348
ISBN 978-1-4331-0300-1
ISSN 0085-2473

Bibliographic information published by **Die Deutsche Bibliothek**.
Die Deutsche Bibliothek lists this publication in the "Deutsche
Nationalbibliografie"; detailed bibliographic data is available
on the Internet at http://dnb.ddb.de/.

Cover image of Buzz Aldrin © NASA/courtesy of nasaimages.org.
Cover image of family watching television, Evert F. Baumgardner, ca. 1958,
© National Archives and Records Administration.

The paper in this book meets the guidelines for permanence and durability
of the Committee on Production Guidelines for Book Longevity
of the Council of Library Resources.

© 2009 Peter Lang Publishing, Inc., New York
29 Broadway, 18th floor, New York, NY 10006
www.peterlang.com

Printed in the United States of America

FOR DAN

CONTENTS

PREFACE AND ACKNOWLEDGMENTS

On the night of July 20, 1969, Neil Armstrong took mankind's first step on the moon, capping arguably the most remarkable engineering feat in history. Less than twelve years after America had been unable to lift a three-pound satellite off the grounds of Cape Canaveral, the country's best minds and a score of workers from coast to coast had implemented a method for sending men a quarter-million miles from home, landing them on another celestial body, and bringing them back safely.

That the world was able to see the event live on television was nearly as astonishing. Not only did the broadcast represent a breathtaking leap in technological mastery, but it also culminated a decade-long battle over information in an open society. What does the public need to know about the civilian space program? When do citizens need to know? And who decides? It is the conflict over these questions that form the core of this book.

Media, NASA, and America's Quest for the Moon traces the information history of America's lunar program through three perspectives. First, the book examines how gatekeepers to the manned space program struggled with providing "the widest practicable and appropriate dissemination of information concerning its activities," a charge given the National Aeronautics and Space Administration at its birth in 1958 with no guidelines for how to accomplish it. In the following years, internal battles within NASA gradually moved the agency from a "do first, talk second" stance that told of missions only after the fact to an "open program" ethos that espoused total candor, in sharp contrast to their Soviet counterparts. Yet, NASA's reticence in times of crisis would lead critics to charge that the agency's acronym actually stood for "Never A Straight Answer."

Second, the book focuses on the relationship between space advocates and the media. Wernher von Braun's influential articles in *Collier's* magazine during the 1950s proved that print outlets could play powerful roles in turning America's attention to the heavens, but as manned space flights began in the early 1960s, NASA's most fruitful

partnership was with the still-new field of television journalism. For broadcast networks, space coverage became a balancing act between public service and the drive to win: While trying to show critics that the medium was not the "vast wasteland" described by Federal Communications Commission Chairman Newton Minow, network executives spent huge sums of money in a ratings race that often devolved into "competitive inanities," in the words of one network executive.

Third, the book recaptures the shared experience of millions of Americans as they watched missions on television or read about them in the nation's print media. Aside from liftoff, most aspects of space flights were conducted away from camera view, leaving it to networks to try and duplicate spectacular feats. While television offered extensive and expensive arrays of animations, simulations, models, and other visual aids, viewers' attention to the lunar program waxed and waned as they struggled with the question of whether the government's massive expenditures to conquer the moon were worth it. Often, the answer was not what NASA or the networks had hoped for.

This book represents the combined efforts of numerous people who contributed in ways large and small. My friend and colleague David Copeland encouraged and prodded me to pursue this project, then provided keen advice and sharp editing skills throughout the research and writing processes. Without David's guidance, it's doubtful this book would have been written.

Elon University, the institution that allows me to ply my trade each day, backed this venture in more ways than I can list. Paul Parsons, Dean of the School of Communications, supported my research with encouraging words and strong recommendations, and fellow faculty members offered good wishes and graciously covered my teaching and service responsibilities as I finished the manuscript. I am indebted to the university's Faculty Research and Development Committee, which generously granted funds for source material and awarded a semester-long sabbatical so that I could complete the book. The staff at Belk Library was of great assistance, but special thanks goes to Interlibrary Loan Coordinator Lynn Melchor, whose success

in obtaining obscure books and articles in a timely manner was a thing of wonder.

I owe a great debt to librarians, archivists, and staff at a number of research facilities. The Vanderbilt Television News Archive compiled and delivered several hours of broadcast clips from the late 1960s. Ruta Abolins, Director of the Walter J. Brown Media Archives and Peabody Awards Collection at the University of Georgia, deserves a special nod for converting a two-inch videotape entry of televised space coverage into a usable digital format. Patrick Cox was helpful in setting up my visit to The Center for American History in Austin, Texas, and Margaret Schlankey's expertise was invaluable in navigating the material in the Walter Cronkite Papers and the *New York Herald-Tribune* morgue files. At NASA Headquarters in Washington, D.C., Jane Odom offered valuable guidance, and Liz Suckow was tireless in locating and pulling documents related to the agency's public affairs efforts. A note of gratitude goes posthumously to veteran journalist Robert Sherrod, whose interview transcripts for a never-completed book were donated to the space agency and provided a wealth of insight into the inner workings of the NASA public affairs operation.

Last, but far from least, my wife, Deborah, offered constant encouragement and never complained when my work on this project took me away from responsibilities at home. Her comments on drafts often brought clarity to what had been a haze of confusion. Her love and support bring me constant joy.

TURNING ANY MERCHANDISE:

at you are pleased with your selections(s). Please
his form. Items listed as back ordered (B) have not
:, but will be shipped as soon as we receive them
been charged and will not be shipped. If you are
: fill out the form below and return with your
weeks of receipt.

addressed to:

eturns

)03

service department can be reached Monday
473-1452, or email custserv@strandbooks.com.

**)er as well as a brief explanation for each item
his form with your return.**

Reason For Returning

INVOICE
FED I.D. #13-567-9545
DUNS 04-416-5884

shop online strand**book**

SOLD TO MICHAEL LA PLACE
117 EAGLECROFT RD
WESTFIELD NJ 070903924
USA

CUST. PHONE:
CONTROL NO.: 54552 50803

INVOICE DATE	ORDER #	ACCOUNT #	REP.	SHIP VIA
7/31/09	50772	454552		AMZHALF REG

QTY. ORD.	QTY. SHIP	B/C W	CAT. NO.	PRODUCT NO.	
1	1		AMZ	1-43310-300-1	MAKEMSON, H MEDIA, NAS
1	1				
					YOUR AMAZON ORDER NUMB

↑ THESE ITEMS WERE OUT-OF-STOCK
B=BACK ORDERED C=CANCELLED W=WANT LIST

Strand Book Store 828 Broadway (at 12th St.) N.Y., N.Y. 10003
(212) 473-1452 • Fax (212) 473-2591
Strand Book Annex 95 Fulton St., N.Y., N.Y. 10038

)m

Content: Books
Return Postage Guaranteed

SHIPPED TO MICHAEL LA PLACE
117 EAGLECROFT RD
WESTFIELD NJ 070903924
USA

XES	PAGE#	CUSTOMER/PURCHASE ORDER #	ORDER DATE	INVOICE #
	1		7/30/09	0902540

AND TITLE

MERICA'S QUEST FOR THE*

NVOICE TOTAL

MOUNT DUE

02-9432505-3521869

DISCOUNT PERCENTAGE, OR
SP=SPECIALLY PRICED

PLEASE READ BELOW BEFOR

Your order has been carefully packed and we h
immediately check the contents against the items
been charged and are not contained in this shi
back in stock. Items listed as cancelled (C) hav
unsatisfied with any portion of your order,
shipment **within**

Return's shou
Strand Book
3rd Floor / A
828 Broadwa
New York, N

If you have any further questions our cust
through Saturday 9:30 AM to 6:30 PM EST at

**Please list the quantity and ISBN or catalog
you are returning and in**

QTY	ISBN/Catalog #	

PERMISSIONS

Chapter 1

"The Seer of Space": Capturing America's Imagination

"Here is how we shall go to the moon," wrote the prophet.

He envisioned a giant, wheel-shaped satellite serving as the staging area. There, 1,075 miles above the Earth's surface, scores of workers would assemble three spacecraft, each 160 feet long and 120 feet wide. Two of the ships would be designed to make a return trip to the satellite; the third would carry just enough fuel for a one-way voyage, leaving extra space for supplies needed for the six-week stay.

It would take six months, he estimated, for twice-daily cargo ferries from the home planet to deliver the nearly 13,000 tons of materials needed for the construction project and voyage. Once the ships were built, 50 scientists and technicians would board for the 239,000-mile trip.

The spacecraft, he told his readers, would lift off slowly from the satellite, one after another, each powered by an array of powerful rockets. The satellite, traveling at 15,840 miles per hour, would supply most of the needed velocity; the rockets would generate the additional 3,360 miles per hour necessary to reach the moon.

Thirty-three minutes after liftoff, the prophet calculated, the rockets would be shut off. For the next four days, as the three craft gradually decelerated to 800 miles an hour, scientists and technicians would keep a watchful eye on critical navigation, life support and mechanical systems.

On the fifth day, he wrote, the craft would be 23,600 miles from the landing site and under the increasing influence of the moon's

gravity. At this stage, the captain would need to make the first of two critical adjustments necessary to keep the craft from crashing into the moon. He would turn the ship one-half revolution so that the tail was now headed toward the lunar surface, and four spider-like legs would emerge from the bottom of the craft.

The prophet felt the second adjustment was too complex for human hands. At 550 miles above the moon, an automatic pilot, controlled by a computer tape, would fire a set of rockets designed to break the ships' fall. As the craft began their final descent, the prophet envisioned a "big telescopic shock absorber" emerging from the center of the landing gear. Its round shoe would touch the lunar surface first; if the ship came down too hard, the shoe's sensor could instruct the rockets to fire with more intensity in order to soften the rough landing.

"For a few seconds, we balance on the single leg," concluded Wernher von Braun. "Then the four outrigger legs slide out to help support the weight of the ship, and are locked into position. The whirring of machinery dies away. There is absolute silence. We have reached the moon."[*]

Readers of von Braun's "Man on the Moon: The Journey" in the October 18, 1952, issue of *Collier's* magazine were not the first to be tantalized with visions of lunar travel. Nearly a century earlier in the novel *From the Earth to the Moon*, Jules Verne envisioned a giant cannon as the catalyst for the trip, the author including detailed calculations of the force necessary, he believed, to launch the vehicle and three passengers out of Earth's gravitational pull. At the turn of the century, H.G. Wells created "cavorite," an anti-gravity substance that allowed a spaceship to reach the lunar surface in his novel *The First Men on the Moon*. And just a year prior to von Braun's article, Arthur C. Clarke's *Prelude to Space* imagined a two-stage space vessel–a nuclear-powered "Beta" vehicle designed for launch and Earth re-entry, and an attached "Alpha" stage that would go to the moon, return to the orbiting Beta craft and deposit the crew, then detach and remain in orbit for later flights.[#]

While parts of von Braun's story may have had characteristics of a Verne or Wells tale, the author and his publisher were not selling the

article as a fictional diversion or whimsical vision. *Collier's,* one of the country's most popular magazines with more than three million subscribers in the early 1950s, had set out seven months earlier to tell "the story of the inevitability of man's conquest of space" and had employed several of America's most brilliant scientific and engineering minds to do it. While there were several authors in what became known as the *"Collier's* Space Series"–spanning two years, eight issues and twenty articles–von Braun was its preeminent contributor. His articles marked the beginning of the press's interest in space exploration as an attainable aspiration and set in motion a systematic mindset that would shape the eventual U.S. plan for conquering the moon. In the process, the engineer/author captured the nation's imagination and became the de facto face of American space efforts for years to come. "It is difficult to overestimate the impact of the articles," one twenty-first century historian writes, "on the burgeoning U.S. space program." Or, it seems, to overstate von Braun's impact on the American consciousness.[§]

The seeds of the *Collier's* space series were planted in October 1951 when well-known popular science writer Willy Ley organized a space travel symposium at the Hayden Planetarium in New York City. The audience of more than two hundred people included researchers, scientists, representatives from pro-space organizations, and two writers from *Collier's.* After hearing presentations on such subjects as "Engineering and Applications of the Space Vehicle" and "Legal Aspects of Space Travel," the writers returned and told managing editor Gordon Manning that, in their judgment, space travel would be worthy of coverage in the magazine. Soon after, Manning got word of a space medicine conference in San Antonio and sent a new associate editor to cover it.[‰]

The new editor, Cornelius Ryan, had been with the magazine for just a few months, but he had already established a strong journalistic pedigree. A native Dubliner, Ryan began writing for Reuter's at the age of 21 and covered World War II for London's *Daily Telegraph* (in 1959 he would author *The Longest Day,* an award-winning account of the pivotal Normandy invasion). After the war, he immigrated to the United States and served brief editor stints with *Time* and *Newsweek.* While Ryan had some familiarity with aeronautics, having covered the air war over Germany, the concept of space travel held little if any

interest to him, and he approached the assignment less than enthusiastically. "I don't know what these people are talking about," Ryan said over a drink in the hotel bar after the first day's presentations. "All I could find out so far is that lots of people get up there to the rostrum and cover a blackboard with mysterious signs."&

Soon, Ryan found himself surrounded by three of the world's most esteemed space experts, each of whom tried to make order of the chaos swimming in his head. On one side was the chair of the Harvard astronomy department, Fred Whipple, whose research on meteors was supported by the U.S. military. Also present was UCLA professor Joseph Kaplan, a pioneer in the field of aeronomy, the study of the physics and chemistry of the upper atmosphere.

Orchestrating the impromptu seminar was Wernher von Braun. A civilian currently employed by the U.S. Army, he was most famous for work he had conducted in the name of Adolph Hitler's Third Reich. While in his early 30s, von Braun had directed Germany's experimental guided missile program, and he designed the V-2 long-range rocket that terrorized England and Belgium in the waning months of World War II, the weapon killing more than seven thousand people.'

As Allied troops poured over German borders in early 1945, the United States and Soviet Union engaged in a new type of battle for the spoils of war. And in the fight for German brainpower, von Braun and his missile team was the biggest prize in "Project Paperclip," the then-secret U.S. mission that captured and sent to America more than seven hundred of Germany's best minds with the express purpose "to exploit German scientists for American research and to deny these intellectual resources to the Soviet Union." (

By fall 1945, von Braun was stationed in Fort Bliss, Texas, teaching the U.S. military how to fire captured V-2s at the nearby White Sands testing range. He found the American facilities to be a far cry from those Hitler had provided him at Peenemünde on the Baltic coast. "That job took eight months," von Braun said. "We seemed to be expected to do it in two weeks, but shooting a V-2 is a complicated and dangerous business. Especially the rusty, dried-out V-2s we had at White Sands. And the facilities there were unsuitable for efficient shoots. Frankly, we were disappointed with what we found in this country during our first year or so."'

In terms of missile productivity, the next four years would not get much better for von Braun. Security clearances were difficult to come by, given his German past, and successful clearances came with a price–even tighter restrictions on travel, since the United States feared that von Braun might be kidnapped by the Soviets, not only for his technical prowess but also for insight on how America planned to use it. In the few missile projects where he was allowed to have a role, von Braun was frustrated that he was not consulted on what he believed were crucial decisions.*

With his military rocket work at a virtual standstill, von Braun focused his attention on his lifelong aspiration–manned space exploration–and pondered how to project his vision onto the consciousness of the American public. For if his dreams of extraterrestrial travel were to come true, von Braun would have to convince citizens that it could actually be accomplished, and that it would be worth the considerable effort and cost.

"The ideal thing is to have 100 percent secrecy and all the money we need," von Braun would say years later. "When the Kremlin wants ballistic missiles it tells the scientist to meet the schedule and don't worry about public relations. Here we must have money and public support. Congressmen must believe in what we're doing, and they won't until the public believes in us." As the 1950s began, von Braun had a huge task in front of him–only 15 percent of Americans thought the country could put a man on the moon before the century was out."+

Von Braun's first idea had been an ambitious one, and it was an initial failure. He spent the better part of three years writing "Mars Project," which on its face was a science fiction novel but in reality was von Braun's plan for reaching the Red Planet, including a 120-page technical appendix of calculations. Character development was not a strong suit of von Braun's writing though, and publishers, while impressed by his technical expertise, had no idea what to do with the mass of numbers contained within the manuscript. "We're all agreed we can't publish it," wrote one of the nearly twenty editors who would eventually reject the book, "and the only thing I can think of that we might do with it is build a rocket ship.""

Von Braun's luck began to change in 1950, coinciding with his transfer to Huntsville, Alabama, where an abandoned World War II

arsenal was being transformed into a more suitable site for missile testing and development. At the same time, von Braun also began cultivating a relationship with the American press, which slowly became more interested in the man who just five years earlier had examined preliminary plans for a long-range missile designed to strike New York City. While still unpacking in Huntsville, von Braun was interviewed by journalist Daniel Lang, whose ensuing article in the April 21, 1951, edition of *The New Yorker* set a template that would be followed by the U.S. press for years to come. Although von Braun was German, his narrative bore great resemblance to the classic American success story."#

First, there is the moment where the protagonist finds his purpose, and for von Braun, he said, it happened while a still a teenager, when he read a magazine article about an imagined moon voyage. Von Braun could not recall the article title, the magazine or the writer, but he described it as a defining moment to his American audience: "It filled me with a romantic urge," he told Lang. The American success story often includes an inspirational historical figure, and von Braun obliges by invoking a fellow European: "I knew how Columbus had felt.""$

Second, the American success story requires "the big break," and von Braun's came at an abandoned dump on the outskirts of Berlin, where he and several other budding space enthusiasts were testing homemade rockets with some degree of success. One day in 1932, he told Lang, three members of the German army pulled up in a black sedan to watch a launch. Von Braun and his colleagues needed money, the German army was looking to rebuild, and the World War I terms of surrender said nothing about rocketry. Von Braun accepted the army's offer of workers, equipment and better facilities, and a career in missiles was born."%

The big break came at a significant price. While the German government poured money, men, and materials into his rocket projects, the resulting discoveries would be used not to explore space but to wage devastation on Allied civilians in wartime. Now, living in the United States after the war, von Braun's past was problematic on its face, but it would have been impossible to overcome had the public gained access to the dossiers compiled by the Army and Operation Paperclip. Those files contained clear evidence that von Braun's V-2

had been built on the backs of as many as sixty thousand enslaved workers at the vast, subterranean Mittelwerk production plant, twenty thousand of them perishing through exhaustion, disease, starvation or murder. The documents also showed that von Braun had not only run the German missile program but also was a major in Hitler's SS, just one rung below Adolph Eichmann, the so-called engineer of the mass deportation and execution of millions of Jews. Deep in the archives lurked a letter that showed von Braun not only knew of the slave labor but also was active in recruiting it."[&]

Most of these unsavory facts were shielded from the American public, the damning evidence deemed "classified" by a government willing to overlook von Braun's past in exchange for his engineering brilliance. The Army's official line was that von Braun's Nazi association was strictly a necessity to retain his job under the brutal Hitler regime, and a largely compliant American press either accepted the explanation or dared not question it, lest they lose what little access they had to military sources. In addition, it would be years before survivors of the Dora concentration camp who manned the Mittelwerk would make their stories public. In this information void, von Braun had the opportunity to control the story of his German past and write his own history. He made the most of it, portraying his inventions, and therefore himself, as having been exploited."[']

"We felt a genuine regret that our missile, born of idealism, like the airplane, had joined in the business of killing," von Braun told his American audience. Besides, he reminded the interviewer, the Nazis had not yet gained power when he, as a 20-year-old, made the deal with the German military. As for regrets over the destruction and death caused by his V-2, von Braun claimed he had none, saying his discoveries had been misused, in a similar manner as Einstein's theories had been to develop the nuclear bomb."[(]

Having molded his past, von Braun turned to the future. He discussed his recently completed Mars novel, but then directed his interviewer's attention to a celestial body much closer to Earth. "Personally though, I'd rather go to the moon than to Mars, even if the trip is shorter," von Braun said. "After all, a journey to the moon is unquestionably a possibility. ... All that's needed is adequate funds and continuity of effort."["[)]

As von Braun slowly became more visible to consumers of American media, his circle of scientific colleagues also began to grow through a small but increasing number of organizations that shared his optimism about the feasibility of space travel. One such group, the British Interplanetary Society, invited von Braun to give a paper at its meeting in September 1951. Although he was unable to attend in person–travel abroad was still problematic for von Braun–a collaborator delivered "The Importance of the Satellite Vehicle as a Step Towards Interplanetary Flight," which outlined the technical aspects of "The Mars Project."[*]

As it turned out, von Braun's audience went beyond the fifty scientists in attendance or even the larger scientific community, as the American popular press, in small ways, began to take notice. Readers of the *New York Times*, for example, got their first glimpse of von Braun's Mars vision with its coverage of the conference that featured a rack of headlines deep inside the September 7, 1951, issue:

SCIENTIST PROJECTS
JOURNEY TO MARS

Astronautical Congress Gets
Details of Flight by Rockets,
Held Not Many Years Off

EARTH SATELLITES IN PLAN

Proposal Even Estimates Time
For Interplanetary Travel
And Number in Crew[#+]

Now, two months after the *Times* article was published, von Braun was the lead pitchman for what likely was the most highly educated three-man sales team ever to grace a San Antonio hotel. Von Braun, along with scientific colleagues Whipple and Kaplan, began explaining to the slightly dazed *Collier's* editor how space flight could be close at hand and what was needed to make it happen. "The three of us worked hard at proselytizing Ryan," Whipple recalled years later. "That evening he appeared to be highly skeptical about any possibility of artificial satellites or space travel." Drinks led to dinner, questions were replaced with answers, and slowly, Ryan's haze of confusion and doubt melted away, thanks in large part to von Braun,

"one of the best salesmen of the twentieth century," in Whipple's estimation. By night's end, Ryan would agree with that assessment.#"

"His dreams, his ideas are mesmerizing," Ryan would later say. "He is so effective that he could sell anybody anything. Even used cars!" By midnight, an exhausted Ryan had been converted. *Collier's* would spread the space gospel according to von Braun.##

Within a month, the magazine had put its plan into motion: a published "symposium" with articles from a number of experts about the possibilities and potential issues surrounding manned space exploration. Scientists such as Kaplan and Whipple would contribute articles, as would Ley, who in 1949 had published the popular and influential *The Conquest of Space*. Von Braun's assignment was to outline his overall vision: giant rockets for Earth liftoff, a constantly orbiting space station and manned expeditions to other planets. His article served as the five-thousand-word centerpiece, for which he would earn $1,000–more than he received per month from the Army. Far from dreading the extra work, von Braun's night job seemed to energize him after a long day of technical work at Redstone Arsenal: "I mix me [*sic*] some martinis, put a Brandenburg concerto on the record player, and just write and write ... until Maria [his wife] gets out of bed and reminds me that I must be in the office two hours from now."#$

Von Braun sent his manuscript to *Collier's* during the last week of 1951, and Ryan spent the next two months getting it and the other articles into shape for publication. Ley's constantly smoldering cigars may not have been welcome ingredients in the creative process, but his boundless knowledge was, as he helped Ryan explain complex concepts to a general audience. Their work not only had to pass the editorial judgment of the *Collier's* hierarchy, but also the watchful eye of the U.S. government: As a federal employee, von Braun had to get official clearance for anything published.#%

Collier's also understood that it wasn't enough for its authors to describe the amazing flying machines necessary to make the trip; readers needed to *see* the vessels. For that task, the magazine turned to three of the nation's best artists, led by Chesley Bonestell, who two years earlier had lavishly illustrated Ley's *The Conquest of Space*. Von Braun was central in this process as well: He sent his graph-paper sketches of the dream ships to New York, where Ryan would copy

and send them to the assigned artist. Once the artist finished a working drawing, he would send it to von Braun, who would mark it up with corrections and suggestions and return. On one occasion, artist Fred Freeman adapted this circular through-the-mail process, traveling to Huntsville in late January to meet with von Braun and discuss a cross-section rendering of his space station.#&

As the publication date approached, *Collier's* publicity team prepared an all-out media assault, dubbed "Operation Underground," designed to push the space issue's visibility beyond the estimated twelve to fifteen million people who were said to see a typical installment of the magazine. What von Braun at the time called "by far the greatest public advertising campaign for spaceflight and the artificial satellite ... the world has ever seen" contained multiple facets. *Collier's* publicity director Seth Moseley arranged for American Express to have the spaceship drawings of Bonestell, Freeman and co-contributor Rolf Klep prominently featured in the company's display windows in Manhattan and central Philadelphia (followed the next month by the company's "announcement" of the first American tour to Mars, year of departure to be determined, including tours to attractions such as "an atomic-sonic research laboratory" and accommodations at the hotel "Corona Borealis"). Nearly three thousand information kits were sent to media outlets and schools, and less elaborate press releases targeted twelve thousand daily newspapers and a number of wire services and syndicates.#'

The star of the publicity campaign was von Braun, who was scheduled for at least seven television appearances in a forty-eight-hour span, concluding on the day the space issue hit newsstands. Armed with scale models of his proposed craft, von Braun made his national television debut on March 13 as a guest on NBC's *Camel News Caravan*, an early precursor to today's network evening newscasts that was hosted by John Cameron Swayze and boasted of more than 5 million viewers. The next morning, he was back on NBC for an interview with Dave Garroway on the fledgling *Today*, which had made its debut two months previous. In the afternoon, von Braun reprised his vision of space travel for the estimated 1 million viewers of CBS's *The Garry Moore Show* and that evening made an appearance on the ABC kids' show *Tom Corbett, Space Cadet*.#(

If potential readers were intrigued by von Braun's presentations on television, they likely were astonished when they picked up a copy of *Collier's* that week. A spectacular Bonestell drawing of von Braun's rocket high in orbit over the Pacific Ocean dominated the cover of the March 22, 1952, issue (its distribution began a week earlier), but perhaps equally arresting to many readers was the bold statement in the upper right hand corner that "Man Will Conquer Space <u>Soon</u>." Inside, an editorial leading the package emphasized, "What you will read here is not science fiction. It is serious fact." And just how serious? The answer, *Collier's* asserted, could be a matter of life or death: "Moreover it is an urgent warning that the U.S. must immediately embark on a long-range development program to secure for the West 'space superiority.' If we do not, someone else will. That somebody very probably would be the Soviet Union."#)

Indeed, the Cold War was a considerable subtext in *Collier's* first space issue. While much of von Braun's centerpiece "Crossing the Last Frontier" emphasized his artificial satellite's use as a launch site for interplanetary missions and as an observation point for astronomical gazing, he also made clear its possibilities in times of geopolitical strife. Von Braun had told readers of *The New Yorker* a year earlier that military use of rocketry was only "a means to an end" to achieve space travel, but he knew his work would have to be of more urgent benefit to gain favor with the public, and therefore policymakers. The increasingly tense relationship with the world's other new superpower provided the opening: A giant telescope would keep tabs on the movements of the Soviet Union or any other hostile nation, and if hostilities escalated, the space station could be transformed into a war weapon of horrifying efficiency:

> Small winged rocket missiles with atomic warheads could be launched from the station in such a manner that they would strike their targets at supersonic speeds. By simultaneous radar tracking of both missile and target, these atomic-headed rockets could be accurately guided to any spot on the earth.#*

The *Collier's* "symposium" was reviewed with some skepticism by other press outlets. *The Christian Science Monitor* found it a topic seemingly "more fit for science fiction articles than serious planning," while acknowledging that previously stated Soviet aspirations in

space gave the issue some significance. A *Washington Post* editorial recognized the strategic advantage of von Braun's satellite being able to watch the Soviet Union at all times but worried about its potential abuse domestically. "In fact there wouldn't be much privacy for anybody anywhere," the *Post* wrote. "Living on earth would be rather like living in one of these new-fangled glass penitentiaries or within range of the two-way television apparatus described by the late George Orwell in *1984*."[5+]

Such concerns seemingly were not shared by citizens who had been exposed to the von Braun plan, and its designer began to approach minor celebrity status. Six days after von Braun's network television debut on *Camel News Caravan*, his speech to the American Rocket Society in suburban Washington drew an overflow crowd of five thousand people, and at least three thousand more had to be turned away. Upon his return to Huntsville, von Braun began receiving a steady stream of fan mail ranging from half-baked plans for space devices to earnest queries from children who wanted to build his spaceships or make the extraterrestrial trips. And the overwhelming positive feedback reaching the *Collier's* offices convinced its editors to turn the first symposium into a book and to devote two fall issues of the magazine to lunar travel.[5"]

Accompanied by another blitz of orchestrated media publicity, the second *Collier's* space issue in mid-October 1952 featured von Braun's highly detailed proposal for landing men on the moon, "The Journey." As in the magazine's first space installment, the artists' renderings of von Braun's dream ships were "spectacular and virtually incredible," as noted by *The New York Times*. From a probable landing site ("Sinus Roris is ideal for our purpose"), to efficiency in vehicle assembly ("All construction parts are color-coded"), von Braun seemed to have most everything figured out. Obstacles remained, von Braun cautioned, "But the project could be completed within twenty-five years. There are no problems involved to which we don't have the answers–or the ability to find them–right now."[5#]

Some in the scientific community weren't so sure, and von Braun faced one such critic in a public forum three days after "The Journey" hit newsstands. While presenting an academic paper at Ley's second space conference, Dr. Milton Rosen, director of the Navy's Viking rocket program, said that von Braun's plans "are based on a meager

store of scientific knowledge and a large amount of speculation." Future space exploration and the nation's defense would be at risk if the country pursued "any one of the fantastic projects for a space ship that have been proposed for the last few years."[33]

The episode was notable for a number of reasons, including the fact that Rosen's paper was nearly scrapped by Ley because it criticized the plan he and von Braun had worked on for *Collier's*. Von Braun intervened, however, correctly recognizing that a hint of controversy would garner more coverage for the conference, and hence, interest in his own blueprint for space conquest. Second, it shed light on the uncertainty, and in some cases disbelief, within the scientific community over the feasibility of von Braun's plans, characterized by *Time* soon afterward as a fight between dreamers such as von Braun and "practical missile men" such as Rosen. While *Collier's* readers may have been convinced of the inevitability of space travel, many of von Braun's scientific colleagues doubted the numbers added up.[34]

The following week, *Collier's* continued the space series, featuring a co-authored article by von Braun and Whipple describing how the lunar explorers would examine the moon once they arrived. Reader response was again overwhelming and led the publishers to make two decisions: Turn the moon articles from the consecutive issues into another book (released as *Conquest of the Moon* in late 1953) and continue the series with an exploration of how the crews would be chosen and prepare for their journey. The magazine devoted three consecutive issues to those topics in early 1953, with von Braun taking more of an advisory role. His byline returned to *Collier's* that summer as a co-author with Ryan, the two describing a low-orbit "baby" satellite with three monkey passengers that would serve as a first exploratory step to space travel.[35]

The series concluded in April of 1954 with another von Braun-Ryan collaboration, "Can We Get to Mars?" that was based in large part on von Braun's oft-rejected "Mars Project." By that point, the relationship between Ryan and his contributors had become strained: The editor had been left out of the loop when Ley and Bonestell made a verbal agreement with another publisher for a new Mars book; meanwhile, von Braun was displeased with Ryan's editing of the final article, which the engineer thought focused too much on the difficulties of a trip to the Red Planet.[36]

While precise measurements of how many people read the *Collier's* series are impossible to come by, evidence strongly suggests that it had a significant effect on how the public viewed space travel. From 1949 to 1955, the percentage of Americans who thought a manned mission to the moon would occur within fifty years had more than doubled, thanks in large part to the work of von Braun, Ley, and others in popularizing the notion of viable space travel. Perhaps more importantly, the series was central in creating what some call the "von Braun paradigm," a systematic mindset privileging manned space exploration over robotic probes, with the key building blocks of shuttles from Earth and an orbiting space station that serves as a jumping-off point to a lunar base or to other planets. While the scale of von Braun's plans was never realized, the overall model became the archetype for the American civilian space program. It would remain so for decades to come.[1]

On the popular front, momentum from the *Collier's* experience would soon catapult von Braun into another media venture that would boost his prominence to even greater heights. Just days after the final *Collier's* installment hit newsstands, von Braun received a call from a representative of Walt Disney. Would von Braun, the official asked, be interested in appearing on a new television show the studio was planning?[2]

The new show was in actuality a vehicle to finance and promote a new California theme park. In early 1953, ABC had agreed to kick in $500,000 cash and co-sign for $4.5 million worth of construction loans for the building of Disneyland; in return, Disney would produce a series for the struggling network themed around the park's four areas. The studio's stock of films provided a wealth of programming to fill episodes for Adventureland, Frontierland and Fantasyland, but studio executives were stumped about what to do for Tomorrowland.[3]

A somewhat eccentric Disney animator and producer named Ward Kimball came up with the answer. Kimball, a key creative figure behind such Disney classics as *Fantasia* and *Snow White and the Seven Dwarfs*, had a reputation for being a bit unconventional: He had a fully restored, full-sized locomotive on his property and would occasionally wear loud outfits to the office just to see if anyone was pay-

ing attention. Kimball had been reading the Collier's series and became fascinated with the notion that actual space travel was just around the corner. On April 17, 1954, Kimball and two colleagues met with Walt Disney and began mapping out a direction for a program on the topic.[+]

Kimball not only understood the show's potential built-in audience, but also that its appeal needed to be broadened. "The facts are fascinating," Kimball told Disney during the meeting, "but if you lighten it up with cartoons or something, it would make a complete family deal." Disney agreed, but later cautioned his staff to make sure the line between fact and fantasy was clear.["]

By the end of the meeting, the famously frugal Disney was so taken by the idea that he handed Kimball a blank sheet of paper and told him to "Write your own ticket," a sequence that left witnesses flabbergasted. Within a month, the "Rockets and Space" program had evolved into a two-part episode. Eventually, Disney would pour $1 million into three one-hour programs on space, an unheard-of financial commitment for 1950s television.[#]

While Disney fare often was pure escapism, its chief demanded a reliance on scientific realism for the Tomorrowland TV project. "I think that's very important for this series," Disney said during a May 14 meeting, "a science factual presentation."[$]

For the shows to be "science factual," Disney needed a strong base of technical know-how. Not surprisingly, the studio drew upon the expertise of the Collier's team, which over the previous two years had successfully convinced many Americans that space travel was more than wishful thinking by producing concrete data then explaining it in layman's terms. Ley came aboard first, joined a couple of months later by von Braun, who first had to negotiate a contractual release from another producer whose proposed space series for CBS was foundering. Heinz Haber, a specialist in space medicine who contributed to the Collier's series, rounded out the scientific team.[*]

Von Braun, in particular, held Disney spellbound as he shared his vision for space. "Walt listened wide-eyed, his mouth open in pure rapture at what he was hearing," Kimball would recall years later. "I realized then how fascinated he was with things scientific and with the scientists themselves."[&]

During production of the programs, von Braun would don his Army hat by day, consulting with Los Angeles-area rocket contractors, then moonlight at the Disney studios. The working relationship between the space experts and the Disney staff was similar to that which occurred during production of the *Collier's* series. Von Braun first would sketch his spaceships, which were slightly scaled back from his earlier conceptions, not only to avoid copyright problems with the magazine but also as a response to criticism from scientists that his ideas were much too grandiose. Von Braun then reviewed the scale models produced by the Disney artists and also provided a wealth of information on an array of technical details. The sessions often lasted long into the night, fueled in part by coffee and pastries served by a shapely and well-paid female artist who was instructed to cue up the classical music on the tape player and keep her considerable pictorial skills to herself.*'

The *Disneyland* television series premiered in late 1954 and soon was garnering large audiences for a desperate ABC, but these early ratings would look paltry after the airing of the "Man in Space" episode on March 9, 1955. An estimated audience of at least 42 million Americans watched on their tiny, black and white screens as Walt Disney began the program by telling viewers the following hour would integrate "the tools of our trade with the knowledge of the scientists to give a factual picture of the latest plans for man's newest adventure." Disney had decided to have all three experts appear on camera, the benefit of added technical authenticity outweighing concerns about the trio's noticeable German accents, ¹ and their comments were skillfully merged with tricks of the Disney trade. This merging of art and science was used to great effect during Haber's segment on the effects of weightlessness, his narration accompanying the animated gyrations of "homo sapiens extra-terrestrialis," a cigar-chomping character whose twists, turns and rolls were superimposed on a grid.*(

Toward the end of the program, von Braun introduced his rocket, which now sported a fourth stage designed largely to avoid legal trouble with *Collier's*. Its designer told viewers, "If we were to start today on an organized, well supported space program, I believe a practical passenger rocket could be built and tested within ten years." A spectacular Disney animation followed, depicting a launch of von

Braun's rocket on a Pacific island "where man is dedicated to just one cause–the conquest of space," said a narrator.[*]

In total, the broadcast of "Man in Space" succeeded in its goal of clearly laying out the specifics of space travel in an accurate yet entertaining manner. "With solid scientific information and his own brand of humor," wrote *Washington Post* critic Lawrence Laurent, "Disney demonstrated that complex subjects can be explained to all levels of education and intellect."[**]

The airing of "Man in Space" had impact well beyond the general public and television critics. At least one high-level Soviet space official heard about the film and asked the president of the International Aeronautical Federation for advice on how to obtain a print from the studio. A special pre-screening of the film for more than six hundred members of the American Rocket Society at the new Disneyland garnered mostly favorable reviews from the technically oriented crowd. And one story, perhaps apocryphal, had President Dwight Eisenhower asking Disney for a copy to show to officials at the Pentagon. The Eisenhower-Pentagon story may or not be true, but Kimball did float the idea of promoting the next space episode by claiming that "Man in Space" had spurred the president's July announcement of a planned 1957 launching of the first U.S. satellite. "For God's sake don't put it that this show triggered the presidential announcement," von Braun wrote back, fearing that the White House's reaction would seriously hamper actual spaceflight efforts, and the promotion was scrapped.[&+]

As it turns out, a presidential seal of approval was not necessary for success of the second Disney space program, "Man and the Moon," which aired the final week of 1955. In the episode, von Braun unveiled the "bottle suit," a small, one-man space vehicle with multiple mechanized arms designed to work on assembly of the space station, which would be 250 feet in diameter and be supplied with electrical power by means of a nuclear reactor. To demonstrate the trip from the station to the moon, the Disney producers chose live action over animation, employing studio actors on sets built to replicate von Braun's designs. At one point, a meteor struck the spaceship, and a bottle suit-clad member of the crew emerged to make the necessary repairs.[&"]

Despite Disney's insistence on being "science factual," the program did take a few liberties. Scientists, both real and aspiring, wrote in to protest the "whoosh" made by the rockets as they traveled behind the moon, noting that there is no sound in space. Years later, Kimball would defend such embellishments as necessary aspects needed to achieve the desired balance between fact and entertainment.

"That is the license you have to take," Kimball would later say. "Von Braun always went along with it. Willy Ley would say, 'You vud not hear the sound of it.' And that's the difference between von Braun and Ley. That's why von Braun sold the space program. He had imagination."[&#]

The following day, a reviewer for *The New York Times* called Disney's moon episode "a television treat ... that combined scientific fact with diverting fancy." Observing a group of children who were watching the program, the *Times* writer noted that while the kids doubted some of the scientific information–the moon's temperature fluctuations of more than four hundred degrees were a bit hard for the youth to grasp–"they attended almost all of the show diligently. They often were amused and they accepted a few facts about the earth, the moon and the atmosphere that they never had heard before.[&$]

"Considering that this knowledge was being absorbed voluntarily during holidays from school, it would seem that Mr. Disney and television really scored a coup." So had von Braun, at least in terms of his media career. In his day job, von Braun was regrouping from a significant professional setback.[&⁑]

It would have been easy for Wernher von Braun to savor life on New Year's Eve 1955. Now a U.S. citizen, he had a beautiful German wife, two adorable daughters and enough disposable income–thanks in large part to his *Collier's* and Disney ventures–to maintain a houseboat on a northern Alabama lake. In his primary job as chief of Army missile development, von Braun was becoming more secure. While von Braun's aspirations may have been directed at outer space, his military employers were focused on how his missiles could be deployed against enemies on Earth. It was weapons development that

kept von Braun in business, and in late 1955 business was booming. Von Braun's Redstone ballistic missile had its first successful test nearly two years earlier, and a newly awarded project dubbed Jupiter, a joint Army-Navy venture with a goal of delivering a nuclear warhead fifteen hundred miles to its target, seemingly bode well for he and the nine thousand other employees at the forty-thousand-acre Redstone Arsenal.&&

Yet, 1955 had been a discouraging year for von Braun, as his dream of space exploration appeared to be sinking in a morass of bureaucracy. The previous year, a group of military and civilian space experts, including von Braun and Whipple, had drawn up a plan to take artificial satellites out of the realm of concept and into reality. The Navy would develop the satellite and its instrumentation; von Braun's team would supply the rocketry to get the payload into orbit. Later, Air Force logistical support became part of the "Orbiter" project, which still needed Pentagon approval before launch.&'

This flowering of inter-service goodwill would be brief. In spring 1955, the Defense Department assembled a committee to choose one of three satellite launch projects for the International Geophysical Year, a global scientific collaboration set to begin in July 1957. It was unlikely the Air Force's highly speculative proposal could be completed in time for I.G.Y., leaving the decision between Orbiter, now being touted solely by the Army, and a new Navy project under the guidance of Milt Rosen, who had publicly dismissed von Braun's *Collier's* space plans as mere speculation nearly three years earlier at Willy Ley's space conference.&(

While von Braun believed his Redstone launch vehicle was much more proven than was the Navy's Viking, a majority of committee members were swayed by the Navy's promise of a larger and more scientifically complex satellite payload. In addition, the Eisenhower administration, fearing an international backlash if the satellite launch was perceived as a military excursion, favored Rosen's bid because it was deemed a "civilian" project: Its rockets were designed by the Naval Research Laboratory for scientific purposes and not weaponry, and its funding would come in part from the National Science Foundation.&)

In August 1955, the Navy's proposal, later to be named Vanguard, officially was chosen to launch the first U.S. satellite. A dismayed von

Braun wondered whether his success as a popular writer had antago-
nized those committee members who voted against his Orbiter bid.
Convinced that the Navy would not be able to adhere to its optimistic
development timetable, von Braun and his team covertly managed to
keep Orbiter alive by dressing it up as a reentry test vehicle, but Van-
guard had the clear right-of-way to the launch pad.[&*]

Soon, von Braun's seemingly secure position within the ballistic
missile program also would be in jeopardy. In fall 1956, Secretary of
Defense Charles Wilson ruled that the Air Force would manage fu-
ture development of intermediate range missiles, a decision that
would effectively put Redstone Arsenal's Jupiter project out of busi-
ness by the end of 1957. While some observers felt it was unlikely the
von Braun team would be broken up, its future suddenly was quite
cloudy.['+]

A resentful Army responded to Wilson's decision with action,
scoring the United States' first-ever successful launch of an interme-
diate range missile in June 1957, von Braun's Jupiter traveling fifteen
hundred miles from its Cape Canaveral launch site and underscoring
the three previous test failures of the Air Force's Thor. But the Army
also responded with words, using the media to court public opinion
in its inter-service squabble.['"]

One such effort held potentially dire consequences for a Redstone
Arsenal officer. Earlier in the year, Colonel John Nickerson was
charged with espionage for including Army-classified information in
a memorandum he produced for members of Congress and the press
that criticized the defense secretary's decision to privilege the Air
Force in missile development. Nickerson pled guilty to lesser charges,
but the subsequent sentencing hearing in June 1957 garnered a great
deal of national press coverage. The most prominent witness was von
Braun, who not only testified in defense of Nickerson ("any trouble
he may be in now is a direct result of his dedication") but also trum-
peted the recent success of his own rocket ("I have no doubt that the
Jupiter is far superior to the Thor"). The relatively light penalty–a pay
cut and one-year suspension of rank in a case that could have brought
a thirty-year prison sentence–resulted from Nickerson's distinguished
record and von Braun's testimony that the leaked information was
not deemed confidential by the Air Force. The episode also suggested
that while the Army may not have approved completely of Nicker-

son's methods, it had few problems with using the press to advance its agenda.'#

Another effort to promote von Braun's Army missile technology that summer was much more coordinated and much less covert. For three weeks in July, a sixty-three-foot-tall Redstone missile was parked in New York City's Grand Central Station under the sponsorship of Chrysler, the primary civilian contractor for the weapon. The Army would supply a bare-bones fact sheet on the missile: range of two hundred miles, diameter of seventy inches, deployment in Europe next year. The manufacturer would manage the logistics and cover the costs associated with transporting and assembling the rocket, which was no small task given that it weighed more than four tons even without fuel or a nuclear payload and required two railroad cars to haul all the components. When the shipment arrived at the Track 16 gate, workers had to remove brick from the station's doorway to get the components inside; they later had to cut a hole in the domed roof to accommodate cables necessary to raise the rocket to an upright position.'$

Once in place, the exhibit became a curiosity with a level of popular appeal that would have made P.T. Barnum proud. Few Americans had ever seen a missile, and so many commuters stopped to gawk at the hulking Redstone in its first hours of display that passengers on arriving trains had to wait to disembark until the crowd thinned out. Schoolteachers brought classes on impromptu field trips, the students asking questions about how the missiles were fueled and navigated. Parents were more likely to inquire about the unmanned weapon's cost and effectiveness against the Soviets. Unfortunately, not everyone involved with the exhibition had been briefed on the correct answers. One spectator asked an Army guard why the missile had a small porthole near the booster; so the pilot could see where he was going, the well-meaning soldier replied.'§

Despite such minor glitches, the display became such a cultural happening that it merited a cartoon in *The New Yorker* depicting Grand Central Station's information booth, a hole in the roof and an inquirer asking, "Where can I find the guided missile exhibit?" By the end of its three-week Manhattan engagement, the Redstone review had attracted an estimated 5.5 million spectators and provided a flood of positive press for Chrysler, the Army, and indirectly, von Braun.

By fall though, the same Grand Central visitors who had marveled at a six-story-tall American rocket would be rendered anxious by a Soviet sphere just slightly larger than a basketball.'&

Americans had been warned. As early as mid-1955, U.S. press outlets were reporting Soviet intentions of launching a satellite during I.G.Y., and by June 1957, Soviet scientists were telling foreign reporters that their satellite would be in orbit no later than the end of the year. But given the Soviets' penchant for secrecy and the mutual distrust between the two superpowers, such claims often were met with great skepticism from the West, if not dismissed outright as blustering propaganda. In August 1957, many American reporters had doubted Soviet reports of the first successful test of an intercontinental ballistic missile, questioning whether the Soviet definition of "successful" included the missile actually flying the allotted distance or hitting its target.''

There was no doubting the Soviets when Sputnik went into orbit on October 4, 1957, in part because Americans could experience it themselves and not just rely on proclamations from *Pravda*, the USSR's most prominent newspaper. Radio operators, both amateur and professional, located from Halifax to San Francisco, described noises over the airwaves that evening that ranged from "pinging sounds" to "like the sound of a cricket," which was the call of the satellite's signal to the Earth below. NBC and CBS broke into evening commercial radio and television programming to transmit Sputnik's signals to bewildered audiences.' (

It was a Friday afternoon when news of Sputnik's orbit broke in the United States, and few officials in Washington were available for immediate comment to the media. Most diplomats had already left for the weekend, Congress was out of session, and President Eisenhower, relaxing at his Gettysburg retreat, left it to his press secretary to convey a lack of surprise at the Soviet feat.')

America's most popular space expert would be absent from the immediate press coverage as well. CBS sent a Birmingham television crew to the gates outside Redstone Arsenal, and the installation's phones rang incessantly with queries from reporters and broadcasters. But there would be no statement forthcoming from von Braun or

any members of the Huntsville team, at least immediately, under or-
ders of the new secretary of defense, Neil McElroy. For several days,
von Braun was noticeably absent from American coverage of the
Sputnik aftermath, one news article reporting he had gone into seclu-
sion.'*

Other prominent scientists were not so constrained in their public
reactions. Six years earlier, Joseph Kaplan and Fred Whipple had
helped von Braun convince *Collier's* to tell the story of space explora-
tion, now they were tracking the new artificial satellite and trying to
put it in perspective for the nation's press. Kaplan, now chairman of
the United States National Committee for I.G.Y., emphasized the
positive: "From the point of view of international cooperation the im-
portant thing is that a satellite has been launched." Whipple was less
sanguine, ominously suggesting that the successful launch of the 184-
pound orb–eight times larger than any satellite in American devel-
opment–"indicates the Russian potential in the area of missiles," with
their prospective ability to be successfully launched with nuclear
warheads at U.S. cities.¹One astronomer went further the following
day, telling NBC commentator Paul Taylor that the "incredible stu-
pidity" of the Vanguard decision allowed the Soviets to gain superi-
ority in space. (+

Indeed, much of the post-Sputnik press scrutiny focused on the
decision two years earlier to forgo von Braun's Orbiter project and
pin U.S. hopes on Vanguard, which subsequently had become mired
in production delays and an inability to stay within budget. In the
same issue of *The New York Times* that announced Sputnik's launch-
ing, reporter Richard Witkin wrote that a number of leading scien-
tists, none of whom were named in the article, believed that the
United States would already have a satellite in orbit if the von Braun
plan had been allowed to flourish. It is not known whether any mem-
bers of the Huntsville team were clandestine sources for the story, but
it wouldn't have been without recent precedent: The slap on the wrist
given Colonel Nickerson earlier in the year would have been little de-
terrent for someone determined to bring perceived Pentagon slights
to light. ("

The finger-pointing turned into full-blown controversy a few days
later when high-ranking Army officials involved with the missile
program stated on the record that Orbiter could have been success-

fully in orbit two years previously–"the Army group thought it up, said we could do it, and by God we would have done it," said one general–if not for Navy interference. Another general declared, "Quote me as saying that the wisdom of this course of action [Vanguard] remains to be evaluated. It did not result in the first world satellite." In addition, a high-level rocket designer at Redstone Arsenal called the Sputnik launch "a lost battle in the cold war" and called for an investigation. (#

Swiftly, the top level of the Army moved to quell the expanding furor by ordering its missile experts to stay silent, with limited effect. Within a couple of days of the Army edict, a wire service story recounted the Vanguard decision and told of the Huntsville team's disappointment and ultimate belief their rocketry would have made the difference. One member of the von Braun team, making it clear his play to the court of public opinion, said, "Now, the newspapers and all the radio and other comments about the Russian satellite are making the grassroots population of this country aware of the true picture. When the confusion dies down, they may take another reading in Washington and we will find out where we are headed." Later in the month, crusading columnist Drew Pearson reported that six satellites sat abandoned in a warehouse at Redstone Arsenal, and that auditors under the direction of the Eisenhower White House had visited the site earlier in the year to ensure that no Army money was being spent on satellite development. (\$

The Army's gag order would soon cave in under the weight of press requests for von Braun. While he still could not talk about the Vanguard decision (he already had a long-standing order to not comment on specifics of either the Soviet or U.S. programs), he could share his views on himself and the overall state of the space race. Less than three weeks after Sputnik's launch, *The New York Times Magazine* invited its readers to "Visit With a Prophet of the Space Age" and learn more about a man whose predictions of space travel suddenly didn't seem so otherworldly.

The story carried many of the earmarks of Daniel Lang's *New Yorker* piece of more than six years earlier, especially concerning von Braun's German past: The V-2 was wrongly put to military purposes, as a man of science he was not to be blamed (this time, his culpability likened to that of a U.S.O. girl who hands out doughnuts to soldiers),

and, besides, he once had been jailed by Heinrich Himmler, head of the Nazi SS, for failing to produce rockets quickly enough. The *Times* article was not entirely flattering–the reporter suggested that von Braun's somewhat unruly blond hair "gave him the look of a cherubic Mephistopheles"–but the overall effect was to emphasize that von Braun was now "almost completely Americanized," as he easily referenced catchy advertising pitches of the day, discussed hotrods and called his youngest daughter his "Alabama belle." (%

As for Sputnik, von Braun was at once complimentary to the Soviets, scornful of those who previously doubted the scientific possibility of a successful satellite launch, and livid that his new country didn't do it first. Most tellingly, he distanced himself from the interservice squabbles over the direction of the U.S. satellite and missile programs. "Most of us feel strongly that we should be Americans first and Air Force, Army and Navy men second," von Braun said. "Perhaps now there will be freer exchange between the services." A high-level government agency might be needed to better coordinate the various military and civilian space efforts, he added. (&

On November 3, 1957, the Soviets launched their second Sputnik, this time with a canine passenger, causing even greater consternation among the American public. Days later, the Pentagon announced that the Army would be allowed to launch satellites in addition to the Navy's Vanguard program in an attempt to catch up to the Soviets, albeit with the caveat that if Vanguard were successful, the Army launches would be scrubbed. Von Braun was back in the satellite game, and his return was marked with a lengthy exclusive question-and-answer with the Associated Press that annoyed people on both sides of the political aisle. Von Braun renewed his call for a governmental agency to oversee long-term U.S. space aspirations, a suggestion that was unpopular with fiscally conservative allies of President Eisenhower. Von Braun also seemed to criticize the previous administration when he said the United States was at least five years behind the Soviets in missile technology, largely because of neglect immediately after World War II. Citing the desire of a war-weary country to focus on consumer goods and services, von Braun said near the end of the interview that "There was no ballistic missile development program in the United States between 1945 and 1951 because there was no obvious need for it, no interest for it and no money for it."

Some supporters of Harry Truman did not read past the headline though and accused von Braun of unfairly pinning the perceived U.S. missile lag on the former president. ('

Von Braun's reputation as a galactic guru would be further cemented in mid-November when his picture graced the cover of *Life*, which in 1957 had a circulation of more than 6 million copies targeted toward a predominantly white, middle-class, God-fearing constituency. Derided by critics as an "editorial variety show" focused just as often on the trivial as on the consequential, *Life* regardless was an icon of 1950s American culture. ((

Life was particularly renowned for its photography, and the magazine's package on von Braun included twenty-three photos, the content of which reflected not only the political and social inclinations of its subscribers, but also the popular press's seeming disinterest in more deeply exploring his Nazi past. Only three of the von Braun photographs were from his days in Germany (including one of von Braun walking with Nazi brass at Peenemünde), fewer than the number of pictures showing his Huntsville home, wife, and children. ()

The accompanying articles contained an element of fortuitous timing for both *Life* and its subject, as news of the second Sputnik launch broke as the interview was being completed in Huntsville. Far from being the Nazi crackpot some suggested when he first presented his ideas to the American public, von Braun was now "The Seer of Space," a "thoroughly Americanized German" and the "free world's top practical rocket man" who represented the country's best hope for catching up to the Russians, a few dissenters notwithstanding. (*

"One lady wrote that God doesn't want man to leave the Earth and was willing to bet me $10 we wouldn't make it," von Braun told *Life*. "I answered that as far as I know, the Bible said nothing about space flight, but it was clearly against gambling.")+

Von Braun may not have been a gambler, but he was not averse to risk-taking. Presenting his audacious, tangible plans for spaceflight to the American public in the early 1950s had exposed von Braun to the potential peril of alienating dissenters in the scientific community and to immense ridicule if his calculations proved foolhardy. While manned exploration of the moon was still a distant dream, the successes of the Sputnik launches somewhat vindicated von Braun's vision and certainly solidified his public reputation as America's oracle

of outer space. However, the Russian triumphs also denied von Braun the spoils garnered by those who had put the first artificial satellites in orbit, an accomplishment he had so desperately desired. Now, as 1957 neared its close, the prophet faced the prospect of not even being the first American to successfully orbit a satellite. The Navy was rushing Vanguard to the launch pad.

CHAPTER 2

"Do First, Talk Second": Information and the Early Space Shots

For more than a century, the Cape Canaveral lighthouse had warned sailors to steer clear of its scraggly shores. Not that the mariners would have found much of value had they landed on the inhospitable plot of Florida real estate. Human inhabitants were few, their challenges plentiful: Oppressive summer heat, scraggly terrain, and clouds of ferocious mosquitoes welcomed those who did dare settle.

But by the late 1950s, more than fifteen thousand workers each day were streaming to the Cape. While development and assembly of long-range missiles was based at contractor and military sites across the country–from Baltimore to San Diego, Detroit to Huntsville–their trials took place at a site officially known as the Air Force Missile Test Center but dubbed "Missileland" or "Earthstrip No. 1" by Cape residents and center workers. There, twice a week on average, scientists, technicians, military brass, and captains of industry would hunker down in squat, concrete blockhouses to observe and record the latest excursion of a Redstone, Thor, Atlas or one of the other 20 or so missiles under consideration by the Army, Navy or Air Force.[1]

As the 1950s progressed, consumers of American media had become increasingly interested in how the United States was faring in its head-to-head battle with the Soviet Union for missile supremacy, a vital contest not only for the nation's defense but also for beating the Russians into space. For most of the decade though, the small press contingent covering the Cape got little help from official sources. The launch facility was strictly off-limits to unauthorized personnel, and

the Air Force, which was in charge of all launch information, had no interest in extending credentials to the media.

In some cases, if the mission was not top-secret, Air Force public affairs officers might draft a terse statement containing the name of the missile, launch time, and, perhaps, whether the test was successful. The document would then make its way to Pentagon censors, who would likely strike a few lines. If the remaining text passed security muster, an official would then, in a sign suggesting indifference, stamp the cover sheet "no objection": The information could be made public if someone down the line chose to do so. On occasion, an enterprising reporter might glean a bit more information by talking to an officer who wanted more credit for his branch's success, or who believed the official lack of candor gave the public a mistakenly negative impression of the United States' status in the missile race.[2]

The layout of the Cape's launch facility made it impossible to veil completely the missile program. There were two public beaches just a few miles away: Titusville, to the north, was favored by some photographers, but most of the press set up shop south of the Cape at Bird Watch Hill, a knoll just outside of Cocoa Beach. It was better than no view at all, but the perch had significant drawbacks. On occasion, a cantankerous Air Force officer might send a low-flying helicopter over the hill to stir up sand and ensure photographers couldn't focus on the launch. More often than not, the Air Force simply froze the media out, in more ways than one: With no announced launch time, reporters and photographers often endured long, cold, wind-blown vigils in the winter months. To break up the monotony during night launches, veteran correspondents might trick a cub reporter into watching the lighthouse rather than the actual launch pad, but more often, the waits were long, dull, futile affairs.[3]

With official information difficult if not impossible to come by, reporters turned to the locals, who were extraordinarily plugged-in to the patterns at the Cape. One of the most-repeated stories centered on a weary photographer who was in midst of a lengthy vigil at Bird Watch Hill. He had nearly persuaded himself to pack up his gear when a small boy walked up and said, "Get your camera ready, mister. It's going off in seven minutes." Like clockwork, the missile did.[4]

In some ways, such accuracy was not all that surprising. Most of the area's residents either worked directly in the missile program or

knew someone who did. But the ability of locals successfully to predict launches also stemmed from keen powers of observation. A dozen generals sitting down for drinks at a motel lounge might be a tip-off that something big was brewing. Conversely, a group of Cape technicians failing to show up at the bar for their usual happy hour libations could be another clue. An airport runway worker might see Wernher von Braun stepping off a transport plane, a waitress might notice a team of Chrysler executives having lunch at the Missile Bar-B-Q, and before long, Highway A1A would be lined with cars filled with residents headed to the beach for a picnic and a missile launch rather than dinner and a movie. "The security here is intense," one Cape housewife told a reporter in 1957, "but the grapevine is terrific!"[5]

The grapevine, in many ways, had rendered the Air Force's minimal information policy obsolete by late 1957. The Cape "isn't very secure anymore," one officer lamented to a magazine reporter. "The word always gets out." This despite the fact that in more than seven years of operation and more than 450 missile tests, no Cape Canaveral launch had been preceded by official media briefings or the release of press kits. That would change as the Navy prepared to launch Vanguard and its satellite payload.[6]

One reason the Vanguard launch would be different was that President Dwight Eisenhower had let the cat out of the bag two months earlier. Looking to calm public alarm, Eisenhower met with the press days after the Soviets launched the first Sputnik. While the president emphasized U.S. strengths in ballistic missiles and told reporters the Soviet feat had raised his apprehensions about the country's defense "not one iota," he also announced that a Vanguard test was scheduled for December, much to the horror of the secretary of the navy, who would write Eisenhower to express his dismay.[7]

Eisenhower's prepared statement had emphasized that the United States was not in a "race" with the Soviets and that a full-scale working satellite wouldn't be launched until spring 1958. Despite these caveats, many in the American press portrayed the pending Vanguard test as an "answer" to Sputnik's initial triumph in space: "Like it or not," *The Washington Post* wrote in an editorial shortly after Eisenhower's announcement, "this country is in a race, and we had better start to run." Congress added to the pressure as well, with sev-

eral legislators calling for investigations or a new satellite and missile program on the scale of the "Manhattan Project" that developed the atomic bomb.[8]

The Vanguard project toed a narrow line between military and civilian purposes, which also became a natural source of friction between the press and information specialists. Although the project was based on the Navy's technology and would be operated under Naval responsibility, it was deemed a civilian project under the auspices of the International Geophysical Year. Given such, the press argued, the old rules about access should no longer apply.[9]

The launch site though was still controlled by the Air Force, which largely stuck to its tight-lipped policies for Vanguard. A case in point: Officers refused to give weather information—a vital factor in any launch—to the press even though it was available on a base telephone recording. Although the Navy was in charge of the Vanguard program, it had no information presence at the Cape. And while the Pentagon promised press access to the "official" launching of the larger satellite scheduled for the following year, it made no such provisions for this highly visible "test."[10]

An assistant defense secretary for public affairs took stock of the situation and concluded that it would be better to cede some accommodation to the press than to engage in a futile effort to plug the leaks coming out of the Cape. In November, going over the heads of Air Force information officers and ignoring the protests of Navy scientists, Murray Snyder and a deputy named Herschel Schooley began making Vanguard fact sheets available to the growing media contingent. For photographers' use, two flatbed trailers were dispatched to nearby beaches. The officers also promised to alert media assembled on Bird Watch Hill when a launch had been scrubbed. As the mission neared, Schooley had expanded the effort to include press conferences.[11]

The Defense Department's plan was intended to better manage the message and stamp out rumors, but leaks to the press kept springing up as the launch drew closer. In late November, newspapers were quoting sources close to the program that Vanguard's launch was set for December 4. Soon after, Martin Company, the primary civilian contractor for the program, unveiled Vanguard's "baby satellite," while on the same day, an anonymous source told the *Christian Sci-*

ence Monitor that the United States might launch a "full-sized" twenty-one-pound satellite, rather than the grapefruit-sized miniature orb, in order to maximize propaganda value of a successful mission.[12]

The Pentagon's fact sheets stressed that an orbiting satellite was not a primary goal of the Vanguard test, and a Martin executive went further to temper pre-launch enthusiasm, telling those assembled at a banker's convention that "I won't be surprised if it doesn't work at all." Such proclamations were largely overlooked by a press more intrigued by comments such as those of a Pentagon missile director who boasted that the United States could have Soviet-sized satellites "whenever we want them." Despite its intentions, the Pentagon's off-the-cuff information effort did little to keep expectations from spiraling out of control as the launch neared. "Thus this week's Vanguard shoot cannot be divested of its historical quality," wrote one *New York Times* reporter, "whether it is officially described as a preliminary or the main event."[13]

The ensuing countdown only served to further heighten the nation's anxiety, as weather and technical difficulties kept pushing the mission back. Over a ninety-six-hour span, Vanguard's launch was delayed or scrubbed at least fifteen times, each hold decision transmitted over American electronic media and chronicled in the nation's newspapers. The printed media reported not only the delays but also apparent dissension within the ranks. A midnight curfew, imposed by Vanguard officials wary of worker fatigue, drew the ire of some Canaveral technicians when one launch attempt was scrubbed less than fifty minutes away from the end of a half-day countdown. Reporters likewise were piqued when the Bird Watch Hill notification agreement fell through, and members of the press were left to wait for a launch that had been canceled hours before.[14]

On December 6, the weather cleared, the technical problems were seemingly fixed, and Vanguard was set for a late-morning liftoff. CBS had gained a strategic foothold in the race to be first to report the feat, having rented a beach house situated miles from the Cape but with an advantageous long-range view of the launch pad. At the zero-hour of 11:45 a.m., a young Harry Reasoner, armed with binoculars, was positioned on the porch. Inside the house, the wife of another CBS correspondent kept a telephone line open to headquarters. As Reasoner would later recall:

I saw an unmistakable flash of flame and the pencil-thin white rocket began to move. "There she goes!" I shouted. "There she goes!" shouted Virginia into the telephone. "There she goes!" shouted the CBS executive in New York, hanging up the phone and charging off to get the bulletin on the air.

We beat ABC and NBC certainly. There was only one problem. A tenth of a second after I shouted, "There she goes!" I shouted, "Hold it!"[15]

The problem was that Vanguard didn't go anywhere. The rocket, and the hopes of a nation, unceremoniously rose four feet off the launch pad before crumpling into a ball of flames. The tiny satellite was ejected, unharmed, into the Florida thickets, its transmitter sending out beeps that sounded ever so mournful. "Why doesn't someone go out there, find it, and kill it?" asked newspaper columnist and *What's My Line* panelist Dorothy Kilgallen, summing up the emotions of many Americans.[16]

It was only a test, those close to the missile program would remind Americans, and such trials had a low success rate. But Vanguard had long ago morphed from audition to opening night, thanks in part to obsessive media coverage. Its malfunction now was treated as a disaster of epic proportions, "one of the best publicized and most humiliating failures in our history," in the words of then-senator Lyndon Johnson.[17]

The humiliation was felt worldwide. The international press called the U.S. effort "Flopnik," "Dudnik," and "Sputternik." And that was from America's allies. A pro-Communist newspaper in Rome carried a cartoon of the two orbiting Sputniks yawning while waiting for their American counterpart to join them. At U.N. headquarters, Russians jeered their American counterparts by asking whether the United States would like technical assistance under a Soviet program designed to aid underdeveloped nations.[18]

The Soviet media, which didn't subscribe to the American notion of "breaking news" and usually waited well after an event's conclusion to write a single, definitive, propaganda-laden account, reported the Vanguard debacle with great haste, by their standards. The news agency Tass released a story with plenty of facts and few Communist overtones a mere ninety minutes after the missile's explosion and added a rare update thirty minutes later containing comment from the American scientists. Within a couple of days, *Pravda* printed an

article more rife with Soviet orthodoxy, ridiculing the Vanguard orb as "no larger than a baby's ball" and accusing politicians of forcing a hurried launch in hopes of using the orbiting satellite as a diplomatic sledgehammer against nations wary of allowing U.S. military bases on their soil.[19]

Everyday Americans were well aware of the international ridicule being heaped upon their country, but their frustration was aimed not at scientists for failing to develop a successful missile but rather at information specialists for allowing such close scrutiny. While some citizens thought the public airing of the Vanguard failure demonstrated a strength of America over its Soviet counterpart—"Even though we failed, it is a great thing we can talk about our successes and failures as we go along," said one New Yorker—most felt that the nation would be better served by following the Soviet policy of keeping a satellite under wraps until it was in orbit. In a sampling of person-on-the-street opinions compiled by *The New York Times,* a bartender said that Vanguard "should have been top secret. The rest of the world will think we're damn fools in view of what the Russians have done." A Wall Street stockbroker added, "I think the way the whole thing was handled was very stupid. We should have kept our mouths shut, the way the Russians did, until we got our missile aloft." A professional public relations representative noted, "We put out a lot of advance publicity, so this failure makes us look foolish. Had we kept quiet until we made a successful launching, we would have inspired the world."[20]

Newspaper editorial commentary also faulted the Vanguard publicity effort. "When the driver has stalled the car at a railroad crossing it doesn't help for back-seat drivers to intrude," wrote the *Christian Science Monitor.* "Let him get the car started. Then and only then can the rest of us join in the celebration."[21] A *New York Times* editorial concluded, "The men charged with the responsibility of our satellite and rocket program will serve their country best if they say as little as possible about their progress until they have concrete achievement to report. An attitude of putting deeds before words is clearly in the best interests of the country."[22]

On this issue at least, editorial page writers and legislators seemed to be largely in concert. The chairman of the House Committee on Government Information called for more openness rather than less in

the missile and satellite programs, but a congressional din clamoring for silence drowned his lonely voice. The Senate Armed Services Committee chairman suggested those in charge of the project would have been better off had they "launched the rocket in the middle of the night ... than to have had all this fanfare over a dubious experiment." Senator Hubert Humphrey said the technical failure of the rocket was not as shocking as "the enormous amount of razzle-dazzle, Madison Avenue publicity which the Administration insisted on pouring out to the world." Republican congressman Gerald Ford agreed in part with his Democratic colleagues, but added, "the press must share the blame" with its incessant coverage and "overemphasis on a minor technical defeat."[23]

Sufficiently chastised, the Pentagon and the Vanguard team ended 1957 by telling reporters that another launch was being prepped for early the following year but that no advance announcement would be made concerning the attempt. In mid-January 1958, as Navy technicians assembled a new Vanguard entry on its Cape launch tower, they could look at a similar platform a few hundred yards south and see their Army counterparts feverishly putting together Jupiter C, a revved-up von Braun Redstone augmented with clusters of small solid-fuel rockets from the Jet Propulsion Laboratory. Together, these rockets would, Army engineers hoped, lift a thirty-one-pound, bullet-shaped satellite into Earth orbit. It still appeared the Army would vie for the honor of launching the second U.S. satellite in space though, as Vanguard still had first clearance for launch.[24]

As the dueling rockets were being prepared, the relationship between Cape commanders and the press worsened. At Christmas, Major General Donald Yates banned photographic equipment from the public beaches surrounding the launch facility, and on January 13 he warned the press that he was considering drastic action to "keep from giving information to the Russians." The next day, unexpectedly, Yates offered something of a truce. Yates would brief newsmen about upcoming launches, but only if the reporters agreed to not print or broadcast anything until there was "fire in the tail" of the rocket at liftoff. In addition, reporters who continued to overdramatize interservice rivalry in the missile program would risk losing access to launch information, Yates warned. It was certainly far from the full access many newsmen desired, but it was a step in the right direction,

at least making the never-ending Bird Watch Hill vigils unnecessary and allowing media outlets to make better plans for their coverage.[25]

Eleven days later, with a mute press watching from various locations established by Yates around the Cape, Vanguard's countdown reached T-minus fourteen seconds before being stopped by a fuel leak in the rocket's second stage. The drama went unreported under terms of the information agreement, but members of the media now had to start preparing for another launch: The Army would finally get its chance.[26]

On the final night of January, eighty-five newsmen gathered in an RCA building just more than a mile away from the Cape's launch towers. Von Braun's Jupiter C, its shape enhanced by a series of Air Force floodlights, was clearly visible to a media contingent that had endured similar waits each of the previous two days, only to see the planned launches scrapped due to high winds. Absent on this cold Florida night was the rocket's chief engineer. In an attempt to reduce the number of media members at the Cape and avoid the frenzy that accompanied the failed Vanguard test in December, von Braun and other prominent members of the technical and scientific team had been shuttled to Washington, where a press conference had been planned if the launch were successful.[27]

At about 10 p.m., A *London Daily Telegraph* reporter slipped into a Cape phone booth, connected with the home office, and instructed his editors to hold the front page: "It looks as if the bird might go up tonight." Forty-eight minutes later, the four-stage rocket blasted off from the pad, many in the American press contingent shouting encouragement as it sped out of sight. Seven minutes after liftoff, three short rocket blasts jettisoned the satellite at a speed of eighteen thousand miles an hour into, it was hoped, Earth orbit. Just before 1 a.m. eastern time, a tracking station near San Francisco picked up the satellite's signal as it crossed overhead. By whatever name–Explorer, Alpha 1958, "our Sputnik"–the satellite had made its first trip around the Earth and officially brought America into the space age.[28]

The timing of the launch meant that morning newspapers would have to scramble to chronicle Explorer for their readers, but television broadcasters showed a great deal of hustle as well. The world may have been focused on the space race between the United States and the Soviet Union, but competition between America's two leading

television networks–NBC and CBS–was heating up also. On this night at least, NBC seemed to gain the upper hand, going on the air three minutes after liftoff. David Brinkley first told viewers of the successful launch, his report interrupting the debut of his new "Comment" public affairs show (themed that night, coincidentally, on the missile program). Twenty minutes later, NBC reporters Roy Neal and Herb Kaplow gave viewers eyewitness accounts of the launch, but it was after their signoff that the real scramble began. As Kaplow remained at the Cape for updates, Neal and two photographers sped to a nearby private airfield where the network had chartered a small plane and hired a pilot. The flight to Jacksonville was uneventful, but the subsequent drive from the airport to the local NBC affiliate was not, as their car suffered a blown-out tire. Riding on the car's rim, the crew continued on to the studios of WFGA, where they transmitted film of the launch back to New York. Late night NBC viewers saw footage of the Jupiter C at 2:06 a.m., just more than three hours after its actual launch, and several hours before CBS was able get its footage on the air.[29]

With Explorer safely in orbit, its three scientific masterminds entered an auditorium in downtown Washington in the wee hours of February 1 and were greeted by rousing applause from a packed house of journalists generally not known for outbursts of admiration. For more than two hours, the trio fielded questions, their answers recorded and transmitted by a horde of television cameramen and audio technicians. Finally, around 3 a.m., someone suggested that the American team lift up the scale model of the rocket, and a bevy of cameras began clicking to capture a moment that would become the iconic image of the mission. Those buying afternoon newspapers would see three jubilant men of space hold the mini-Jupiter C over their heads in triumph. William Pickering, head of the Jet Propulsion Laboratory, manned one end. James Van Allen, whose scientific instrumentation on the satellite discovered the radiation belt that would eventually garner his name, supported the center. At right was a smiling Wernher von Braun, who six years earlier had captured the nation's imagination with his articles in *Collier's* magazine. Now, von Braun had brought the country a much needed, if largely symbolic, achievement in space exploration.[30]

"We can compete only in spirit, and not in hardware yet," von Braun said, reminding the country that the Soviets had put much heavier and more sophisticated satellites into orbit. The Explorer feat, however, gave many Americans hope that manned space travel was closer to becoming reality, and U.S. media reinforced the notion that von Braun would be the one leading the effort. "Man belongs wherever he wants to go," von Braun said assuredly in a *Time* magazine cover story the following week, "and he'll do plenty when he gets there."[31]

With Explorer's success came a greater national commitment for space exploration. Space enthusiasts such as von Braun had long lobbied for an organization to coordinate the wide-ranging score of initiatives already under way and to create a long-term national plan for space travel. In October 1958, those suggestions turned into a full-blown federal agency. The new group's nucleus would be the forty-three-year-old National Advisory Committee for Aeronautics, but the agency would have greatly expanded duties and powers from those of its predecessor. The new National Aeronautics and Space Administration not only was charged with conducting its own research in its own facilities, working collaboratively with contractors, and launching space vehicles, but the agency would also set and implement policy for the overall direction of civilian space flight.[32]

The new NASA was handed a monumental task and one vexing question: How would it deal with the dispersal of information? Previous space-related missions were largely under military control, and given the tenor of the Cold War, facts about those operations were subject to high levels of secrecy. However, NASA's charter, established with the National Aeronautics and Space Act, required the new agency to provide "the widest practicable and appropriate dissemination of information concerning its activities and the results thereof." Aside from requiring two yearly reports to Congress, the act gave no mandates or guidelines for what "practicable" or "appropriate" meant, leaving it to administrators to figure out how to fulfill its information obligation.[33]

Work on that front began before NASA officially came into existence, and fortunately for the agency, its information point man had a

great deal of experience. Walter T. Bonney had been in charge of information for the old NACA and had a track record of good relations with the press, having won a public relations award from the Aviation Writers Association in 1956. Bonney had previously garnered more notice for NACA as a key player in development of American air power, but he recognized that in his new role, he would be speaking not only for an organization but also for an entire country's space program. "NASA will be employed as an instrument of U.S. policy," Bonney wrote in a September 1958 memorandum to incoming NASA administrator Keith Glennan, underlining the words to emphasize their crucial importance. "For the reason just stated, if for no other, the competence of NASA to communicate–to use effectively the techniques of information transmission–must be expanded to an extent very much greater than was ever conceived as necessary or desirable for NACA."[34]

In defining the role of his new information office, Bonney first acknowledged the Space Act's mandate "to provide the people of the United States with maximum information about the agency's accomplishments." What came next though in the memo was reminiscent of the inter-service battles of the pre-NASA era, when competing branches of the military vied for credit and continued funding from government: "We should speak of our work modestly, but with enough vigor to be heard (If we don't, others soon will clamor to take our space assignment from us.)."[35]

The twice-yearly reports were outlined with primary importance, given their mandate in the Space Act and their eventual role as evaluative instruments by policymakers. "It is recommended that the NASA Semi-Annual Report be prepared with a specific reader in mind–the Congressman," Bonney wrote, the words underlined for emphasis. "If this is accomplished, the Report will be widely read also by the American taxpayer, whose support NASA needs for its programs." In drafting these documents, Bonney emphasized the need for simple language and the "use of motion pictures and other visual materials as well as the written word." The agency needed to be truthful, but "In a very real sense, these documents must be considered as 'sell presentations,'" Bonney wrote, suggesting that the public's right to know was not as important as advancing the agency's best interests.[36]

The language in Bonney's memo promoted the spirit of openness–"We should be frank about our failures as well as our successes"–but candor had its limits, particularly in light of the high failure rate of missile tests. Bonney referred to a press blitz just weeks earlier surrounding the Air Force's attempt to send a missile to the moon. The Pioneer probe was preceded by intense media scrutiny and ended with highly visible failure when NBC viewers, watching on an exclusive seven-minute tape delay, watched the rocket explode seventy-seven seconds after liftoff. Bonney's memo also, indirectly, invoked memories of the Vanguard debacle, his language strikingly similar to that used by critics of its massive media buildup. "Whenever possible, we should talk about our projects <u>after</u> they have proved out, not before" Bonney wrote. He also recognized such measures "will not always be possible or even desirable," without speculating what those occasions might be.[37]

NASA also needed to communicate outside the borders of the United States, Bonney recognized, in light of Cold War tensions. "Our problem is not only to explore outer space for peaceful rather than military purposes but to insure that the world knows what we're doing," Bonney wrote, advocating ties with existing entities such as the State Department. Closer to home, the new agency would need to develop in-house publications serving those working at the various NASA research centers, draft procedures for managing media access for satellite launches, establish liaisons with other governmental agencies involved in space work, and assemble a team of "reporters" who could clearly gather mission information and present it clearly to journalists and the nation.[38]

It was a daunting set of responsibilities, and it quickly became clear that this new information effort would require not only a change in focus but also a significantly larger workforce than the half-dozen or so staffers Bonney had supervised in his previous job. "When you analyze the workload of the Office of Public Information as it was under NACA in light of the workload today, you arrive at a frightening conclusion," wrote deputy information director Herb Rosen in a November 1958 memorandum. "If we are to provide minimal services to the news media, we must work our current staff 10 to 12 hours a day, plus 10 hours or more spread over the weekend. But, as an agency trying to serve the news needs of the whole world, a minimal

standard is wholly inadequate." Rosen, presenting an organizational chart "developed between fire-fighting sessions," envisioned twenty-four information staff members at NASA headquarters working in four departments: News Bureau; Movies, TV and Radio; Special Events and Pictorial; and Reports. An additional seven staffers were needed, Rosen estimated, to handle public information duties at NASA centers across the country.[39]

By Christmas 1958, the NASA public information team was setting up shop in the Dolly Madison House in Washington, and the staffing problems were alleviated somewhat with seven new hires. Among the new faces was Dick Mittauer, who was assigned to work with members of the electronic media and had experience both in broadcasting and as a congressional press secretary. Harry Kolcum, a former Virginia newspaper reporter, came aboard, as did a young reporter from the *Washington Evening Star* named Paul Haney. In one of Haney's first tasks, he wrote a two-paragraph insert for a Lyndon Johnson speech in which he coined the term "astronaut." Otherwise, the main job was to "try to figure out what a public information officer should do," Haney recalled years later. The nature of the new agency's emergence, cobbled together with parts from various civilian and military entities, made the change of career even more daunting. "NASA, I like to point out to people, was sort of put together at a federal yard sale on a Saturday," Haney said, recounting how employees didn't "know what the hell they've got or how to account for it, where it is or how it functions, and that's exactly where NASA was."[40]

Bonney began to put some of the procedural framework in place during the first two months of 1959, ordering that all press requests be routed through the Office of Public Information. Another directive required each NASA center to establish its own public information office and coordinate its media efforts with headquarters. Such steps were necessary for the fledgling agency, but by spring, they were hardly sufficient as a new element was introduced to the space program: celebrity.[41]

They were seven of a kind, brought together for their technical skill, superior intellect, stable emotional makeup, and physical attributes. Each had volunteered for the chance to become the first Ameri-

can in space and each had survived perhaps the most grueling audition in the history of mankind. Out of 175 million Americans, only 110 had satisfied the minimum requirements: male, age less than 40, height less than 5-feet-11, excellent physical condition, college degree, military jet test pilot. In March 1959, thirty-two finalists were invited to attempt an exhausting series of tasks designed to test their ability to handle the stresses of space flight. Over the following weeks they were poked and prodded, baked at 130 degrees Fahrenheit and violently spun at forces a dozen times greater than Earth's gravity. They had been blasted with a series of earsplitting high-frequency noises and placed in pitch-black, soundproof isolation rooms for three hours. Each endured more than two-dozen tests of intelligence and personality under the constant watch of two psychologists assigned to live with each candidate.[42]

By the second week of April 1959, seven men remained, and they waited at Langley Field in Virginia to begin their transition from test pilot to astronaut. Each had served his country exceptionally: Scott Carpenter, Wally Schirra, and Alan Shepard with the Navy; Gordon Cooper, Virgil "Gus" Grissom, and Donald "Deke" Slayton with the Air Force; and John Glenn with the Marine Corps. Each was thoroughly versed in the hazards of his chosen career, a field where a split-second lapse in judgment or a tiny mechanical glitch could result in instant death, so they were prepared for the anxiety associated with sitting atop a sixty-foot-high tube filled with eighteen tons of explosive rocket fuel. But their military exploits, most conducted in obscurity, would do little to equip them for the onslaught of media and public scrutiny about to be thrust their direction. Of all the tests the Mercury 7 had endured, the most dreaded, for some, was the last: Meeting the American press corps.

A day prior to their public debut, the Mercury 7 were introduced to a new addition to the NASA information team, a diminutive dynamo named John A. "Shorty" Powers. At 5 foot, 6 inches and 145 pounds, his nickname seemed appropriate, but it belied his deep, baritone voice and unabashed self-confidence. Like the astronauts, he was a decorated military pilot: Powers flew transport planes during World War II, delivered supplies to Germans during the Berlin Airlift, and completed fifty-five bombing missions during the Korean War. Unlike most of the astronauts, he had experience dealing with the

press and public. In the mid-1950s, Powers became a primary de-
signer of a plan to create better relations between the Air Force and
civilians residing in the vicinity of its bases, no small task given the
roars and sonic booms that often shook the homes of those in the
flight patterns. By 1956, he was in charge of public information for the
Air Force's ballistic missile program and, collaborating with NBC's
Roy Neal, had helped arrange the elaborate near-live coverage of the
failed 1958 Pioneer launch.[43]

Now, just days after being transferred from the Air Force to
NASA, Powers addressed the chosen seven and tried to prepare them
for what was to come. He instructed them to immediately call their
wives and other family members, not only to share the good news but
also to alert them for the press torrent that would be unleashed the
following afternoon. Incredulous, Schirra initially scoffed at Powers'
prediction of a media frenzy and temporarily balked at calling his
family in Hawaii.[44]

Haney's assignment was to prepare the astronauts for their initial
press conference, and he did his homework by calling former *Wash-
ington Star* colleague Bill Hines and United Press International corre-
spondent Joe Mylar to find out what types of questions reporters
might ask. Through their vast military experiences, the seven astro-
nauts could probably handle any queries about the demands of flight
or their new mission, but Haney told them that the press would have
little interest in those aspects. "They're going to ask you about your
religion," Haney said. "And you can say 'none' or 'the Great Jeho-
vah,' or whatever, but make sure you [answer]."[45]

On the morning of April 9, 1959, the seven astronauts, accompa-
nied by Powers and other staff, boarded a plane at Langley Field for
the short flight to Washington. The unveiling of the astronauts was
hours away, but the press had caught word that they were to land at
National Airport and had staked out the Butler Aviation Hangar. As
the plane taxied in, Powers saw the mass of media assembled to get
an uninvited first glance at the nation's new heroes. "We turned right
around, taxied away and took off," Powers recalled later. "We flew
down the river until we were sure we were out of sight, then turned
around and flew back up the river and landed at Bolling (Air Force
Base). We called ahead and tried to get Bolling to give us a couple of
cars. By this time, some of the news guys were racing from National

Airport across the bridge trying to catch us at Bolling. We barely got away from them."[46]

At the Dolly Madison Building that afternoon, it quickly became clear that a former ballroom with creaky floors and no ventilation would be overwhelmed with a teeming mass of reporters, photographers, and film crews assigned to chronicle the beginning of a new era. NASA staffers navigated a maze of electrical cables strewn about the floor as they tried in vain to bring in enough chairs to seat everyone. Waiting restlessly behind a curtain as their 2 p.m. unveiling neared, the astronauts could hear the marginally controlled chaos, which only ramped up their anxiety.[47]

"Shepard, I'm nervous as hell," Slayton said. "You ever take part in something like this?"

Shepard smiled. "Naw." Pausing, he raised his eyebrow. "Well, not really. Anyway, I hope it's over in a hurry."

"Uh huh. Me, too," Slayton responded anxiously.[48]

At about 2 p.m., the astronauts were seated.

"Ladies and gentlemen, may I have your attention please," Walt Bonney began. "The rules of this briefing are very simple. In about sixty seconds we will give you the announcement that you have been waiting for: the names of the seven volunteers who will become the Mercury astronaut team. Following the distribution of the kit–and this will be done as quickly as possible–those of you have p.m. deadline problems had better dash for your phones. We will have about a 10- or 12-minute break during which the gentlemen will be available for picture taking."[49]

As reporters for afternoon papers grabbed the press packets and sprinted out the door to file their stories, a sea of photographers pushed their way to the base of the stage and started frantically snapping shots of America's new heroes. "I've never seen anything like it before," Slayton would recall later, "It was just a flurry of light bulbs." Slayton and his six colleagues watched members of America's Fourth Estate elbow and shove each other for position, a few crawling on the floor for hopes of a better shot, others placing the lens inches away from an astronaut's face. "I can't believe this," Shepard said, just loud enough to be heard by the unruly mob. "These people are nuts."[50]

Bonney broke up the photo shoot about fifteen minutes later, and then NASA administrator Keith Glennan made the official announcement: "It is my pleasure to introduce to you–and I consider it a very real honor, gentlemen–Malcolm S. Carpenter, Leroy G. Cooper, John H. Glenn Jr., Virgil I. Grissom, Walter M. Schirra Jr., Alan B. Shepard Jr., and Donald K. Slayton–the nation's Mercury Astronauts!"[51]

The room of journalists erupted with a standing ovation. "My God," thought Slayton, "They're applauding us like we've done something already."[52]

The first media question–what did each astronaut's "good lady" think of the assignment?–indicated that Haney's instincts about the press conference's tone were right on track. While Slayton replied, "What I do is pretty much my business, profession-wise," and Shepard added, "I have no problems at home," it was Glenn who gave the press what it wanted to hear. "I don't think any of us could really go on with something like this if we didn't have a pretty good backing at home, really," Glenn said. "My wife's attitude towards this has been the same as it has been all along through my flying. If it is what I want to do, then she is behind it, and the kids are too, 100 percent."[53]

As the press conference progressed, it became clear the media cared little about the flying credentials of the seven or how well those skills would translate to their newly assigned task–surely, the unprecedented testing and selection process had seen to that. Instead, the line of questioning focused largely on whether the astronauts had the moral qualifications necessary to represent the United States in its battle with the Soviet Union for space supremacy.

While none of the seven made any major gaffes, it was clear some were more comfortable in the setting than others. Cooper, who said he felt at a "disadvantage to have to speak loud," and Grissom, who said the press conference was the most stressful part of the entire selection process, were particularly ill at ease. Reporters detected in Shepard's short, direct answers a confident and competent astronaut, although not a particularly likeable one.[54]

While his colleagues answered the media queries in measured, direct, and sometimes-nervous tones, Glenn hooked the press by being glib. Glenn had a built-in advantage over his six colleagues, having

been in the media spotlight for a record-setting transcontinental flight in 1957 and a subsequent appearance on the TV show "Name That Tune." Two years later, he made the most of those experiences as the Mercury 7 were introduced to the nation. Asked why he volunteered, Glenn said a Mercury flight would be "the nearest to Heaven I'll ever get." What did Glenn's wife think of the assignment? "I have been out of this world for a long time and might as well go on out farther," Glenn reported. What was the roughest part of the physical? "If you figure out how many openings there are in the human body, and how far you can go into any one of them, you can answer which would be the toughest for you," answered Glenn. When the seven astronauts were asked whether they believed they'd safely return to Earth from their missions, six raised one hand; Glenn raised both.[55]

And while each of the astronauts took Haney's advice and stated their Protestant beliefs–some admitted to more regular church attendance than others–Glenn positioned his faith as the central factor in his professional success. "I am a Presbyterian, a Protestant Presbyterian, and I take my religion very seriously as a matter of fact," said Glenn, recounting his experiences as a Sunday school teacher and a church board member. "I was brought up believing that you are placed on earth here more or less with a sort of 50-50 proposition, and that is what I still believe. We are placed here with certain talents and capabilities. It is up to each of us to use those talents and capabilities as best you can. If you do that, I think there is a power greater than any of us that will place the opportunities our way."[56]

While all of the astronauts performed adequately in their public debut, it was Glenn who moved front and center in the eyes of the press, which then superimposed his devotion to God and family on the rest of the Mercury 7. They were no longer seven individuals, each with different tastes, motivations and levels of adherence to the sanctity of marriage. They were now, as presented by the press, the best the United States had to offer in its battle against the Soviets for space supremacy. The symbol of the American space program was no longer a former Nazi rocket engineer, but rather a group of clean-cut supermen.

"What made them so exciting was not that they said anything new but that they said all the old things with such fierce conviction,"

an adoring Scotty Reston wrote in *The New York Times.* "They spoke of 'duty' and 'faith' and 'country' like Walt Whitman's pioneers."[57]

The Mercury 7's initial press conference set in motion a narrative of Americana that would only be amplified by the country's most popular magazine. In August 1959, *Life* announced to its 6 million subscribers that it had secured the exclusive rights to the astronauts' first-person stories. The deal had been set in motion that spring by NASA's Bonney, whose objective was to avoid a scenario that, in his words, would have "John Glenn write for *Life,* Alan Shepard for *Look,* and Gordon Cooper for the *Post,* and their wives for various women's magazines." NASA's mandate for "the widest practicable and appropriate dissemination of information" would seem to preclude any exclusive arrangements with a media outlet, but in a policy paper presented to the Eisenhower administration, Bonney made a distinction between the astronauts' personal stories and those concerning their official duties with the agency. Indeed, there had been precedent for military officers to write personal accounts for hire, and the White House gave Bonney approval to proceed. Bonney then consulted prominent Washington attorney and agent Leo D'Orsey, who offered to represent the astronauts on a pro bono basis. During the summer, D'Orsey queried several magazines about their interest in the astronauts' stories: *Life,* as it turned out, was the lone bidder.[58]

The astronauts' first *Life* installment in mid-September ran for eighteen pages and included color photographs by Ralph Morse of the astronauts in training. Each astronaut, with the help of *Life* writers Loudon Wainwright, Don Schanche and Patsy Parkin, authored an account that differed little from those of his colleagues. An anecdote from test pilot days, followed by descriptions of astronaut training, an acknowledgment of danger, a sense of duty in accepting the mission, and a projection of what the first flight might be like were elements of virtually each story.[59]

The first articles were not particularly noteworthy other than being ostensibly penned by the astronauts themselves; much of the information about training and the planned missions had been made available to other media outlets through press conferences and interviews. For most of the press corps though, the *Life* arrangement engendered a great deal of animosity, and not only because of professional jealousy over the special access granted the magazine.

Rumors of *Life*'s payout–confirmed a couple of years later to be nearly $25,000 per year, per astronaut–raised serious questions of whether the seven should be garnering extra income stemming from their involvement in a taxpayer-funded program. Such grumbling was mostly behind the scenes, at least for the time being. Full-blown media criticism of the *Life* deal was to come later.[60]

The *Life* arrangement extended to the families also, and the astronauts' wives graced the magazine's cover a week after their husbands had occupied the same position. "Seven brave women," a headline blared, were going to reveal their "inner thoughts and worries," each wife offering "an intimate portrait of her husband." Some of the accompanying photos (the Glenns singing around the family organ, the Schirras nestled on a couch) suggested an idyllic family life. Other pictures (Shepard's wife and kids playing solitaire without him) were indicative of the reality that the astronauts weren't home all that often.[61]

In retrospect, the most telling photograph in the issue was a horizontal shot of the Coopers. Gordon Cooper was at the far left of the frame, back to camera, working at a desk. Wife Trudy was at the far right of the picture, reading in a chair. The physical space between them could not have been more than ten feet, but the framing of the picture made them seem miles apart. "Having my husband become an Astronaut hasn't brought any great change in our lives," Trudy Cooper wrote in the accompanying article. "He has always had to travel and fly a lot, so he is home no more or less now than he ever was." In her carefully crafted copy, Trudy Cooper was the devoted wife who made the most of the family's limited time together.[62]

Friends and colleagues knew that the photograph was closer to reality: The Coopers recently had been separated, and the marriage was in serious trouble. But NASA's silent prerequisite for each astronaut was to be a family man, primarily for the agency's own image (although one school of thought held that an astronaut distracted by marital problems might make a catastrophic error in flight). Press outlets such as *The Washington Post* bought in to the narrative, telling readers that family would give each of the seven "something to hold to in his strange and possibly terrifying new world." The Coopers would struggle with the dichotomy between their public and private

lives, as would most of the Mercury 7 couples. Years later, the Coopers divorced, as would the Carpenters and the Slaytons.[63]

The introduction of the Mercury 7 gave the space program a human face, but the outpouring of public emotion forced NASA to examine more closely its nascent information policy. The agency had adopted a "do first, talk second" stance in its short existence, choosing to say nothing about missions until their completion, then report their success or failure to the media and the nation. The policy worked "gratifyingly," in its first year, according to a Bonney memorandum, but he also recognized its clear flaws. It seemed rather inconsistent to withhold information about future operations from the press when many of those initiatives had been revealed through the twice-annual reporting procedure mandated by Congress. Contractors were eager to gain credit for their role in a project and occasionally leaked information to the press. And, the Air Force continued to hold pre-launch press briefings at Cape Canaveral for all missions, including those related to NASA.[64]

Bonney recognized that manned flight would bring an additional set of challenges to "do first, talk second." In an August 1959 memo, Bonney presented a laundry list of Mercury "facts of life" that would make the policy's implementation increasingly difficult: The public perception of a space race with the Soviets, press attention given the Mercury 7 press conference and announcement of plans for a manned space mission, a "goldfish bowl" media atmosphere that would certainly surround test launches, and the inescapable conclusion that "Virtually everything the Mercury Astronauts do, as part of their training or otherwise, is of the greatest interest to everyone."[65]

The memo did not advocate scrapping "do first, talk second," but it did make a clear case for candor in the distribution of after-the-fact information. Bonney wrote, "Even if it were possible–it is not–it would be a grave error for us to seek, by conducting Project Mercury in total secrecy, to avoid the criticisms and the ridicule which will result from our inevitable disappointments in the 'next couple of years.' Around the world, we are fighting for the minds of men."[66]

Bonney's choice of words indicated a shift in rationale for increased candor in the space program. Reporting progress to Congress

and the public to fulfill the Space Act's mandate was still important, but as 1959 wound down, program transparency became a weapon of Cold War ideology. Chris Clausen of the Jet Propulsion Laboratory summed up this role in a statement reprinted in NASA documents:

> It can be shown that our policy of honesty and candor in reporting our entire program and not only successes represents, in microcosm if you will, one of the basic differences between our philosophy and the Russian doctrine. It is the difference between rubber stamp elections and of free elections; the difference between contempt for the right of people to know and the thoughtful regard we have for our citizenry; in short, it is the difference between a civilization that is sure and proud of its strength and a dictatorship whose insecurity must be protected by secrecy.[67]

Other aspects of the initial information policy had been refined as well. No longer were the congressional reports deemed "sell documents" as Bonney had suggested the previous year. "The distinction between publicity and public information must be kept constantly in mind," Bonney wrote in the August 1959 memo. "Publicity to manipulate and 'sell' facts or images of a product, activity, viewpoint, or personality to create a favorable public impression, has no place in the NASA program." The primary goal of the office, Bonney wrote, must be "to furnish Congress and the media with facts–unvarnished facts–about the progress of NASA programs, and to furnish these facts as promptly and in such detail as circumstances dictate."[68]

This new emphasis was also reflected in Cape launch operations. Under the post-Vanguard agreement forged between the Air Force and the media, reporters had gained weekly briefings and somewhat better vantage points to view launches. Now, reporters also had access to NASA-produced advance press kits stamped "HOLD FOR RELEASE UNTIL LAUNCHED" that contained more details about missions. Within three hours after liftoff, in a procedure recalling that of the Explorer flight, NASA guidelines mandated a Washington press conference with leaders of the technical team. Such arrangements made for improved relations with the media and more accurate coverage, at least in the eyes of some reporters. "At first, we treated an exploding missile as just that," recalled Howard Benedict, who became the Associated Press correspondent at the Cape in 1959. "Nobody ever told us what was going on or why a particular missile had

failed. As we developed more sources we did a better job, and the new spirit of candor enabled us to do it more thoroughly."[69]

As the 1950s wound down, it was true that press access to the space program had increased incrementally. Many obstacles to coverage remained, however, leaving journalists to occasionally employ elaborate tactics to outfox the gatekeepers. One such effort enabled Edward R. Murrow to give television viewers a unique glimpse of a Cape launch and the lengthy, frustrating, expensive process leading up to the event.

Murrow's voice was familiar to virtually every American in 1959. If you were an adult, you likely came to know him through the radio, his signature "This Is London" sign-on becoming a nightly fixture for millions of CBS listeners desperate for information during World War II. After the war, Murrow successfully transitioned to television, teaming with producer Fred Friendly to create the critically acclaimed documentary series *See It Now*, most famous for its 1954 broadcast exposing the demagoguery of the Red-baiting Senator Joseph McCarthy. But five years after the legendary McCarthy broadcast, Murrow's relationship with his network had neared its breaking point. *See It Now*, never a ratings winner, lost its sponsor in 1955, and CBS, weary of Murrow's penchant for tackling controversial subjects, let the series languish as an occasional special for three years before finally killing it.[70]

By fall 1959, Murrow and the network were even at odds over his vastly more profitable and decidedly less divisive celebrity chat program *Person to Person*. At the height of television's quiz show scandal, when it was revealed that many of the contests were fixed, CBS company President Frank Stanton announced that his network would aim for more truthfulness and transparency in other types of programming as well. As one example, Stanton cited "Person to Person" for giving the impression that the show's conversations were off-the-cuff rather than on previously agreed-upon subjects. Murrow, on a year's leave of absence from the network, fired back during a London speech: "Dr. Stanton has finally revealed his ignorance both of news and of requirements of TV production."[71]

As the Murrow-Stanton feud raged in the nation's press, another potential tempest involving the two was brewing behind closed doors at CBS. Before Murrow took his leave, he and Friendly worked on the

first installment of a new occasional documentary series titled *CBS Reports*. The premiere episode, "Biography of a Missile," would follow a rocket project as it progressed from concept through the production stage. The highlight of the film, the missile's launch from Cape Canaveral, had network officials sweating as the airing date of October 27, 1959, neared.

Stanton not only ran CBS, but he also served in several advisory roles for the Eisenhower administration, including a top-secret "stand-by cabinet" designed to keep the federal government operational in the aftermath of nuclear war. Less than a week before the first *CBS Reports* was to air, Stanton attended a White House-arranged briefing with leading U.S. scientists. During a presentation about the missile program, George Kistiakowsky, a veteran of the Manhattan Project and now science advisor to the president, turned to Stanton and said, "that's why Ike wouldn't approve your people getting into the silo."[72]

Stanton wasn't completely sure what Kistiakowsky was referring to, but he had a good guess. Stanton, who had previewed much of "Biography of a Missile," knew that Murrow and Friendly planned to cap the show not with the standard NASA-supplied launch footage available to any television outlet, but by having viewers experience the rocket's sound and fury from the perspective of launch engineers based near the pad. Then, Stanton remembered seeing footage of camera equipment inside the Cape blockhouse. It appeared that CBS had been inside the very building deemed off-limits by the White House.[73]

Back at CBS offices, Stanton called in Friendly and asked how the network got inside the blockhouse.

"Oh," Friendly replied. "That was simple. The White House wouldn't let us go in, so we got a GI to put the camera in there."

"Were you or any CBS employee in there?" Stanton asked.

"No, not at all," said Friendly. "The deal was that as soon as they were going to fire, we were in a motor scooter and we tore out. So, we technically were not there."

"But I heard the launch," Stanton said.

"Oh, yes, because we recorded the sound."

Stanton asked how the material got through military censors, and Friendly's answer revealed a stroke of journalistic genius. The sound

alone was sent to one military clearance office, the silent film to another. Separated, the two elements raised no red flags and were approved for release. Back at New York, editors married the audio to the moving pictures, and CBS had a spectacular climax for its presentation.[74]

As broadcast, "Biography of a Missile" was "a sobering demonstration of the immense difficulties that are being encountered by our rocket experts," concluded a *New York Times* reviewer. The documentary captured the brashness of the rocket's Alabama-based designers, focused on the painstaking skill of its Detroit welders, and put viewers behind the scenes of a California engine-thrust test. The blockhouse sequence at the Cape served as the key punctuation mark: The missile, eighteen months in development and costing more than $5 million, barely lifted off the ground. "It came to be almost like a human being. And then in five-and-a-half seconds it was all over," said Murrow's voiceover as the rocket turned into a ball of flames.[75]

The show's postscript, footage from a successful Juno launch, gave viewers a better appreciation for how significant such an achievement was. From lucid descriptions of the rocket's components, to a lesson from von Braun on the physics of rocket thrust, the documentary contained "the clearest exposition, the most simple explanation of the problems of rocketry and missilery ever put on television," wrote the *Washington Post*'s Lawrence Laurent. Home viewers were similarly impressed, many calling the network or its affiliates to request that the show be re-aired.[76]

In light of the ongoing quiz show scandal, the broadcast also demonstrated that television was capable of being much more than the "wires and lights in box" Murrow had warned broadcasters about during a scolding address the previous year. "Murrow proved that a blockhouse has more drama, more impact and more educational value than an isolation booth," Laurent wrote. In total, *The New York Times* concluded, "Mr. Friendly, Mr. Murrow and their associates in 'C.B.S. Reports' have started a new television series with distinction." The new series would go on, but Murrow's time at the network was running out: In less than two years, he would leave television to direct the United States Information Agency.[77]

❖❖❖

In its short existence, NASA's public information office had made significant strides to bring more openness to the space program and to foster better relations with the press. But in May 1960, the agency was caught in a lie that not only threatened to unravel all that hard work but also fanned the flames of an international incident.

A May 3 NASA press release that a weather plane had gone missing in Turkey garnered scant media attention, but its contents became much more intriguing two days later when Nikita Khrushchev, at the end of a four-hour speech to the Supreme Soviet, his nation's most powerful legislative body, announced that a United States spy plane had violated their nation's airspace and had been shot down. Advisers close to President Eisenhower were split over whether he should address the charges: Silence might be interpreted as an admission of guilt, some argued, while others advocated waiting to see what else the Soviet premier had up his sleeve. Eisenhower ultimately decided to have press secretary Jim Hagerty prepare a statement.[78]

During the lunch hour on May 5, the fifteen or so permanent White House correspondents gathered around Hagerty's desk as he read from a sheet of paper. "At the direction of the President," Hagerty said, "a complete inquiry is being made. The results of this inquiry, the facts as developed, will be made public by the National Aeronautics and Space Administration and the Department of State." Naturally, several of the reporters left the White House and walked over to the Dolly Madison House to pick up NASA's statement. "What statement?" came the secretary's reply. Seeing the growing press contingent, Walt Bonney retreated to his office, called Hagerty, then returned to tell the reporters that a release would be forthcoming that afternoon.[79]

Bonney returned to his desk and hastily drafted a statement based on information not gathered by his staff but supplied by the Central Intelligence Agency. He was unaware that Eisenhower's security council had decided hours earlier that the State Department should handle all press inquiries about the incident. At 1:30, Bonney stood on the same stage where a year earlier he had introduced the Mercury 7 and began reading. The downed U-2 and those like it had been used by NASA since 1956 to study upper-atmospheric conditions around the world, Bonney said. The civilian pilot had reported problems with his oxygen, Bonney continued, which might explain why he veered

off his assigned flight pattern. The plane was clearly marked with a NASA seal and carried no military equipment, Bonney later added, admitting that the U-2 had photographic equipment "but they are not reconnaissance cameras. They are cameras used to cover cloud pictures." When officials at the State Department read Bonney's statement, they were aghast at the level of detail NASA had provided, not only because it wanted the U-2 program to remain as secret as possible but also because it gave the Soviets a number of facts that could be easily disproven.[80]

The elaborate cover story unraveled two days later when Khrushchev revealed to the Supreme Soviet and the world that the U-2's pilot, Francis Gary Powers, survived and had been captured. The American ruse, predicated on the assumption that the pilot either died in a crash or followed instructions to kill himself, had been exposed, and the State Department and the Eisenhower administration were forced to make a humiliating admission: America was spying on its Cold War adversary and had lied to the world about it.[81]

The U-2 incident had potentially grave consequences for NASA as well, its false statements not only threatening to undermine the trust it had earned from the press but also calling into question its stated position as an agency interested only in peaceful pursuits. In its reporting of congressional hearings that summer, the nation's press largely gave NASA a pass. In terms of NASA's ability to tell the truth, the agency was portrayed as a victim that was mistakenly given the impression that the CIA-supplied information was correct and had been cleared with the State Department when it in fact was neither. As for NASA being merely a passive conduit for an international spying scheme, hearing transcripts released to the press echoed the assurances of NASA's No. 2 man, Hugh Dryden, that the agency had no specific knowledge of what the CIA was up to. Much of the testimony was blacked out for security reasons, though, and post-hearing comments by Senate Foreign Relations Committee chairman J. William Fulbright that Dryden "knew a good deal about what was going on" hinted of a somewhat more robust nexus between NASA and the CIA. It would later emerge that the relationship was a holdover from Dryden's days with the old NACA, when he agreed to let that agency serve as a cover for CIA spy planes. Only a few people within NASA knew of the arrangement.[82]

By fall 1960, questions about NASA's role in the U-2 program had largely faded from public scrutiny, but the agency's public information staff still faced a host of challenges. Planning for the manned Mercury missions was the most pressing issue and the most difficult, a looming task complicated by the uncertainty surrounding a new presidential administration. In October, the information office's work became even more problematic with the resignation of Bonney, who left the agency to take a job with a California aerospace company. Bonney's legacy within NASA was relatively untarnished by the U-2 debacle, one staffer writing in a memo that his tenure as director of the public information office was one of "a solid record of achievement" and high morale among his subordinates. The continuation of both, the NASA employee continued, would depend on strong leadership from Bonney's replacement.[83]

Shelby Thompson took over as director of NASA's Public Information Office in November. Over the next two-and-a-half years, the job would change hands five more times.

CHAPTER 3

"Oh, Go Baby!":
Televising Mercury

Shorty Powers referred to his line as the "Dr Pepper telephone." The astronauts' spokesman could count on it ringing at 10, 2 and 4, the times prescribed by a popular ad slogan for quaffing the soft drink, or at seemingly any other point of the day or night. It had been twenty-four months since the Mercury 7's first frenzied press conference, and while no human had gone into orbit yet, the media's voracious appetite for information showed no signs of letting up. *Life* may have had exclusive rights to the astronauts' personal stories, but reporters for other media outlets kept Powers' extension busy with requests concerning their training regimens and possible future missions. Powers' duties were twofold: Keep the media informed about the astronauts while serving as a buffer so they could get some work done. Sometimes, the tasks extended well beyond banker's hours, as was the case in the pre-dawn hours of an April morning, as a slumbering Powers fumbled for the receiver in his quarters at Langley Air Force Base.[1]

The voice on the other end belonged to a United Press International reporter: A Soviet had become the first man to orbit the Earth, and could Powers, the seven astronauts and NASA's head of manned space flight each give a comment?

"It's 3 o'clock in the morning, you jerk!" Powers snapped. "If you're wanting something from us, the answer is we're all asleep," he added before slamming down the phone.[2]

Powers' response, dutifully sent over the wires and subsequently published in newspapers across the country, was hardly the comment the image-conscious agency desired. A few hours later, new NASA chief Jim Webb would go on network television to give a more media-savvy response, offering congratulations to the Russians and reminding Americans that their own space program might soon put a man into orbit.[3]

Embarrassed by Powers' outburst, NASA headquarters instructed him to apologize to the reporter. Powers refused. "Quite the contrary," Powers telegraphed acting NASA public information director Bill Lloyd in response, "it is my intention to write a letter to the president of the United Press International advising him that I think his agency owes me and the American people an apology for irresponsible reporting."[4]

On the surface, the Powers response would appear to be insubordination. But in reality, Powers didn't answer to NASA headquarters. On the organizational chart, Powers reported to Bob Gilruth, director of the Space Task Group, the agency's organization in charge of the Mercury program. Gilruth, Powers wrote, agreed with how he had handled the 3 a.m. call. An agency-wide apology would be "a public announcement that my services are unsatisfactory," Powers wrote Lloyd, and would be grounds for him to be returned to the Air Force.[5]

Powers never offered an apology. Nor did he resign. Nor was he fired. Gilruth's backing was a huge factor, but a power vacuum in the information apparatus at NASA headquarters also helped Powers survive the flap: Lloyd was the third man in six months to direct NASA's public affairs efforts. Powers had called the agency's bluff by threatening to quit and demonstrated that headquarters ultimately had little to say about his terms of employment. As long as Gilruth was satisfied, Powers would continue to be the gatekeeper to the astronauts. Powers was emboldened. Events over the next year would only serve to further enhance Powers' clout and feed his already substantial ego.

At the time, Powers' outburst was merely a footnote to the more significant story of another Soviet space triumph. Americans who where shocked, angered, and embarrassed over Sputnik greeted the

news of Yuri Gagarin's first-ever manned orbit of the Earth with re-signed disappointment. Coming in second was no longer a novelty, and NASA officials and elected leaders had braced the public for months by stating that the Soviets were on the verge of achieving an-other "spectacular." Those same sources were tapping an intricate two-step around the space race: America is not trying to match the Soviets step-for-step, they would assure reporters, while in the next breath touting a U.S. lead of 37-to-12 in successful satellite launches. Still, the new American president knew it would be fruitless to gloss over the toll the more-publicized Soviet triumphs had taken on the country's psyche and chose to prepare citizens for more disappoint-ment. "The news will be worse before it is better," John F. Kennedy said at a press conference after Gagarin's flight, "and it will be some time before we catch up."[6]

Still, there were signs that America might be getting close to a mini-spectacular of its own. Weeks earlier, NASA announced that a manned Mercury sub-orbital mission would likely come before sum-mer, and to heighten the drama, the agency engaged the nation in a game of "guess that astronaut." The first American in space would be chosen from a pool of three Mercury astronauts–Gus Grissom, Alan Shepard and John Glenn–just before the mission, agency officials said. The excluded four were trotted out at another press conference to re-assure the nation they did not consider themselves second-class as-tronauts.[7]

Over the next several weeks, speculation swirled about who would get the nod, many journalists privately rooting for Glenn to be picked and writing for publication that the tea leaves looked favor-able for him. A few stories suggested Grissom might be chosen since his branch, the Air Force, ran the military's space program, while other articles suggested the Air Force had leaked Glenn's name in an attempt to discourage NASA from choosing the Marine. Few touted Shepard, who, despite having become more garrulous after seeing Glenn dominate the Mercury 7's introductory news conference, was still perceived by most journalists as the dour "Icy Commander." Publicly, all three astronauts stuck to the script, none revealing that they had already received their mission assignments.[8]

As the nation guessed which astronaut would go up first, NASA's public information office wrestled with how to accommodate the

throng of media that would cover the American attempt. A significant change in press operations had already gone into effect at the start of the year, stemming from a December 1960 summit arranged by Keith Glennan in the final weeks of his tenure as NASA chief. Glennan, concerned that press coverage of the Mercury program was shallow and failed to accurately convey the complexity of the missions, asked Benjamin McKelway, editor of the *Washington Evening Star*, and Russell Wiggins, editor of *The Washington Post*, what NASA could do to improve the quality of reporting. The editors' recommendations were straightforward: More pre-launch information, delivered to more media outlets, containing more detail about difficulties and objectives, and, in the most significant change, released seven to ten days before launch instead of being held until there was "fire in the tail" of the rocket.[9]

NASA representatives in attendance, still cognizant of the Vanguard failure more than three years earlier, initially balked at the editors' suggestions. They argued that immediate release of information would only contribute to a pre-launch media frenzy and open the agency to charges that it was creating alibis for use if a mission failed. The editors countered that public buildup before launches was now unavoidable, given the intense interest in the space program, and that the press, the public, and the agency would each be better served by a more full vetting of a mission's challenges before the rocket left the launch pad. More agency candor, the editors suggested, would create "an account of credibility" with the press that would negate charges that NASA was conditioning the public for failure.[10]

By Christmas 1960, the editors' position, with slight modification, had been adopted as NASA policy. The changes were significant for the press, but so was the accompanying tone, at least on paper. In a letter to the president of the National Association of Science Writers, Glennan wrote that the new rules would "enable responsible newsmen ... to cooperate with us in telling the public not only what we are doing and why, but also to improve public understanding of how much of our work is necessarily experimental." Instead of treating the press as an adversary, NASA would now try to engender a sense of partnership.[11]

Glennan had also reached out to television in his final year at NASA. In a letter sent to presidents of each of the three networks,

Glennan asked for their help in explaining to the public the scientific value of the civilian space program. "The effectiveness of television as a medium for communication of a concept is obvious and great," Glennan wrote. "As a public service in these days of confusion, few topics could be more profitably explored."[12]

Indeed, television had shown flashes of brilliance in public affairs programming. By the end of the 1950s, 50 percent of the country's citizens said television was their main source of information, and defenders of the medium could point to Ed Murrow and Fred Friendly's work on *See It Now*, the airing of the 1954 Army-McCarthy hearings, and a smattering of critically acclaimed documentaries as evidence of television's potential to inform and enlighten. Television's detractors looked at the ratio of such programming in context of the entire broadcast schedule and concluded that half the country was ill-informed. The network evening newscasts were only fifteen minutes in length, and public affairs programs often were relegated to the "Sunday afternoon ghetto" when few were watching.[13]

Critics both outside the television industry and within it took aim at network executives for being too devoted to ratings at the expense of fulfilling the public interest mandate prescribed by the Federal Communications Commission. "The top management of the networks, with a few notable exceptions, has been trained in advertising, research, or show business," Murrow told broadcasters during a scathing address in 1958, "but by the nature of the corporate structure, they also make the final and crucial decisions having to do with news and public affairs. Frequently they have neither the time nor the competence to do this." As the 1960s began, many insiders considered television news departments as "the orphans of the industry," often neglected and seldom seen.[14]

Glennan's February 1960 plea to television came at an opportune time though, as the network heads had recently experienced a come-to-Jesus moment with public affairs programming. Three months earlier, the quiz show scandals had burst wide open when the popular and handsome Charles Van Doren told Congress that his successful run on NBC's *21* had been a sham. A spellbound nation had been duped into thinking his performance had actually been a contest, and several other shows, it was revealed, had committed similar fraud. For television's critics, the disclosures were evidence that the medium

had seriously lost its way. The networks responded by wresting control of entertainment programming from sponsors, talking at length about standards and codes, and putting a greater emphasis on its news divisions: "The pursuit of respectability after the quizzes has made them very important," Jack Gould wrote in the *New York Times*. New documentary series sprang up on network prime time schedules in 1960, and when the networks produced a series of televised debates between presidential candidates Richard Nixon and John Kennedy that fall, television drew both record audiences and critical praise for a dignified presentation, signifying that the medium was ready to be taken more seriously.[15]

Coverage of America's first manned space mission held the promise of similar benefits for television. On one hand, broadcasters saw the event as a chance to further demonstrate the medium's maturation into a tool capable of not only transmitting breaking news but also explaining it in the responsible manner suggested by Glennan. Well-executed, the coverage could serve as a powerful rejoinder to those decrying the vacuous fare of a typical broadcast day. On the other hand, each executive could also foresee the potentially gargantuan audience and plotted how to snatch viewers away from his two competitors.

NASA would insist that the television networks cooperate to some degree. For months, the agency had worked with broadcasters to develop a plan for pooling coverage of launch activities within the grounds of the Cape. For the space agency, shared responsibility of television production would eliminate the logistical nightmare of accommodating three virtually identical network production teams on site and establish better control of what could and what could not be broadcast. For the networks, sharing resources would help alleviate redundancy and trim costs in budgets that were already ballooning.

The result was "one of the largest coordinated news teams ever assembled," according to one trade publication, with ninety journalists, cameramen, and technicians dispatched throughout the Cape. By draw, NBC's Roy Neal was named pool coordinator for America's first manned space flight, and network colleague Jim Kitchell accepted the task of pool director. They would oversee talent and technicians from all three networks. CBS correspondent Richard Bate was assigned to cover the astronaut emerging from his preparatory quar-

ters in the pre-dawn hours. Five remote-controlled ABC cameras would monitor the Redstone rocket during countdown, while NBC's Herbert Kaplow and a CBS camera crew would be stationed near the firing pad until forty-five minutes before the scheduled launch. Meanwhile, a four-man ABC camera crew would team with CBS's Charles von Fremd to report from the press area located 7,000 feet from the launch site. Additional crews would be dispatched to ships and tracking stations in the Atlantic to follow the flight and the capsule's recovery.[16]

Coverage of activities inside the Mercury control room was a particularly thorny problem that ultimately was settled over martinis in a Washington hotel bar. Neal spoke for the media pool, while Haney and Powers represented NASA's public information office. Joining them was a burly, chain-smoking, crew-cut sporting aeronautical engineer named Walter Williams, the operations director of Project Mercury. The media needed up-to-date information on the mission's status to paint an accurate picture for the American public, Neal said, and much of that information would come from inside mission control. Williams balked at putting reporters and cameras in the command center, fearing live public scrutiny would put added pressure on flight controllers and technicians already charged with making decisions that could result in the life or death of the astronaut. In the middle were Haney and Powers, who agreed with Williams' assessment yet recognized that getting information out of mission control and promptly into the hands of the press served NASA's best interests.[17]

After an hour of stalemate, Williams, the one member of the group who did not make his living as a communicator, came up with a solution: Cameras were out, but NASA could put an information officer in the control center and have him relay flight information to the press and public.[18]

"Gee, I wish I'd thought of that," Haney muttered to himself as he turned to look at Powers, whose list of responsibilities had just gotten longer. "He'd never worked any news," Haney recalled years later. "He had no feeling for news whatsoever." But Powers' background in aviation and his powerful baritone made him a natural to be stationed in the control room and keep Americans apprised of mission details, so they thought.[19]

The pool arrangements were in place, but questions remained as to precisely when the telecast would be aired. The decision was complicated by fears that the first U.S. manned mission was another Vanguard in the making, a hasty, meager, and ultimately disastrous attempt to answer a Soviet space feat. The Mercury's 15-minute up-and-down flight into the Atlantic Ocean would pale in comparison to Gagarin's two-hour lap of the Earth, even if everything went according to plan. But veteran Cape journalists, who had watched numerous unmanned missiles explode on the pad or veer wildly out of control after liftoff, worried that Americans were on the verge of seeing an astronaut killed live on their television screens. As the launch date neared, some congressmen felt the pre-flight publicity had already gone too far and called for a cancellation and a later covert launch attempt, while some of their colleagues mounted a last-ditch effort to convince the networks to show the entire mission on tape delay.[20]

Haney had advocated live broadcasts since shortly after his arrival at NASA, but his plan to have all mission information released in real time had been soundly rejected in several bids during the Glennan era. When Jim Webb took over the agency, Haney decided to pitch the proposal again. Like his predecessor, Webb didn't think much of the idea, but he added that Haney was free to run it by the new Kennedy administration. A day before the scheduled launch, Haney's plan was still awaiting final approval when he received a call from Kennedy press secretary Pierre Salinger, who inquired about how an astronaut could be rescued if there were trouble.[21]

"Paul, the President's wondering about that escape (system) on the Mercury," Salinger said. "He wondered what the history of it is."

Haney, who had read about the device the previous night, reported that it had worked in 56 of 58 tests. Haney heard some nervous laughter in the background, then the words he wanted to hear from Salinger: "The President says go ahead. Give it a go."

Haney joyfully threw the telephone as high as he could, banging it off the ceiling. "That was the phone call that put the public information program in business," Haney recalled years later. "I never did get anything signed. All the engineers wanted something signed in tripli-

cate and notarized, and I asked Salinger about it later, and he said, 'Oh, shit, we don't sign that stuff.' "[22]

The implementation of Haney's plan would have to wait a few days. The initial May 2 launch was scrubbed due to bad weather, but not before the press learned that Shepard had been in a nearby hangar for three hours, waiting to board the capsule. The delays would stretch four days, raising not only the country's anxiety but also the tab the networks were running up on pool coverage. "Postponing," Neal said, "defeats the budget and God knows the budget for a public service show of this kind will probably be a record high." The pool and the networks' own news teams were joined in their wait by more than 360 print journalists on the scene, including representatives from 63 foreign publications, and a score of local and regional broadcasters who had turned the makeshift Cape press area into a maze of trailers, cables and antennas.[23]

On May 5, 1961, NBC began its Mercury television broadcast at 10:22 a.m. eastern time, one minute before its network competitors signed on. All three networks dutifully reported to the nation seemingly every detail of Shepard's day: 1:05 a.m. wakeup call, followed by shower, shave, breakfast, physical exam, donning of pressure suit. Pool cameras delivered glimpses of Shepard emerging from a van at the launch site and crawling into the tiny capsule. Correspondents recounted the delays that had totaled more than two hours, first for weather, then for equipment problems. Each network interspersed the pool dispatches with its own commentary from New York and reporting from near the Cape, CBS having set up shop in a station wagon on one of the area beaches, and NBC having created a bureau out of a local rental house. The press was not privy to everything: Accounts of a frustrated Shepard telling engineers to fix the technical problems and "light this candle," or of the astronaut emptying his bladder into his spacesuit during the long wait, would each be left to the historical accounts.[24]

As the launch neared, typical Friday morning activity in America ground to a halt. In downtowns and city centers across the country, crowds gathered in front of department store windows to watch the televisions on display, or huddled around parked cars to hear radio accounts. Store cash registers went silent. School lesson plans were ditched. Patrolmen stopped directing traffic. At the White House, the

president's security council adjourned its meeting and gathered around the television in his personal secretary's office. "Come in and watch this," Kennedy called to his wife, Jackie, who was passing in the hall.[25]

At Shepard's home in Virginia Beach, his wife, Louise, also sat transfixed in front of the family's television. In her lap sat a transistor radio.[26]

At 10:34 a.m., two television cameras stationed 2,500 feet from the launch pad captured the yellow, diamond-shaped flame trailing the Redstone missile as it left the Earth. The missile was briefly obscured by a cumulus cloud, then reemerged and continued upward, soon to ascend in a graceful arc. Many viewers felt their throats tighten as they tried to reconcile the beauty of the flight with the apprehension they felt over the fate of the man atop the rocket. It was a moment almost beyond words, but veteran correspondent Merrill Mueller found poignant ones for NBC radio listeners: "He looks so lonely up there."[27]

The voice that interested Americans the most belonged to Shorty Powers. NASA declined to air radio conversations between Shepard and mission control, so it was up to Powers to update an anxious viewing and listening audience on the Mercury's status and the condition of the astronaut. Powers, seated next to Walt Williams in mission control, fortunately could report that everything was going according to plan. The capsule had separated from the Redstone precisely as designed, the escape mechanism had successfully detached, and Shepard had now taken control of the capsule. Things were going so well, in fact, that Powers had time to create new lingo.[28]

"The astronaut reports that he is A-OK," Powers announced to the world, even though Shepard had said nothing of the sort.

The flight director grinned and shook his head. "A-OK. Okay, Shorty, if that's what you want," he thought to himself. Little did he know that Powers had just added a catchphrase to the American vernacular.[29]

A mere seven minutes after liftoff, Shepard maneuvered the capsule into its descent. Those inside the control center would soon hear a series of grunts and groans as Shepard struggled to speak while fighting G-forces that briefly would make him feel like he weighed 1,600 pounds. Those watching on network television saw a pool video

feed of weary and apprehensive Cape employees or a still photograph of the waiting aircraft carrier *Lake Champlain,* where ABC's Bob Lodge was ready to narrate the suspenseful conclusion. As Powers told America that the astronaut reported all systems were "A-OK," and that the monitors attached to Shepard indicated his medical condition was "A-OK," Lodge described the descent, the helicopters sent to rescue Shepard, and the astronaut's arrival on the aircraft carrier in "a climax that left a viewer with a feeling of relief mixed with awe," wrote Gould in *The New York Times.*[30]

The telecast lasted little more than an hour and was far from perfect, but it succeeded in making the public feel like active participants in Shepard's brief trip.

"The television picture was often shaky and several times the cameras completely lost the main object," wrote Lawrence Laurent in *The Washington Post.* "The commentary was hesitant, uncertain and contained a few mistakes. Yet, yesterday's TV coverage of the astronaut test at Cape Canaveral added up to the most exciting, most moving program in television history."[31]

The mission's success also allowed the press to tout the advantages of America's "open" system in language similar to what NASA had used two years earlier in internal memoranda arguing for a more transparent information policy. "With the United States system, it is necessary sometimes to suffer failure publicly," wrote Laurent. "At times, however, it is also possible to make all of the population a participant in our great successes." The *Christian Science Monitor* recognized that without television's instant verification of the mission's success, "Quite possibly the United States would be in the spot which the Soviet Union now occupies, where half the world is still doubtful that the Soviets told the full story of their man-in-orbit achievement."[32]

In a press conference after Shepard's recovery, Kennedy hailed the mission as a symbol that the United States could accomplish just as much as the Soviets, and do it under the full scrutiny of the world. At the same time, the new president addressed critics, particularly those in the nation's print media, who had accused the administration of putting the country's stature at risk with an excess of pre-flight publicity:

What I think is somewhat unfair is when press men themselves or editorial writers criticize NASA for attempting a big build-up with all of the implications it would have to our prestige and standing if there's a failure. We are not responsible, at least we're making every effort not to be responsible, for encouraging a press concentration on this event because, quite obviously, if we fail, we're humiliated here and around the world.

But in a free society, if a newspaperman asks to be represented and to come then he can come. So I think everybody ought to understand that we're not going to do what the Russians did, or being secret and just hailing our successes. If they like that system they have to take it all–which means that you don't get anything in the paper, except what the government wants. But if you don't like that system, and I don't, then you have to take these risks. And for people to suggest that it's a publicity circus, when at the same time they're very insistent that their reporters go down there, does seem to me to be unfair.

What is fair is that we all recognize that our failures are going to be publicized and so are our successes–and there isn't anything that any one can do about it–or should.[33]

Individual reporters were used to Kennedy's critiques. The president, a "repressed journalist" according to one White House staffer, read voraciously, and he had already earned a reputation for collaring reporters who he felt had slighted him. One such intervention came one night on an airport tarmac, when Kennedy confronted a magazine writer with a copy of a recent article. "There's one item right in that, the rest are wrong," Kennedy said, using the headlights of the presidential limousine to illuminate the alleged inaccuracies. Now, for the second time in a week, Kennedy seemed to be taking aim at the newspaper industry as a whole. Days earlier, Kennedy had addressed the American Newspaper Publishers Association convention in New York and implored his audience to "heed the duty of self-restraint" and avoid printing stories that might benefit the enemy. The statements, coming on the heels of the disastrous "Bay of Pigs" excursion into Cuba and subsequent White House criticism that too much pre-invasion information had made its way into the nation's newspapers, were greeted in a lukewarm manner by many editorial writers. "In days of peril especially the country needs more facts, not fewer," wrote one paper, with another suggesting Kennedy "should insert his finger in the leak at Washington before pleading with editors to ignore the flood."[34]

Kennedy believed newspaper editorial policy generally swung too far to the right. He found television to be much more pliable in advancing his agenda, an attitude that would be reflected when he addressed the National Association of Broadcasters convention a few days after Shepard's mission. The president brought along the astronaut, introducing him as "the nation's number one television performer" who had garnered such high ratings for their networks. After Shepard went backstage, Kennedy lauded the broadcasters in attendance for their coverage. "There is no means of communication as significant as that in which you are involved," Kennedy said to "the guardians of the most powerful and effective means of communication ever designed." Television broadcasters "have the opportunity to play a significant role in the defense of freedom all around the globe," Kennedy said, by encouraging a free flow of ideas and helping to educate citizens of the world to make "free and informed choices."[35]

Kennedy's words served as validation for many broadcasters in attendance, "an indelible seal of approval on their good housekeeping job in serving the public interest during the past year," according to a *Variety* article that noted television's role in the Nixon-Kennedy debates and an increased public affairs emphasis.[36]

Television's era of good feeling would last twenty-four hours. The following day, Kennedy's new FCC chairman would speak to the same gathering and assail the medium as a "vast wasteland" in desperate need of a makeover. "For every hour the people give you," Newton Minow told broadcasters, "you owe them something. I intend to see your debt is paid with service." In the past, renewal of an FCC license had been pro forma unless a broadcaster had committed a gross violation of regulations, but Minow's speech signaled a more active regulatory body that would take a closer look at programming. By summer, Minow had advocated extending FCC oversight to the networks, and in the fall, he attacked broadcasters for a "virtual news blackout" in the hours dominated by sitcoms and westerns. "The world goes on during prime evening time," Minow said, "but you wouldn't know it if you were watching television." Some broadcasters worried that the FCC chairman's criticisms would evolve into regulatory coercion over their programming choices, but they also had another reason to take him seriously: Letters to the FCC were running sixty-to-one in favor of Minow.[37]

Television's coverage of the second sub-orbital Mercury flight in July 1961 would not comfort Minow or his fellow critics. To viewers, Gus Grissom's mission looked quite similar to Shepard's until the capsule began its descent. As Powers' voice told the public that Grissom was in radio contact with Shepard, NBC and CBS showed close-up scenes of Shepard talking on a headset in Mercury Control. In reality, the footage was taken during a "perfect flight" dress rehearsal earlier in the week, NASA's only restriction being that networks could not air the video until Grissom's missile had left the launch pad.[38]

What might have seemed like a good idea to network producers during the planning stages turned into an embarrassment after the capsule splashed down, the pictures of a stone-faced Shepard incongruous with Powers' commentary that the men in Mercury Control were relaxed and smiling. NBC compounded its woes in the anxious moments during Grissom's ocean rescue (a hatch had blown open shortly after splashdown, letting in water that imperiled the astronaut and eventually sunk the capsule) by showing generic footage of a helicopter approaching an aircraft carrier without telling viewers that it was not a live shot.[39]

"It was more than confusing. It was misleading," wrote *Variety* columnist Art Woodstone of the two networks' miscues, adding that ABC's coverage, while unimpressive, could at least wrap with a clear conscience. While spokesmen for CBS and NBC apologized for not making the nature of the Shepard control room footage more clear, some within the television industry feared the incident might renew debate over authenticity that had flared during the quiz show scandals. Meanwhile, other critics took NASA to task for turning astronauts into actors, a step that called into question the agency's pledge to be more transparent than their Soviet counterparts. If candor was a key component of Cold War ideology, wrote Jack Gould, the least America do was was practice it at home.[40]

The networks still had a lot to learn about covering space missions, but they would have plenty of chances to improve. Hours after Kennedy had phoned Grissom to offer his congratulations, the president signed into law a bill authorizing a nearly $2 billion NASA budget for fiscal 1962, an act that, in the president's words, "demonstrated united support for a new and vigorous space program." In

less than two months, Kennedy had announced a goal of placing a man on the moon before the end of the decade, convinced an intrigued but wary Congress that the idea was worth pursuing, and secured the initial round of funds necessary to implement the plan. The next major step in that goal would be to place a man in Earth's orbit. Such a mission would be much longer, much more complicated, and would present a host of new challenges for television and the press.[41]

During his first two years with NASA, Shorty Powers' run-ins with the press had been relatively few, 3 a.m. phone calls notwithstanding. Reporters generally found him accessible, and they appreciated his stamina and composure during press briefings that would occasionally last three hours. But by early 1962, the dynamic between Powers and the press had begun to change. Reporters learned that "A-OK" had been a Powers creation, not a direct astronaut quote, and they began to discover that he was making up other "facts": His tale about Grissom going fishing the day before his mission and eating the catch was one of the more silly fabrications. The press also noticed that "we" was creeping more and more into Powers' discussions about the Mercury 7 and that Powers took great pains to note he was present during pre-flight activities. Other critics charged that Powers, buoyed by press clippings that lauded his updates during the Shepard mission, went out of his way to get in front of the television cameras. The animosity cut both ways: Behind the scenes, Powers would rail about reporters' lack of knowledge and their practice of "blue journalism, and flamboyant writing."[42]

As the media gathered at the Cape in January 1962 for a news briefing on John Glenn's attempted Earth orbit, a more adversarial tone had taken hold. No astronauts were present, nor were any technical members of the Mercury team, just Powers and associates offering a "sense" of what Glenn was feeling and a few details about the mission. As one reporter noted:

> Having been sent to cover the event and having been promised full information consonant with the safety of the mission and the efficiency and privacy of the principals, newsmen were instead lectured on their own responsibilities, admonished not to sleep in the sun during important activities, warned archly against rumor-mongering, and given an number of

either inaccurate or improvised answers to perfectly legitimate questions. They were advised also (and we for one found it rather hard to believe) that Colonel Glenn had said something about doing his job and hoping the newsmen were doing theirs.[43]

The tone got no better over the coming weeks as the Glenn mission was continually delayed due to a series of problems. While NASA was a civilian program, some of the old military ideas about public information remained. The space agency was relatively forthcoming if the most recent postponement stemmed from weather or the Mercury capsule, but much less willing to share information if the problem was with the Atlas launch missile, which also served as a military weapon. "Of course we know just what the trouble is, but I'm not telling you," Powers snapped to a reporter after one such cancellation.[44]

At least the network pool was in fine shape, so it seemed. It was ABC's turn to coordinate the Cape coverage, and despite the network's dismal position in the ratings, it had a highly capable production team. Lou Shollenberger, considered "the best nuts and bolts man in the business" for his ability to handle multifaceted broadcasts, drew the pool coordinator's position. He managed a production plan that remained largely intact from Shepard's mission, with a few refinements. Unmanned cameras operated by NASA would surround the launch pad, with another placed on a crane 1,500 feet away to capture liftoff. The room where Glenn would don his spacesuit was equipped with a camera, as was the room through which the astronaut would enter the spaceship. Crews were assigned to various observation points near the Cape, and to three aircraft carriers in the Atlantic splashdown area. The pool had explored the possibility of live video coverage from the recovery, but balked at the $1.25 million cost for equipment alone.[45]

In terms of access, the television pool had won a couple of new accommodations. The networks were particularly adamant about being able to broadcast Glenn's comments from space, but NASA was reluctant to hinder the astronaut from speaking freely in case of an emergency. Eventually, the two sides reached a compromise: The pool would supply two audiotape editors, who would record the conversations coming into Mercury Control and select newsworthy

portions to be played during Powers' updates. NASA also agreed to an earlier start time for live pool coverage on launch day, but the agency continued to balk on a video camera inside Mercury Control, even when the pool proposed it be permanently fixed on the map tracking the flight.[46]

The pool arrangement was a veneer of cooperation, however, one much too thin to mask the building resentment among its members. NBC announced plans to broadcast live Glenn's air-to-ground conversations, which were easy to pick up on shortwave radio, only to relent to pressure applied by the agency and other members of the pool. NBC was also at the center of a more serious dispute over previously filmed interviews with Glenn, the network's two competitors charging NASA with changing an embargo date to a time more amenable to NBC's schedule. ABC's protest accused NASA of a "wholly unwarranted act of dishonesty and favoritism" and the network joined CBS in running the interviews a day early. The competition had become a bitter one that resulted in "dissolved friendships and strained relationships," a tone that would continue throughout Project Mercury, according to one NBC producer.[47]

The mounting delays also put broadcasters on edge, but there were other tangible effects from the cancellations. The January 27 scrub alone had cost the pool $500,000, and in mid-February, CBS reported a $750,000 loss due to the series of postponements. There was a physical toll as well: On February 10, Shollenberger fell off a ladder while adjusting an antenna and suffered a concussion, broken ribs and a cracked pelvis, leaving the pool coordinator's duties to ABC colleague Frank LaTourette.[48]

During the wait, the networks each aired special programs previewing the mission. An airing of CBS's *Eyewitness* included a brief segment with a Mercury engineer about the space vehicle, but the remainder of the thirty-minute program was devoted to Glenn and perpetuated his personal narrative that emerged during the Mercury 7's first press conference. Correspondent David Dugan traveled to Glenn's hometown of New Concord, Ohio, and reported, "There's the same classic all-American quality about the town that typifies everything you hear about John Glenn himself." Charles von Fremd's interview with the astronaut focused on the danger of spaceflight and

whether his religion helped he and his family deal with the uncertainty.[49]

"I guess we try and live our religion day in and day out," Glenn replied, adding that he disliked people who "only call on their Maker when the chips are down and when they feel they need divine help to get through something." The show concluded by asserting "Glenn is spiritually prepared to face his test next week." Stories with similar religious overtones about the astronaut appeared in other press outlets during the wait.[50]

Several interesting undercards at the Cape gave the assembled reporters other topics to write about and further justify their ballooning expense accounts. There were several successful missile launches to report, but the failures were more newsworthy. A unique "buckshot" composite rocket loaded with five satellites lifted off beautifully, then promptly dumped its payload into the Atlantic Ocean. A Ranger launch brought reports of possible moon pictures, those hopes later dashed when officials told the press that the missile would miss its target by 23,000 miles and go into permanent orbit around the sun.[51]

For entertainment, there was the human carnival. Thousands of "bird watchers" had descended on the Cape; some were archetypes for the stereotypical American dream, others were symbols of the country's decadence. There were college kids and contractors' wives, salesmen and bowling alley operators, many sleeping in cars or camping on the beach. The more seedy side of America also was well-represented, "a jungle of inflammable blondes, Billy Minsky strip-teasers, press agents, reporters, technicians and a considerable number of other characters" in the words of *The New York Times'* Scotty Reston. Just feet away from press headquarters at the Starlight Motel in nearby Cocoa Beach, a waitress was shot and killed, her estranged husband later confessing after a suspenseful manhunt. There was the occasional local gadfly who would collar a reporter and bitch about the national media's portrayal of his community before stomping off to watch a missile launch. And if reporters got tired of carousing or people-watching during the wait, they could kill the boredom by grabbing a newspaper and catching up on more earthly headlines: Notorious mob boss Lucky Luciano died of a heart attack, and *The Tonight Show* selected Jack Paar's replacement—a game show host named Carson.[52]

The one person who seemed to keep his cool throughout all the delays was Glenn. "The additional time will only increase our sharpness," he was reported to have said after the first delay in January. "Well, there will be another day," Glenn said after being locked in his capsule for five hours in another aborted attempt, and another scrubbed launch brought a Glenn response of, "Sure I'm disappointed … but this is a complicated business," according to NASA.[53]

Of course, there was always the possibility that the words were concocted by Powers and not uttered by the astronaut. As Glenn prepared to enter the capsule yet again, Powers circulated the story that the astronaut had spent the previous day running on the beach and playing with sea turtles. One wire service reporter who included it in his story got a call the following evening. On the other end of the line was the man who was hours away from being flung out of Earth's atmosphere.

"Don't you know," said an agitated Glenn, "that it is a federal offense to disturb turtle-nesting places on the coast?" The next morning, as Glenn entered his space capsule, readers of some newspapers were set straight with a correction: America's soon-to-be newest hero had not disturbed the balance of nature.[54]

When Glenn entered the capsule again on February 20, 1962, the networks had already spent $3 million on a flight that hadn't left the ground. Paying their share of the pool expenses through the numerous delays ran up the bill, as did new innovations. CBS was particularly conspicuous on this front, installing a 12-by-16 foot television screen in Grand Central Station designed to attract the attention of commuters and allow the network to interview bystanders as the flight unfolded. At the Cape, the network made a significant upgrade from the station wagon dispatched for the Shepard flight, unveiling the "CBS News Control Center," a trailer stationed 9,000 feet from the launch pad.[55]

Inside the CBS trailer, a man who had failed college physics would soon explain how those scientific concepts were being applied to send Glenn around the Earth. While many of his broadcast contemporaries were viewed as little more than news readers, Walter Cronkite had earned his journalistic chops, spending eleven years as a

print reporter for United Press covering, among other beats, World War II and the Soviet Union. When a Kansas City radio station offered Cronkite a significantly better-paying job as a Washington correspondent in the late 1940s, he initially balked, telling his potential employer that "News is a newspaper's business, and it isn't radio's business." Cronkite relented, and in 1950, CBS hired the reluctant broadcaster, whose network debut was an impromptu chalk talk explaining the complexities of the Korean War. Two years later, Cronkite was anchoring the network's political convention coverage.[56]

An attempt to make Cronkite a chatty morning talk show host fared poorly in the early 1950s, but he soon found a niche with CBS current affairs programs such as *Eyewitness* and *The 20ᵗʰ Century*. As America's space program expanded, so did Cronkite's interest in the subject, and he devoted a number of episodes to the topic. In recent years, Cronkite had given viewers a close-up look at still-under-development marvels such as the X-15, a research aircraft designed for outer space travel, and the Saturn, Wernher von Braun's latest missile progeny. Cronkite's interviews with technicians and space officials underscored the difficulties that had yet to be overcome, but his unbridled enthusiasm for interplanetary travel shone through as well. In a 1959 episode of *The 20ᵗʰ Century*, Cronkite had asked a NASA official "Given a reasonable healthy old age, what are my chances of getting to the moon?"[57]

On this February morning, Cronkite would be earthbound. By 9:30 a.m., he had already performed a two-and-a-half-hour verbal juggling act, interspersing his own commentary with live reports from correspondents around the world. Cronkite was also, indirectly through his on-site producers, getting instructions from CBS headquarters. As launch time drew closer, those within earshot of the network's New York control room could hear producer Don Hewitt on the telephone with Cape producer Robert Wussler, pleading with him to get Cronkite refocused on the drama at hand:

> Look, Bobby, from here in we've got to give the countdown every minute. Tell Walter, every minute ... Right now ... For God's sake, Bobby, I said right now ... The countdown ... Well, why doesn't he do it? He's talking about every other goddamn thing under the sun and he isn't giving us the countdown ... (voice rising) I don't care what Walter says, make him stop talking and give us the countdown![58]

At NBC's New York headquarters, producer Chet Hagan eschewed the chaos of his network's control room for his own relative sanctum a floor above. In the company directory, the 9-by-12 space was officially office number 586, but to NBC news staffers it was known as "Hagan's Throne Room." Inside, as Hagan and two assistants monitored five video feeds coming into the building, the producer conducted a perpetual editorial meeting through an elaborate eight-way teleconference setup. At an instant, Hagan could talk with reporters or producers at four remote sites, order directors in the control room to air or kill a segment, instruct studio on-air talent to speak more clearly, or, if things got dicey, get the network president's immediate advice and consent.[59]

Viewers across America were unaware of the behind-the-scenes jockeying that was going on at all three networks. The 10,000 people who had gathered in front of the giant CBS television screen at Grand Central Station stood in utter silence, eyes lifted upward toward the projected image of the Atlas rocket, hearts and minds with the man sitting on top of it. In Arlington, Virginia, Glenn's wife had borrowed two televisions from a friend and placed them near the set already in the family's living room. "We want to watch all the networks," Annie Glenn explained. She was joined by 60 million of her fellow citizens who gathered around sets in homes, schools and workplaces.[60]

At 9:47 a.m., they all listened as Shorty Powers counted down the final 10 seconds. Then the rocket fired.

"Ignition. Lift-off!"

At Grand Central Station and the beaches near Cape Canaveral, there was a smattering of applause, then a return to silence.

"The MA-6 is off the launch pad, at forty-seven minutes after the hour," reported Powers.

As the rocket arced upward, CBS viewers heard Cronkite the journalist take a backseat to Cronkite the space booster.[61]

"Oh, go baby!" exclaimed Cronkite.[62]

Not everyone could get to a television. In seventy-five New York subway stations, the loudspeakers crackled: "Colonel John H. Glenn Jr. has just taken off in his rocket for orbit. Please say a prayer for him." The request would be repeated every ten minutes for the next five hours.[63]

Within minutes, Glenn was in orbit, an announcement that brought a loud roar from the crowd in Grand Central, followed by tears or silent prayer for some, emotions that were felt similarly by citizens across the country. Broadcasters would have little time to explore their feelings though, as the mission moved into a much more difficult phase. With the capsule more than one hundred miles above the Earth's surface, television would spend the next several hours covering what was essentially a radio event. NASA's periodic voice updates from Powers and occasional recorded excerpts from Glenn's air-to-ground conversations would be crucial but brief, leaving the networks with a lot of airtime to fill.[64]

Exacerbating the problem was a significant technical limitation: There were only two video transmission circuits coming out of the press facility at the Cape. The pool feed tied up one line continuously, leaving the other line for three network on-site teams to share in 10-minute intervals. To fill some of the slack, each network's New York control room had on file numerous pre-taped packages, ranging from technical primers on Mercury's guidance system, to interviews with Glenn's parents.[65]

The networks also dispatched correspondents to other sites foreign and domestic, their reports often sounding quite similar: Viewers could see NBC's Sander Vanocur dutifully report that President Kennedy was watching television at the White House, then flip the channel and watch CBS's Nancy Hanschman inform America that Glenn's wife and family were doing the same at their Virginia home. NBC's plan for exclusive segments from the San Diego production plant of Atlas missile contractor General Dynamics had been scuttled by the network's own blunder. When NBC mistakenly sent out a press release touting its scoop, the other two networks angrily complained and eventually gained permission for similar remotes, although NBC retained first choice of interview subjects.[66]

The networks also rolled out embellishments so that viewers would see more than talking heads for the next several hours. NBC had transformed its gargantuan Studio 8H in New York into a virtual flight control center featuring a replica of the orbit map in Mercury Control and a giant screen that projected the live pool feed from the Cape. In another part of the studio, network meteorologist Dr. Frank Field prepared weather maps charting the planned landing area.

CBS's tracking device was a globe with a miniature Mercury suspended upon it, and the network displayed the elapsed time on a mock-up of the capsule's instrumentation panel. Some found the spacesuit-clad actor at the CBS controls a bit ironic given that the network often charged NBC with bringing a showbiz approach to news.[67]

The technical wizardry wasn't always that helpful in keeping viewers apprised of the mission's progress, and on-air talent also struggled to keep up. Near the end of the first orbit, CBS had Glenn a half-continent farther along than did NBC. Within minutes, NBC had somehow leaped ahead, putting Glenn over the Atlantic Ocean while CBS still had the astronaut over Georgia. CBS's account seemed to be closer to the official account given by Powers, but Cronkite's statement that Glenn was "traveling almost faster than it's possible to talk about it" didn't engender confidence in any network's accuracy.[68]

The tape-delayed conversations with the voluble Glenn needed no augmentation (although CBS found it necessary to train a camera on an electronic spectrum analyzer that displayed a visual representation of the audio waves). Viewers sat in wonderment as they heard the astronaut describe geographic features and thousands of mysterious "luminous particles" that had surrounded the craft (later determined to be ice crystals produced by the capsule). They heard Glenn's graciousness when, after being told he had just seen the lights of Perth, Australia, the astronaut instructed the tracking station to "Thank everybody for turning them on, will you?" And viewers got a chuckle when Powers recounted Glenn's request that four hours of flight time be added to his Marine Corps pay sheet.[69]

The broadcasts would be tests of stamina and patience for those in front of the cameras. While two of the networks essentially split the anchor duties–NBC stationed Frank McGee in New York and Roy Neal at the Cape, while ABC had a similar arrangement with Bill Shadel and Jules Bergman–CBS's coverage all flowed through Cronkite. Throughout Friendship 7's mission, Cronkite's indirect jockeying with headquarters for control of the broadcast continued. Once, when Cronkite was trying to explain a bit of NASA jargon, Hewitt grumped, "What's Walter talking about now? What? He said Norman Somebody. Oh, nomenclature. Well, tell him to speak more clearly." At another point in the broadcast, an associate producer jot-

ted down an instruction from New York and handed it to Cronkite. Displeased with the request, the anchor ignored it. The producer duplicated the directive on a second note, which Cronkite pushed away. When Cronkite saw a third note headed his way, he responded by whacking the producer's arm hard enough to make him wince in pain.[70]

Cronkite would appear on screen 140 times by the end of the evening, and despite the occasional disagreements with his producers, he won the day with both the public and critics. His straightforward explanations, in the words of one observer, "made engrossing sense of a miracle otherwise beyond the comprehension of the hundred million Americans who were watching." Cronkite's segues and on-point questions of correspondents "tied CBS-TV's coverage together neatly, brilliantly, objectively, factually," wrote another critic. Few Americans cared "that his deep-down rooting interest always was there," the least of whom being Glenn's mother. A few days later, surrounded by a score of dignitaries at the Cape, she would tell her celebrity son that the person she most wanted to meet was Cronkite.[71]

Each of the anchors would face his greatest test after 2 p.m. eastern time as Glenn was nearing the end of the third orbit and preparing for re-entry. On ABC, Bergman gave a display of pyrotechnics, igniting some "solid fuel" to demonstrate the retro rockets that would slow down the craft so that gravity could pull it back toward Earth. On NBC, McGee said, "We are approaching a climactic moment," one that was complicated by apparent difficulties on Friendship 7. From Mercury Control, Powers told the viewing and listening audience about a signal that had suggested a problem with the heat shield designed to keep the astronaut and the craft from burning up on re-entry. Further testing indicated that the heat shield was intact, Powers said, but flight controllers had decided to leave the retro rockets strapped on the capsule to hold the shield in place, just in case. On CBS, Cronkite sensed a serious tone in Powers' voice but suggested that he may be projecting "our own tension" onto what the NASA spokesman had said. In retrospect, Cronkite's perception was correct: Flight controllers were unsure whether the signal had actually been in error, and they were anxious about the straps on the retro rockets. If the heat shield really was loose, no one was certain that the straps would be enough to hold it in place.[72]

Just after 2:30 p.m., Powers reported that Mercury Control had lost voice communications with Glenn, a development that had been expected: Radio waves were unable to penetrate the fireball that surrounded the red-hot metal can as it fell back into the Earth's atmosphere. Eight restless minutes later, CBS correspondent Bill Downs, stationed on the U.S.S. *Randolph*, reported that Friendship 7 had been spotted by a Navy destroyer, news that elicited a huge cheer from the throng at Grand Central Station and similar outbursts throughout the country.[73]

It would be more than twenty minutes before the U.S.S. *Noa* placed Friendship 7 on its deck. In the interim, Downs scrambled to find someone who had viewed the climactic finale. He finally collared a witness to the splashdown, then begged the pool directors to put him on the air. Never mind, replied the pool: Shorty Powers had already reported details of the landing. Downs' retort would not have passed muster with network censors.[74]

When an emotional Powers reported that Glenn was on board the recovery ship, "a hale and hearty astronaut after his history-making flight," a nation celebrated. CBS, curiously, was the only network to capture the public sentiment with crowd shots of the ecstatic Grand Central crowd and of paper streaming down from office windows on Madison Avenue. All three networks aired a cringe-inducing press conference with Glenn's wife and two children on the family's Virginia front lawn. A session already plagued by inane questions became even more muddled when a CBS reporter put headphones on Mrs. Glenn so she could talk directly with Cronkite, a technique that the network had been using with increasing frequency to the great annoyance of the other two networks. In the chaos, Annie Glenn was forced to summon nearly as much poise as had her husband during re-entry.[75]

Despite blemishes like the Glenn family interview, television had acquitted itself well in the coverage of Friendship 7. The largest daytime audience in the history of television, 40 million homes, had tuned in, with the average viewer watching for five hours and fifteen minutes. If quality were quantifiable, the medium would have garnered equally impressive numbers. The day's coverage was "a glowing page in the history of communications," wrote one reviewer, echoing Jack Gould's sentiments about the "dazzling display of mod-

ern electronics at work, a display that suddenly made the world seem smaller than ever." Glenn's almost-live conversations, in particular, had revealed "a global communications network as it had not been previously exposed," Gould wrote, and demonstrated that the world "could be linked into a huge party line." Later in the year, when readers of Marshall McLuhan's *The Gutenberg Galaxy* saw the term "global village," they could nod knowingly.[76]

When Glenn returned to Cape Canaveral three days later, the networks again suspended regular programming to air the ceremonies. Television seemed only to further validate the astronaut's inherent virtue, capturing his warmth (heartfelt embrace with his wife), humor (showing his ID badge to a Cape security guard), and patience (explaining the inner workings of the capsule to his parents). A later celebration in New York City allowed viewers to see what to that point was the largest ticker-tape parade in the nation's history. Charles Lindbergh had received a similar reception after his historic transatlantic flight nearly thirty-five years earlier, but television allowed Glenn to share his moment live with his admirers from coast to coast. Glenn's appeal to the American public only seemed to grow the longer he appeared on camera. Why should Glenn be the eventual choice to make the moon mission, asked the fawning Scotty Reston in *The New York Times*, since "we need him so badly on Earth?"[77]

Broadcasters, still smarting from the FCC chairman's criticisms, basked in Glenn's glow. One trade publication asserted that the quality of coverage both in flight and on the ground was simply part of its heritage and not a response to Minow, but the magazine couldn't help but tweak him by ending the column with "Wasteland indeed!" As the excitement died down though, industry insiders began wondering whether the "damn the schedule" tenaciousness had been worth it. Factoring in both network costs and lost local affiliate ad revenues, television lost at least $6 million on its coverage. "The industry covered itself both with glory and red ink," one industry publication wrote. "Now the accounting, and the question: How many Glenns can television afford?"[78]

The two leading networks were able to recoup some of their expenses through their sponsors. NBC had a stable of advertisers led by Gulf Oil, CBS partnered with the Federal Savings & Loan Foundation, but ABC's only source of revenue came when the pace of news

slowed and the network was able to fit in a commercial sold for the regularly scheduled program that had been preempted. Not surprisingly, ABC was speaking the loudest for fiscal restraint.[79]

"The future? I don't know," said ABC news chief Jim Hagerty. "A more modified pool? Less manpower? There should be planning for the future which will cut costs but still let us do the job." Hagerty's counterparts were acutely aware of the costs, but unable to shake their instincts to beat their rivals. "Competition in the coverage of news stories is a healthy tradition in broadcasting journalism," said CBS News president Dick Salant, whose addendum about considering changes "which would benefit both the public and broadcast journalism" didn't sound all that convincing.[80]

Viewers smitten with John Glenn had also developed an affinity for the person who had kept them updated throughout the astronaut's journey through space. During Friendship 7's voyage, Shorty Powers had been on the air much longer than he had been for the brief suborbital shots, and his calm tone seemed to have an even greater soothing effect on an anxious public. Not only was he "just about the best-known public relations man in the world," according to *Time* magazine, but he also had transformed into a minor celebrity. He seemed to relish and cultivate the latter role, but in doing so, he gave ammunition to critics who found him self-aggrandizing. His work as a publicist was nearly "as important as actually flying the missions," he told one publication, and he made sure to note that "millions will be hanging on every word" he uttered during a space flight. In NASA's next manned mission though, Powers would face scrutiny for what he didn't say.[81]

The flight of Scott Carpenter began to unravel shortly after he took orbit. Carpenter became enamored with the ability to maneuver the capsule into various tilts and rolls, using too much fuel in the process and falling behind on several scheduled experiments. On his second orbit, the fuel problems worsened and the temperature both inside the cabin and inside Carpenter's space suit reached troubling levels. NBC's Neal, monitoring conversations between the Cape and tracking stations around the globe, connected the dots and predicted that the problems were not grave and that the third orbit would go on

as scheduled, being proven correct a half-hour later when NASA gave the official go-ahead.[82]

In retrospect, Mercury Control would have been better off canceling Carpenter's last lap. The tracking stations became increasingly concerned about Carpenter's tone of voice, which seemed to relay a hint of panic. Not trusting the automatic control system, Carpenter chose to try and manually put the capsule into its correct angle for re-entry. He was off by 10 degrees, and in the resulting confusion, he fired his re-entry rockets seconds too late. Carpenter was now destined to miss his splashdown target by hundreds of miles, if he returned at all. The shortage of fuel would give Carpenter few opportunities to maneuver the capsule to keep it upright; if the spacecraft tumbled, it and the astronaut would perish in flames.[83]

Carpenter acknowledged Grissom's report of landing conditions at the recovery area with a "Roger" just before losing voice contact. This had been the most excruciating phase of Glenn's flight, the roughly four-minute "blackout" period during re-entry. "We are still attempting to re-establish contact with the Aurora Seven spacecraft," Powers told the world. "We expect to establish contact momentarily. This is Mercury control standing by."[84]

Four minutes passed. Silence.

In Mercury Control, engineers' minds began racing. Had the craft made it through the inferno of re-entry? Had the parachute opened? How far had the ship drifted past the recovery area? And what was Carpenter's status? Some feared, given the astronaut's highly agitated state during the last orbit, that he had suffered a heart attack.[85]

More silence. Walt Williams turned to Shorty Powers and said, "We've lost him." Powers, knowing his boss did not merely mean there was a communications problem, began digging through his notes to find the procedure for announcing the suspected death of an astronaut.[86]

Finally, five minutes after the blackout began, mission control picked up a burst of radio activity. Much of it was garbled, but 15 seconds of the transmission was clear. It contained data indicating that the ship's instrumentation was working and electrocardiograph readings of Carpenter's beating heart. The capsule and the astronaut had survived.[87]

The Voice of Mercury remained silent.

Ten minutes. More waiting. At Grand Central station, seven thousand pairs of eyes were now transfixed to the giant CBS screen. In parks, visitors sat on benches with radios held up to their ears, while Tiffany's shoppers found their way to the electronics department to monitor the coverage. The only words from Powers came in ominous tones: "We are still working at establishing contact with the Aurora VII spacecraft." Reporters monitoring the Cape's shortwave frequency listened to Grissom's repetitive drone–"Aurora 7. Aurora 7. Do you read me?"–and feared the worst. As the wait dragged on, an emotional Cronkite told viewers, "I'm afraid ... we may have ... lost an astronaut."[88]

Broadcast anchors and reporters, operating without knowledge of the brief data transmission from the falling spacecraft, faced the delicate task of conveying the seriousness of the situation without articulating the worst-case scenario. Viewers, trying to fill in the gaps, found solace in reporters' guarded optimism one moment, only to be sobered the next when a different correspondent took a noncommittal, wait-and-see approach.[89]

Finally, forty minutes after Carpenter lost radio contact with mission control, an encouraging word from Powers went out to the nation's radio and television audiences: A Navy plane had picked up an automatic tracking signal from the spacecraft. Twenty minutes later, Powers told the world's citizens what they had wanted to hear: "We have just received a report that an aircraft in the landing area has sighted the spacecraft and has sighted a life raft with a gentleman by the name of Carpenter riding in it." Just more than two hours later, a helicopter would pluck the astronaut from the ocean and deliver him safely to the aircraft carrier *Intrepid*. Aurora 7's mission was over, but its repercussions were yet to come.[90]

"Certainly there will be few days in any of our lives to match this one and the excruciating drama of that long three-quarters of an hour," Cronkite told CBS viewers during an evening wrap-up. "Never before have we lost contact both by voice and radar with a returning capsule. There was no precedent for this one."[91]

Carpenter, already in hot water for his failure to follow procedure, dug himself a deeper hole by telling reporters that "No one knew where I was–and I didn't either." The quote, coupled with a photo of a seemingly carefree Carpenter floating in his raft, further infuriated

flight controllers whose hurried calculations had correctly estimated where the capsule had splashed down and hastened the astronaut's recovery. Carpenter would never fly another space mission.[92]

Powers, just three months removed from becoming a household name during the Glenn flight, would now experience the flip side of fame and take a pummeling from the nation's press. Powers argued that he acted appropriately by not revealing Aurora 7's data transmission after the blackout and waiting for visual confirmation that Carpenter was safe: "I felt it wasn't proper for me to guess or speculate," Powers would say years later. For most members of the media contingent, however, it was the most egregious example of reporters having to fend for themselves that day to gauge the seriousness of problems ranging from excessive heat in the cabin to a lack of fuel. "To abandon TV and radio commentators to their own instantaneous judgment on highly scientific difficulties is neither fair to them nor a wise national course to pursue," Gould wrote in *The New York Times*.[93]

For members of the press such as Cronkite, the lack of candor was "inexcusable incompetency" and called into question NASA's commitment to conduct its business in the open, particularly in times of potential peril. The incident certainly caused the media to lose what little faith they had in NASA's most visible non-astronaut. Average Americans still thought of him as the Voice of Mercury. To many reporters, he was now "that idiot Powers."[94]

CHAPTER 4

The "Open Program": NASA Builds a Constituency

Julian Scheer caught the space bug in 1956.

In the six years since his graduation from the University of North Carolina, the young reporter had built an impressive résumé through his coverage of politics and the burgeoning civil rights movement at the *Charlotte News*. His college buddy, Nelson Benton, was on a similar career trajectory as a local television reporter, a path that would eventually land Benton a correspondent's job at CBS. On this day, Benton asked whether Scheer would like to tag along as Benton's Air Force Reserve unit went on a weekend trip to Cape Canaveral.[1]

Scheer accepted. Before he returned from Florida, he was hooked. Space flight, Scheer thought, is going to be a huge story, and he wanted to be in the middle of it.

His employer was not so easily convinced. So while Scheer continued to write about more earthly matters near Charlotte, he occasionally paid his own way to the Cape to see more launches and learn more about missiles. By 1959, Scheer had collaborated with rocket engineer Theodore J. Gordon on the successful book *First into Outer Space*, and the newspaper would soon relent and assign Scheer to cover the Mercury program.[2]

By spring 1962, Scheer's enthusiasm had been doused by the realities of the space beat. Like many reporters, Scheer had tired of jostling with five hundred of his colleagues at a lone pre-launch press conference and being fed quotes of dubious authenticity by surly NASA information officers. In July, Scheer resigned from his newspaper and sat down to write a novel focusing on civil rights. Scheer hadn't fin-

ished the first chapter when he got a call asking him to return to space: This time, for the other side.[3]

The man who placed the call, NASA chief James Webb, had been on the job for just more than a year and now knew all too well why at least seventeen previous candidates had turned down the gig. Mercury was ongoing, but the next step in manned spaceflight, Gemini, was already coming in well over budget and would soon be mired in numerous production delays. The project designed to ultimately take man to the moon, Apollo, was barely off the drawing board, planners having only recently agreed on the method for the final approach and lunar landing.[4]

The technical problems were largely for his deputies to fix though, as Webb had no background in rocketry. He had been a manager, first as budget director and an undersecretary of state in the Truman administration, then as an executive for an oil company owned by powerful Oklahoma senator Robert Kerr. In his new duties, Webb focused on NASA's organizational structure, relationships with Congress and contractors, and on this day, an image of the agency that had taken a beating in the months following John Glenn's triumphant flight. The exclusive *Life* contract with the Mercury 7, a sore spot with the press from the beginning, came under renewed scrutiny during the spring with the announcement that the astronauts were investing the proceeds into several real estate ventures, including a posh, million-dollar motel near Cape Canaveral. That the hotel would house Mercury press facilities raised conflict-of-interest concerns, as did the potential for the astronauts billing the government for staying in a room that they owned.[5]

Soon, a new media controversy would emerge when a real estate developer offered each of the Mercury 7 a free house in Houston, where a new manned spaceflight center was under construction. The deal, while not technically illegal, seemed to go against an edict by President Kennedy against gifts for government employees. At an uncomfortable press conference notable for the absence of any NASA headquarters representation, Leo D'Orsay, the astronauts' pro bono business representative, said the deal fell through because the agency had deemed that the agreement would "not be in good taste." Shorty Powers, the astronauts' official spokesman, countered that the agency neither approved nor disapproved, but that it did pass along concerns

that public "misunderstanding" about the transaction might "undercut the stature of the astronauts and the stature of the program."[6]

The astronauts had bowed out of the Houston offer and would eventually divest themselves of the Cape-area hotel, but disclosure of the deals had caused the public to dial back its adulation of the Mercury 7. "One wonders what has happened to the publicized disavowal by these men of any intention to profit personally from their researches," a Yonkers doctor wrote to *The New York Times*. "Somehow they have discovered gold in them thar' galaxies." A minister expressed his "deep indignation and sadness" in a letter to *The Washington Post*: "I had thought I would be proud to have my son be an astronaut. Not so now, for I have no interest in his admiring those who seek personal gain from their role in our country's effort to explore outer space. I don't want him to choose a career with an attached get-rich-quick scheme."[7]

Powers' handling of Scott Carpenter's misadventure in space–the "Voice of Mercury" leaving the press and public in the dark about the astronaut's status for nearly an hour–marked the third straight month of bad headlines for NASA. The accumulated publicity snafus only hinted though at the more systemic dysfunction that permeated the agency's public information effort. A general lack of direction from headquarters was the prime culprit, which wasn't surprising, given that five men had held the title of NASA public affairs director in less than two years. Three of those men–a biologist, a sociologist, and a corporate executive–had no experience in the field when taking the job. Even when more capable hands directed the office, no procedures existed to ensure coordination between headquarters and the various field operations. As a result, centers often created their own policies on the fly, the subsidiaries in effect wielding more power than the central office.[8]

So Webb turned to the recent newspaper exile and asked him to submit a proposal for how the office of public affairs could be better organized and project a better image of NASA. Scheer set aside his novel and took a month to draft a plan. Upon receiving it, Webb asked its architect to come to NASA headquarters.[9]

"I accept your offer to work for me," Webb said as Scheer entered his office.

Both men laughed, but Scheer quickly realized that the NASA chief was serious. Scheer explained that he wanted to devote the next year to his book, but Webb would have none of it.

"You can write that novel ten years from now. I want you to run this program just as you've outlined it," Webb said. "Do you have the guts to do that?"

Scheer paused.

The novel would never be written.[10]

The change at NASA would be gradual. Scheer was initially brought aboard as a "consultant" in fall 1962 as he learned the ins and outs of the agency, but as Scheer settled in, decisions from above were being made that would affect the remainder of his tenure. Scheer had hated the *Life* deal as a reporter, and he quickly discovered that a number of people within NASA agreed with him, including, at the time, his boss. Webb's already negative attitude toward the magazine had grown more so during one of the canceled Glenn launches, when the astronaut's wife refused a visit from Vice President Lyndon Johnson as *Life* photographer Ralph Morse and writer Loudon Wainwright sat inside her home. When Webb phoned *Life* publisher C.D. Jackson to voice his displeasure, Jackson fired back that his magazine wasn't getting enough return on its investment, since, in his view, NASA was putting out so much information for general public consumption. When Annie Glenn finally did see her husband lift off weeks later, Morse and Wainwright watched with her. LBJ did not.[11]

The Glenn incident gave credence to charges that the *Life* deal gave the magazine control of the space agency. Other opponents were concerned that the arrangement contributed to a "prima donna" attitude among the astronauts, overshadowing the thousands of men and women who were making the space program possible. Now, the newly emerging public perception of the astronauts as money grabbers led more officials within the agency to advocate that the contract not be renewed after Mercury's conclusion.[12]

The *Life* deal still had plenty of supporters within NASA, though. Some administrators approached the contract cynically, saying the magazine's human-interest angles ensured at least one positive press portrayal of the space program. Other arguments made sense to even

the most fervent opponents of the agreement. Each astronaut's military salary, less than $15,000 per year, did seem low considering the potential danger and demands on his time. By splitting the *Life* pot equally, the agency avoided a scenario where individual astronauts would become the subject of bidding wars and also made it less likely that they would seek out other moonlighting opportunities. And while astronauts welcomed the salary supplement from *Life*, the free $100,000 life insurance policy may have been as important a boon, since their hazardous careers made it impossible to buy a policy on the open market.[13]

Proponents also argued that the exclusive deal protected the astronauts' families from media harassment. For those who had been at NASA when the Mercury 7 was introduced, this may have been the most persuasive line of reasoning. Memories of the frenzied press swarming the astronauts' homes, or of reporters following the astronauts' children to school and asking teachers whether the kids were as smart as their dads, were still relatively fresh. The deal gave families only one publication to service, giving them more control of the time, place, and manner of media interactions.[14]

The astronauts had reasons other than financial to like the *Life* deal. Deke Slayton regarded the magazine's writers and photographers as "more allies than as adversaries," an attitude that prevailed during the few times when the magazine engaged in some good-natured journalistic sleuthing. On one such occasion, when Shorty Powers barred the magazine from a secret desert survival training exercise, writer Don Schanche pieced together the approximate location by talking to Carpenter's son and a staff sergeant at a military base in Nevada. Morse then hired a pilot to scout out the desert; when they located the site, Morse had the pilot fly back to the airport while he dropped bags of flour at strategic road intersections. When the astronauts arrived for their training, Morse was waiting for them, having used the smashed bags as landmarks as he navigated his rented Jeep. The astronauts got the last laugh when Shepard and Wally Schirra rigged a flare to the Jeep's ignition, engulfing Morse in smoke and ruining the vehicle.[15]

The *Life* staff had also demonstrated a dedication to the astronauts and their families that went beyond simply writing a positive story. When Carpenter's wife decided she wanted to go to the Cape for her

husband's mission, Morse secured a rental house for her, stocked it with food, and designed an elaborate, multi-car scheme to drive her and her kids from the airport without being followed. Still, *Life* staffers couldn't gloss over everything. When it appeared Carpenter might have perished upon re-entry, Wainwright pulled Morse aside and asked whether they should leave the house and give Rene Carpenter some privacy. "We don't," Morse said. "We're here as the press, we don't leave, we stay and cover it. We make our apologies and stay."[16]

At the time, it looked doubtful that *Life* would have such access for much longer. Webb's disapproval of the deal was shared by most of NASA's public affairs staff and, perhaps more importantly, President Kennedy. The Mercury 7 had already begun lobbying, though, using a visit to Lyndon Johnson's ranch in May 1962 to plead their case. That summer, Glenn would visit Kennedy at his vacation home to make another push to renew the agreement.[17]

"I did not deny the old argument that a soldier going into combat might share an equal danger with astronauts," Glenn recalled later, "but I felt that if there was enough interest in that soldier's home life, background, or childhood, then he too should have the right to receive compensation for opening his home, his family, and his innermost thoughts to public scrutiny that would not otherwise be available."[18]

By late summer, Kennedy and other decision makers were warming to Glenn's viewpoint, and they also became more receptive to the logistical advantages of the *Life* deal. Powers, one of the few public affairs staffers who was for the agreement, argued that exclusive access for one publication made for fewer agency headaches—"rather than seven or fourteen continuing problems [the *Life* deal] reduced itself to the handling of a single system."[19]

As a NASA committee worked toward a final resolution, members of the press weighed in. They noted that paying astronauts for their stories seemed to contradict a Kennedy executive order prohibiting federal employees from accepting outside financial deals "as a result of, or primarily relying upon, information obtained through their employment," but media representatives such as *New York Times* managing editor Turner Catledge also argued the deal eroded the space program's sense of shared national mission. "The more I con-

sider this total situation, the more unhappy I am that a dollar sign should be placed on a national accomplishment," Catledge wrote to Webb in late August 1962. "[W]hatever property rights there may be in the stories of the astronauts, and I personally quail at the notion that there should be any property rights at all, these property rights belong to the American people and not to individual citizens."[20]

Ultimately, NASA and the Kennedy administration would not agree with Catledge. In September 1962, the agency reconfirmed the astronauts' right to sell their "personal stories," but at Kennedy's insistence, NASA added a number of caveats designed to mollify critics and alleviate the "controversial aspects" of the original *Life* contract. Mindful of the tempest over the Mercury 7's real estate deals, the agency issued a "guideline" for astronauts present and future to avoid any investments that hinted of impropriety. Additional amendments banned commercial endorsements and mandated an additional mission briefing for non-*Life* members of the press.[21]

Another new rule, requiring astronauts to get NASA approval before appearing on television, radio or film, was particularly notable given a controversy that had erupted just days before the new policies were unveiled. In a televised interview with Walter Cronkite, Schirra said that the agency had erred by not being more candid when it appeared Carpenter had been lost, and he also asserted that Glenn's heavy load of speeches and personal appearances "have just about wiped him out of the space program," taking Glenn away from important engineering tasks. NASA quickly rebutted the content and assured the country that the astronauts were still on the same page, but the location of the interview posed another problem for the agency. CBS cameras had been inside Schirra's home, giving the network an angle that previously had been exclusively the domain of *Life*. When the magazine's competitor, *Look*, featured a Cronkite-bylined article about Schirra complete with family photographs, the other astronauts made clear their anger: Gordon Cooper refused to speak to Cronkite for months.[22]

While the new policies cleared the way for a new astronaut authorship contract, a deal would not be reached for nearly a year. As Scheer moved into a more permanent role as a co-administrator of NASA public affairs in early 1963, he was obligated to uphold the terms of the original *Life* agreement, but he did so with a more strict

interpretation of what was personal versus what was public domain. "I had objected to the contract as a reporter, and now I found myself managing it," Scheer recalled years later. "If one of the astronauts told his wife, 'I was scared shitless when the heat shield rattled,' I would step in and say, 'Sorry, but that's technical. You can't use that.' *Life* got really annoyed with me, but I just didn't believe anybody should have exclusive rights to the accomplishments and deeds of a government employee."[23]

Occasionally, Scheer would have to use the power of diplomacy rather than the editor's pen. As Cooper prepared for the final Mercury mission in May 1963, the astronaut threatened to use his *Life* story to blast the medical staff for sticking a seemingly endless procession of needles in him during testing. When Slayton, now in charge of the astronauts' office, told Cooper he couldn't criticize the medics, Cooper became even more resolute. The dispute made its way to Scheer, whose soft-sell approach eventually convinced Cooper to drop the language from his article. Such conciliation stood in stark contrast to how Scheer would bring the Shorty Powers era to a conclusion.[24]

A late 1962 survey of print and broadcast correspondents who covered NASA found that while the press generally agreed with the agency's information philosophy–"A free society carries out its rituals in the open" was one representative response–it had serious concerns about how the policy was executed. Much of the blame was heaped upon the "Voice of Mercury," who was accused by many of spending more time cultivating his own image than delivering information to the press. While television viewers perceived Shorty Powers as the calm voice reassuring an anxious public, the press saw a publicity-hungry charlatan whose words advocating openness usually proved empty. "This is show-biz to Shorty, I am convinced," wrote one reporter. "Powers gravitates to a TV camera like a moth to a light bulb," wrote another.[25]

If Powers had merely been camera-hungry, the complaints could have been dismissed as professional jealousy, but there were more substantive reasons for the media discord. Powers' propensity to speak for the astronauts, even when they were at his shoulder, grated

on the media, as did the continued policy of delaying broadcast of air-to-ground astronaut conversations, even though their shortwave radio frequencies were public knowledge. "Every launch was a battle with Shorty Powers," Cronkite would later recall. "He had no sense of public relations. We had to ferret out every fact the best way we could."[26]

And with Powers as the *de facto* chief of information, the playing field in the battle for that information was rarely level. Since Mercury began, Powers had refused to give a copy of each mission's flight plan to representatives from newspapers and magazines. While Powers distributed a copy to each of the networks for planning purposes, NBC correspondent Jay Barbree knew how to obtain it a bit earlier than his competitors. The price: One bottle of Jim Beam.[27]

As the press gathered to cover Cooper's liftoff, Scheer decided to make the flight plan policy a battleground. Scheer thought the document should be made available to all media on philosophical grounds, but more importantly for Scheer, the showdown's resolution would indicate how devoted NASA headquarters was to reining in Shorty Powers. "I decided to test the system and see which one of us was really in charge," Scheer recalled years later.[28]

Few had tried to curb the tempestuous Powers since his infamous "It's 3 o'clock in the morning, you jerk!" response to a reporter after Yuri Gagarin's flight two years earlier. In Scheer, however, Powers would now face an equally strong-willed adversary. "(Scheer) didn't pull his punches," recalled NASA public affairs colleague Brian Duff. "One of the phrases I remember with Julian–he'd lean back with a cigarette curling up into one eye and somehow never managed to blink. He'd say, 'I'll tell you one goddammed thing,' and he'd scratch his stomach at the same time and you'd think 'This guy is tough as nails!'"[29]

To no one's surprise, Scheer's initial request that Powers "get the copy machine running" and distribute the flight plan to all media went nowhere. "They don't need it," Powers replied.[30]

The flight plans, Scheer responded, would be distributed if he had to do it himself.[31]

The next move by Powers would be made under the old assumptions about his relationship with NASA headquarters. In the past four years, nearly a half-dozen people in Scheer's position had come and

gone, while Powers had built a reputation as the world's best-known publicist. "A new man," Scheer would later say, "coming in and posing changes and constraints and guidelines was difficult [for Powers] to accept, and I think rather logically, because this too could have been a passing thing. You never know how long these people are going to last."[32]

Powers, sure that he would be the last one standing, went all in. "I'll resign."

Scheer accepted.[33]

A stunned Powers told his NASA allies, who tried various means of taking matters into their own hands. Bob Gilruth, the lead administrator for Mercury who had backed Powers on the 3 a.m. flap two years earlier, took the news particularly hard, confronting Scheer at a Cape watering hole. "You can't do that to Shorty," a teary Gilruth would say before trying to take a swing, according to Scheer's version of events. Soon, Brainerd Holmes, the lead administrator for manned space flight, would tell Webb a version of the Scheer/Powers confrontation designed to save Shorty's job. Webb's determination that Holmes' story veered significantly from the facts was a crippling blow to an already crumbling relationship. Webb would soon start making plans to find Holmes' replacement.[34]

Webb also kept his word about allowing Scheer to run the public affairs office as he saw fit. Seeing that the power structure had significantly changed, Powers developed second thoughts about his immediate departure, apologized to Scheer, and asked to stay on board through the Cooper mission. Once more, television viewers would hear Powers' countdown, unaware that it would be his last.[35]

Powers had never prepared anyone else to handle the duties of the "Voice of Mercury," but Cooper's 34-hour trip gave Paul Haney the opportunity for on-the-job training. Haney performed adequately while Powers rested, but the rest of the information plan encountered numerous snags during the mission. Poor lighting in the capsule undermined the first U.S. attempt to broadcast live video images from space, and NBC had again underscored the absurdity of the voice transmission delay when correspondent John Rich, monitoring shortwave radio in Tokyo, repeated Cooper's actual words upon reentry, beating NASA's own accounts.[36]

After Cooper's return, television news executives capped the end of the Mercury program by expressing public exasperation over what they saw as unreasonable restrictions during the final mission and its prelude. Particularly galling was NASA's insistence that the agency produce pre-taped packages on astronaut experiments and technical aspects of the mission, then distribute the segments to broadcasters. "NASA doesn't try to manage our coverage of space shots as much as it tries to control it," CBS producer Don Hewitt told *TV Guide*. "I'm not implying that NASA is trying to cover up anything, but most of this stuff we prefer to cover on our own. As a news organization, this is our function. NASA should not function as our news agent."[37]

NASA's ongoing refusal to allow a camera into the control room for the Cooper flight was another publicized point of contention. Officially, the agency said it had once experimented with a live camera during a control room simulation, but the presence of the video equipment had led to a critical error by an engineer. "Is a $450 million project worth jeopardizing just to give the networks a better picture?" Haney asked, but other signs pointed to a more obstinate reason for the camera ban. An ABC producer claimed that he had received the go-ahead from the Mercury project manager to install the control-room camera, only to have Powers refuse. When the producer objected, Powers reportedly threw him out of the room.[38]

"They'll give you that old argument that nobody ever gets to look at the Russian manshoots, so look how much better off we are–but that doesn't apply here," Hewitt said of NASA's attitude toward the media. "And it's definitely not a matter of security. It's because NASA wants to project a better image of itself to the public. Since this is a seller's market, we must go along with them. If U.S. Steel or some other organization ever tried to control the way we cover them, we'd tell them to drop dead."[39]

By late summer, Hewitt and his fellow critics would no longer be able to direct their displeasure toward Shorty Powers. The "Voice of Mercury" did not go quietly, though. After the Cooper flight, Powers took a month off and went on a paid lecture tour for a company that was bidding for the astronauts' new publishing contract. While the arrangement looked ethically questionable at first glance, it was Powers' comments about women that doused NASA hopes for his graceful exit. Asked why the Americans had failed to match the Soviets by

putting a female into orbit, Powers replied, "We haven't found a woman in the country who is totally qualified. ... Anyway, what would you get from putting women into the space program?"[40]

In early August 1963, NASA officially announced that Haney was replacing Powers, who soon would be transferred to a temporary role created so that he could work the additional year needed to receive his military pension. Finally, the agency could do what Powers had advocated to the press when rumors of his dismissal surfaced during the Cooper mission: "Lets put it to bed, and get on to the moon."[41]

The resolution of the Powers/Scheer showdown left no doubt as to who was in charge of NASA's public affairs operation. A November 1963 announcement would codify what had been in practice since late summer: Scheer, reporting directly to the head of NASA, would oversee a newly organized office. A division dedicated to touting how "spin-off" of space technologies could be used in commercial products was moved elsewhere, leaving Scheer in charge of three divisions. Special Activities focused largely on traveling NASA exhibits and requests for speakers, while Educational Programs served schools in a number of ways ranging from pamphlets, to films, to teacher workshops. Public Information, the care and feeding of the nation's press corps, would undergo a number of changes that signified a new way of doing business.[42]

One such important move began a year earlier, when a number of NASA information staff members were assigned to exclusively cover one of the agency's three primary program offices: Advanced Research and Technology, Space Science, or Manned Space Flight. The change was designed to give public affairs personnel a more expert understanding of the agency programs they would have to explain to the press and public, but it also served as a not-so-subtle push to convince scientists to release their findings more promptly, a battle where victories came grudgingly. "A scientist is a man who wants to be judged by his peers," Walter Pennino, a deputy director of public information, told a trade publication in 1964. "He's apt to cling to information he develops until he can present it to the scientific community. He'll sit on it until he's ready to go with it. We have to fight with them all the time. After all, they're on the taxpayer's payroll, and in-

formation ought to be gotten to the public quickly and in understand-able form."[43]

While Scheer's staff worked on prying information out of reluc-tant hands, he spent much of 1964 studying how his office had been managed in the past. The findings were sobering. "There was little or no unity or coordination of action among the various elements of Public Affairs," a NASA document concluded. "The field centers were highly autonomous and received little or no guidance or direc-tion from Headquarters except in a crisis. The substantive program was largely reactive and consequently wasteful. Headquarters oper-ated very much like another field center–instead of making policy, providing direction and guidance, and coordination." If anyone re-mained unconvinced of the dysfunction, Scheer could point to the budget: Due largely to a lack of planning, Public Affairs spent nearly 40 percent less than it had requested in fiscal year 1964.[44]

One move toward better coordination was implemented in late 1964 with a reassignment of the men who oversaw the information needs for each of NASA's three major technical programs. Al Ali-brando, for example, would now be directly under Scheer's supervi-sion as the Public Affairs Officer for Manned Space Flight, but he would also have responsibilities to George Mueller, the new lead ad-ministrator for the program. Alibrando, in essence, became a mid-dleman, working with field staff such as Paul Haney in Houston to ensure that each center's message was in concert with the overall di-rection set by Manned Space Flight, and reporting to Scheer on how those efforts dovetailed with the overall NASA information plan. Some field staffers resisted the creeping influence of headquarters, but an increasing number saw the advantages of swapping autonomy for security and direction from above.[45]

Those who bucked the system, either inside or outside the agency, quickly discovered that Scheer had the complete backing of his boss. On the surface, they were NASA's odd couple despite their shared North Carolina roots. The ever-polite, fast-talking Webb would "play that good ol' Southern boy 'I just fell out the turnip truck' routine," recalled one former colleague, "and he was a master at it. By the time you were finished talking to him, you had agreed to all kinds of things that you'd never conceived of before." In contrast, the brash, irreverent Scheer had no qualms about bullying someone who stood

in his way, or punctuating his salvos with a flurry of choice language. "My feeling always was that if Julian had worked for another administration it would not have lasted a year," Duff recalled. "If [Scheer] thought a reporter had screwed him, or even worse, had played fast and loose with Jim Webb or with the program, he would tell them in four-letter words."[46]

From the press's view, the change of attitude brought by Scheer was more important than NASA's structural overhaul. The unequal access and stonewalling that characterized the Powers era seemed to be waning. "We are going to get information out and we are going to tell the truth," Scheer told a journalism trade publication in 1964. "It's ridiculous to have an information program predicated on anything else. I complained like everybody else when I was reporting and I couldn't get information that officials were withholding. I didn't like it, and I am not going to be a party to that kind of stuff now."[47]

Not surprisingly, Scheer was most lauded by print reporters. The substantive changes Scheer brought to NASA were important to them, but they also appreciated the empathy he brought as a former colleague. "They have to be part engineer, part scientist, and part police reporter," Scheer would say of those in his former profession. "They have to be able to stand in a phone booth at any hour of the day or night, witness a space shot that man has never witnessed before, and dictate a story on a complicated scientific event that will be so interesting a New York taxi driver will want to read it. The next day they may have to attend a symposium on geophysics given by a scientist who talks only in the terms of a scientist. On top of that, they have to be experts on Capitol Hill, the structure of the legislative process and budgetary matters."[48]

Scheer had been in official control of public affairs for a few months when positive press critiques of his performance made their way into journalism trade publications. "Julian is a guy you can go to and find out what the top guys are thinking," said one reporter in 1964. "Julian is the best in the business," added another journalist. "NASA is the only agency in town that has been willing to take its lumps with its laurels."[49]

Although the climate between NASA and the press had improved, resentments remained, many centering on a new publishing arrangement for the astronauts that was signed in fall 1963. After a

protracted bidding process, *Life* retained the magazine rights to the astronauts' personal stories, and Field Enterprises, publisher of the World Book Encyclopedia, won book and newspaper syndication rights. Over the next four years, the deal would prove to be a losing proposition on several fronts: Field took a financial bath as the Gemini program fell behind schedule, the press continued to complain bitterly about unequal access and the inclusion of mission details in ostensibly "personal" stories, and Scheer had to deal with petulant astronauts who suddenly had to be prodded to fulfill the obligations of their contract.[50]

"It was fine when it was just the Original 7," Scheer recalled. "Then we brought in more astronauts. And the first group didn't like it that the new guys were going to get an equal share of the pot. Suddenly, the pie was being sliced up into tinier pieces, so their devotion to *Life* magazine really fell off."[51]

Scheer also had a continuing task of educating NASA scientists and engineers about the role of his office. "This was an agency made up with people who had come out of industry–and industry is not a very open society," Scheer would recall years later. "Others had come out of the military. And the military, of course, had never liked talking to the press. I don't think there was ever a day in my nine-and-a-half years at NASA where I said, "Here's what we're going to do' without some technical person saying 'No, we don't need to do that.' It was a constant, never-ending battle."[52]

While others at NASA argued he should be more overt in promoting the space program, Scheer insisted his role was to distribute accurate, timely information. "We are not doing what is known in the public relations business as flackery or publicity or public relations or propaganda," Scheer said during a NASA meeting in the mid-1960s. "We are simply not in this kind of business. We are not buying refreshments, we are not supplying free trips, we are not slapping anyone on his back, we are not spending our time at the Press Club bar. We feel that we have a service to offer and we offer our service as best we can and we have to stand on that performance. Therefore, what we are in public information is a news operation. We don't put out publicity releases. We put out news releases. When we have news, we disseminate it."[53]

Scheer's interpretation of the mandate's language would evolve to what eventually became known as the "open program," a philosophy some public affairs staffers eagerly extolled as a virtue of its own accord, not needing to be justified by public opinion or how it compared to the secretive nature of most Soviet space shots. Not surprisingly, during a dress rehearsal for another NASA meeting, a Scheer subordinate proudly projected a slide proclaiming, "We have an open program because we respect the public's right to know."

"Destroy that slide!" Webb called from the dark. "I'm not in the business of the public's right to know. There are others like the attorney general who will take care of that. It's good public policy to have an open program."[54]

For NASA's chief, the "open program" had little to do with fulfilling a legal mandate. Years before researchers codified information transparency as an important public relations technique, Webb recognized its utility in building a constituency for manned space flight. Occasions when NASA had been less than forthcoming not only had brought short-term embarrassment, but also had eroded overall public confidence in the agency. And a willing public was critical if America was going to get to the moon by 1970. A congressional rubber-stamping of NASA budget requests was no longer a sure thing, as critics began questioning the wisdom of sinking billions of dollars a year into a "moondoggle" when so many problems loomed on Earth.[55]

The critiques were not confined to a fringe element of the populace or either side of the political aisle: President Eisenhower decried the "fiscal recklessness" of a space program that cost $5 billion a year by 1964, while allies of Democratic senator J.W. Fulbright advocated that some of that money be redistributed toward improving education and the inner cities. Nor was there a scientific consensus on whether the space program was a net gain to the country or to the pursuit of knowledge. One physicist jokingly suggested that it would be more efficient for the United States to weld 20 billion silver dollars together and walk to the moon, but others found it less amusing that the ten thousand scientists working on NASA projects dwarfed the thirteen hundred who were studying heart disease, mental health and cancer for the National Institutes of Health. What NASA needed in this environment, Webb and Scheer understood, was a continuous

plan for public understanding of the space program, not just a periodic pitch for more money.[56]

"You should never get it in your head that public relations will get your budget passed," Duff would later say. "That's too near term. Public relations is a long-term building of understanding and positive regard." And in that process, candor was key. NASA managers could deliberate in private, but if the policy was going to work, they would need to give a full, public accounting of decisions once they were made. Honesty was indeed NASA's best policy, one that was practiced, so the story went, most fervently by its leader.[57]

"Jim Webb is incapable of lying," Scheer was fond of telling reporters. It was a line Scheer would stick to years later, even when the facts suggested otherwise.[58]

CHAPTER 5

"... Competitive Inanities ...":
Gemini and the Networks

It was like no other high-speed chase before it. Gemini 8 had covered 105,000 miles in six-and-a-half hours to catch Agena, the unmanned space vehicle that had a one-hundred-minute head start from the launch pad. Now, piloting his capsule 185 miles above Brazil, Neil Armstrong had just made the first-ever hookup of two orbiting spacecraft seem easier than parallel parking a Volkswagen Beetle on a quiet residential street. "We are docked. And he's really a smoothie," Armstrong reported to ground engineers and technicians, who were ready to shuffle out of Mission Control and let a new shift take over.[1]

Next on the schedule for Armstrong and fellow astronaut Dave Scott was a routine systems check and some sleep, but within moments, the sense of calm was shattered. "Well, we've got serious problems here," Armstrong radioed back to Earth. Minutes later, a clearly shaken Paul Haney would tell the press the frightful news: Gemini 8 was spinning wildly out of control, and the astronauts could find no way to stop it.[2]

As Americans turned on their televisions that evening in March 1966, broadcast journalists kept them apprised as Gemini 8, now detached from Agena, became stabilized and ground controllers improvised a plan for emergency re-entry. Once the oft-neglected "orphans" of their networks, the news divisions were now well-fortified symbols of their employers' power and influence. They had come of age in November 1963, their non-stop broadcasts helping a nation cope with the murder of its president. Now, television was

poised to give a similar effort, if necessary, to help Americans understand why two of their astronauts were in peril and what was being done to bring them home safely.

The country, once enthralled by the flights of Alan Shepard and John Glenn, responded with anger. At all three networks, switchboards were overloaded with thousands of callers who were irate that their regularly scheduled entertainment programs were being interrupted or pre-empted. "I missed out on Batman finding the clues," said one 20-year-old from Queens, who was upset that ABC had ruined an episode of his favorite show with three updates on the troubled spacecraft. "We tune in to see 'The Virginian' and we get this dopey Gemini stuff," said a caller to the NBC affiliate in Chicago. At CBS, harried phone operators were too busy to appreciate the irony: Callers were complaining that a real-life interplanetary crisis had bumped the dim drama *Lost In Space*.[3]

Viewers who didn't take the time to pick up a phone were likely turning off their televisions. When ABC finally dropped *Batman* for continuing coverage of Gemini 8, the network's Arbitron rating immediately dropped from 34.3 to 21.4; by the time the craft began re-entry a few hours later, it had fallen to a microscopic 6.2. CBS's ratings were off 10 points from the usual mark garnered by *The Beverly Hillbillies*, and NBC, while taking the smallest ratings hit, didn't receive a single call in praise of its coverage of the troubled mission while dealing with several thousand phone complaints. "Horrible as it sounds," wrote one observer in the national press, "the night's events did tend to substantiate network rebuttals to professional critics across the country that the current morass of banal TV entertainment is 'what the viewers want.'" What they didn't want, it appeared, was any more space flight coverage.[4]

A year previously, NASA had returned to manned space flight with high hopes and even higher anxiety. The Gemini program had to meet several critical goals if America was to reach the moon: The two-man crews ultimately would have to withstand long-term flights in weightlessness, complete tasks while floating outside of the capsule, and successfully dock their ship to another spacecraft. But in addition

to the innumerable engineering and scientific challenges faced by NASA, the agency also had to deal with waning American resolve.

In the 22 months since Mercury ended, John F. Kennedy, the man who uttered the challenge to put a man on the moon by the end of the decade, had been silenced by an assassin's bullet. NASA budget requests, largely unquestioned in the glow of the Mercury 7, were coming under increasing scrutiny as growing problems in the United States moved to the fore: poverty, civil unrest, and an expanding military commitment in Vietnam, in particular. And, just days before the first manned Gemini was to launch, the Soviets beat the Americans to yet another milestone when Cosmonaut Alexei Leonov became the first man to walk in space, leaving many to wonder if the United States was destined to be second on the moon despite the massive expenditures. On the eve of Gemini 3, Walter Cronkite reminded CBS viewers that the American space program was well ahead of the Soviets in several important areas. "Our satellites, not the Russians', are relaying telephone messages and television pictures between the continents. Ours, not theirs, are taking pictures from outer space that have pushed weather prediction generations ahead," Cronkite said. He could not gloss over the fact that the Russians had a significant lead in manned space flight.[5]

Cronkite's profession looked much different than it had four years earlier when he manned the CBS station wagon for Alan Shepard's first Mercury mission. The network news divisions had gained a great deal of critical respect in the recent past, much of it garnered through their performance in the aftermath of the Kennedy assassination. Suspending all entertainment programming and commercials for nearly four days, the three networks covered the tragedy with an unprecedented level of effort, grace, and excellence. Viewers flooded the networks with overwhelmingly positive calls, letters and telegrams, and the new FCC chairman, in stark contrast to his predecessor Newton Minow, praised television for "meeting this tremendous challenge" and for "the manner in which it fulfilled its vital public trust."[6]

The competition in television news had become much more heated as well, a development that greatly affected how the networks covered space. CBS had coughed up its news ratings lead a few months before the Shepard mission, passed by an unlikely two-headed juggernaut at NBC. The pairing of an earthy Montanan with

an urbane North Carolinian for the 1956 political conventions had been "an accident of casting," according to one NBC executive, but by the early 1960s, Chet Huntley and David Brinkley had become the most popular newsmen in America. *The Huntley-Brinkley Report* differed greatly from any nightly newscast before it. The anchors were stationed in two different cities–Brinkley reported government news from Washington, Huntley anchored everything else from New York–yet viewers perceived a chummy rapport as they referred to each other as "Chet" and "David." In reality, the bond was largely manufactured: While the two were amicable, they were not particularly close, and the use of first names was actually a signal for the control room to switch the broadcast signal between locations.[7]

The truly revolutionary breakthrough was how *The Huntley-Brinkley Report* sounded. While CBS writers tended to take a wire-service, "just the facts" approach to news, NBC's copy was breezy and often wry, no more so than when written by Brinkley. "I was staggered to see this convention start on time," Brinkley once said during political coverage, "and so were the delegates because they weren't here." On another day that was particularly slow for news, Brinkley ended his segment by announcing "There's nothing happening in Washington today of any consequence whatever." In contrast, critics saw CBS's copy as "banal," "perfunctory," and "dull," and even their chief rival, Cronkite, would recognize that "Huntley and Brinkley have entertainment value, something that we have not directly eschewed and something that we must be seeking."[8]

CBS had hoped to knock Huntley and Brinkley off their game in September 1963 by expanding its evening news from 15 minutes to a half hour. NBC followed suit a week later, but lagging ABC, with a news budget nearly 90 percent smaller than its competitors, stayed to the old format. "What are they going to keep filling 30 minutes with?" said one ABC news staffer. "Sometimes you can't even fill 15 minutes." The change did little to dent NBC's ratings lead, but the war of words kept television critics busy chronicling the salvos. "NBC is a fine organization," said CBS News president Dick Salant shortly after the evening news expansion, "but all they've got is a pitcher and catcher," a not-so-subtle dig at his competition's reporting, editing and technical staff. Brinkley fired back by noting that the head of CBS News had no journalistic training: "I have no interest in the com-

ments of a CBS lawyer. Mr. Salant is going into an area he knows nothing about."[9]

In March 1964, CBS moved Salant upstairs and took another run at Huntley-Brinkley by putting Fred Friendly in charge of its news division. The elevation of Ed Murrow's former producer was a signal to television critics such as Jack Gould that "the journalistic fur is going to fly." CBS executives hoped that the hulking Friendly could concoct a formula that would close the news ratings gap with NBC; outside observers wondered whether the "gangling non-conformist" would try to counter Brinkley's ironic delivery by bringing the crusading tone of the old *See It Now* over to the evening news. The network's executives were largely concerned about the numbers, but observers also believed that a more competitive challenger to NBC was important if television was to fully blossom as a legitimate news source. "A healthy and enthusiastic CBS News is of prime importance to the viewer," Gould wrote as Friendly took over. "Bonafide competition in conveying the substance of news and energetically digging beneath surface events is not as prevalent as it should be on the home screen."[10]

Friendly's tenure as news chief got off to a rocky start. After CBS badly lost the ratings battle during the 1964 Republican national convention, network chairman Bill Paley ordered Friendly to remove Cronkite from coverage of the Democratic event, spurring speculation that the anchor might resign. When the team of Robert Trout and Roger Mudd fared even worse in the Democratic convention ratings, Friendly reinstalled Cronkite as anchor for election night coverage, and CBS rebounded with a critically acclaimed broadcast of Lyndon Johnson's landslide victory.[11]

Cronkite had survived, but Friendly still faced a number of obstacles in chasing down television's news leaders. Huntley and Brinkley were two well-entrenched stars with a long track record of success, and their momentum would be hard to overcome, but NBC News had important structural advantages as well. If Friendly wanted to air a news special on CBS, he had to vie with network programming executives for the ear of company president Frank Stanton, whose substantial interest in news was tempered by his training in audience research. If NBC news chief William McAndrew needed a similar clearance, he had a virtually unobstructed path to his network's

president, a stocky, bespectacled, bow-tie wearing, vodka drinking ex-reporter who began his media career by earning $17 a week at the *New York Herald-Tribune.*[12]

Given his journalism background, Robert Kintner's commitment to public affairs programming was not surprising. While the head of last-place ABC in the mid-1950s, Kintner had approved the network's landmark 188-hour, gavel-to-gavel coverage of the Army-McCarthy hearings. A decade later at NBC, Kintner canceled an evening's entire prime-time lineup to air a three-hour analysis of U.S. foreign policy. Such programming stood in stark contrast to the pap Kintner selected for much of NBC's entertainment lineup, but Kintner understood that the financial windfall from programs such as top-rated *Bonanza* allowed him that latitude. As long as the network hit gross revenue targets set by parent company RCA, Kintner was left alone to make whatever programming decisions he saw fit, and he, more than his counterparts at the other two networks, applied those dividends to news. By 1965, NBC was more than merely meeting its financial obligations; it had pulled into a virtual tie with longtime leader CBS in the overall ratings, and among many critics, NBC's "adult tone" and commitment to public affairs had put it at the head of the class. Having caught CBS, Kintner was not about to let his network falter in space coverage.[13]

In March 1965, the network news divisions took their ratings battle to "Trailer City," the NASA-provided area for remote broadcasting facilities located nine thousand feet away from Gemini 3's launch pad at the renamed Cape Kennedy. Each network was staked a thirty-by-one-hundred-foot plot, on which it crammed four or five mobile homes that had been converted into broadcasting studios and control rooms. One trailer on each plot had an anchor desk on the roof, where Cronkite, ABC's Jules Bergman, or NBC's Roy Neal would soon tell the viewing public about the Titan rocket looming over their shoulder and the two men on top of the missile. At the anchors' disposal was an arsenal of specially created visual aids, many provided by civilian contractors eager to promote their contributions to the space race, ranging from the computer system guiding the craft, to the parachutes that would slow its descent to earth, to the tubes of food providing astronaut nourishment.[14]

Each of the anchors had been at the Cape for weeks, putting in long days to educate themselves about the new craft, the two astronauts, and any contingency that might pop up during the mission. Unlike the military-controlled "Bird Watch Hill" era of the late 1950s, the media had plenty of source material to draw from. NASA had produced its own 48-page mission guide, which was supplemented by a defense department packet containing plans for the ocean recovery, a huge technical book from Titan contractor Martin, and a similarly sized volume from Gemini capsule builder McDonnell. Each anchor had his own method for organizing other information gleaned from news conferences and interviews; in Cronkite's case it was a self-designed two-hundred-page briefing book with section dividers such as "HOLDS—Built-In Holds," and "DELAYS—Why?"[15]

Broadcasters seemed to have lost their edge though during the long hiatus since Cooper's last Mercury mission. NBC viewers wondered whether the Cape duo of Neal and Merrill Mueller were even listening to each other as each stepped on the other's lines, creating an extra layer of complexity for New York anchor Frank McGee. Those watching CBS had the opposite problem, hearing nothing but silence for two minutes after launch as Cronkite made his way down from the roof to the studio inside his trailer. In the interim, Cronkite had missed several messages about the mission's status and drew the conclusion that there was a problem with the craft's orbit. It would be more than two hours before Cronkite would realize his error and apologize. "[T]he networks filled materially and immaterially as best they could," one reviewer wrote. "The wonder was that, after previous coverage of six suborbital and orbital manned space flights, they could not do better. If our space program had made as little progress, we wouldn't be off the ground."[16]

Neither the anchors nor their production crews were completely to blame for a lackluster broadcast. They were fighting an uphill battle, since to the layman, there was little new about Gemini 3, save the extra man in the capsule. There were no space "firsts" to tout as milestones, and at a glance, the mission seemed virtually the same as Glenn's flight three years earlier, each having the same number of orbits and a similar amount of flight time. Americans may have chuckled that Gus Grissom, blamed by many for plunging a Mercury capsule into the Atlantic, had dubbed Gemini 3 "The Unsinkable

Molly Brown." Others were alternately amused or disgusted when learning that fellow astronaut John Young, with the help of Wally Schirra, had smuggled an illicit corned beef sandwich onto the craft. Few viewers were enthralled as they had been during Mercury. Maps and mock-ups might fill air time, but they couldn't overcome the growing sentiment that space flight had become quite routine. "There are few spectaculars left," Huntley told NBC viewers in a taped segment during the third orbit, an opinion seemingly shared by an increasingly indifferent viewing audience.[17]

Thanks in part to Grissom and Young's successful testing of Gemini 3's maneuvering and guidance systems, there would be "spectaculars" to come, and television executives had already spent months planning how to cover them. The networks' task would not be easy: Subsequent Gemini missions would be much longer in duration, and most of the breathtaking moments would not be available for live broadcast, due to either technical limitations or a lack of NASA will. In meeting these challenges, news divisions wrestled with questions of legitimacy and accuracy, while at the same time pondering how to parlay a complex and expensive array of simulations and animations into a ratings windfall.

Gemini 4, scheduled for June 1965, would be much more ambitious than its predecessor. With an itinerary of 62 orbits, it would far surpass the Soviet record for a two-man mission, come in close proximity to an orbiting rocket stage, and be the first U.S. space flight to feature a manned space walk. The mission also would last four days, compared to the four hours of Gemini 3. "This is supposed to be a test of endurance for the astronauts," said NBC's McGee. "I think it will be one for us."[18]

Additional logistical challenges faced the networks on planet Earth. Gemini 4's launch would be at Cape Kennedy, but after liftoff, the mission would be controlled from the Manned Spacecraft Center, a still-in-progress 1,620-acre complex located near Houston. For the record, NASA said the new facility was necessary because of the increasing complexity of space flight, and its specific location was chosen because of its climate, access to the ocean, and ease of access to contractors in New Orleans and Huntsville, Alabama. Critics coun-

tered that placement of the center, which already had cost U.S. tax-payers $260 million, had more to do with the influence of Rep. Albert Thomas, a Houston Democrat who chaired a House appropriations sub-committee that controlled the U.S. space budget.[19]

Whatever the reasons, networks now had to make plans to staff two sites: "Trailer City" would remain entrenched at Cape Kennedy, but the networks also had to finance, build, and equip studios in Houston. The positioning of the new facilities was suggestive of each network's relative status in television's news ratings: NBC built its glass-walled studio on the roof of a seven-story hotel, CBS resided directly below, and ABC occupied a space off to the side. At night, a large, flashing neon NBC logo signaled the network's predominance.[20]

NASA's two-way communications system made it possible to cover the entire mission from either location, but the networks arranged for mass transport of talent as the flight progressed. At CBS News, Cronkite and more than thirty fellow employees would board an airplane shortly after Gemini's liftoff to join the network's journalists and producers already in Texas. ABC anchor Jules Bergman would make a similar trip, but NBC's McGee would instead return to New York and anchor the remainder of the mission from network studios.[21]

Journalists working in Houston reported to Building 6, a new two-story press center. Print reporters had working space in a large, one-hundred-table room on one end of the building, with broadcasters occupying a similar area on the opposite side. Each of the three networks had leased its own working space, and a press conference room on the ground floor could accommodate 150 journalists for periodic updates.[22]

Some found symbolism in the fact that the media building, located across the highway from Mission Control, was the only one that NASA had constructed outside the fence of the Manned Spacecraft Center. Leading up to a mission, reporters might be able to enter the actual complex with a NASA escort, but it was also possible that their only venture inside the fence would be at a press conference nine days after the astronauts had returned to Earth.[23]

Media members assigned to Houston began their work in earnest two weeks before the mission with a news conference, followed by

interviews with the lead astronaut crew and their backup crew. Other briefings and demonstrations would follow in subsequent days, and some journalists would take the opportunity to go inside the fence and watch the "network simulation" staged in Mission Control largely for the benefit of television broadcasters desperate for visuals.[24]

Paul Haney, now in charge of public affairs at the Manned Spacecraft Center, had advocated extensive pre-launch NASA commentary long before the first Mercury flight, and he now saw his vision realized with Gemini. A few hours before liftoff, NASA would begin real-time updates on pre-flight activities, piping the updates through a public address system and making them available for live broadcast. Public affairs officer Jack King would keep the press apprised of developments at Cape Kennedy, and once the craft left the launch pad, Haney would begin delivering similar reports from Houston. Through the remainder of the mission, Haney or an associate stationed in Mission Control would give scheduled updates over the public address system twice an hour, or more frequently if events warranted. In addition, Haney also instituted "change of shift" news briefings, where flight controllers gave further detail about the mission's progress before going home for the day. If a reporter missed anything, transcriptions of the various sessions were coming off press center copy machines virtually twenty-four hours a day.[25]

Broadcasters claimed something of a victory before launch when NASA loosened its tape-delay-only policy on conversations between the astronauts and the global tracking stations, promising to air some of the dialogue live. When combined with Haney's periodic commentary from Mission Control, the exchanges could potentially make great radio. Television needed more visual interest though, and live video feeds from space were still not in the cards. To compensate, the networks acquired their own mock-ups and visual aids designed to illustrate the mission. CBS's devices included a lighted tracking map that updated the craft's position every two minutes and a scale model of the Titan rocket that could be modified to reveal a cutaway view of its internal components. ABC countered with a working model of the Titan's engines, a full-size replica of Gemini's control panel, and a ten-foot rotating globe designed to track Gemini's path.[26]

NBC trumped its competitors by shelling out $100,000 for an exact replica of the entire capsule. Housed in the network's New York studios, the 19-foot-tall model captured virtually every detail of Gemini, including a simulated rocket system that shot out carbon dioxide. "We conceived of the replica as a primer on the Gemini flight," said NBC producer Chet Hagan. "The flight will be terribly complicated and most of us aren't engineers." NBC had planned for the full-sized reproduction to mimic the various turns and rolls of the actual craft, but when testing indicated the mock-up would not withstand the strain, the network got out its checkbook again to order a second model, at one-quarter scale, to perform those tasks. In the week leading up to Gemini 4, each network would bombard its viewers with self-promotional advertisements–more than three hundred airings, in the case of ABC–touting the superiority of its fake space gear and its overall coverage plan.[27]

In contrast to the early Mercury missions, the networks had also lined up paying sponsors to absorb some of the enormous coverage costs. ABC, accustomed to eating many of those expenses in the past, signed on Bristol-Meyers, while CBS continued to be supported by the Savings and Loan Foundation. In NBC's case, the network expanded the "Instant News Special" arrangement with Gulf that had been used during election coverage and breaking events such as Nikita Khrushchev's ouster. The agreement gave the oil company sole sponsorship of Gemini's periodic updates and longer nightly summaries, and a single phone call to Gulf headquarters in Pittsburgh could secure further sponsorship of mission coverage or of any other news event. The company's arrangement with NBC was cost-effective: In part because there were no production costs, "instant sponsorship" constituted less than 20 percent of Gulf's total ad budget.[28]

Thanks to its parent company, NBC also would have one huge technical advantage for Gemini 4. In the early 1950s, RCA had won a major battle when the FCC reversed course and selected its color broadcasting system as the country's standard. A decade later, the implications of that decision were just beginning to have a significant effect on what viewers saw at home: NBC broadcast half of its 1964 schedule in color, while CBS, the loser in the FCC fight, continued to show all of its regularly scheduled shows in black and white. By January 1965, consumers had gone crazy for color, orders for the new

sets increasing by 70 percent over the previous year, some buyers willing to wait months for delivery of certain models. When a research study that spring indicated that color could increase ratings of a program by 80 percent, the networks rushed to total implementation. NBC quickly announced its programming would be virtually all-color by fall, ABC committed to at least six hours per week of color programs, and the lagging CBS promised two color variety shows in September 1965 and an all-color prime time by late 1966.[29]

Color's contribution to space coverage would become clear at 11:16 a.m. on June 4, 1965, when NBC viewers saw the orange and red flames of the Titan missile add vibrant realism to Gemini 4's launch. "There is just no comparison pictorially and aesthetically between watching such an event as the launch in color and black-and-white," wrote one reviewer. The imagery was fleeting though, and within moments, the Gemini capsule was out of camera range, leaving the networks to their own relatively paltry visual devices. "Television coverage of space flights begins as a grand show," Lawrence Laurent would later write in *The Washington Post*, but what came after liftoff was, in his words, "a wistful, unsatisfying radio report to which incidental pictures are added."[30]

During the most dramatic part of the mission, Ed White's walk in space, even the audio elements would prove to be disappointing. As Gemini sprinted through space at five miles per second, White floated outside the capsule in near ecstasy, using a specially designed air gun to move himself about. The conversations between White and Gemini 4 pilot Jim McDivitt had the tone of kids at play: At one point, when White had maneuvered himself in front of the windshield, McDivitt lightheartedly chided him for smearing it. Sadly though, while the astronauts' banter was broadcast live to an estimated 50 million American viewers, and to millions more in Europe thanks to the new Early Bird Satellite, much of it was inaudible. "It was like trying to hear KDKA in Pittsburgh on headphones in the mid-nineteen-twenties," Gould wrote in the *New York Times*. The networks also struggled to visually approximate the feat: ABC hired professional dancers and suspended them on wires in front of a Gemini mockup. "If a set owner began the day with notions of sophistication in the space age," Gould wrote, "they were thoroughly shattered by the end of Major White's twenty-minute outing."[31]

Throughout Gemini 4, television would not distinguish itself. A scientific magazine would later pan the networks' coverage as being "plagued with errors, faulty interpretations, difficulty in ad-libbing and, in one case, outright embarrassment over an inability to define so simple a word as azimuth." A number of the elements touted as bringing realism to the broadcasts seemed more like gimmicks: At one point, ABC had put Bergman in a NASA-engineered vital signs vest and compared his heart rate to that of the astronauts.[32]

America's two favorite anchors, covering a space flight for the first time, weren't faring well either. Some observers attributed Huntley and Brinkley's absence from live coverage of previous NASA missions to the influence of Texaco, which had sponsored the duo's nightly news program and was reportedly not willing to have them appear on broadcasts bankrolled by a rival. The pair became free to cover space, so the story went, once Gulf added sponsorship of *The Huntley-Brinkley Report* to its advertising budget. NBC insiders told a different story: Kintner, chagrined that television critics had warmed to Cronkite's folksy space approach and wary that the CBS anchor might transfer that success to the nightly news, had ordered his star duo to go on-site for Gemini coverage.[33]

There was one problem: Huntley and Brinkley thought space to be a bore. "Brinkley felt it was too technical a subject for him," said NBC producer Jim Kitchell. "McGee, of course, did his homework, but I couldn't trust Huntley and Brinkley. I would provide them with all the research and information, and they just wouldn't read it. They'd read the summaries in the press kits." Huntley and Brinkley's indifference showed throughout as they anchored the Houston segments of Gemini 4, critics deriding the pair for idle chatter. Brinkley's cool detachment might work on the evening news, but more critics were finding Cronkite's "perfect blend of knowledge, professionalism and warmth" on CBS to be a more appropriate fit for space flight.[34]

Re-entry and splashdown proved unsatisfying as well for television viewers. Gemini's blackout from radio contact, a period attended to with great anxiety as John Glenn hurtled back to Earth three years earlier, now seemed like a simple lull in the proceedings. Haney's comprehensive updates from Mission Control, delivered with the exuberance of a radio traffic reporter in a one-stoplight town, left little for pool reporter Dallas Townsend to add from the recovery ship.

And the networks' attempts to simulate what could not be shown live troubled critics such as Laurent, who chided the attempts as "pretense and make believe" in *The Washington Post*.[35]

"The photo animation of a space capsule's re-entry and film of Navy crews practicing recovery causes a certain amount of confusion," Laurent continued. "Children, who had been permitted to view coverage in classrooms, came home with reports that they had watched the re-entry, splashdown and recovery. Worried parents called this newspaper and asked anxiety-filled questions. Most of them didn't care for the explanation." Viewers indeed felt like participants, but some wondered exactly what it was they were taking part in.[36]

The day after Gemini 4 returned to Earth, television viewers finally saw the wonder that had been White's walk in space. A slow-speed camera had captured the event, and when the capsule returned, NASA developed the film and copied each frame four times to reach the U.S. broadcast standard of twenty-four frames per second. Viewers got a black-and-white preview in the morning, but that afternoon, owners of color sets tuned to ABC or NBC saw the stunning blue-and-white of earth below the floating astronaut; the red, white, and blue of the American flag on the astronaut's uniform; and the shiny, golden "umbilical cord" that kept him connected to the spacecraft. On NBC, a viewer could compare the NASA film to the one shot by the Soviets during Leonov's recent walk and observe a much more agile White appearing to stand on his head or float like a swimmer. The footage was almost dazzling beyond words, even for those close to the space program. "It almost looks like it's staged," one NASA official said. "It's so beautiful."[37]

As the film rolled, network executives pored over ratings reports and looked for a way to claim victory. ABC had spent $1 million on its coverage–an amount that would have equaled one-fourth of its total news budget two years earlier–with little positive effect on viewership. CBS trumpeted slightly higher ratings on days of liftoff and splashdown, the two days when all networks were covering Gemini 4 for a similar duration. Meanwhile, NBC boasted that its coverage garnered the largest percentage increase in overall daytime audience. Any ratings successes were tempered though by the financial ledger: Despite the sponsorship agreements, the three networks were a com-

bined $6 million in the red when factoring in production costs and lost ad revenue.[38]

Those financial realities weighed heavily on the three network news chiefs when they met at CBS headquarters shortly after Gemini 4 had safely returned to Earth. Gaining better access for splashdown and recovery from NASA was part of the agenda, but Friendly, NBC's McAndrew, and ABC's Elmer Lower came out of the summit claiming a renewed enthusiasm for the network pool arrangement, advocating more shared responsibility for elements such as interviews with astronaut wives and children. "We could serve the public better by working together on the noncompetitive parts of these events," said Friendly, who called the meeting. "A reporting pool would overcome what I call the 'beast of reporting'–the camera that is manned for seventy-two hours and you wind up with two minutes of picture." Observers, seeing the large newspaper ads the leading networks had taken out to tout their Gemini ratings supremacy, doubted broadcasters could curb their competitive appetites.[39]

If observers only examined the pool broadcasting arrangements, they would conclude that Gemini 5 marked a period of harmonious convergence among the networks. A bid to broadcast live video from the ocean recovery was shot down by the Department of Defense, but the cooperative agreement for television coverage was expanded in several other areas. A color video feed of liftoff would be available to all networks, and additional remote sites, such as the astronauts' homes, would be part of the shared reporting pact. The $1.5 million price tag for the pool was still substantial, but still represented for each network a 66 percent savings over what it would cost going it alone.[40]

Gemini 5's eight-day flight would last twice as long as any U.S. mission before it, and the networks prepared with more vigor than ever. ABC planned eighty-one one-minute status reports, five fifteen-minute nighttime wrap-ups and six half-hour specials, its competitors making similar arrangements. The three rivals also geared up with competing "space centers" equipped with the latest wizardry. Newspaper readers were primed for NBC's coverage with ads touting the network's "continuing color coverage," with "spectacular visual de-

vices" that were "designed to recreate for viewers exactly what's happening in space." Turning the page, readers might also have found a Macy's ad that promised to deliver a new color set before NBC signed on from the Cape. An RCA twenty-one-inch model with all-wood cabinet would set consumers back $458.[41]

Whether in color or black and white, Gemini 5's initial launch attempt was torturous to sit through. For seven hours, as the countdown was continually stopped for a laundry list of problems, the networks stubbornly stuck to live coverage instead of cutting away to other programming. "Surely somebody at one of the networks ought to have had enough sense to cry enough," wrote one television critic. "That somebody didn't is the measure of how far this idiotic competition to avoid being 'scooped' has atrophied network thinking."[42]

At least one person in network news agreed heartily. "As I watched," CBS's Friendly said the following day, "I knew we in television news had gone in for an escalation as stupid as the arms race." Declaring that the network news industry had devolved into "competitive inanities," Friendly decreed that his network would sign on no earlier than thirty minutes before future launches, and added that the network was considering scrapping gavel-to-gavel coverage of political conventions.[43]

Bob Kintner, who notoriously lived in his office during space flights and demanded that other executives at NBC do the same, would not agree with Friendly, nor would the other two network news chiefs. ABC's Lower responded that "unpredictable news events don't lend themselves very well to generalizations," while NBC's McAndrew said it "makes better sense" for NBC to report "news accurately, report it fully, and report it first–in that order." By starting coverage three hours before launch, McAndrew said, "we believe NBC is discharging that basic responsibility."[44]

The networks' war of words intensified a few days later when Gemini 5 actually did get off the ground. As promised, CBS began its coverage thirty minutes before launch (two-and-a-half hours after NBC), but it was the network's decision early that afternoon to break away from the mission that made headlines. When NASA announced that an electrical problem might force the mission to be cut short, NBC was the only network still covering the flight live. CBS (as well as ABC) would quickly get back on the air, but the gap would cause

its chief rival to accuse the network of journalistic dereliction. In large newspaper ads, NBC boasted that it was the only network that offered continuous coverage of the "key step toward a moon landing. As such, it was an event of vital importance–an event demanding complete and detailed coverage."[45]

Television critics, growing weary of the journalistic tit-for-tat, likened the CBS-NBC squabble to that of two society women arguing over whose charitable work was more admirable. Some scoffed at Friendly's assertion that CBS was performing a public service by scaling back coverage, given that the programs bumped for space shots often consisted of soap operas. NBC may have won the immediate ratings war, but its all-space-all-the-time coverage also became the subject of parody when columnist Art Buchwald imagined the network sustaining live broadcast throughout a forty-eight-hour delay by interviewing the astronauts' laundry man. A significant number of viewers also seemed to think the emphasis was overkill: As NASA worked out Gemini 5's electrical problems, thousands of professional football fans called NBC and CBS to protest that exhibition games had been pre-empted.[46]

In terms of quality, though, other evidence suggested that all three networks' space broadcasts were becoming more sophisticated and informative, marking a gradual shift away from what critics called "the Saccharine family interview and the 'illustrated radio' talks by technical specialists." NBC was particularly lauded by one magazine for its "breadth of subject matter, accuracy and visual quality," but the dialectic between cooperation and competition, it seemed, was resulting in a positive synthesis for viewers of all three networks. Gemini 5's splashdown, in particular, was prime evidence of this dynamic. The networks' animations were becoming more realistic and were supplemented with a better product from the shared pool arrangement: Live radio reports from a plane circling above the capsule gave viewers additional eyewitness accounts of the recovery, reviewers noted, and photographs transmitted nearly instantaneously from the recovery ship confirmed that the astronauts had returned safely.[47]

The pool's performance during Gemini 5's splashdown and recovery showed that Friendly's summit with his fellow network news chiefs had not been completely for naught. Mission delays had wiped

out much of the potential financial savings from the shared arrangement, but the increased access brought those who were watching a bit closer to the realities of a space flight's conclusion.[48]

Viewers would get closer still to Gemini's next mission, a two-week odyssey designed to test whether America could arrange a high-speed meeting of two manned spacecraft floating more than one hundred miles above the Earth's surface. Gemini 7 would lift off first and remain in orbit for the duration; Gemini 6-A (a previous Gemini 6 had been scrubbed) would leave days later and attempt to maneuver within feet of the preceding craft. As the mission neared, negotiations between the networks and NASA were gradually opening more of the program to the public, but not without recriminations.

One accommodation had been long in coming, but ultimately had limited utility for broadcasters. For the first time, cameras inside Mission Control would be turned on, but the agency agreed only to display maps and charts, not engineers at work, doing little to alter the reality that the new space center was a visual dead end. "The pictures out of Houston are of buildings and press briefings," Cronkite said. "They could be buildings and press conferences anywhere."[49]

Broadcasters were also less than pleased that NASA had taken over recording and editing of astronaut-to-ground conversations, a task that in the past had been handled by editors from the network pool. The networks chafed as well about having to wait 60 seconds to broadcast those conversations on television when they could be picked up by anyone owning a World War II-era shortwave radio. Such decisions added to the growing perception that the pool was being moved further away from the space program and being turned into a mere conduit for NASA-produced images. The change also added to the resentment building among network representatives toward Julian Scheer, the former print reporter turned NASA gatekeeper. Scheer, newspapers reported, told television broadcasters that he didn't much trust their medium.[50]

Television technology though would bring new perspective to the space program. Thanks to a powerful new camera lens, television viewers for the first time watched a capsule separate from its booster rocket during Gemini 6's ascent, but the live broadcast of the craft's ocean recovery was even more remarkable. As video cameras focused on the floating capsule on the ocean, a new portable satellite transmit-

ter aboard the recovery ship flung the image on its own 23,000-mile trek to the Early Bird Satellite, then back down to a transmission point in Maryland, where it was fed over standard television transmission lines to the networks. "The electronic conquest of distance somehow seemed more vivid and miraculous than ever," wrote Jack Gould, noting surprisingly clear details such as the capsule's scorched heat shield and the unruly strands of hair on the divers assisting in the recovery. The cost–some reports claimed ITT charged up to $22,000 an hour–made widespread implementation of satellite technology unfeasible for now, but its potential had never been more clear.[51]

Two days later, Gemini 6 commanders Wally Schirra and Tom Stafford were able to watch live television coverage of the recovery of Gemini 7 colleagues Frank Borman and Jim Lovell. Half of the eventual Gemini missions were now complete, but despite the advances in broadcast technology, the public was not breathlessly awaiting the remaining flights. Commentators such as Brinkley noted the growing public indifference, which was increasingly shared by his journalistic colleagues. NASA handed out 400 fewer press credentials for Gemini 6/7 as it had for the previous mission, and when one newspaper asked, "Has the Romance Gone Out of Covering Space Shots?" few argued that it hadn't.[52]

As the networks scrambled to report the fate of star-crossed Gemini 8, two of the key figures in television's race for space supremacy were no longer involved in the decision-making process. Officially, Kintner was still on the NBC payroll, but he hadn't reported for work in months. Kintner's heavy drinking had never been a secret, but when it was accompanied by boorish behavior during a series of affiliates' meetings in Acapulco, NBC rescinded its offer to make Kintner network chairman and instead gave him a lame-duck executive title devised to ease him gracefully out of the organization. Friendly had left CBS a month before Gemini 8's launch, resigning after the network chose to show a rerun of *I Love Lucy* instead of live coverage of Senate hearings on Vietnam. Friendly's and Kintner's imprints on television space coverage remained with their networks, but angry viewers piqued at missing favorite shows had little interest in how the pair's legacy contributed to what was being broadcast.[53]

To be fair to the angered fans of *Batman* and other interrupted entertainment shows, television was offering little new information as NASA scrambled to figure out a plan for Gemini 8's re-entry. For once, ABC was a bit ahead of its competitors in reporting the mission's status thanks to producers who eavesdropped on a restricted NASA audio feed and tipped off anchor Jules Bergman about what the agency was going to do. What viewers saw mostly though were reporters and anchors trying in vain to fill time between the sporadic official updates from Paul Haney. During one lull, Cronkite asked CBS correspondent Steve Rowan about a large lighted building at Houston. "The lights are burning late tonight," Cronkite said, to which Rowan replied that they were always on in that building. "I'm glad to have you straighten me out, and I'll never forgive you for it," Cronkite said with a laugh. Later, fellow correspondent David Schoumacher told Cronkite, "If you think I'm going to get involved in that building again you're out of your mind."[54]

The countless hours of preparation by the networks' on-air talent now seemed wholly inadequate to keep up with a highly fluid situation, and to viewers, it seemed that the broadcasters were guessing about the mission's status. "Where is it now?" Cronkite asked on air at one point while poring over a giant reference book. "These things are not easy to read. It's worse than reading an airline timetable." At NBC, the elaborate models of Agena and simulations of the docking procedure were now worthless: For more than three hours, McGee vamped while standing on a studio floor that had been converted into an ocean map with models of recovery ships. When NASA announced that Gemini 8 was making its descent toward the Pacific, NBC rolled out its previously prepared animation for re-entry. "We don't know for sure that this is happening," McGee said, "but this is what should be happening."[55]

NBC stayed with the story until well after midnight, when the two astronauts were finally aboard the recovery ship. When the sun rose the next morning, attention turned to audiotapes of the astronauts' conversations, which had been impounded overnight by NASA, Haney saying their "voice levels" would give the wrong impression. Reporters, interpreting Haney's comments to mean that Armstrong and Scott had panicked as the capsule spun out of control, angrily demanded that the agency release the tapes. By afternoon,

NASA relented, and reporters heard the relative calm of the astronauts throughout the ordeal. Years later, Scheer and Haney would each call the initial decision a mistake brought about by fatigue and human error. The delay though would open the agency to new charges that it was unnecessarily restricting access to the space program.[56]

One critique, rich with irony, came from Shorty Powers, the one-time "Voice of Mercury" who had been dumped nearly three years earlier for withholding information from the press. Powers had resurfaced as a partner in a Houston radio station that devoted twenty-four-hour coverage to space missions in progress, and he assailed the withholding of the Gemini 8 tapes as "a great disadvantage to accurate, non-speculative reporting, as well as a gross insult to the intelligence of the general public."[57]

An even more vocal critic was Elmer Lower, who cited the tape incident as the most recent example of agency stonewalling when it came to information. In a series of public addresses given weeks after Gemini 8, the ABC news chief revealed the simmering feud between networks and the new Scheer-led NASA information apparatus. Lower characterized NASA as "one of the larger sacred cows in the federal establishment" and as an organization that repeatedly "displayed a lack of cooperation with the news media." He cited the agency's bureaucracy as one factor that "has hampered us frequently in planning and executing space coverage," but he also alleged more sinister means of controlling the media, accusing NASA of tapping reporter's telephones at Cape Kennedy.[58]

While Lower attacked, he also prodded NASA about live telecasts from the capsule, something that the Soviets had already accomplished a year earlier during the first-ever walk in space. "The space agency's attitude toward live television" was all that stood in the way of such an American telecast, said Lower. "We think the American space program is thrilling, tremendous. And that's why we are so insistent that there be live television from space, so that the entire world can share this experience."[59]

NASA's stance against television in the spacecraft was hardly unanimous, and in fact, the agency had already transmitted some live video images during Gordon Cooper's last Mercury flight. The poor quality, unfortunately, made that attempt utterly forgettable. As the

Gemini program progressed and better video equipment became available, Scheer and Haney had pushed the agency for another try. Engineers had vetoed putting a camera in the cramped capsule, but the Gemini program manager later approved mounting a video unit on the unmanned Agena docking vehicle. The plan made it all the way to NASA headquarters and George Mueller, who oversaw the manned spaceflight program. "If you have a million dollars to spend on a TV camera for Agena," Mueller said, "give it back to me and I will reprogram it to a more useful area." Live television of astronauts in flight, for now, was dead.[60]

Americans already were seeing live pictures from the lunar surface though, thanks to unmanned vehicles that were scouting out the moon for a future manned landing. The Ranger 9 probe in 1965 had flashed nearly one hundred still photographs back to American television audiences, now, a year later, Surveyor would bring more views from the moon. Space buffs watching NBC in the wee hours waited nearly two hours for the first Surveyor picture to make its way from the probe's twenty-two-pound camera, and were undoubtedly unimpressed by a low-resolution shot capturing part of the spacecraft. After sunrise, photos of higher resolution and better composition made their way to viewers of all three networks.[61]

Days later, the absence of cameras on Gemini 9 would leave the networks to simulate Gene Cernan's unsuccessful walk in space. NBC hired legendary puppeteers Bil and Cora Baird to orchestrate space-suit-clad dolls in concert with reports from Mission Control, while CBS, broadcasting from McDonnell Aircraft facilities in St. Louis, employed an engineer who portrayed the astronaut while suspended from what the network called "a Peter Pan rig." The end of the flight would be much more realistic, as viewers for the first time saw the returning capsule float through the haze and splash into the ocean on live television.[62]

There would be no new televised "spectaculars" during the last three Gemini missions, but as NASA perfected techniques necessary for conquering the moon, television would dutifully serve as the box-of-record. The public's excitement over space flight may have waned, as had ratings, but television remained determined to bring a full ac-

counting to those who were still interested. As M.J. Arlen of *The New Yorker* noted, watching NBC while the Baird puppets tried to keep in sync with a Gemini 12 mission audio feed during a two-hour spacewalk was "in some ways ... very boring." But while little of the astronauts' conversation was understandable to the layman, "it was marvelous just to have it there like that," Arlen continued, "and rather nervy–the way the *Times* is nervy when it suddenly erupts with twenty-five thousand words of a Papal encyclical, running in an unbroken, unreadable torrent of gray across those pages."[63]

Hidden beneath the drone of astronauts and engineers was a renewed optimism that the manned space program had rediscovered its way. While there was no spontaneous national celebration as Gemini 12 concluded, the incremental successes Americans saw on television screens during the two-man phase gave hope that their investment might be starting to pay off. In contrast to his frank assessment on the eve of the first Gemini mission that the United States was woefully behind the Soviets in manned flight, Cronkite wrapped up the final mission by emphasizing to his viewers just how far the American program had come. "The Russians have not launched a single manned spacecraft in the twenty months since the series of ten American Gemini flights began," Cronkite said. "They may be husbanding a surprise–a huge space bus, a manned orbit of the moon, even a landing. But they may also have just plain fallen behind."[64]

The upcoming year held the promise of even greater American achievements, as Project Apollo prepared to take center stage after six years of development. As the networks planned coverage for as many as three manned Apollo missions in 1967, NASA's public information machine estimated it would need to produce four hundred news releases, answer twelve hundred telephone queries, and set up six hundred interviews with NASA officials to handle the media crush. The year had barely begun when all those plans became moot.[65]

CHAPTER 6

"Never A Straight Answer":
The Apollo I Fire

The fire began near Gus Grissom's leg. No one had noticed the two small sections of electrical wire that had worn bare by repeated closings in an equipment door, or the nearby faulty tubing that leaked flammable vapors from a glycol coolant, or the resulting tiny glow that now slowly climbed some nylon netting, gaining strength as it fed on the pure oxygen that flooded the Apollo cabin.[1]

At 6:31:04 p.m., the tiny glow became an open flame that attached itself to Grissom's spacesuit. Ed White, who nineteen months earlier had to be coaxed back into a spacecraft floating more than one hundred miles above the Earth, now burst out of his center seat in a desperate attempt to get out of a vehicle that had yet to leave the ground. White knew it would take at least a minute and a half to open the capsule's heavy, complicated hatch, a luxury of time he and his two fellow crew members would not have on this January 1967 evening. Within seconds, the capsule ruptured, the resulting convection shooting flames over the seats of Grissom and White, and down the back of fellow astronaut Roger Chaffee.[2]

Less than twenty seconds after the fire began, the past, present, and future of American space flight lay dead two hundred feet above the base of Pad 34 at Cape Kennedy, overcome by a billowing, choking cloud of smoke and gas. Grissom, one of the original seven astronauts, would later be found face up on the floor. Above him lay White, whose Gemini 4 walk in space was still considered by many Americans to be the most spectacular NASA feat to date. Chaffee,

who was training for his first spaceflight, never made it out of his seat.[3]

For years, NASA had feared that a space catastrophe would occur in front of hundreds of journalists and millions of television viewers, but the agency's darkest hour ultimately had come during a complicated yet routine systems test conducted away from the gaze of reporters and photographers. Over the next few hours, days, and weeks, NASA would wrestle with what to tell the press and public, and when, its decisions leaving many critics doubtful whether the space agency had ever been committed to candor.

NASA's Jack King had been stationed inside the concrete blockhouse a few hundred yards away from Pad 34, giving periodic updates to wire-service reporters throughout the flight simulation for Apollo 1, or AS-204, as it was officially known. The "plugs-out" test, designed to check that all systems of the missile and spacecraft would operate exactly as designed, precisely at the correct moment during countdown and liftoff, had been plagued from the start. "It was a very long day. We had all kinds of communications problems between the spacecraft and the control center," King recalled later. "The test dragged on, and then, and then out of nowhere we heard, 'Fire in the spacecraft!'"[4]

King had listened and scribbled notes as workers fought the intense smoke, heat, and fumes to open the hatch. After five minutes, the pad leader, aware he was speaking on an open line, reported back, "I cannot describe what I saw."[5]

King picked up the phone and dialed the home number of Cape public affairs chief Gordon Harris. They would all be working late.[6]

Harris rushed to the Cape press center, located on the tenth floor of a Cocoa Beach office building. A half hour had passed since the fire broke out, and the din of ringing telephones indicated that the media already knew something had gone horribly wrong. Yes, there was a fire, Harris would confirm to reporters who were able to get through. No, we have no other information.[7]

As Harris answered phones in Florida, Paul Haney had just finished buying a car in Houston, a purchase made necessary when Haney's divorce became final that morning. Mission Control had lim-

ited involvement in the test, but since the astronauts were based in Houston, the center's lead public affairs officer rushed back to work. Haney phoned King and the two began working on a press release.[8]

But what to say? Houston had not finished notifying the astronauts' wives, and the agency wanted to spare them a trauma that years earlier had been inflicted upon Faith Freeman, who found out from a newspaper reporter that her astronaut husband, Ted, had been killed in a jet crash. Still, the barrage of press inquires pouring into Cocoa Beach and Houston demanded some sort of response.[9]

An hour and nine minutes after the fire, King phoned Associated Press reporter Jim Strothman, while Harris called United Press International's Al Rossiter with NASA's first official statement on the fire. The official announcement read:[10]

> There has been an accidental fire at Launch Complex 34 during the plugs-out test of the Apollo/Saturn 204 involving fatality. More will be announced after next-of-kin have been notified. The prime crew was in the spacecraft.[11]

NASA's use of "involving fatality" would be the first of many curious moves by the agency's public affairs wing. King and public affairs chief Julian Scheer would later say the term was designed to be intentionally ambiguous since not all of the astronauts' family members had been notified of the deaths. Some reporters were adamant though that the original phrase issued by NASA was "involving a fatality," and that the agency later re-typed the release and excluded the article "a" for posterity. Part of the conversation between Harris and UPI's Rossiter, related to a journalism trade publication by the reporter, gives credence to the latter scenario.[12]

"Was it a crew member?" Rossiter asked.

"Yes," answered Harris.

"A prime crew member?" Rossiter followed.

"Yes," Harris said.[13]

One hour and thirty-four minutes after the fire began, UPI sent its first bulletin, announcing that an astronaut was dead. Moments earlier, AP had distributed Strothman's report of "a fire killing at least one person, possibly an astronaut," although Strothman had heard from his sources that at least two of the crew members were dead. It

would be another half hour before NASA announced they were all gone. In explaining the delay between announcements, Harris would later tell the press that "We had every reason to believe (all three were dead), but we had no confirmation," but NASA critics would later charge that the drip-by-drip release of information was a calculated strategy designed to let the nation down easy, and perhaps buy time for the agency to figure out how to handle the disaster's aftermath.[14]

Late that night, Haney convened the first official NASA press conference on the accident, a gathering that Scheer had tried to stop. Earlier statements from the president and various NASA officials were sufficient, Scheer argued, but a years-old agency disaster plan unearthed by Haney indicated that the event was called for, and that Houston was the site designated to host it. In reality, there was little for Haney to add, aside from noting that the craft was "heavily damaged," that the accident would "have a major effect on the Apollo program," and that audio and film recordings of the accident had been sealed until a board of inquiry could review them as evidence.[15]

"I think it is a fair assumption that death was instantaneous," Haney told the crowd, even though the audiotape he heard earlier that evening told a different story.[16]

The following morning, 150 newsmen gathered at the NASA press center in Cocoa Beach, clamoring for a look at the capsule. It would be more than twenty-four hours before the request was fulfilled. NASA had proposed that only a still photographer and a newsreel photographer be admitted, but after a reporters' revolt, the agency agreed to let one writer join the pool. Elected unanimously by his colleagues for the task, George Alexander of the trade publication *Aviation Week and Space Technology* spent an hour examining the craft, then wrote a nearly two-thousand-word report of what he saw, an account that ran verbatim in publications throughout the country. It began:[17]

> It looked like the inside of a furnace, which it tragically was last Friday evening.
> The interior of Apollo 1, the spacecraft in which astronauts Virgil I. (Gus) Grissom, Edward H. White and Roger B. Chaffee died at 6:31 p.m. (EST) on Jan. 27, is a darkened, dingy compartment. Its walls are covered with a slate-gray deposit of smoke and soot; its floor and couch frame are covered with ashes and debris – most of it indeterminate.

A few things, however, are distinct: a flight-plan book, not so much burned as it was made to resemble ancient parchment by intense heat, slumps against the control-stick column stood at Grissom's right hand. A page from that flight plan lies where Ed White's shoulders once lay; its edges are browned but the printing is still legible. A small bit of the green restraint harness worn by one of the three astronauts rests by White's and Chaffee's positions.[18]

Most other media requests that weekend were denied as NASA dug deeper into a no-information bunker. A press conference the morning after the fire that announced the composition of the inquiry board was cut off after a few questions, leaving reporters a lot of time on their hands and few avenues of information. One local reporter found a story angle for $2.50, the price of a Cape Kennedy bus tour that went on as scheduled. As the driver pointed out the new tragic landmark, the reporter interviewed tourists about the disaster. His journalistic colleagues would have less luck getting people to go on the record: The rescuers who gave interviews to a local paper the night before now told reporters they were under strict orders to stay quiet, a response that was heard with great frequency as usually reliable sources near the space program now dried up.[19]

A second press conference that day, held at a Cape press site located three miles from Pad 34, featured Apollo director Sam Phillips but ultimately raised more new questions as it settled old ones. Phillips' statement that the craft was on "internal power" during the test suggested that the capsule's batteries might have been overloaded, prompting reporters to chase down false leads that someone had failed to disconnect all of the electrical cables running from the craft to a ground power source at the pad. NASA later contradicted Phillips, correctly, by issuing a statement that Apollo was on external power during the hold in the countdown, but then inexplicably reversed course again, telling the media that it would stick to Phillips' original statement.[20]

Phillips also revealed in the press conference that one of the astronauts had yelled "fire in the spacecraft" over the intercom in the crew's final moments, suggesting that death was perhaps not as instantaneous as Haney had suggested the night before in Houston. Harris's later claim that the delay in disclosure was a matter of identification–"we did not know who said it–it could have been one of the

blockhouse crew"–was met with a great deal of skepticism among the press corps.[21]

"Nothing so arouses a reporter's doubting instincts as a 'no comment' or a vague and evasive reply to a question," *New York Times* reporter John Noble Wilford would later recall, and his own instincts led him to Doug Dederer, a local reporter who had covered the Cape since the Sputnik era. Dederer's wardrobe–usually consisting of shorts, a T-shirt, and sandals–led many to label him a screwball, and NASA officials made little attempt to hide their contempt, claiming he played fast and loose with the facts. Wilford knew though that Dederer, who occasionally moonlighted for the *Times*, had a lot of contacts near the space program. Poke around, see what you can find out, Wilford instructed.[22]

"We're on fire–get us out of here!" had been Roger Chaffee's final words.

Hours before the three astronauts were to be buried, a story under Wilford's byline in the *Times* reported that their deaths had not been instantaneous. There had been nearly twenty seconds of screams and unintelligible shouting, an unidentified engineer with access to an audiotape recording of the accident told Wilford and Dederer, as the astronauts "were scrambling, clawing and pounding to open the sealed hatch and escape the inferno." The engineer's story, and similar accounts published in the *Washington Star* and carried to newspapers across the country via UPI, was in direct contradiction to NASA's official assertion that the three never had time to leave their seats.[23]

On the record, NASA declined comment, Scheer telling the press that he would not "answer, day by day, all the reports, rumors and so on that come up." Behind the scenes at the agency, the chronology of who knew what, and when, was contested and would continue to be for years. Scheer would claim that he and NASA chief Jim Webb had no knowledge of the tape's final seconds until the afternoon of Chaffee's funeral, when Haney confirmed that he had heard the excerpt and that the *Times* story was essentially correct (excepting the paragraph about the bodies being burned beyond recognition).[24]

After Chaffee's funeral, during a meeting in a Washington hotel, Haney maintained that he had told Scheer about the tape's contents on the night of the accident, in midst of a long-distance Scheer rant over the convening of the initial Houston press conference. An incensed Webb lashed out at "the erosion of credibility" and wanted Haney fired, but instead settled for a letter of apology. Years later, Haney would maintain that his superiors simply had blinders on. "Scheer and Webb both beat me over the head on account of this tape. I think Webb didn't want to believe the truth about the tapes, and Scheer went along with him," Haney would later say. "They got locked into the proposition that the three astronauts had their lives snuffed out immediately and they refused to believe the evidence to the contrary."[25]

Whoever was ultimately to blame, the fact remained that the tape's revelation added up to the agency's worst public relations embarrassment in a five-day span full of information miscues. "What is the motivation for the information blackout?" wrote the *Houston Chronicle* in an editorial. "One NASA official said withholding of any tape would be an attempt to keep the press from exercising its 'morbid curiosity.' This is not a rational justification. It is cover up."[26]

For many veterans of space coverage, such as fervent NASA critic Bill Hines of *The Washington Star*, the episode was further proof that the agency's "open program" policy was subject to conditions. "The behavior of the space agency in the days after the flash fire at Pad 34 was like something out of a Kafka novel," Hines wrote days after the fire. "When things go well, the NASA mimeograph machines run at supersonic speed. The quality of the information is not always good, but the quantity is sure to be suffocating. When trouble happens, however, it is like letting a mouse loose in a herd of elephants."[27]

Even those predisposed to give NASA engineers and contractors the benefit of the doubt while the fire was under investigation, such as *Technology Week*'s William J. Coughlin, blasted the agency's performance in the immediate aftermath of the accident. "NASA's handling of the public relations aspect of the tragedy was abysmal," Coughlin wrote in an editorial. "The effort to pass off the fiction that the men died instantly was extremely ill-advised and bound to be found out. The deception only enlarged the reporting of the unpleasant facts."[28]

The agency's inability to get its story straight on numerous facts ranging from the craft's power source to the final moments of the astronauts, coupled with NASA's gag order to its employees, led many press observers to suggest that something more sinister was at work. "Under ordinary circumstances, such discrepancies might be explained by confusion," the *Chicago Tribune* wrote in an editorial. "But when information is tightly controlled, as by NASA, it suggests a conscious effort to conceal unpleasant facts or at least withhold them until they can be fitted together in the manner most favorable to NASA and the moon program."[29]

NASA refused media requests to hear the tape, but in an attempt to quell charges that the agency was overly secretive, Webb asked the review board to issue periodic reports on its progress. The move did not slow the growing press criticism. The makeup of the review board itself, filled primarily from NASA ranks, led to more charges that the agency was simply trying to save its own image rather than get to the root causes of the fire. "It is not that the individual board members lack the integrity or wit to find the truth," Hines wrote, "it is simply that the top echelon at NASA, on the basis of past performance, can be expected to denature the report before making it public."[30]

Released ten weeks after the fire, the review board's three-thousand-page report was deemed by congressmen as a "broad indictment" of NASA and Apollo lead contractor North American. The highly pressurized, pure oxygen environment; the abundance of flammable material in the capsule; and the cumbersome escape hatch were targeted as prime factors in the accident, but the report was also critical more generally of sloppy workmanship, a lack of quality control, and ineffective management, characteristics at odds with the tight, efficient structure often touted publicly by Webb as the agency standard.[31]

While some space writers as *Technology Week*'s Coughlin claimed that the report "has effectively laid to rest charges that the board was assembled to conduct a whitewash," others suggested the report missed the target at the real culprit in the accident. "It was not the Apollo team's 'devotion to the many difficult problems of space travel' that was at fault," wrote the *New York Times* in an editorial.

"Guilty rather was the whole irrational public relations environment of the space program with its technically senseless–and as the Apollo tragedy proved, highly dangerous–dedication to the meaningless timetable of putting a man on the moon by 1970."[32]

Others in the media believed the review board focused too much on "what happened" and not enough on "why it happened." Journalists noted that the final report didn't address how North American Aviation had managed to beat McDonnell, which had designed craft for Mercury and Gemini, or highly regarded Martin Marietta for the Apollo contract. NASA's insistence that pressure to get to the moon by 1970 was no factor in the accident didn't jibe with reports that contractors were asked by the agency to fit twelve hours worth of work into each eight-hour shift. And as CBS correspondent David Schoumacher and producer Joan Richman pored over the report, a number of other troubling omissions emerged, which they noted in an internal network document:[33]

> -- why, if there was no worry about ground fire it was decided to remove a great amount of Velcro during a review?
> -- why firemen were standing by and yet had received no briefing on the spacecraft and fundamental rescue and fire-fighting problems?
> -- why fire escape doors were provided on the launch tower and then locked from the outside?
> -- why tests others in the space industry considered essential were waived?[34]

But while NASA took its lumps from some quarters, others leveled criticism at the press for not living up to its role as a watchdog during development of the craft. ABC science editor Jules Bergman, who had honed his skills with a graduate-level Columbia University fellowship and boasted of completing virtually every step of astronaut training, doubted he or his colleagues could have had much impact. "Even if I had a staff of fifty experts in electronics, rocket propulsion, and all other specialties we could not possibly predict and prevent every incident, accident and disaster," Bergman wrote in a defense of his colleagues published in the *Columbia Journalism Review*. Even if journalists had discovered and highlighted the safety concerns, Bergman continued, "NASA would simply have pointed to the success of the Gemini and Mercury programs, and the public

would have been satisfied that safety precautions were just as adequate in Apollo."[35]

Other reporters claimed that they had tried to warn the public of a pending disaster, but were stymied by uninterested editors and producers. Years later, NBC correspondent Jay Barbree would recount a conversation with Grissom where the astronaut pleaded for a story on the Apollo craft's multitude of problems, but the network, according to Barbree, glossed over the safety concerns in a report aired prior to the fire on *The Huntley-Brinkley Report*. Some of Barbree's counterparts in print journalism echoed his belief that the media had little stomach for investigative enterprise when it came to the space program. "We just can't afford to risk tying up the men and the money on stories that might not develop," said one science editor at a large magazine, and a print reporter found that his paper had a limited attention span even after the disaster. "A couple of weeks after the fire, it was just as if the World Series were over," the reporter said. "We couldn't even get our editors to allot the space to report the follow-up hearings in Congress on the fire. I guess they figured the public wasn't interested anymore."[36]

Others in the space press corps looked inward, using the accident as occasion for soul searching. Reporters familiar with the Apollo capsule could easily have looked at some of the materials inside and asked "Won't this stuff burn?" noted one newspaper science writer shortly after the accident. "The answer from NASA would have been that they had tested it at five psi [pounds per square inch]–as they did–and found it okay. But the reporter who took that next step and asked, 'What about *sixteen* psi'–the pressure under which the ground test was conducted–and then gone on from there, could well have done the country a great favor." More than 20 years after the fire, AP's Howard Benedict, one of the most seasoned and decorated space reporters, was still asking, "Had my journalistic instincts been clouded by my enthusiasm for the adventure?"[37]

The most ardent press critics would argue that Benedict and his journalistic colleagues, more than merely being influenced by NASA, had become full-throated cheerleaders for the space program. Starry-eyed reporters seduced by the glitz of the program's "spectaculars" were all too eager to feed on a bounty of pre-packaged information gladly served up by public affairs officers, charged the critics, and

were generally disinclined to probe deeper when the facts didn't add up. The press had become willing partners with NASA, the argument went, in creating what Hines called "The Image," a mythic vision of American spaceflight that was impervious to questions of funding, competence, or discretion.[38]

> The Image is a myth 9 feet tall, compounded in equal parts of John Glenn and Dr. Robert H. Goddard, with just a dash of the Redeemer added for omniscience and omnipotence. Its exploits are chanted off-stage by a Greek chorus composed of Walter Cronkite, Frank McGee, Jules Bergman and Paul Haney.[39]

If Hines had been asked for recent, specific examples to support his theory, he would have had little trouble producing them. While some articles and broadcasts did raise questions about the fire's origins and circumstances in the days immediately following the accident, American media also spent a great deal of resources paying homage. "Grissom ... White ... Chaffee ... They bought the farm right on the pad, cooked in the silvery furnaces of their spacesuits," began a maudlin full-page *New York Times* ad that had been taken out by *Life*. "Think about them, about how they were always willing to force themselves past the point of danger and deep fatigue to perfect their understanding of the machines they flew," the ad continued. Sister publication *Time*, asking readers "Why Should Man Go to the Moon?" answered with gee-whiz assurance: "The possibilities and rewards that wait for man on the infinite frontiers of space are limited only by the human imagination."[40]

Sometimes, media made it appear as if there had been no accident at all. In an episode of *The 21st Century* produced before the accident but that aired just days after the astronauts' funerals, CBS viewers watched as Walter Cronkite toured a North American-designed model of a lunar colony, drove a prototype of a lunar buggy, and talked with rocket pioneer Wernher von Braun about the inevitability of man's colonizing the moon, perhaps as early as the mid-1970s. Near the program's conclusion, Cronkite invoked the spirit of Lewis and Clark as he touted the promise of America's continued commitment to manned space flight. "For the secrets it shields, the treasures it stores, or perhaps simply because it is there, man will colonize the

moon in the 21st century," Cronkite concluded. "And from here he will reach far out into space."[41]

But the view of the press as a monolithic mouthpiece for NASA, the suggestion of an exclusive partnership between the Fourth Estate and the Executive branch, overlooks a different nexus between media and congressional investigators. Legislators not overly familiar with the intricacies of the space program could often find reporters who could get them up to speed and lead them to potentially fertile lines of inquiry. In February, Bergman had tipped off junior Minnesota senator Walter Mondale about a "Phillips Report," an internal NASA study drafted by the Apollo director in 1965 that raised serious concerns about the competence of North American Aviation. When Mondale raised the issue during the opening day of Senate hearings concerning the fire, NASA officials disavowed any knowledge of "any such unusual report," in the words of George Mueller, the lead administrator for the Office of Manned Space Flight.[42]

Yet, when Mueller, Webb, and NASA's No. 2 man Bob Seamans returned to headquarters that February afternoon, a copy of the document lay on the desk of the agency's chief legal counsel. "Even with due consideration of hopeful signs," Phillips' 1965 cover letter read, "I could not find a substantive basis for confidence in future performance" of North American. That evening, Bergman described the document for ABC viewers in significant detail, indicating the likelihood that more than one copy existed.[43]

The revelation shocked Mueller, because he had ordered that the bulk of the original document be destroyed after Phillips had presented it to him in late 1965. A few items were incorporated into briefing material, Mueller would say years later, but much of the documentation had no direct bearing on the problems NASA was having with North American, he would claim. No one at the agency was ever quite sure how the documents came to be bound, or how exactly they resurfaced.[44]

As for Webb, he maintained that he hadn't known that such a study had been undertaken, not an implausible scenario given how much sway Mueller had over the Apollo program. "(Mueller) was running the Office of Manned Space Flight as essentially a separate

organization, to the point that Webb didn't always know what he was up to," historian John Logsdon would later say. "You have to keep in mind that the Phillips Report was originally made for Mueller to see, not Webb."[45]

As congressional requests to review the document intensified in spring 1967, Phillips, Mueller, and Webb would maintain that it was merely a "set of notes," not an official report subject to the purview of investigators. NASA later offered a summary of findings, which didn't slow the demands to see the entire compilation. "If every deficiency in the program were put on the record, we would never fly," said Webb, who also told congressmen that disclosure would harm future relationships between NASA and its contractors, and might have an unfair negative effect on North American's stock price, arguments that had some merit.[46]

Editorial page writers, already jaded by NASA's numerous erroneous statements about the accident, overwhelmingly called on the agency to release the documents in total. "Mr. Webb certainly does not want to reinforce the view of cynics who insist that NASA actually stands for 'Never A Straight Answer'," a *New York Times* editorial stated, while *The Boston Globe*, with significantly more hyperbole, wrote that "The possibility that the whole travesty might be a national scandal of unprecedented proportions does not argue for secrecy. It argues for total disclosure."[47]

Disclosure would come, but not from NASA. Congressman William Ryan released excerpts from the Phillips Report to the press in late April, and then, with more than a bit of grandstanding flourish, gave the agency three days to make the entire document public. When the deadline passed, Ryan distributed copies to waiting reporters. There were few new revelations–most of the document already had been leaked to the press through other sources–but after viewing the report in its entire context, the *Times* concluded that "it is hard to escape the conviction that the only basis for hiding this highly critical document was NASA's desire to cover up errors."[48]

Meanwhile, American journalists kept digging and were more inclined to ask hard questions about the nation's priorities than they had been before the fire. An hour-long NBC news special, *Crossroads in Space*, aired in early April and highlighted wasteful NASA expenditures, such as a Mississippi launch facility that duplicated tasks al-

ready carried out by Huntsville's Marshall Space Flight Center. The space program had become so immense, host Frank McGee concluded, that keeping tabs on its costs and effectiveness had become virtually impossible.[49]

As the congressional hearings drug on throughout spring 1967, Webb and other NASA officials "became reluctant and at times hostile witnesses," observed *The Washington Star.* "The committees responded by converting quickly from their accustomed roles as old friends of the family to become sharp and sometimes angry inquisitors." New embarrassing revelations would also emerge, none more damaging than Webb being forced to admit that North American had been the second choice of an evaluation board for the original Apollo contract, not the first choice as he had testified a month earlier. Webb and other top-level NASA officials had been within their rights to overrule the board, but the contradictory statements concerning the chain of events eroded even more of the agency's little remaining credibility.[50]

A beleaguered Webb, angered to see agency documents leak out through the press and annoyed to see reporters such as Hines feed questions to congressmen during hearings, used some of his testimony to lash out at the media. Not only did Webb accuse the press of bribing NASA employees for inside information, but he also more generally decried the difficulties of operating his program "in the brilliant color and brutal glare of a real-time worldwide mass media that moves with the speed of a TV camera from euphoria to exaggerated detail." Later, he would strongly suggest that "The Image" was purely a press creation, without any agency input or cooperation. "NASA and the astronauts had been built up for a fall," Webb would say, by a press that had portrayed the space program in mythic terms, then treated the fire as "the defacement of an idol."[51]

In a time of crisis, NASA had withdrawn, an information stance that had cost the agency dearly in the court of public opinion. The siege mentality displayed by Webb during testimony permeated the agency for months as it tried to return to the day-to-day business of running a space program. "(Manned Spacecraft Center director Bob Gilruth) on many occasions said to me, 'Why, we've got to make people stop thinking about this fire.' This attitude did not strike me as very constructive," Haney would recall. "I thought that the holds that

were clamped on the agency and this center during that period were extraordinarily restrictive in the information area, and the most restrictive period in public information that I have ever seen in NASA."[52]

By mid-May, the agency was able to begin changing the subject. Whether through design or serendipity, a NASA press conference introducing the trio of astronauts for the next Apollo flight was held on the same day that a House subcommittee wrapped up hearings on the fire. In newspapers across the country, accounts of congressmen telling Webb that "I think you have an obsession with secrecy," and "I'm getting the feeling that you haven't really cooperated with us," stood in stark contrast to astronaut Wally Schirra's comments that "we don't want to suffer any more self-recrimination instead of getting going on the program." A new "can-do atmosphere" was now predominant in the nation's space program, Schirra assured the country, and NASA was proceeding with "orderly haste" to make up for lost time. *The Boston Globe*, suggesting the announcement was timed to dampen congressional enthusiasm for further inquiry into the North American contract, wrote that the press conference was "conducted, through no fault of the astronauts selected for the planned flights, in the manner of a college pep rally at which the football captain and the star halfbacks rouse the student body to a frenzy just before the Big Game."[53]

The tenth anniversary of Sputnik that fall provided another opportunity for space advocates to move the country's focus away from the fire. Newspaper articles marking the occasion told readers that the decade of space exploration had brought myriad tangible benefits to Earth, from medical devices honed to detect cancer, to beer kegs small enough to fit inside home refrigerators. A special episode of NBC's *Today* featured John Glenn's promises of "unknown benefits" to come from the space program, while the president of an aerospace industry trade group claimed that nothing short of a new industrial revolution had taken place since Sputnik, one that proved that no engineering problem was too complex. "That really is marvelous," reverent *Today* host Hugh Downs replied.[54]

While many advocates were touting successes of the space pro-
gram in order to maintain public support, NASA's chief often took an
opposite tack. In numerous public statements during late 1967, Webb
relied on Cold War fears as he warned U.S. citizens that the Soviets
were on the verge of launching larger, more robust booster rockets
and vehicles, while the American space program was slowing down.
Webb's view of the implications, distributed by Scheer as talking
points for other NASA officials to use for public consumption, had a
similar tone as those sounded after Sputnik's launch a decade earlier.
"We face a situation in the future as serious as the placing of Soviet
missiles in Cuba was," proclaimed an internal NASA summary of
Webb's comments. "The Soviet capability to put large payloads over
our heads every hour and a half is something we should not close our
eyes to. It is a psychological threat." Appealing to national pride,
Webb would assert that the Soviets had beaten the United States to
every space milestone, conveniently skipping American firsts in ren-
dezvous and docking, and significant U.S. advantages in satellite
technology.[55]

NASA knew that words alone would not be enough to get past
the fire. What the American space program really needed was a spec-
tacular success, and just as it had a decade earlier, the country pinned
its hopes on Wernher von Braun and his team of German rocket engi-
neers. Since 1962, they had led a nationwide effort to develop the Sat-
urn V, a thirty-six-story tall, 6.2 million pound behemoth designed to
lift man to the moon. Now, in November 1967, the combined efforts
of more than 300,000 workers and engineers, located at more than
20,000 factories and research centers across America, were about to be
unveiled in a high-stakes, unmanned dress rehearsal dubbed Apollo
4. The entire three-stage rocket, many of its components untested in
space, would attempt to put a record 140-ton payload into orbit. The
bold decision, made years earlier, to assemble the rocket and simulta-
neously test the parts "all up" was designed to help America meet the
1970 goal for reaching the moon. If Saturn failed, that goal would al-
most certainly be out of reach.[56]

The day prior to Apollo 4's launch, the assembled media gathered
for two briefings on the test. It was not uncommon for the agency to
split pre-launch press conferences into two sessions, one devoted to
the "nuts and bolts" of the mission, and a second outlining the "big

picture" of where the mission stood in relation to the overall space program. New though was the logistics of the "big picture" session. Instead of bringing a handful of space officials to the press facility in Cocoa Beach, NASA instead bused the entire press contingent to the Cape and a new media viewing site nearly four miles away from Pad 39A.[57]

As Bob Seamans touted the features of America's multi-billion-dollar investment, the hulking Saturn served as a striking visual backdrop for what Hines called "the most expensive stage in theatrical history." Seated near Seamans was von Braun, who "was as much responsible as any individual for the drama being played out here," Hines continued in the following day's edition of *The Washington Star*. More than a decade after von Braun had captured the public imagination with his articles in *Collier's* and television appearances with Walt Disney, "It had finally come to this: A rocket as long as a football field, as heavy as a warship, and as powerful as all the electrical generating stations in the U.S.A.," Hines wrote.[58]

While Hines saw the event as an attempt "to tell NASA's story, on NASA's terms," Seamans was struck by the combative tone of many questions posed by a press contingent still jaded by the omissions and half-truths uttered after Apollo 1. When the press conference was over, a frustrated Seamans sought out Cape Kennedy director Kurt Debus, a veteran of von Braun's German rocket program who had a different perspective on the exchanges.[59]

"I said to Kurt, 'That was pretty rough. I'm sorry you have to go through this kind of thing,'" Seamans recalled years later. "He said, 'It is rough, but you've got to realize that during World War II, we didn't have any competition in the press, and I really believed what Goebbels told me. This is tough, but it's a lot better than the alternative.'"[60]

Early the next morning, the press gathered again at the same site to see whether the giant bird could actually fly. When the first-stage rockets began firing at 8.9 seconds before 7 a.m., it didn't appear so, as orange and then white smoke began to surround the stationary vehicle. Then, nearly 10 seconds after the engines first fired, Saturn began to rise, slowly, silently to those watching at the press site nearly twenty thousand feet away. Five seconds later, the media would finally experience the pulsing sound, 120 decibels at its peak, that had

been created by the giant engines, moving the ground so violently that it rattled the metal roofing erected over the press grandstand and threatened to cave in the trailers each network brought in as remote broadcasting facilities. "Oh, my God, our building is shaking," Cronkite told CBS viewers watching live, "... part of the roof has come in here!" As Cronkite recalled later:[61]

> When the trailer began to shake, the acoustical tiles began to slip through, and one of the ceiling lights came down. The glass of the trailer–it really was two trailers put together–began to bulge inward by as much as three inches. I was concerned that the glass would break, so while I was broadcasting I got up and held the window so it wouldn't come crashing in on us. Naturally I got pretty excited in what I said over the air. My elbow was so sore the next day I couldn't bend it, just from holding the glass in.
>
> Apparently it's not so bad if you stand outside. The press people out there hadn't felt the thing the way I had. They began saying "Cronkite was just building up a story." But John Glenn came over to the press site from (launch control) and he said he was standing behind the glass windows there and it scared the hell out of him. Took me off the hook. We strengthened the building before the next launch.
>
> Afterwards the Pittsburgh Plate Glass people said, "You weren't supposed to hold the window. That's the worst thing you could have done." As I was saying, it's knowledge that counts. Once you know it isn't going to blow up, you don't get too excited about it.[62]

The dummy Apollo capsule on top of Saturn returned to Earth eight-and-a-half hours later, completing a preposterously perfect mission. "That was the best birthday candle I ever had," Saturn project manager Arthur Rudolph, another veteran of von Braun's German rocket program, exclaimed to the press. Rudolph's latest creation, christened on the sixtieth anniversary of his birth, had put his adopted country back on track in the space race. It did not end media criticism of the space program, nor did it eliminate press suggestions that a sprint to the moon still might not be the best course of action. A *New York Times* editorial the next day lauded the engineering feat while scolding NASA again for haste that, in the paper's view, contributed to the deaths of Grissom, White and Chaffee.[63]

A *Washington Post* editorial also marveled at the technical triumph, but less for its effect on the space race and more for what it could mean for tackling the nation's myriad other difficulties. "The scientific skill and engineering ingenuity symbolized by Saturn V will

have to be maintained in this country if it is to survive in the modern world," the *Post* wrote. "Of course we cannot divert to rockets money and talent needed to solve our rural and urban problems. But our human problems can be solved in a first-rate nation easier than they could be solved in a second-rate nation. And our space triumphs are a mark and a sign that the United States is a first-rate nation."[64]

As for the reporters assigned to the space beat, the successful launch did little to rein in their hostility toward NASA. When the press gathered for the second Saturn V test, Apollo 6, in April 1968, new agency deputy administrator Thomas Paine was taken aback by the press's attitude.

> The air of animosity and the frank feeling I got from reporters, to have the damned thing explode on the pad the next day would be the best story they could get, in which case they would have credit lines on the front page, whereas if the damned thing went up, well there wasn't much of a story in that. And also they knew that we knew we didn't know what the hell we were doing, that we were all a bunch of bums, that it was all a great façade. Really, relations with the press were not all that good when I first showed up.[65]

Those relations would not improve after the test, as agency officials were forced to field reporters' questions about why the rocket had suffered three critical engine malfunctions, failures that again threatened to push a moon landing beyond 1970. But while correspondents dutifully chronicled the problems, few of their bylines would reach the front page. Days earlier, plagued by increasing public skepticism about the Vietnam War, President Lyndon Johnson had shocked the nation by announcing he would not seek re-election. And hours after the second Saturn test failed, an assassin's bullet struck Martin Luther King in Memphis. Suddenly, NASA's shortcomings weren't front-page news anymore.[66]

By September 1968, a weary Jim Webb had had enough. Determined to have his successor in place before a new president took over, Webb announced he would retire the following month, but his farewell to reporters on the White House lawn included sharp barbs for a Congress that had slashed the NASA budget to the lowest levels

in six years. "I think a good many people have tended to use the space program as a sort of whipping boy," said Webb, who added that the cuts meant NASA was operating at half capacity, while the Soviets, in his view, were going full speed ahead, as evidenced by the launch days earlier of the high-powered Zond 5, an unmanned craft that had circled the moon. As for the prospect of Americans reaching the moon before 1970, Webb predicted, "the chances of it are less than they were a year ago because we have, of course, less base from which to work."[67]

Press requiems for Webb's tenure were, not surprisingly, less than kind. One writer, comparing a Webb conversation to "taking a drink from a fire hose," gave a backhanded compliment to the outgoing NASA chief. "It won't go down in the records of James Webb's 25 years of government service, but he was a huckster. A good one. Maybe the best Washington has ever seen. Every year since 1961, he has been re-convincing Congress that it is not only desirable, but moral, humanitarian, romantic and mandatory to explore space." On ABC, a sharp Bergman commentary focused much more on the recent past, and the future. "Caught by the tragedy of the Apollo fire, his credibility destroyed by the congressional hearings, Webb lost his usefulness," Bergman railed. "Now the space agency is crippled. It's a one-project agency–Apollo–the scientific and planetary programs have no real money."[68]

But on NBC that evening, Chet Huntley told viewers that not all was lost. After running an excerpt from the Webb press conference, Huntley narrated a taped segment focusing on Apollo 7, a manned orbital mission scheduled just days after Webb was to leave the agency. Huntley described the newly designed hatch–engineered to open in two seconds instead of the ninety it took to free the one installed in Apollo 1–and other safety features that had been instituted since the fire. Then, viewers got a look inside the gargantuan Cape assembly building where a new Saturn V, modified to fix a fuel line problem that doomed the Apollo 6 test, was being prepared for a December launch. By the end of the year, if everything went just right, three Americans just might orbit the moon.[69]

CHAPTER 7

"... The *Good* Earth":
Seeing Ourselves From the Moon

"The whole world is watching," while iconic, was a somewhat inaccurate summary of television's influence in 1968. In many developing nations, television was unheard of, or just a rumor, out of reach for the masses. If you lived in Nigeria that year, your odds of owning one were roughly 1,000 to 1. In India, more than 62,000 citizens would have had to gather around each set in order to accommodate the entire population.[1]

But in the United States, where there was one television for every 2.5 people, Americans were certainly watching the world, which seemed to be disintegrating before their eyes. They saw demonstrating students shut down Columbia University and, with the help of striking workers, nearly the entire country of France. They were horrified, yet again, when broadcasters showed them that a Kennedy had been murdered, this time in the wee hours of the morning in a Los Angeles hotel ballroom. They were perplexed to see their country's troops, in a war they were supposed to be winning, under siege on the grounds of their own Saigon embassy. Soviet tanks rolled into Prague, uniformed police clubbed antiwar protestors in Chicago, Tommie Smith and John Carlos raised their gloved fists in defiance on a Mexico City Olympics awards stand, and starving children cried for help in Biafra, all beamed to the living rooms of Americans from coast to coast.

But as NASA prepared Apollo 7 for the nation's return to manned spaceflight that year, it was unclear what role television would play in the revival. Four years earlier, the Soviets had successfully trans-

mitted a television picture of cosmonauts in flight, but their American counterparts were still bickering over what, if anything, should be broadcast from their orbiting spaceships. A study of television feasibility for the Apollo craft, ordered by NASA No. 2 man Bob Seamans in 1966, had split the agency into two camps.[2]

On one side was the NASA Public Affairs office, which pushed hard for the public to get an "insider's look" at a mission in progress. "We can put up the most exotic sensors to check on radiation and we can discover seventy-five new elements and this won't mean a damn thing to Mr. Jones down the street who pays the tax dollar to keep us in business," Paul Haney, the lead information officer in Houston, said in an unpublished spring 1968 interview. "We could aid their understanding a lot more if we would show them maybe twenty minutes of TV a day during an Apollo mission, which we could do simply."[3]

On the other side was virtually the entire astronaut corps, who thought the proposal to be a publicity stunt that, at best, would interfere with vital mission duties, and, at worst, turn into the most horrifying broadcast in history. "I had this picture in my head of the first TV show in space," Wally Schirra, commander for Apollo 7, would write years later. "We come on the screen, and I say, 'Oh, hi everybody, here we are. Let's have some fun and games.' And then, pooom–'Sorry, we're not here anymore.'"[4]

George Low, the lead administrator in charge of the Apollo spacecraft, largely sided with the astronauts. Citing weight concerns, Low resisted putting a camera in the craft at all, but later proposed that a television camera be used only twice: in the lunar module during the second manned flight, and on the surface of the moon when man finally landed there. In April 1968, Low was overruled by Apollo program director Sam Phillips, who outlined the stipulations in a NASA memorandum.[5]

> 1. The TV camera and associated hardware would be installed at KSC [Kennedy Space Center] with no impact on launch schedule;
> 2. the camera would be stowed during the launch phase;
> 3. a mounting bracket for the camera would be provided in the CM [Command Module] to permit simultaneous viewing of all three couch assemblies, for use in monitoring prelaunch hazardous tests and in flight;

4. the camera could be hand-held for viewing outside the CM during flight; and

5. use of the camera would not be specified on the astronaut's flight planning timeline of essential activities but would be incorporated in the mission as time and opportunity would permit.[6]

Phillips' order would not be the final word on Apollo television. That fall, during the final ground test of the Apollo 7 command module, astronaut Donn Eisele ripped his spacesuit on the camera, which was mounted near his left knee.

"This thing has got to go," Eisele said.[7]

As NASA wrestled with the camera question, television networks were making some difficult fiscal choices about space coverage. At CBS News, a budget of $1.3 million for ill-fated Apollo 1 had been slashed nearly in half for Apollo 7, and the cuts threatened to kill planned live segments from the North American plant in Downey, California, where the network and the contractor had already invested a combined $375,000 into broadcasting facilities and full-scale models of the Apollo craft. Mindful of the network's success with similar remotes from McDonnell Aircraft facilities in St. Louis during Gemini, CBS News vice president Gordon Manning was convinced that ditching the Downey remotes would put the network at a severe competitive disadvantage against its primary rival, which was again turning over its cavernous Studio 8H to an extensive array of charts and mock-ups. In a multi-page network memorandum that was co-signed by Walter Cronkite, Manning pleaded with network news president Dick Salant to save the California segments:[8]

For CBS News to go back to small models and to be confined for all programming after launch to a small N.Y. studio for the most exciting phase of the U.S. space program–the attempted conquest of the moon–will make for very ordinary coverage, and we will really be surrendering our lead in space reporting to NBC. And one must constantly keep in mind the dangers of the Apollo mission. These flights are not likely to be routine. When and if trouble develops the nation will want to know what the astronauts are facing and what they are going through in any particular ordeal. Full-scale models with working dials and equipment will be the only audience-building way to illustrate the troubles–and the achievements on the success side–for television journalism.[9]

After trimming $100,000 from other areas in the budget, Manning was able to save the California remotes, and the network prepared to cover the first manned NASA mission since Grissom, White, and Chaffee died on the launch pad nearly two years earlier. Apollo 7, scheduled for an eleven-day orbital test drive of the command module, lacked the celebratory, circus-like atmosphere that had characterized much of the Mercury era. Funerals, investigations, budget cuts, and a looming deadline had changed all that, as Cronkite noted to *CBS Evening News* viewers two days before the spacecraft left Earth. "The word here is get to the moon–fast–cut out anything that might slow us down and then see if that historic achievement won't somehow put the sheen back on America's space program," Cronkite said from Cape Kennedy.[10]

Later in the same broadcast, taped interviews with the astronauts tried to reassure the public that the rush to the moon wasn't at the expense of safety. Schirra described the new escape hatch mechanism that opened 98 percent faster than the one installed in Apollo 1, and Eisele expressed confidence in the reliability of the Saturn IB rocket that would lift them from Earth. Still, the third member of the crew, Walt Cunningham, understood that a segment of the viewing public would have a morbid curiosity whether this new attempt would get off the ground. "Just like I watched the Comsat [communications satellite] launch the other night, and it was a beautiful launch," Cunningham told correspondent David Schoumacher.

"It was also exciting when it blew up, you know."[11]

Television viewers would see a perfect launch on October 11, 1968, and with the Apollo 7 crew safely into orbit, America turned its attention to the first of nine scheduled television broadcasts from space, slated for the following morning. If everything went according to plan, a specially designed 4.5-pound RCA camera–thirty times lighter and eighty-five times smaller than a standard black-and-white broadcast camera–would transmit slow-speed pictures from the craft to receiving stations in Corpus Christi and Cape Kennedy. There, the signals would be converted from ten to thirty frames per second, then transmitted over standard broadcast lines to the networks. The odds

of disappointment were high though, considering that the twenty-watt transmission would have to travel as much as one thousand miles from spacecraft to ground. "Even if they get to use it, you won't see much," chief astronaut Deke Slayton said in a pre-launch press briefing. "It gives you a lousy picture."[12]

When the time came for the first broadcast that Saturday morning, viewers saw and heard nothing from space, but through no fault of the equipment. Schirra, fighting a head cold, trying to complete a complicated rendezvous with part of the spent booster rocket, and dealing with numerous equipment problems in the just-christened command module, testily responded to requests from the ground "to turn on the television at the appropriate time."

"You have added two burns [of the rockets] to this flight schedule," Schirra snapped. "You have added a urine water dump and we have a new vehicle up here and I tell you this flight TV will be delayed without further discussion until after the rendezvous."

It took nearly twenty seconds for a stunned Mission Control to acknowledge Schirra with a "Roger. Copy." Another twenty seconds passed before Houston came up with another pitch to the obstinate commander.

"All we have agreed to do on this pass is to flip the switch on," the capsule communicator said from the ground, gingerly noting that the astronauts could otherwise go about business as usual. "No other activity associated with TV; I think we are still obligated to do that."

Schirra quickly snuffed out that bid: "We do not have the equipment out, we have not had an opportunity to follow the settings of the equipment, we have not eaten at this point, I still have a cold. I refuse to foul up our time lines this way."[13]

At a press briefing a few hours later, Haney would explain that Mission Control "decided they should accept the crew commander's judgment and that was that. It would overload them to attempt television before rendezvous." But reporters who had heard the exchange between Schirra and ground controllers were struck particularly by the commander's tone. Those who knew Schirra from his Mercury and Gemini days knew he had an independent streak and could be cantankerous, but those traits had a more playful tone back then, when they manifested themselves through pranks such as helping John Young smuggle a corned beef sandwich onto Gemini 3, or play-

ing "Jingle Bells" on a miniature harmonica, as he did during Gemini 6. This iteration of Schirra was surlier than the seemingly carefree one that had entered the space program a decade earlier.[14]

Later that day, Slayton again tried to persuade his Mercury 7 colleague to turn on the camera. At Slayton's shoulder was Phillips, who was prepared to grab the microphone and issue the order directly if Schirra continued to dig in his heels. Phillips' intervention was not needed; the show would go on in two days, Schirra promised.[15]

The commander was true to his word. When the time came for the next scheduled broadcast, Apollo 7 was ready, thanks in no small part to Schirra, who had fixed the malfunctioning camera by lubricating its parts with skin cream from the medical kit. Just before 11 a.m. eastern time on October 14, an estimated 15 million Americans waited with anticipation for the country's first live broadcast from space.[16]

"Here comes the picture," Haney alerted viewers across the country, "and it's white."[17]

Within seconds though, viewers looking at the somewhat fuzzy, black-and-white picture could identify Cunningham, Eisele, and Schirra, who was holding a small card with a message for the television audience: "Hello from the lovely Apollo room high atop everything."

The line, popularized by bandleaders during the glory days of radio, was Schirra's not-so-subtle jab that the broadcast was all about showbiz. It had been suggested by Schirra acquaintance Michael Kapp, a record executive who in turn had an artist friend produce the lettering on fireproof paper. As he had during Gemini, Schirra had again proven to be a master of smuggling non-authorized material onto a spacecraft.[18]

As Schirra put the card away, capsule communicator Tom Stafford remarked about the quality of the picture being received on the ground–"Actually, I'm amazed; It looks real good"–before briefly taking the role of film director. "Hey Donn, how about saying something, since you're paying?" he asked Eisele, before telling the astronaut to "Lean back a little bit, you're too close."[19]

Slayton then jumped in from Mission Control. "You forgot to shave this morning Eisele," he said, to which the astronaut replied, "I lost my razor."[20]

Moments later, Schirra would unveil a second sign–"Keep those cards and letters coming in folks"–that also had roots in radio but was now a closing staple of NBC television's *The Dean Martin Show.* The nation would soon oblige, swamping Schirra's secretary with correspondence. Included in the deluge would be a telegram from the television star himself that expressed mock outrage that the astronauts had stolen his line, while also making light of the boozing that had become a dominant part of his on-stage persona. "P.S. Like all Americans, I'm proud of you," Martin's conclusion began. "Second P.S. I was higher last night than you are now."[21]

As Schirra put away his latest printed message, Cunningham got into the act: "Yes, sir, a pretty show for the whole family. Would you like to get a look out the window with the TV camera? I can give you New Orleans right here."[22]

"O.K., let's take a look and see how New Orleans is this morning," Stafford replied from Houston.[23]

But while Cunningham was changing the camera to a telephoto lens, the craft, moving at 17,500 miles per hour, had already zipped past New Orleans and was nearing the Florida coast. As Cunningham aimed the camera out of the right-hand window, the resulting pictures were not as clear as those taken with the wide-angle lens inside the craft, but viewers could still make out cloud formations and the Florida coastline. Seven minutes and eighteen hundred miles after it started, the historic broadcast ended, "Much better than I expected" being the most common review among Mission Control staff. On CBS, Cronkite told viewers to expect a second broadcast the following day, "Wally Schirra permitting."[24]

The second telecast the next morning proved to be even more freewheeling. "Coming to you live from outer space, the one and only original Apollo Everything Road Show," Eisele opened the broadcast, "starring those great acrobats of outer space, Wally Schirra and Walt Cunningham."[25]

On cue, Schirra floated toward the camera, holding yet another sign: "Deke Slayton, are you a turtle?"

The question was puzzling to television viewers, and the answer was not fit for the airwaves. The line was part of a barroom inside joke that originated with World War II fighter pilots and was cultivated throughout numerous drinking sessions near Cape Kennedy. If

a person failed to deliver the correct response–"You bet your sweet ass I am"–he owed everyone within earshot an adult beverage. Slayton avoided running afoul of FCC standards, yet kept his end of the bargain, by recording the answer offline on an internal NASA tape.[26]

Cunningham then floated toward the camera with another card: "Paul Haney, are you a turtle?" The Voice of Apollo, knowing that whatever was uttered through his microphone would immediately go out to millions of television viewers, was stuck with a bar tab. "You mean he's speechless?" Eisele said.[27]

Schirra then took control of the camera and capped the remainder of the 10-minute telecast with a tour of the craft's navigation system, controls, and switches, while a floating pencil gave the audience a live demonstration of weightlessness. By the time the third telecast concluded the following day–highlighted by a Cunningham demonstration of how the astronauts prepared meals by mixing water in a bag of dehydrated ingredients–the mission had been unofficially dubbed the "Wally, Walt and Donn Show," ten-minute episodes of must-see TV. "The ham in us didn't just surface," Cunningham would write years later. "We damn near brought back vaudeville."[28]

But while television viewers were focused on the latest high jinks on the "Wally, Walt and Donn Show," reporters covering Apollo 7 had become more interested in what one NASA official would later call "the Wally Schirra Bitch Circus." As the mission wore on, transcripts of the conversations between Mission Control and the astronauts, provided in full for the first time by the space agency, indicated that Schirra's truculence had not been limited to his cancellation of the first on-board television broadcast.[29]

As the craft neared its tenth day in orbit, the crew set a record for the most combined man-hours in a single space flight, but the press focused more attention on at least a half-dozen gripes Schirra and Eisele radioed back to Mission Control, bringing the tally to at least twenty since liftoff. "I wish you'd find the idiot's name who thought up this test," Schirra said about an exercise where the spacecraft was to slowly tumble through the sun's rays to test the effect of heat on the craft. "I want to talk to him personally when I get back down."

Eisele added: "And while you're at it, find out who dreamed up the P-22 horizon test," an exercise asking the astronauts to locate the Earth's horizon in the glare of the sun. "That's a beauty also." Moments later, Schirra snapped again at ground controllers: "We have a feeling you are believing that some of these experimenters are holier than God down there. We are a heck of a lot closer to Him right now."[30]

Another episode of the "Wally, Walt and Donn Show" went off without a hitch forty minutes later, but soon after broadcast signoff, Schirra erupted again during another discussion with Mission Control about the horizon test. "I have had it up here today," Schirra barked over the radio, "and from now on, I am going to be an onboard flight director for these updates. We are not going to accept any new games like doing some crazy tests we've never heard of before."[31]

After a long silence, ground controllers could only muster a soft, "Roger," before Schirra finished his tirade. "Each test is going to be reviewed thoroughly before we act on it."[32]

At the next Houston press briefing, reporters pounced on the discontent between the astronauts and Mission Control. "I've covered sixteen flights, and I don't recall ever finding a bunch of people up there growling the way these guys are," said one reporter in prefacing a question to lead flight director Glynn Lunney. "Now you're either doing a bad job down here, or they're a bunch of malcontents. Which is it?"

Lunney paused, in a futile search for the right words. "I would be a little hard pressed to answer that one."[33]

Haney would try to defuse the line of questioning by making light of the astronauts' appearance after nearly two weeks in space. "Something happens to a man when he grows a beard," Haney told reporters. "Right away, he wants to protest." But behind the scenes, those in charge of the flight could hardly conceal their contempt for the crew. Off the record, they answered Schirra's charges that Mission Control was guilty of "stupidity, inefficiency, disinterest and ego" by telling reporters that the ship's commander had paid only passing attention to the flight plan during pre-flight preparations and probably had never read it cover-to-cover.[34]

In official press briefings though, controllers had to swallow their anger and put forward a good front. "Truth be known, it was gnawing in my stomach," recalled Gerald Griffin, an assistant flight director. "It was because I knew all three of them, and what I really wanted to do was grab all three of them by the nape of the neck and say 'Look, damn it, the whole world's listening to you and you're making it damn difficult for us to operate, and I don't care what you think.'"[35]

As accounts of the bickering trickled out to the public, newspaper editorials chastising the astronauts, and Schirra in particular, were balanced by more understanding media perspectives. "There he was, a fellow with a bad cold, trying to do a tough job while people a hundred miles down were harassing him about trying a lot of other things while he was up there," *Washington Star* columnist Mary McGrory wrote of Schirra. "He made space travel sound like any kind of air travel, known to everybody who's ever fastened a seat belt. The food was bad; the cabin was crowded. When passengers tried to sleep, some fatuous announcement came over the public address system." On CBS, veteran commentator Eric Sevareid approvingly cited McGrory while sharing how his own television experience made him acutely aware of the difficulties of doing one's job in the spotlight. "Schirra and company were working not only at the wrong end of gravity but at the wrong end of television cameras at the same time," Sevareid said. "He may have lost his cool, but he didn't lose Apollo 7, and that's what counts."[36]

On the day before Apollo 7's splashdown, the crew made one more broadcast from the craft, Schirra closing the program by holding up one final sign reading, "As the sun sinks slowly in the West." One measure of how quickly the "Wally, Walt and Donn Show" had become part of American culture was how its more famous lines had already been co-opted by more seasoned broadcasters. The previous evening, Cronkite had begun a CBS News segment with "Hello from the beautiful Apollo room high atop everything," before telling viewers he was actually at the controls of a spacecraft simulator in California, where he would demonstrate some of the procedures for reentry.[37]

As for the utility of the in-flight broadcasts, the press noted television's potential application to military, meteorological, and agricul-

tural problems, but skeptics merely found the telecasts "cute and interesting. It is doubtful that they achieved their primary purpose of giving the Earthbound taxpayer, vicariously, a piece of the action," wrote Richard Lewis in the *Bulletin of the Atomic Scientists.* "There may be other uses for the little TV camera than showing spaceflight 'like it is,' but no one in the Apollo directorate could think of them when queried at press conferences."[38]

When they returned to Earth, the stars of the "Wally, Walt and Donn Show" faced NASA reprisals for their off-camera defiance. In a one-on-one confrontation on the recovery aircraft carrier, Slayton ripped Schirra for his rebelliousness toward Mission Control. The reprimand had little to do with Schirra–he had already told NASA officials of his intention to retire after the mission–but Slayton was more concerned about how the commander's outbursts would affect the careers of Cunningham, who mostly stayed above the fray, and Eisele. As time went on, it became clear that lead flight director Chris Kraft's vow to bar the pair from future missions would be fulfilled. As for Schirra, few observers thought he had helped himself in his self-described quest to cash in during his post-NASA career.[39]

Nor did the media necessarily think the Apollo 7 mission–deemed a "101 percent" success by NASA–made America any more likely to make John Kennedy's deadline for reaching the moon. A few weeks later, a dozen reporters having lunch at a popular Cocoa Beach hangout each put up $5 to enter a pool predicting the moon landing date. Only three selected a date before 1970.[40]

The reporters' skepticism was understandable. Apollo 7 had gone well, but the crucial lunar module, the craft designed to actually set men on the surface of the moon, continued to be plagued with difficulties and delays. At best, the craft would be ready for a dress rehearsal in early 1969. But as the journalists dined that November day, NASA was feverishly trying to implement an audacious plan that George Low had dreamed up that summer. Since Apollo 8 could not meet its initial objective of trying out the LM, why not send it on a reconnaissance mission around the moon?

While some NASA officials initially thought Low had lost his mind, the plan made sense on several fronts. If the agency could work

out all of the various problems associated with navigation and lunar orbit while the landing craft was being fixed, it would buy the agency time in its quest to make the 1970 deadline for stepping foot on the moon. The risks though were plentiful. Astronauts Frank Borman, Jim Lovell, and Bill Anders would be asked to ride atop a monstrous Saturn V rocket whose predecessor had failed in its last live test, Apollo 6. While engineers were confident that the rocket had been repaired, no one backed his claims with absolute certainty.[41]

If the rocket worked, the trio still faced a flight plan that, to many observers in 1968, seemed just slightly more plausible than *2001: A Space Odyssey*, Stanley Kubrick's science fiction masterpiece that had graced the nation's movie screens earlier in the year. The astronauts would be asked to pilot a virtually new command module for 250,000 miles, bring the craft within seventy miles of a celestial body no man had ever traveled to before, and execute ten laps around the orb with only partial radio contact with Mission Control. Then, the astronauts would face a quarter-million-mile return trip to Earth's atmosphere, where the ship, traveling at approximately 24,000 miles per hour, would have to hit an extremely narrow pathway, at precisely the right angle, in order to avoid being incinerated or bounced back into orbit with no hope of recovery.

While the plan energized many within NASA, others close to the agency charged that the mission was nothing more than a gimmick designed to rebuild the stature of the American space program. Many in the scientific community seemed to agree, including esteemed British astronomer Bernard Lovell, who in late November made headlines by saying the trip was "hardly worth the risk," especially considering the small amount of scientific data the trip would yield. On CBS, a segment by correspondent Steve Rowan highlighted American scientists who said that photography from the mission would add, at most, a marginal amount of understanding about the lunar surface, a conclusion that Cronkite felt compelled to comment upon when the report ended. "Regardless of the extent of the new scientific knowledge gained by Apollo 8," Cronkite told viewers, "man will have finally achieved his dream since the beginning of time–of going to the moon."[42]

As launch neared, it became clear that the nation had largely subscribed to the Cronkite view of the mission. The "bird watchers"

whose presence near the Cape had waned in recent years had returned in an unprecedented fashion, filling parking lots and makeshift campsites for twenty-five miles up and down the coast. The press was swept up in the excitement as well, submitting a record number of credential requests to NASA and referring to the astronauts in reverential tones. They were the "Columbuses of Space," according to the *New York Times* editorial page, and describing their journey as "a trip to the moon is to underestimate the full significance of their venture."[43]

But no one on Earth seemed able to come up with anything more appropriate to say. Journalists struggled for the right words to express the significance of the journey because "No one knows what it will lead to," Eric Sevareid told CBS viewers as the craft was speeding toward the moon, "as no one knew what lay ahead when Columbus and his men left all horizons behind on the blue blackness of the ocean sea." A Belgrade newspaper's declaration that Apollo 8 was "the event of the decade" seemed to be the understatement of any era, and a London publication's line that the voyage would send "man across the border of the unknown" seemed equally inadequate. Perhaps, suggested *Christianity Today*, the astronauts could add "a biblical perspective" to help sort out the various metaphysical questions raised by the trip, a notion seconded by virtually none of their counterparts in the secular press.[44]

Apollo 8's first twenty-minute telecast, aired live on American television just after the craft had passed the halfway mark to the moon, gave no hint that the astronauts had any special eloquence either when it came to the mission's consequence. Technically, the show was a mixed bag, with very clear pictures from inside the cabin being offset by a malfunctioning long lens that turned a shot of the Earth into a barely recognizable blob. Anders trying to catch a floating toothbrush with his teeth was as close as the crew got to aping the clowning that had characterized the "Wally, Walt and Donn Show" of Apollo 7, and the most quotable line was Lovell wishing his mother a happy seventy-third birthday.[45]

It was like watching "a Eugene O'Neill play done in pantomime," one journalist wrote. "The greatest story ever told," grumbled another reporter after watching the telecast in Houston, "and it's being told by three slide-rules." Another newsman turned to an Apollo official, and

with a lack of tact emblematic of the times, said, "Next time, send three women into space. We know they'll talk when they get there." The show had only begun, though, and no journalists, and only a handful of people at NASA, knew that Frank Borman had packed a script for the climax.[46]

"You're looking at yourselves ...," Borman told television audiences the following afternoon as Apollo 8's camera tried to focus on its home planet, now more than 200,000 miles away. While the black-and-white image was more recognizable than on the previous day, the Earth appeared as a "large, misshapen basketball," according to one reporter, partially obscured by darkness and bouncing around the screen because of a faulty mounting bracket.[47]

That viewers could see the image at all was practically a miracle. Apollo 8's broadcast signal, generated nearly a quarter-million miles from Earth, was being beamed at 2.287 billion cycles a second from four retractable thirty-one-inch antenna dishes at the rear of the spacecraft. In less than six-tenths of a second, the signal was picked up by an eighty-five-foot dish antenna in Goldstone, California. There, the slow-speed 227-line signal was converted to a broadcast-quality 525-line picture, and then sent over cable and microwave circuits to Houston. NASA then sent the signal along overland lines to the three networks for immediate broadcast, or to transmission stations in Maryland and California, where the signal was bounced back up into space, off orbiting satellites, then back down to broadcast facilities in Europe and Japan.[48]

Lovell tried to fill in what the resulting picture lacked in technical quality. Orienting viewers that South America, lying on its side, was in the center of the picture, Lovell described the hues that appeared as merely areas of light and dark on television. "For colors, waters are sort of a royal blue, clouds of course are bright white," he said. "The land areas are generally a brownish, sort of dark brownish to light brown in texture."

After some coaching from the ground on how to position the camera, Lovell became more philosophic. "What I keep imagining is if I am some lonely traveler from another planet what I would think

about the Earth from this altitude, whether I think it would be inhabited or not."

Michael Collins, communicating to the crew from the ground, said, "You don't see anybody waving, is that what you are saying?"

"Well, I'm just kind of curious whether I would land on the blue or the brown part of the Earth," Lovell said.

"You better hope we land on the blue part," Anders quipped.[49]

When the second program ended, attention turned to what was scheduled for the next day. While most Americans slept in the early morning hours of Christmas Eve, Apollo 8 was scheduled to enter lunar orbit. At breakfast time, the country planned to watch live television footage as the ship circled 70 miles above the moon. And as clergy made last-minute changes to midnight services, many in their congregation would screen a second showing of the moon's surface.

But in the final hours of the "pre-lunar era," Charles Kuralt worried that the moon, worshipped and feared for thousands of years, mystifying and magical to literary giants from Shakespeare to Shelley, was about to be rendered mundane. Apollo 8 "will make our generation forever different from any other in the billion years since life began on Earth," Kuralt said at the end of a *CBS Evening News* segment. "Yet, it is just possible in that splendid moment when we gain the moon ... our first emotion will be a shocking sense of loss."[50]

A quick glance at coverage plans for the initial phase of lunar orbit might suggest that America's three television networks each were catering to distinct categories of space enthusiasts. ABC, last to go on the air after 7 a.m. eastern time on Christmas Eve, seemed right for the casual observer who just wanted to see what the moon looked like up close. CBS, signing on as lunar orbit began just before 5 a.m., might be appropriate for the adrenaline junkie who couldn't miss the vicarious thrill of seeing whether Apollo 8 would emerge unscathed after the first-ever trip behind the moon. Hard-core space fans, or insomniacs, had NBC, which began its coverage nearly four hours ahead of its closest competitor. While the decision was reminiscent of the network's "all space, all the time" stance during the Gemini program, its implementation had as much to do with technical logistics as it did news judgment. Transmission of *The Tonight Show*, the only

successful late-night network television program of the era, required that NBC transmission facilities operate until 1 a.m. The cost of shutting down the link and turning it back on less than four hours later, the network determined, was nearly as expensive as simply staying on the air with a mix of mission updates and space documentaries.[51]

In the pre-dawn hours of Christmas Eve, viewers of NBC and CBS waited anxiously as Apollo 8 looped around the backside of the moon. "The first residents of the Earth ever to be out of sight of the Earth," as David Brinkley would later call the astronauts, were also out of radio reach, leaving controllers in Houston as helpless as those watching on television. Thirty-four minutes after the blackout began, reports that a cheering Mission Control had regained voice contact with the craft allowed viewers to finally take a deep breath.[52]

Shortly after sunrise on the East Coast, viewers of all three networks saw the first moving pictures of the lunar surface, presented in 175-mile-wide swaths as the spacecraft passed overhead. The picture during the fifteen-minute broadcast was sometimes ill defined because of a foggy window and bright sunlight, but the astronauts' descriptions of the cratered terrain–"a very whitish gray, like dirty beach sand with lots of footprints on it," in Anders' view–were highly descriptive.[53]

After signing off from the television airwaves, the crew of Apollo 8 turned its primary focus to photographing various landmarks and possible landing sites for future missions. Later that morning, though, Borman radioed Mission Control about some holiday business he left behind in Houston. Addressing members of his Episcopal Church and "people everywhere," Borman read a brief prayer, which Houston recorded for both audiences.

"I was supposed to lay read tonight, and I couldn't quite make it," Borman said when he finished.

"Roger. I think they understand," Houston replied.[54]

Borman had one more inspirational message on board, but it would be saved for that night, as television audiences from Paris to Poughkeepsie watched the crew send back one final transmission of the lunar surface. "We've got to do it up right," Borman told his fellow crewmembers as they made their last arrangements for the Christmas Eve night broadcast, "because there will be more people

listening to this than ever listened to any other single person in history."[55]

At just after 9:30 p.m. eastern time, as many as a half-billion humans, spread across sixty-four countries, settled in for what would be the most extraordinary holiday broadcast in history. As the masses watched their planet through the window of Apollo 8, Borman welcomed them:

> BORMAN: Now we're switching so that we can show you the moon that we've been flying over at sixty miles altitude for the last sixteen hours. Bill Anders, Jim Lovell and myself have spent the day before Christmas up here doing experiments, taking pictures, and firing our spacecraft engines to maneuver around. What we will do now is follow the trail that we've been following all day and take on through to the lunar sunset. The moon is a different thing to each one of us. I think that each one of us–each one carries his own impression of what he's seen today. I know my own impression is that it's a vast, lonely forbidding type existence, great expanse of nothing, that looks rather like clouds and clouds of pumice stone, and it certainly would not appear to be a very inviting place to live or work. Jim, what have you thought most about?
>
> LOVELL: Well, Frank, my thoughts are very similar. The vast loneliness up here of the moon is awe-inspiring and it makes you realize just what you have back there on Earth. The Earth from here is a grand oasis in the big vastness of space.
>
> BORMAN: Bill, what do you think?
>
> ANDERS: I think the thing that impressed me the most was the lunar sunrises and sunsets. These in particular bring out the stark nature of the terrain and the long shadows really bring out the relief that is here …[56]

What followed was "a narrated travelogue live from the moon," according to *The Washington Post*, as the eyes and voices of the astronauts made clear what the black-and-white, low-resolution pictures could not. The sky appeared as "forbidding, foreboding extents of blackness," the astronauts reported to Earth, creating a vivid contrast with the bright moon below. Their descriptions of craters and mountains made the lunar landscape "seem startlingly real," according to the *Post*. "The scientists' conceptions have been verified by the naked eye."[57]

Near the end of the half-hour tour of the moon, Anders told viewers that they were approaching the Sea of Tranquility–so named because its relatively smooth terrain made it a good site for a future landing. Only the climax to the broadcast remained, and the three as-

tronauts, with the broadcast microphone muted, discussed the perfect time to begin it.

> BORMAN: Hey, why don't we start reading that thing, and that would be a good place to end it?
> LOVELL: No, we've got to go into it very nicely. Why don't we, as we go into sunset –
> ANDERS: Right.
> LOVELL: Or is it sunrise? This is sunrise, yes. We're approaching lunar sunrise.[58]

Lovell was holding a tiny flashlight, which faintly illuminated a piece of fireproof paper in Anders' hand. The words contained on the document had been a source of consternation for a number of would-be authors in the weeks leading up to launch. Borman had tried, and failed, to find the right message to close the telecast, so he turned to his friend Si Bourgin, a science advisor with the United States Information Agency. Bourgin, having no better luck, enlisted the help of Joseph Laitin, an assistant press secretary in the Lyndon Johnson administration. After writing a number of failed drafts at his kitchen table late one night, Laitin considered the date of the scheduled telecast and turned to the Bible, hoping that the story of Jesus' birth would serve as inspiration. At 3:30 a.m., a frustrated Laitin looked up from the New Testament and saw his wife. The language he was looking for, she suggested, was in the Old Testament:

"I wouldn't even know where to begin," Laitin said.

"Why not begin at the beginning?" his wife replied.[59]

He did. As would the Apollo 8 astronauts.

"We are now approaching lunar sunrise," Anders said as the audience watched a view of the moon's horizon, "and for all the people back on Earth, the crew of Apollo 8 has a message that we would like to send to you."

Anders paused, then began reading the words Laitin had borrowed from Genesis.

> In the beginning God created the heaven and the earth. And the earth was without form, and void; and darkness was upon the face of the deep. And the Spirit of God moved upon the face of the waters. And God said, Let there be light: and there was light. And God saw the light, that it was good; and God divided the light from the darkness.

Lovell handed the flashlight to Borman, then took the script from Anders and continued reading.

> And God called the light Day, and the darkness he called Night. And the evening and the morning were the first day. And God said, Let there be a firmament in the midst of the waters, and let it divide the waters from the waters. And God made the firmament, and divided the waters which were under the firmament from the waters which were above the firmament: and it was so. And God called the firmament Heaven. And the evening and the morning were the second day.

Borman, holding the camera, exchanged it for the script.

> And God said, Let the waters under the heavens be gathered together unto one place, and let the dry land appear: and it was so.
> And God called the dry land Earth; and the gathering together of the waters called he Seas: and God saw that it was good.

"And from the crew of Apollo 8," Borman concluded, "we close with good night, good luck, a Merry Christmas, and God bless all of you–all of you on the *good* Earth."[60]

On cue, Anders immediately turned off the television camera to ensure that no other utterances from the capsule spoiled the perfect ending. In Houston, Paul Haney, one of the few NASA staffers who knew of the astronauts' plan, paused for a few moments before speaking to the television audience. "That's both Biblical and a geological lesson that none of us will forget. At eighty-six hours and nine minutes into the flight, this is Apollo Control Houston."[61]

As Haney spoke, Si Bourgin and a score of fellow travelers in a Houston airport lounge sat with eyes transfixed on the television screen. Across the country, Americans were equally dumbstruck by what they had just witnessed. "It was like being hit in the solar plexus," Anders would later say of the ending. "It really caught their attention. Particularly when they weren't expecting it."[62]

There was little time to fully appreciate the performance. In a few hours, the Apollo 8 crew would attempt to fire an engine that had worried NASA officials for months. If the procedure worked, the

spaceship would leave lunar orbit and begin a fifty-seven-hour trip home. If the engine failed, the astronauts would be stranded above the moon, and a triumphant voyage would turn into an excruciating nine-day deathwatch as the craft slowly ran out of oxygen.

When Apollo 8 emerged from its final trip behind the moon, Lovell's secular holiday message–"Please be informed there is a Santa Claus"–let Mission Control and the world know the crew was on its way back to Earth. It would take more than two days still, after the spacecraft completed a remarkably perfect splashdown in the waters near Hawaii, before the country could finally exhale and ponder what it had all meant. Shortly after the capsule hit the ocean, Mission Control responded with an emotion that "we haven't seen ever in our history," Haney told television viewers.[63]

NASA's immediate reaction had been a catharsis of sorts, a release of emotion that had built up over nearly two years of sorrow, recriminations, and finally, a frantic push to get the manned space program back on track. Proud citizens watching the splashdown and recovery on television tended to be somewhat more muted in their responses. Some felt a sense of awe: "It's like Buck Rogers," said a public relations consultant, citing the title character of an old science fiction comic strip and radio show while watching Apollo 8's return on an office television set. "When I was a kid, I thought this was impossible. Now it's happening." Others were impressed, yet failed to see how the voyage would make life on Earth any better. "It's quite an achievement," said an Iowa farmer, watching space coverage as a cold rain fell outside his house, "but I don't know if it's worth the chips. I don't think there's anything up there that's ever going to benefit us."[64]

While many struggled to see the tangible gains from Apollo 8, few doubted the psychological benefits, at least in the short term. The astronauts may not have "completely restored" American prestige, as one Italian newspaper asserted, but they certainly had put a spring back in the nation's step. "A year of trouble and turbulence, anger and assassination is now coming to an end in incandescent triumph," Cronkite told CBS viewers during a special wrap-up of the mission. "Being the kind of men they are, they certainly have no taste for being heroes," Brinkley said on NBC, "but in this age of cynicism and skepticism when we almost don't have any heroes, they may have a hard

time escaping." ABC commentator Howard K. Smith noted that the year's earlier horrific, depressing events had resulted in a "grasping and reaching out by people for something to be pleased by. And Apollo flew right into the arms of that embrace."[65]

But Americans savored that embrace for different reasons. For some, the mission's Cold War ramifications were reason to celebrate. Borman's statement that the moon was made not of green cheese but American cheese trumpeted that his country had surged ahead of the Soviets in the rekindled space race, a fact that the press duly noted, in forms ranging from newspaper "scorecards" tallying the nations' achievements in various extraterrestrial categories, to Jules Bergman's enthusiastic inflection earlier in the flight as the craft passed over the lunar surface. "After three million years, man had finally caught up with the moon," Bergman told ABC viewers, "and it was OURS."[66]

While some reactions to the voyage were made in the context of America's prime external foe, others saw Apollo 8 as a victory against perceived enemies within. In an era when Timothy Leary was encouraging American youth to drop acid and "turn on, tune in, drop out," and weeks after Vietnam War opponents had sponsored "National Turn In Your Draft Card Day," Apollo 8's voyage was touted by new NASA chief Thomas Paine as "the triumph of the squares–the guys with computers and slide rules who read the Bible on Christmas Eve." The "silent majority" of middle class conformity that Richard Nixon had successfully courted to win the presidency found comfort that the astronauts "believe in God, the God of Genesis, the God who fashioned the heavens and the earth," in the words of one national magazine.[67]

Some thought they saw in Apollo 8 the sparks of a Judeo-Christian spiritual awakening. The astronauts were "modern magi," in the words of *Christianity Today,* whose "message from the moon has redirected man's focus to God," according to a group of New York rabbis. A member of the Christian clergy was encouraged that "Men who have not prayed unselfishly for many years and men who have not prayed at all, prayed for our fellow citizens in outer space." And when prominent atheist Madalyn Murray O'Hair later filed suit in an attempt to stop future Bible readings from outer space, more than 400,000 of her fellow citizens signed a petition opposing her.[68]

Others, finding the voyage to be a humbling reminder of how small the Earth was in the cosmic scheme of things, took a more Universalist view. Poet Archibald MacLeish encouraged *New York Times* readers to now consider themselves "riders on the earth together, brothers on that bright loveliness in the eternal cold." On ABC, anchor Frank Reynolds commented that the astronauts had "represented not just this nation, but all nations and all men. And if men can reach out to the stars, then surely we can reach out to one another." For NBC's Brinkley, the voyage signaled no less than redemption of the planet's most advanced creature. "Numerous times in 1968 we've seen the human race at our worst: vicious, selfish, stupid and even murderous," Brinkley said. "But near the end of '68, in this last week, we have seen the human race at our best. And at our best, we're pretty good."[69]

Ultimately, a single picture would crystallize collective memory, forever setting Apollo 8 within a context of global unity and shared purpose. Taken by Anders during the fourth orbit of the moon and released to the public days after the spacecraft's return, it was "merely breathtaking," Brinkley said when it was unveiled to NBC viewers in living color. "Looking out from the moon over the moon's horizon, at the bottom, back at the earth. A blue and white agate marble partly in daylight, partly in the dark, floating against an unknown universe of total blackness. It must be the most astonishing photograph anyone has ever seen."[70]

The photo was arresting because, for the first time, man could see his home planet for "how fragile it is," Lovell would say years later. "How it is cloaked in the atmosphere, which really protects us. That the Earth could be easily overcome if we are not careful." Soon to be dubbed "Earthrise," the picture would adorn stamps, posters and T-shirts, and more importantly kick-start an environmental movement. Within two years, the nation would celebrate its first Earth Day and see the creation of the Environmental Protection Agency. In the view of nature photographer Galen Rowell, it was "the most influential environmental photograph ever taken."[71]

"Apollo was designed to go to the moon, but really the biggest thing for all of us was not the moon, which was kind of disappointing," Anders would recall years later. "It was being able to look back at the Earth."[72]

CHAPTER 8

"The Eagle Has Landed": Chronicling the Feat

America was packing for a moon landing, and the TV camera was about to be left behind.

Television, a point of contention within NASA during virtually its entire existence, raised tensions again in early 1969 as the agency raced to put a man on the moon before fall. The success of the in-craft telecasts during Apollo 7 and 8 had done little to quell arguments over broadcasting man's first excursion on the lunar surface. The seven-pound camera would add too much weight to the spider-like lunar module, argued engineers, who were chiefly concerned with getting the crew safely on the moon and back home. "You're going to have to take something else off. That camera is going to be on that spacecraft," countered NASA Public Affairs chief Julian Scheer, resolute that the world be able to see the first human steps on the moon. Chief astronaut Deke Slayton, perhaps taking a page from Wally Schirra's Apollo 7 playbook, told Scheer that even if the camera somehow made it on board, the first men on the moon would be so pre-occupied with mission-critical tasks that they might cancel the broadcast.[1]

In spring 1969, the battle had made its way to a large conference room at Houston's Manned Spacecraft Center. Chris Kraft, NASA's director of flight operations, tried to weigh the proceedings heavily in favor of television on the moon by asking fellow proponents such as chief design and engineering wizard Max Faget to prepare presentations on the system and how it could be used. For the final presentation of the day, Kraft had asked his lead communications engineer to

objectively analyze the positives and negatives associated with broadcasting from the moon's surface. Kraft blanched when he saw the summary slide his subordinate had prepared: Television was a luxury the moonwalk could do without.[2]

The room burst into pods of discussion and debate, and when the din died down, Kraft stood up. "We can't believe what we're hearing," Kraft said, acknowledging the displeasure equally felt by Faget. "We've been looking forward to this flight–not just us, but the American taxpayers and in fact the whole world–since Kennedy put the challenge to us. Now you're willing to exclude the people of Earth from witnessing man's first steps on the moon? I don't believe it, and if you think about it, I don't think you'll believe it either."[3]

Faget followed with an equally impassioned plea, and those in attendance slowly began to nod. If appeals to national pride or their fellow citizens didn't change their opinions, their position on the NASA food chain did: Most in the room ultimately reported to either Faget or Kraft. Soon, Neil Armstrong, Buzz Aldrin, and Michael Collins, the three men who were tapped to make the voyage, were nodding as well.[4]

The conflict over lunar television was far from the only internal battle Scheer was fighting in early 1969. His tenuous relationship with Houston lead information officer Paul Haney, never good after their disputes over the handling of the Apollo 1 accident, was becoming even worse. Scheer was increasingly convinced that Haney had fallen into a similar trap as Shorty Powers had during Mercury, becoming enamored with his role as the "Voice of Apollo" to the detriment of his other duties of running a full-time public information operation at the Manned Spacecraft Center. Like Powers, Haney was nearly as well known as those who had flown the missions, appearing with astronauts on Bob Hope television specials and taking on a heavy speaking schedule across the country. For his part, Haney chafed at what he saw as interference from headquarters and the frequent and sometimes tart "Scheergrams" from his public affairs superior that questioned his judgment.[5]

Haney could not count on support from his colleagues in Houston, either. Haney had long since lost the trust of Manned Spacecraft

Center director Bob Gilruth, and he would incur the wrath of Slayton when more than 80 newsmen showed up for a mid-April dress rehearsal of the first moonwalk. Slayton, convinced that Haney had broken an agreement that only a small number of pool reporters would cover the exercise, told Scheer about the fiasco. Days later, Scheer would issue a directive assigning Haney to NASA headquarters in Washington, effective within a week.[6]

Haney responded by going to the one constituency he had left: the media. During a press conference that Haney arranged off NASA property, he told reporters of Scheer's order, chronicled various times he had been "harassed" by headquarters, and claimed that Scheer had called him a "God-damned liar" during a March meeting concerning Haney's future in Houston. Haney's appeal elicited sympathetic response from reporters who told readers that Scheer's move was "raw, cruel," and from Shorty Powers, who was fired from his job as the "Voice of Mercury" by Scheer six years earlier. "I know exactly how Paul Haney feels," Powers told the press. "We have disagreed on a lot of things. But the same things that happened to Paul happened to me."[7]

The press conference had little effect on Scheer, who wouldn't budge from his decision to move Haney to Washington. Within days, Haney resigned from the agency, and Scheer quickly installed Brian Duff into the lead public affairs role in Houston. Duff had worked with Scheer before, directing NASA special events before leaving to work for the National Urban Coalition. Now, less than three months before man was scheduled to arrive at the moon, Scheer asked Duff to perform triage on Houston's public affairs apparatus. Duff found little wrong with the structure and the personnel–"These guys really knew what they were doing," Duff recalled–but its leadership had drifted.[8]

"(Haney) was in a totally impossible situation," Duff recalled. "He got in trouble in Washington, and they promptly called (Bob) Gilruth and Chris (Kraft) and bawled them out. Then they'd call Haney and say, 'What the hell do you think you're doing?' Haney had no friends in either camp.

"Haney's problem was that he forgot that no matter how big and how wonderful and how competent the people were in Houston, they were still part of the larger organization. Houston was not the space

program, NASA was the space program, and NASA was still run by Washington–maybe not run by Washington, but Washington had legitimate concerns about what happened and Washington's job was policy. Washington's job was getting the budget through. Washington's job was public acceptance. Those functions required that Washington had to be able to tell you certain things at certain times."[9]

Aside from grasping the natural order of things within the NASA hierarchy, Duff also became quickly convinced that Haney's "Voice of Apollo" duties had put more than just a time constraint on his other role. "People who'd never heard of Bob Gilruth knew Paul Haney," Duff said years later. "Some people called him the 13th astronaut or something like that. That's death. Public affairs is not supposed to be a visible function, in my view." Soon after arriving in Houston, Duff made clear that he would have no announcing role in any future mission, including the one that put man on the moon.[10]

"Part of my reason was to create a different style of management, but I also wanted to keep reminding the senior staff that I was senior staff, and not publicity hound, or even more, a radio announcer," Duff would recall. "I've seen public affairs officers who try to justify their job by going around with a camera taking pictures. Sometimes that's necessary, but it's death. If your (subordinates) think of you as a photographer, they won't think of you as someone who can give them advice on some of the most important issues that they have to face."[11]

As Duff took over in Houston, the most important issue was Apollo 10. Set for late May, the flight would be a virtual step-by-step dress rehearsal for the ultimate mission, except for the actual landing. The new lunar module, tested in Earth orbit during Apollo 9 earlier in the year, was to come within nine nautical miles of the lunar surface before returning to the orbiting command module.

On-board television for Apollo 10 was one area where neither Duff nor Scheer encountered internal resistance, thanks in large part to the enthusiasm of commander Tom Stafford, who hoped that extensive broadcasts from space would boost both public interest and congressional support for further space exploration. In sharp contrast to the attitude of Wally Schirra's crew as they prepared for Apollo 7, Stafford embraced a new color television system and lobbied the most reluctant NASA officials to include it in the flight plan.[12]

"Tom came to my office in Houston one fine day and asked me to go with him to witness a demonstration of color TV," George Low, NASA's administrator in charge of the Apollo spacecraft, wrote years later. "I did this in one of the engineering buildings in Houston and immediately became enthusiastic. I believe I was as much for color TV on Apollo 10 (after I had seen the demonstration) as I had been against the black and white TV on Apollo 7." Eventually, Low would sign the directive ordering the camera to be installed in the command module, using a different colored pen for each letter in his name.[13]

The color television camera, while new to the space program, was based on technology that CBS had developed nearly thirty years earlier. The "sequential" system, which used a rapidly spinning wheel with red, green, and blue filters to reproduce color, had been rejected by the FCC as the nation's commercial standard in the early 1950s because it was not compatible with existing black and white sets. The twelve-pound camera installed in Apollo 10, now developed by Westinghouse, had a relatively simple mechanism and performed well in low light conditions, making it a good choice for the rigors of space travel and the dimly lit command module. The camera would for the first time send back video from space at the American broadcast standard of 525 lines per frame, and a specially engineered system in Houston would convert the "sequential" signal to the "continuous" signal needed for American broadcast.[14]

Once in flight, the Apollo 10 crew had no qualms about using the new equipment, logging more time on the network airwaves in the first four days than was allotted for then entire eight-day mission. Three hours after launch, viewers saw the first live transmission of a space maneuver as the command module docked with the lunar module. During another telecast on the first day, the astronauts showed the nation the third stage of the rocket booster after it had separated from the spacecraft, and later, the world saw itself in color from 22,000 miles away.[15]

"The transmission from Apollo 10 reduced the earth to the comprehensible dimensions of a store-bought globe," Jack Gould wrote in the next day's *New York Times*. "Brown land, blue seas and white clouds were compressed into a 21-inch image that could only invoke a hushed awe over what was being witnessed in the familiar surroundings in one's home."[16]

Three days later, the astronauts gave the world its first tour of the moon's surface since the Apollo 8 Christmas Eve telecast, only this time in color. The following day, television viewers watched the lunar module, given the nickname Snoopy, glisten in the sun as it orbited above the moon, then get smaller as the command module, dubbed Charlie Brown, moved away. By the time the crew members were preparing for splashdown, they had logged more than seven hours of television broadcast time from space, nearly twice the amount transmitted by the three previous Apollo missions combined.[17]

Apollo 10 was nearly perfect from a public affairs standpoint, the only blemish being some earthy comments from the astronauts that made their way into broadcasts and transcripts of air-to-ground conversations. That Gene Cernan had yelled "Son of a bitch!" when Snoopy went into violent gyrations after its landing stage was jettisoned was understandable to many; fewer likely appreciated another astronaut reporting that "The crew status is at tired, and happy and hungry and thirsty and horny and all those other things." After the mission, NASA received more than a few letters objecting to the crew's "profanity, vulgarity, and blasphemy," but Cernan was just as likely to encounter people who "were looking for an astronaut to be a human being and not a robot."[18]

More importantly, Apollo 10's success meant that there would be no more dress rehearsals. "We now know we can go to the moon," said NASA chief Thomas Paine after splashdown. "We will go to the moon."[19]

If everything went to plan, Apollo 11 would leave the Earth in fifty-one days, but the press briefings for the mission were set to begin in a mere three weeks. NASA's Public Affairs office was already deep into production on a press information kit that eventually would balloon to 250 pages, more than five times larger than the media packet assembled for the first Gemini mission. Requests for press credentials were pouring in at a record rate that would ultimately result in nearly 3,500 passes for news personnel representing fifty-seven countries. To accommodate the groundswell of European interest in the moon landing, NASA was preparing to open a branch informa-

tion office in Paris, where briefings would be held for journalists who were unable to make the trip to the States.[20]

While NASA cranked up its information machinery to handle the press crush, the agency was also wrestling with appropriate symbolism for the mission. Congress mandated that a U.S. flag be placed on the moon, but NASA was sensitive to concerns that its unfurling would be interpreted internationally as an American territorial claim. The Michael Collins-designed Apollo 11 logo seemed to be in the right spirit with an eagle carrying an olive branch in its beak, but some NASA officials found the open talons too hostile and decided to have the bird carry the vegetation in its claws. To give the event more of an international flavor, the agency adopted Paine's suggestion that the crew carry along miniature flags of all U.N. nations and leave behind a tiny disk containing microfilmed messages of goodwill from leaders of foreign nations.[21]

The crowning piece of international unity was to come in the form of a plaque that would be attached to the lower part of the lunar module that remained behind on the moon. The prototype featured drawings of the Western and Eastern Hemispheres, signatures of the three astronauts and President Nixon, and the following phrase: "Here Men From The Planet Earth First Set Foot Upon The Moon– July 1969, A.D.–We Came In Peace For All Mankind." A few months earlier, the White House had suggested a single change–"came" was struck in favor of "come"–which was adopted, and the plaque went into final production.

The agency moved on to other pressing affairs until early July, when Paine and Scheer were hastily summoned to the White House to give a briefing on the roles Nixon and Vice President Spiro Agnew would play during the mission. As a Nixon aide thumbed through a document that outlined Agnew's appearance at Cape Kennedy for the launch, a Nixon "phone call" to the astronauts on the lunar surface, and the president's appearance on the recovery ship for the splashdown and recovery, he came to a page containing a drawing of the lunar module plaque. The aide took out a pen and inserted the word "under God" after "Peace."

"But this is a universal thing," Scheer argued. "What about the people on Earth who do not worship ..."

"Damn it, Julian, the president is big on God!"

"Big?"

"Listen," the aide said, "We have to go to church services with Billy Graham! I'm telling you, the president will want God."

The aide took the document to Nixon, then returned it to Scheer minutes later with a wry smile. On the ride back to NASA headquarters, Scheer turned to the plaque page and saw that Nixon had initialed the change.

"What are you going to do?" Paine asked.

Knowing the plaque was already completed, Scheer answered, "I guess the answer is nothing."

"I didn't hear that," Paine said.[22]

Scheer also had to ensure that the Apollo 11 astronauts were fulfilling their contractual obligations under their publishing agreement. Field Enterprises, having taken a financial beating in the arrangement, had bowed out two years earlier, again leaving *Life* magazine with sole rights to the astronauts' "personal" stories, and those of their immediate families. The financial stakes were significantly higher though than they had been for previous space crews. In addition to its typical coverage of a mission, *Life* planned to turn the astronauts' own stories into a book, prefaced by science fiction author Arthur C. Clarke and serialized in the magazine. *Life* also had a significant stake in a Norman Mailer book project, paying a reported $100,000 for the rights to publish three excerpts, while a subsidiary of its parent company Time, Inc., had paid the Pulitzer-winning author another $150,000, sources said, for the hardcover book rights. The press speculated that the assorted projects could net the astronauts $1 million over the coming year, albeit split sixty-three ways among astronauts past and present, or their widows.[23]

Mailer had arranged a waiver from his usual publisher in order to pursue the moon book, in part because he believed that the special privileges accorded under the *Life* deal would allow him greater access to the astronauts. Not long after beginning the project though, Mailer reported to *Life* editors that the astronauts were leery of him, a sentiment shared by Chris Kraft, one of a number of NASA officials who refused to cooperate with the author. "I figure if these other guys

have been writing about space for years," Kraft recalled years later, "why should I do something to help Mailer make a million dollars?"[24]

Armstrong would never talk directly to Mailer either. The author's only contact with the man who would set foot on the moon came at NASA pre-launch briefings, where the non-*Life* press contingent was also becoming frustrated with Armstrong's all-business responses. Reporters who hoped their questions would elicit extensive philosophical musings over the historical significance of the mission were continually disappointed to hear Armstrong unemotionally discuss "peripheral secondary objectives" and "single-point systems." While fellow astronauts Aldrin and Collins shared a few insights into their families and personal history, Armstrong kept similar details to himself.[25]

"Will you take personal mementos to the moon, Neil?" one reporter asked.

"If I had a choice, I would take more fuel," Armstrong replied.

"Will you keep a piece of the moon for yourself?"

"At this time, no plans have been made."

"Will you lose your private life after this achievement?"

"I think a private life is possible within the context of such an achievement."[26]

Mailer would later write that Armstrong was "extraordinarily remote," and that he "surrendered words about as happily as a hound allowed meat to be pulled out of his teeth," sentiments shared by most of the press. What did come out from Armstrong's mouth, Mailer wrote, was a "mixture of modesty and technical arrogance, of apology and tight-lipped superiority." Armstrong's reticence was not an act though, nor fueled by hatred for the media, but simply Neil being Neil.[27]

"I think he was quite happy with his own persona," Collins would later recall. "It was not so much that he was *unable*; it was more that he was *unwilling*. He was unwilling to share with other people." Bill Anders, a member of the backup crew for Apollo 11, remembered that, "Neil wasn't an expansive guy. He was totally professional–not overly warm but not cold. I don't remember him and I sitting around having a casual conversation about 'What are your kids doing?' or 'Have you seen any good-looking blondes lately?' Not

that Neil would not have a drink or two with you, but he was a straight arrow in all the ways that counted."[28]

Armstrong didn't take himself all that seriously either. He humbly told the press that at least ten other astronauts could have been picked to make the first steps on the moon, and he lauded the thousands of engineers, technicians and workers around the country that made the trip possible–"It's their success more than ours," he said. Behind the scenes, Armstrong seemed genuinely perplexed over the intense public interest over the trip he was about to make. When told a few days before liftoff that as many as one million people would be gathering around the Cape for the launch, Armstrong replied, "Well, God knows why they're making such a big deal out of this."[29]

While NASA awaited the arrival of 5,000 "distinguished guests"– an array of visitors drawn from the ranks of politicians, ambassadors, executives, entertainers, and less glamorous walks of American life– an uninvited contingent was gathering outside the gates of Cape Kennedy. "The Poor People's Campaign," organized by Martin Luther King's Southern Christian Leadership Conference in the final months of his life, had come to the launch site to protest the largesse bestowed on Apollo while millions of Americans lived in poverty. The group, now led by the Reverend Ralph Abernathy, found a bevy of television cameras more than willing to juxtapose the impoverished black faces with the multi-billion dollar rocket sitting on the launch pad.

"This woman gets $82 a month and a one-room shack," said Hosea Williams, another leader in the SCLC, as he gathered a Georgia mother and her nine children before the press. "Why should we be worrying about sending three men to the moon when here are 10 people dying of starvation? If we can spend $100 a mile to send three men to the moon, can't we, for God's sake, feed our hungry?"[30]

To be sure, the SCLC protest was not the only outpouring of sentiment questioning the nation's priorities on the eve of America's trip to the moon. In the spring, Senator Edward Kennedy had advocated reallocating the NASA budget to urban problems, but only after his deceased brother's goal of reaching the moon had been achieved. (Apollo 11 would soon serve another purpose for the senator: When

he drove his car off a bridge and into a pond at Chappaquiddick, killing a young female staffer, the moon mission bumped reports of the accident off the front pages of newspapers across the country.) Black Panther leader Eldridge Cleaver was calling the mission a "circus to distract people's minds from the real problems, which are here on the ground," but Cleaver, on the run from attempted murder charges after a shootout with police, was speaking in exile from Algiers. This protest carried the imprint of the martyred King and was at NASA's front door.[31]

"I was concerned that we handle the Abernathy situation in the coolest and most correct possible fashion to minimize any reflections, any ability that Abernathy might have to seize the stage and hold it to the detriment of the lunar program," recalled NASA's Paine, who was particularly worried that a failed mission would bring even more press attention to SCLC's charge that the billions of dollars allotted for Apollo were a waste. "Even though I had a good deal of sympathy with Abernathy's objectives, it was very important that we not allow it to do harm to the NASA program."[32]

The day before Apollo 11 was to leave Earth, the press watched as Paine met the protestors in a large field near the entrance to Cape Kennedy. Abernathy spoke first, asking NASA to admit ten of the SCLC families inside the gates to view the launch, support his group's movement to combat hunger in the country, and use its technical expertise to solve other problems facing the nation. A moved Paine quickly granted the first request, then addressed the other two.[33]

"If we could solve the problems of poverty in the United States by not pushing the button to launch men to the moon tomorrow, then we would not push that button," Paine told the crowd. "Great technological advances such as Apollo are child's play compared to the tremendously difficult human problems with which you and your people are concerned."[34]

Early the next morning, as some of the world's most famous people boarded NASA buses to go inside Cape Kennedy, so did ten poor black families from the South. On the trip in, they would be served breakfast.[35]

The SCLC contingent was taken to a viewing area set aside for families of NASA employees, while on another section of the Cape grounds, the VIPs were arriving, creating "a miniature Who's Who of

white America," according to *Time*. The mere "very important" peo-
ple, craning their necks to get a glimpse of the "very, very important"
people, learned that the famous were just as miserable as they were in
the sweltering Florida heat: As Lyndon Johnson mopped his brow
with a handkerchief, Vice President Agnew sucked on ice cubes, a
paisley-clad Johnny Carson fanned himself with a contractor's bro-
chure, and sweat-soaked *Tonight Show* sidekick Ed McMahon called
down from his bleacher seat for a can of soda. Comedian Jack Benny,
somehow able to wear a business suit and not break a sweat, was the
exception to the rule.[36]

In the final hour before liftoff, the people watching, the backslap-
ping, the autograph seeking, and the handshaking in the VIP section
all seemed to relegate the pending launch to an afterthought. But
when the countdown reached T-minus-2 minutes, the small talk
stopped and all eyes turned to the giant Saturn V in the distance. Jack
King's piped-in commentary from the launch area, often drowned out
by banter during the celebrity mixer, now came through loud and
clear, as it did to the estimated 25 million television viewers in Amer-
ica, and untold others watching in thirty-three other countries.[37]

Thirty seconds and counting," King said. "The astronauts report it
feels good. T-minus twenty-five seconds ... Twenty seconds and
counting ... T-minus 15 seconds. Guidance is internal ... Twelve,
eleven, ten, nine, ignition sequence starts ... Six, five four, three, two
..."

For a moment, King's voice cracked. "My God, we're going to the
moon," he thought to himself as he gathered his composure.

"One, zero. All engines running." King paused as the Saturn
slowly lifted from the launch pad. "Liftoff. We have a liftoff, thirty-
two minutes past the hour. Liftoff on Apollo 11."[38]

As the crowd felt the pulsing thunder left in the rocket's wake and
watched as an object the size of a skyscraper become a tiny dot,
"There wasn't any shouting," Eric Sevareid would tell CBS viewers
moments later. "When it was up and gone there was a little clapping
and a lot of people wiping tears away. A sense of relief for the safety
of those three frail mortals in that craft that vanished in the sky." Back
in the VIP section, reporters scoured the crowd of dignitaries, search-
ing for reactions from the rich, powerful, and famous. Agnew's
statement that "Anything I say would be anticlimactic" was not much

help, but a radio newsman desperate for a good sound bite thought he had scored a coup by collaring conservative icon William F. Buckley.[39]

"You're an eloquent man, Mr. Buckley. How would you describe what you've just seen?"

"With silence," Buckley replied.[40]

At the other viewing site, correspondents sought out the leader of "The Poor People's Campaign," whose response was perhaps the most telling testament to the spectacle that had just taken place.

"I really forgot we had so many hungry people," Abernathy said.[41]

Over the next three days, as Apollo 11 sped toward the moon, many other Americans seemed to be putting their troubles aside, also. Pulitzer-winning cartoonist Herblock captured the mood by depicting a man in an easy chair on top of the moon, watching television, as a smoggy Earth below smoldered with "War," "Poverty," and "Prejudice." Millions of citizens followed the journey through daily live color telecasts from the spacecraft and periodic updates from reporters on the mission's status.[42]

At the same time, the approximately one thousand network employees assigned to Apollo were gearing up for the moon landing and what would be the longest broadcasts in television history. By noon on July 20, all three networks would be bringing viewers live Apollo 11 coverage, telecasts that would run continuously for the next thirty hours (NBC and CBS chose to sign on an hour earlier, each claiming it had been the first to expand its coverage).[43]

While Armstrong and Aldrin's two-hour excursion on the moon's surface would be captured by television cameras and sent by pool arrangement to the networks, NASA's contribution to the landing would be audio-only. To supplement the oral exchanges between the astronauts and Houston, and to fill time when the spacecraft was on the back side of the moon and out of radio reach, each network invested as much as $500,000 in a variety of gear designed to make viewers feel as if they were actually making the trip.[44]

ABC, working with half the budget of its competitors, managed to equip its West 67th Street studio with a command module replica

mounted on a hydraulic lift to simulate various angles of flight, and the third-place network augmented its fake lunar module by hiring an astronaut who had worked on the real one. ABC's array of animated simulations may not have been as refined as those at NBC and CBS, but Jules Bergman's use of a new device called the "telestrator," which allowed its user to draw on the screen, would decades later become a vital tool for football analysts explaining the intricacies of the two-deep zone.[45]

NBC had again turned its gargantuan New York 8H studio into a virtual Apollo command center. One area featured a twelve-foot-wide photograph of major craters near the planned landing area; nearby was a three-dimensional model of the moon. A map of the moon's equator, twenty feet in length, was ready to help track the flight path of the lunar module. Another area of the studio housed a full-sized model of the lunar module, complete in exacting detail, down to the instrumentation and shiny Mylar covering.[46]

CBS's Studio 41, a space usually dedicated to producing soap operas, featured Walter Cronkite's anchor desk, sitting twenty-four feet above the floor and backed by a drawing of the Milky Way. On one side of the desk was a six-foot diameter globe of the moon; on the other side was a similarly sized representation of how Earth would appear to the astronauts. An array of equipment sat ready to simulate various aspects of the flight, much of it tied into a computer designed by the creator of HAL, the human-like computer in *2001: A Space Odyssey*. CBS's computer held thousands of space terms, could project hundreds of diagrams and animations to the public on a moment's notice, and was programmed to greet the network's anchor with "Good evening, Walter."[47]

CBS's larger visual aids were spread across the country. At a Grumman facility in Bethpage, New York, a full-scale lunar module sat ready on a quarter-acre model of the moon's surface. From North American Rockwell's plant in Downey, California, the network could show viewers a forty-foot walk-through model of the solar system, or a full-sized replica of the command module supplemented with a real live astronaut. In Arizona, correspondents and experts stood ready for demonstrations of the lunar walk and the tools that would be used to gather moon dust and lunar rocks.[48]

CBS's most intriguing investment though came in personnel. When millions of television viewers tuned in to watch man arrive at the moon, they would hear commentary from Wally Schirra, the astronaut who had infamously refused to go on the air as he orbited the Earth during Apollo 7. Many of Schirra's old NASA colleagues, who still considered his actions mutinous, were less than amused by his newfound devotion to the medium.[49]

When "Man on the Moon: The Epic Journey of Apollo 11" signed on for its marathon telecast on the morning of July 20, 1969, CBS viewers watched Cronkite settle into the tasks he would handle for the next sixteen consecutive hours: update the audience on the craft's status, keep tabs on the time remaining before the next major event, and seamlessly transition among a score of correspondents and guests located in the studio and scattered throughout the world. As viewers awaited the scheduled late-afternoon landing, they were wisked to points near and far for reasons sublime and silly.[50]

At the White House, Dan Rather reported that a late-morning religious service included a rendition of the first and fourth stanzas of the "Navy Hymn" and a reading of Genesis by Apollo 8 astronaut Frank Borman. From England's Jodrell Bank Observatory, Morley Safer interviewed renowned astronomer Sir Bernard Lovell about the Soviet unmanned spacecraft Luna 15, which was also nearing the moon for reasons that were unclear. From Houston, a Bruce Morton interview with Apollo 10 commander Tom Stafford was interrupted when Cronkite asked about rumors that the lunar walk might happen a few hours ahead of schedule. At Disneyland, Haywood Hale Broun sought the wisdom of the spacesuit-clad Mickey Mouse and Goofy.[51]

Back in the New York studios, Harry Reasoner moderated a mini-debate between Arthur C. Clarke and Kurt Vonnegut concerning the alleged dividends from the space program. From Italy, Winston Burdett reported that the Pope was tracking the American mission from his summer residence, while behind the Iron Curtain, Marvin Kalb found that students in Bucharest were treating Apollo as their own personal adventure. CBS affiliates from Seattle to Wichita, St. Louis to Hartford, told of local citizens' reactions, ranging from national pride to fear that the astronauts would bring a horrible germ back to Earth.[52]

Just before 2 p.m. eastern time, Apollo 11 faced its first major test of the day, as the lunar module, now containing Armstrong and Aldrin, was set to separate from the command module. It would be a test too for CBS director Joel Banow and his team of technicians in the New York studio, who had rehearsed extensively over the previous days to precisely synchronize the maneuvers of their pretend craft with the actual ones a quarter-million miles away. As communications between Houston and the spacecraft were piped in, Cronkite's narration blended the real mission with the one created by CBS.[53]

"That call to Eagle is to the Lunar Module. The Command Module's call-word is Columbia," Cronkite said, explaining the NASA communications. "Our simulation shows a sophisticated maneuver at this time, as Mike Collins in the command module takes a good look at the lunar module, checks it out by visual observation."[54]

Moments later, Armstrong radioed back that "The Eagle has wings," indicating that the craft had successfully separated. Collins then fired an engine to move the command module away, a procedure duplicated at precisely the right moment in the CBS studio, to the delight of Banow and his crew. Off camera, Schirra created a much more subtle graphic representation of the feat: He took off his lapel pin depicting the docked craft and replaced it with separate command and lunar module pins.[55]

The stakes were even higher two hours later as Eagle fired its descent engine to make its final drop to the moon. Banow's team members had rehearsed the landing by using a copy of the flight plan, but in order to precisely sync the models and animations with the actual event, they needed to track what was being said in Mission Control and 250,000 miles away in space. Armstrong's and Aldrin's words began their journey to CBS and its competitors through tiny microphones that led to a three-foot-square box onboard the ship. Inside the box, a signal processor collected the voices and virtually every other piece of information being generated by the craft's sensors and computers, joined the various data into a single frequency of 2,282.5 megahertz, amplified the signal from a half-watt to twenty watts (roughly the same power of a hand-held transistor radio), and pumped the signal through a twenty-six-inch dish antenna. Just over a second later, the signal would be caught by the giant deep space receiving antenna at Goldstone, California, relayed to Maryland's God-

dard Space Flight Center for unpacking into its individual parts, then routed to Houston where NASA would send the astronauts' voices over regular telephone lines to the networks.[56]

To CBS viewers, the lunar approach seemed to be going well. To simulate movement, Banow's crew aimed a projection of a lunar module above a cratered rolling conveyor belt representing a sixty-mile-wide swath of lunar surface. In the final moments, viewers saw an animation of a descending lunar module shooting out flames, and then, when Aldrin said, "Light's on. Down two and a half," CBS cut to a shot of its lunar module's control panel, where a light under the "LUNAR CONTACT" label flashed on, seemingly right on cue. But seconds later, as Aldrin's continued stream of numbers and directions indicated that the ship was still hovering over the lunar surface, CBS viewers slowly peered over the top of a pile of simulated moon rocks in Bethpage, New York, to discover that the network's fake craft had already landed safely.[57]

Banow desperately wished there was a rewind button, but there was no chance for a do-over. It would be nearly 30 more seconds, at 4:17:41 p.m., until Eagle caught up with its CBS twin. As viewers stared at a stationary spacecraft situated inside a Grumman aircraft hangar, they listened as the moment of touchdown left a veteran journalist nearly without words.[58]

> APOLLO 11: Descent engine command override, off. Engine arm off.
> SCHIRRA: We're home.
> APOLLO 11: 413 is in.
> CRONKITE: Man on the moon!
> MISSION CONTROL: We copy you down, Eagle.
> APOLLO 11: Houston ...
> CRONKITE: Oh, Geez.
> APOLLO 11: Tranquility Base here. The Eagle has landed.
> MISSION CONTROL: Roger. Tranquility, we copy you on the ground. We got a bunch of guys about to turn blue. We're breathing again. Thanks a lot.
> APOLLO 11: Thank you.
> CRONKITE: Oh, boy.
> MISSION CONTROL: You're looking good here.
> CRONKITE: Whooh. Boy.
> APOLLO 11: We're going to be busy for a minute ...
> CRONKITE: Wally, say something, I'm speechless.
> SCHIRRA: I'm just trying to hold on to my breath.[59]

Moments later, Cronkite was able to speak, addressing the historic moment with a mix of boyish wonder and engineering jargon. "Boy! There they sit on the moon! Just exactly nominal wasn't it ... on green with the flight plan, all the way down. Man finally is standing on the surface on the moon. My golly!"[60]

Only, it hadn't been "exactly nominal." While technicians in the CBS studio were celebrating the landing–there was so much noise that a soundman had to ask Banow to quiet the crew–the reaction in Houston was less boisterous. NASA engineers had been "about to turn blue" because of a series of serious problems in the final moments. The "1201" and "1202" calls from Aldrin during the descent were reports of alarms indicating that Eagle's computer was dangerously overloaded; if they had persisted, it could have resulted in Armstrong having to execute an emergency abort in an attempt to return the craft to the command module. The statements of "60 seconds" and "30 seconds" coming from Mission Control were alerts that the craft was about to run out of fuel. And while flight data told NASA that Armstrong had taken over partial control of Eagle in the landing's final moments, only the pilot knew that he had done so because the ship's computer was sending the craft straight toward a huge crater surrounded by automobile-sized boulders.[61]

Armstrong would soon share with Mission Control and the world the rough outline of the improvised landing, but despite the army of reporters and virtually unlimited amounts of space and time allotted to Apollo 11 by print and broadcast news organizations, there seemed to be very little enterprise in ferreting out the other elements of the touchy final approach. A press conference with Paine an hour after the landing featured questions such as "What was the emotion the astronauts displayed?" "Have you received a congratulatory note from Russia?" "What was the mood of the President?" When CBS wasn't trying to locate precisely where the Eagle had landed (NASA didn't know either), its correspondents were interviewing travelers at JFK Airport, or tourists at the Smithsonian and Disneyland, who were "glad to be Americans" after a feat that was alternately "fabulous," "spectacular," or "wonderful."[62]

More meaty examinations were unlikely to be found on CBS's rivals. At least one of the scientific experts employed by the networks

later reported a "great sense of sitting around and not being used." A log kept by a young magazine intern who was assigned to keep track of NBC's coverage revealed a lot of talking but little analysis:[63]

> In the first hours after lunar touchdown, there seems to be a failure to keep abreast of breaking news … insufficient explanation of the "minor problems" that arose: the communications difficulties, the landing. … Topless showgirls in Las Vegas are shown uncorking champagne at the moment of landing. … Ray Scherer report from NBC's European Space Center … still more reactions than news. Good feature on the fantastic interest and coverage in West Germany, an unconscious ironic set-up for later talk with von Braun. Cologne experts give frighteningly clipped comments. … BBC moon expert Patrick Moore: "No admiration can be too great. This is obviously a moment that humanity can never forget." … Mrs. Armstrong tells reporters, "I'm just about as excited as you all are." Still more reactions. Rev. Herman Weber in special Wapakoneta (Armstrong's hometown) service. … Mrs. Pat Collins with intelligent, sharp rejoinder to the newsman's limp question, "Isn't Mike a little disappointed up there with the others down on the moon"–"Don't you think he's probably with them in spirit?" Asked if she'd watch the moon walk on TV–what an idiotic question–she came back, "Oh positively–Is anyone going to bed?" … Interview with Sen. Muskie … A Truffaut-esque piece on space pioneer Hermann Oberst and his protégé von Braun – the old codger eats cake while von Braun drones on about the old man's visionary contribution.[64]

It would be four days before *New York Times* reporter Richard Witkin, as well as ABC's Jules Bergman, would piece together the story of the alarms and just how touchy the final approach had been.[65]

As the dinner hour approached, the network news teams were preparing to temporarily step aside for the entertainment division. NASA's mission plan called for the astronauts to sleep before taking their scheduled walk on the moon around 2 a.m. eastern time, putting their rest period during network prime time hours. Feeling that regular episodes of *Bonanza* and *The Ed Sullivan Show* were insufficient to mark the upcoming momentous event, the networks had planned several hours of entertainment-based moon programming. ABC had hired Duke Ellington to write and perform a special song, "Moon Maiden," Steve Allen was brought in to sit at the piano and play songs about the moon and romance, and *The Twilight Zone* creator Rod Serling conducted a roundtable discussion with science fiction writers. NBC hired Danny Kaye to co-host its *Special Within a Special* with John Chancellor, a show that promised dramatic readings from

Van Heflin, James Earl Jones, and Julie Harris. CBS's offerings were highlighted by an Orson Welles-narrated compilation of clips from classic science fiction films.[66]

Just after 6 p.m., each network's expensive, star-studded show was relegated to the cutting room. The astronauts, too wound up to sleep, had received permission from Houston to take their moonwalk during prime time. Many of the entertainment segments never made it on the air. After watching a few of the offerings that were broadcast the following day, Jack Gould concluded to *New York Times* readers that "Mr. Armstrong served the viewers in more ways than one Sunday night."[67]

As Armstrong and Aldrin methodically checked and rechecked the bulky spacesuits and portable life support systems that would keep them alive during their moon outing, Americans gathered for late-evening watch parties large and small. In an Elkhart, Iowa, farmhouse, chocolate chip cookies and grape soda awaited a dozen friends and family members who had crowded around the living room television. In Reno, Harolds Club was serving up Moonshots–a vodka-and-apple juice concoction served in a spacecraft-shaped glass. In New York's Central Park, where three huge television screens were set up for each network's telecast, a youthful crowd of ten thousand braved periodic heavy rain and munched on lunar dogs (30 cents, 40 cents with chili) or a moon picnic including a bottle of Burgundy ($1.95). The more free-spirited members of the crowd fired up joints.[68]

As viewers nibbled and waited, they watched as the networks filled time. On CBS, Cronkite held up the early edition of *The New York Times*, which used the largest headline type in its history to shout "MEN LAND ON MOON." Each network showed more run-throughs of its fake lunar module, demonstrating yet again how the astronauts would emerge and descend to the moon's surface. At a watch party in a New York apartment, several guests argued whether one network's simulation of the moonwalk was actually the real event. "We've seen everything in simulation," one young woman said. "They might as well do it all in simulation."[69]

As 11 p.m. neared on the East Coast, personnel inside a stuffy control room at NBC were confronted by an array of monitors with

labels such as "HOUSTON," "VIDEOGRAPH," and "CAMERA 6." In the back row, James Kitchell, the executive producer of the network's space coverage, fingered a row of switches that could at any moment put him in contact with anchors David Brinkley and Frank McGee in the "Huntley Brinkley Deck" a few doors down, Roy Neal in Houston, or various other correspondents stationed in locales from London to Tokyo. In the front row, director Tony Messuri was taking directions from Kitchell and shouting out orders to a gaggle of technicians who were trying to turn seeming chaos into a seamless television broadcast.[70]

McGee's report to the viewing audience that "Neil Armstrong's on his stomach, feet first, coming out," ramped up the adrenaline in the control room and around the world to an even greater level. A quarter-million miles away, Armstrong made his way to the second rung of Eagle's ladder, reached to his left, and pulled a lanyard, opening a compartment that housed a shoebox-sized Westinghouse television camera that would document the remainder of his descent in black and white (a color camera that could withstand the heat on the moon's surface was still in development).[71]

Inside the lunar module, Aldrin installed a special circuit breaker, and within moments, the first ghostly images of Armstrong standing on the ladder were being picked up by the giant receiving dish at Goldstone, California. There, technicians quickly converted the low-resolution, slow-speed video to the American standard of 525 lines per frame, 30 frames per second, and sent it along landlines to Houston.[72]

When the television signal arrived at the Manned Spacecraft Center, there was at least one significant problem: It was upside-down. The camera had been intentionally mounted that way in order to better secure it, but someone at Goldstone had forgotten to toggle a switch that flipped the image for television viewers. Within seconds, Goldstone technicians fixed that error, but they were unaware of another serious issue with the moon video that was being sent to Houston. Goldstone's scan converter had been set with way too much contrast, resulting in a mostly black image, making it hard for those at NASA to see exactly what was happening.[73]

Despite the quality, NASA quickly routed the video over land-lines to the networks, setting in motion a flurry of activity in the NBC control room.

"Set me up 'First Live Pictures from the Moon,' baby!" Messuri shouted to a technician responsible for on-screen titles.

"Go to Houston!" Kitchell shouted.

"And *take it!*" Messuri followed, completing the order to put the feed from the moon onto television screens across the country.

"Here it comes!" exclaimed Kitchell, who was watching a monitor marked "PROGRAM." The control room burst into cheers as it saw an image that would in an instant be displayed in Reno bars, Iowa farmhouses, and a muddy Central Park field. After being bounced off an orbiting satellite, it would also reach crowds in London's Trafalgar Square, Tokyo's Ginza, and a host of other locales throughout the world. The transmission was far from universal–Russians would see only taped highlights, and Chinese media ignored the event alto-gether–but an estimated half-billion people were now glued to a ghostly image of Armstrong, centered in the frame, standing on the ladder. Behind him, the lunar horizon cut a distinct horizontal diago-nal across the bottom third of the screen, the overexposed moon creat-ing a sharp division with the utter blackness of space.[74]

Armstrong slowly made his way down the ladder, then dangled a leg toward the lunar surface.

"The foot!" Messuri cried in NBC's control room.

"Put 'First Step on the Moon,'" started Kitchell, before realizing that Armstrong was just measuring how much of a jump he would have to make from the bottom rung. "Wait! He's not on the moon yet. So far, he's just on the foot pad."

"That's OK," Messuri said. "After all, what's the foot pad con-nected to?"

"The shin bone," called another voice in the control room.[75]

"I'm at the foot of the ladder," Armstrong announced to the world. "The LM foot beds are only depressed in the surface about one or two inches, although the surface appears to be very, very fine-grained as you get close to it. ..."[76]

Suddenly, the television picture got significantly better. The Hon-eysuckle Creek tracking station in Australia had also been receiving the telecast from the moon and was having much better luck convert-

ing it. The improved Australian image, arriving in Houston via satellite, was now being shipped to the networks. Minutes later, an even better feed captured and converted at Australia's Parkes Observatory would make its way to Houston and viewers in America.[77]

After his description of the lunar surface, Armstrong announced, "I'm going to step off the LM now." In New York, Messuri ordered his now silent NBC control room to "Take it! 'First Step on the Moon.'"[78]

Armstrong bounced off the ladder's bottom rung, and spoke the words he had come up with earlier that evening: "That's one small step for man, one giant leap for mankind."[79]

After a long pause, Armstrong told of how the moon dust collected on his boot like finely powdered charcoal, and Kitchell ordered his NBC team to start getting ready for a scheduled presidential phone call to the astronauts. In the moment, the producer allowed himself a pause of wonderment. "It's unbelievable," Kitchell said, to no one in particular. "Unbelievable!"[80]

For the next twenty minutes, Armstrong would be alone on the lunar surface. In Houston, Janet Armstrong talked to her television screen and implored her reserved husband to "Be descriptive now, Neil" as he began taking still pictures and secured a "contingency sample" of lunar material in case he was forced to retreat quickly to the spaceship. "It has a stark beauty all its own," Armstrong told viewers of the landscape he was viewing. "It's like much of the high desert of the United States." After coming down the ladder, Aldrin provided his own succinct description: "magnificent desolation."[81]

Soon, Aldrin would narrate as Armstrong opened a metal cover that revealed the plaque of global unity that had been of such intense interest to the White House in the days leading up to launch. After Armstrong read the text, Aldrin helped him move the camera and set it on a tripod approximately forty feet away from the lunar module. Armstrong gave television viewers panoramic shots of the north, west and south, then with the help of Mission Control, aimed the camera so the edge of the lunar module was in the left side of the picture. To the right, he and Aldrin would within minutes erect a specially designed three-by-five-foot American flag that had been stiffened with wire to give the appearance of "flying." As Armstrong and Aldrin struggled to fully extend the flag and deploy the pole in

the hard lunar crust, Collins, orbiting above in the command module, checked in with Mission Control:[82]

> HOUSTON: I guess you're about the only person around that doesn't have TV coverage of the scene.
> COLLINS: That's right. That's all right. I don't mind a bit. How is the quality of the TV?
> HOUSTON: Oh, it's beautiful, Mike. Really is.
> COLLINS: Oh, gee, that's great. Is the lighting half way decent?
> HOUSTON: Yes, indeed. They've got the flag up and you can see the stars and stripes on the lunar surface.
> COLLINS: Beautiful. Just beautiful.[83]

Minutes later, Houston instructed Armstrong and Aldrin to gather near the flag. In network control rooms, directors superimposed a video feed of President Nixon over a portion of the moon picture, as the Commander-in-Chief placed what he labeled "the most historic telephone call ever made," and certainly the one that traveled the most distance.[84]

> NIXON: Because of what you have done, the heavens have become a part of man's world. And as you talk to us from the Sea of Tranquility, it inspires us to double our efforts to bring peace and tranquility to earth. For one priceless moment, in the whole history of man, all the people on this earth are truly one. One in their pride in what you have done. And one in our prayers, that you will return safely to earth.
> ARMSTRONG: Thank you, Mr. President. It's a great honor and privilege for us to be here representing not only the United States but men of peace of all nations. And with interest and a curiosity and a vision for the future. It's an honor for us to be able to participate here today.
> NIXON: And thank you very much and I look forward - all of us look forward to seeing you on the Hornet on Thursday.
> ARMSTRONG: Thank you.
> ALDRIN: I look forward to that very much, sir.[85]

It had been nearly 60 minutes since Armstrong had stepped off the ladder, and there was still more than an hour to go in the lunar excursion. There were more experiments to set up and more moon rocks to collect, tasks that were already behind schedule. Operating in gravity that was one-sixth of the Earth's, the two bounded across the screen like "exuberant kangaroos," in the words of one publication, leading one young viewer to remark, "I'm glad people can have a good time on the moon." Joan Aldrin, at home in suburban Houston,

watched her husband's jumpy, black-and-white movements and was reminded of the era of silent movies.[86]

As he watched the astronauts frolic, an NBC News executive standing outside the network's control room suggested to a visiting journalist that the worldwide transmission had a decidedly democratic flavor. "I hear they're getting a great picture in Bucharest. And in Belgrade. And, you know, nobody has the inside track on these pictures. The scientists in Houston, the President of the United States, all of us in this room, perhaps Serbian peasants–they're all seeing the same fantastic live pictures at the same time. Nobody any better than anybody else, really. Maybe that holds something pretty good for all of us."[87]

While many viewers across America remained glued to their sets, others slowly drifted away as the mooncast rolled on through the midnight hour on the East Coast. At the Central Park Moon-In, the crowd in front of the three televisions began thinning as people began checking out the band playing nearby or seeking out another celestial snack from the vendors. At another watch party outside Rockefeller Center, a crowd that once numbered twelve hundred had shrunk by approximately 75 percent as the last half-hour of the moonwalk was broadcast. "I'm used to it already," a young man said at another New York party. "When you get blasé about people going to the moon, you know you've changed," a young woman replied.[88]

In Houston, Julian Scheer, the man who had lobbied so hard for the first excursion to be televised, looked at the two astronauts on the screen and could only think of the danger that remained.

"Now that you've done it," Scheer thought to himself, "get the hell back in the spacecraft and come home."[89]

Scheer had reason to be worried. The following afternoon, Armstrong and Aldrin prepared to fire a single rocket engine that was designed to lift the top portion of the lunar module off the moon and return them to the orbiting command module. As Collins busily consulted his "cookbook" of emergency procedures, he considered the horrible possibilities if Eagle couldn't get at least 50,000 feet off the moon–the minimum distance needed to try any rescue. "My secret terror for the last six months has been leaving them on the moon and

returning to Earth alone; now I am within minutes of finding out the truth of the matter," Collins would later write.[90]

Back at NASA, Scheer and his staff had prepared a contingency file outlining exactly what would be said, by whom, and at what time if the engine failed to fire and Armstrong and Aldrin were left to die a slow death on the lunar surface. "I exercised the discretion of cutting off the final conversations, if the astronauts couldn't get off the moon," Scheer would later recall. "I felt that if a crewmember wanted to say farewell to his family, he should have the privacy to do that. I knew there would've been a great clamor to release those tapes, and I know that forever more I would've been criticized for not doing so."[91]

The television camera, still sitting on its tripod outside Eagle, had been shut off the night before. The $400,000 device added too much weight for the liftoff, engineers had determined, and would be left behind. There was no independent power source to operate the camera for liftoff, so the networks again readied simulations to use in conjunction with the NASA audio transmissions. ABC had a model on an eighteen-foot moonscape, complete with an acetylene torch hose that would replicate the rocket's firing, while NBC and CBS had animated sequences at the ready.[92]

At the instant that Armstrong fired Eagle's engine, CBS's Banow ordered his crew to start the film that was designed to mimic the next seven minutes of the mission. As Armstrong and Aldrin sped off the moon, viewers around the country saw a rendering of a lunar module, sitting motionless. In the New York control room, Banow yelled "Oh, my God!" as he realized what had happened: The animation had been produced with ten seconds of "lead film," and no one had edited the sequence to start with the frame just before ignition. As the CBS craft finally began its journey, Banow tried to determine exactly when to cut it off to avoid the further embarrassment of having CBS's rocket continuing to fire after Armstrong shut down the one escaping the moon's grasp. Inexplicably, at the moment when Armstrong said, "Shutdown," CBS's engine stopped also.[93]

On air, Cronkite had celebrated the successful lunar liftoff with, "Oh boy! Hot diggety dog!" In the control room, Banow looked at his animation and could only utter, "Thank God."[94]

❖❖❖

Three days later, the crew of Apollo 11 made a nearly perfect splashdown in the Pacific and were taken to the carrier *Hornet*, where President Nixon waited to greet them in the first act of his tour of Asia. That afternoon, viewers around the world were taken to a large area inside the *Hornet* and watched as Nixon strode in to the sounds of "Hail to the Chief." They saw Nixon stop in front of an Airstream trailer endowed with the presidential seal and begin waving at a cur-tain-covered window. Moments later, the curtain opened to reveal Armstrong, Aldrin, and Collins, who were behind glass, beginning an eighteen-day quarantine to ensure they had not brought any space illnesses back to Earth.[95]

For the next several minutes, Nixon played the role of awkward talk-show host, telling the astronauts "Gee, you look great!" while asking them whether sea sickness was the biggest hazard of the mis-sion, making sure they knew who won baseball's All-Star Game, and mentioning that he had asked each of their wives for a "date"–a state dinner in the astronauts' honor. His sidekick Frank Borman, who had kept his name in the public spotlight by spending much of the mis-sion with the president, made a cameo appearance. Nixon's claim that the mission had been the "greatest week in the history of the world since the creation" was intended to increase the gravity of the event, but it may have come as some surprise to those believing in the virgin birth and resurrection.[96]

Later, after Nixon took off for his foreign tour and the networks returned to their regular programming, the astronauts looked for ways to kill time while their quarantine trailer made its way back to Houston. The quarters had been equipped with a number of creature comforts: exercise equipment, a bar, and a television with tapes of network coverage from their mission. As the three astronauts watched footage of the million or so "Bird Watchers" who had crowded around the Cape for liftoff, experienced the outpouring of public emotion as Eagle landed, and saw the wonderment of other humans as they saw two of their own bound across the moon's sur-face, Aldrin turned to his history-making colleague.

"Neil," Aldrin said to Armstrong, "we missed the whole thing."[97]

EPILOGUE

As Apollo 11 entered the final moments of its countdown, Wernher von Braun sat quietly in his seat in launch control, bowed his head, and repeated the Lord's Prayer. Days later, like millions of Americans, the architect of America's lunar conquest watched on television as two men frolicked on the lunar surface and fulfilled the prophecy he had set forth for consumers of American media nearly two decades earlier. After the craft's safe return to Earth, von Braun set his sights on what he saw as the next logical step: a manned mission to Mars.[1]

Three months after the first moon landing, von Braun submitted his plan for post-Apollo space exploration to Cornelius Ryan, his former collaborator at *Collier's*. Ryan, now working for *Reader's Digest*, had been overwhelmed by von Braun's powers of persuasion in the early 1950s, but he, like many of his colleagues in the media, was no longer dazzled by the promise of space travel. After numerous revisions, including a rewrite by a NASA official, the magazine decided in early 1970 to scrap von Braun's article altogether.[2]

"Seriously, cynical as that may be," Ryan wrote in a memo to his editor-in-chief, "the truth is that the tone of this country right now, in my honest opinion, is not very conducive to large expenditures on the space program."[3]

For NASA, the conquest of the moon was more than an astonishing technical achievement. The agency's promise to operate as an "open program" seemed to be finally fulfilled also, as live television pictures, a parade of press briefings, and a staggering amount of written information (transcripts of the conversations between the astronauts and the ground consumed nearly one million mimeographed sheets alone) provided American media with unprecedented access.

"The flight of Apollo 11 was a public relation man's and a reporter's dream," wrote one correspondent a few days after the astronauts had safely returned home. "Rarely before has an agency of any government exposed itself so completely to public view when it was engaged in the most critical moments of its duties." Much of the credit went to NASA public affairs chief Julian Scheer, whose embrace of the "open program" concept was hailed by a majority of the press. Scheer was "probably the most respected public affairs officer in Government," the reporter continued, "because his office and NASA in general have been so frank."[4]

In April 1970, the "open program" concept would be put to a vigorous test when an oxygen tank explosion crippled the Apollo 13 spacecraft and put into grave doubt whether the astronauts would survive. In stark contrast to NASA's reactions during Scott Carpenter's Mercury misadventure and the Apollo 1 fire, the agency quickly and frankly told the world of the problem and kept media informed for the next four days as engineers and flight controllers devised a plan for returning the astronauts to Earth. For years, NASA had balked at putting pool reporters into Mission Control, but the performances of Time-Life's Jim Schefter and NBC's Roy Neal finally proved the value of such an arrangement. Schefter's early bulletin alerted the nation's media to the explosion shortly after it had occurred, and Neal's access and expertise allowed him to correct errors of fact that were popping up on other outlets. When Cronkite told viewers that the astronauts would run out of oxygen in a couple of hours, Neal reached the CBS anchor through an intercom connection and said NASA had figured out a way to get air from another source. Cronkite would correct his mistake.[5]

Scheer had succeeded in fostering better NASA relations with the American press corps, but his support within the agency and from space advocates was far from universal. George Mueller had essentially operated his own public affairs arm in the Office of Manned Space Flight until his resignation in late 1969 and charged in later years that Scheer had not done enough to foster "the kind of cooperative relationship with the media that would be most productive." The view that NASA should do more to "sell" its message also had a receptive audience among some members of Congress, most notably influential Texas representative Olin Teague, whose negative attitude

toward Scheer also had a personal dimension: During Apollo 9, Scheer had refused to give special accommodations to a planeload of the legislator's friends. By early 1970, Teague had convinced colleagues to trim Scheer's budget by $1.5 million, and in February 1971, interim NASA chief George Low executed Teague's wishes and obtained Scheer's resignation.[6]

NASA embraced some of Scheer's legacy, while letting other aspects fade from institutional memory. Television, resisted with vigor by a number of NASA officials throughout the 1960s, was now a staple of space missions. Five months after Scheer's dismissal, viewers of Apollo 15 watched Dave Scott and Jim Irwin drive a new lunar rover vehicle across the moon's surface, then later witnessed the lunar module's blast off from its spider-like base, all in vibrant color. A decade later, NASA would provide live pictures of liftoff and landing for the space shuttle's debut, giving the television audience "a gratifying and spellbinding visual and emotional experience," in the words of critic Tom Shales. The "open program," however, seemed like ancient history after the Challenger disaster in 1986, when NASA was roundly criticized for being inaccessible and insular–similar criticisms that the agency had faced nearly twenty years earlier when the Apollo 1 astronauts died on the launch pad. Some lessons would have to be relearned.[7]

As for the television networks, CBS had emerged the clear winner in its battle for space ratings supremacy, trouncing NBC 45 to 34 nationally during Apollo 11. The fear of former NBC head Bob Kintner that Cronkite would parlay his folksy space approach to success in the overall news race seemed to be confirmed also, as *The CBS Evening News* completed its eighteenth straight month in first place. *The Huntley-Brinkley Report* had suffered mightily from the NBC duo's differing stances during a 1967 actor's strike (Huntley crossed the picket line; Brinkley did not), and veteran television critics watching Apollo 11 coverage came to the conclusion that the old order was not returning, which it wouldn't. Cronkite would dominate television news for the next decade.[8]

"In alertness, diversity and knowhow CBS was ahead by a wide margin," Jack Gould wrote in *The New York Times* shortly after Apollo

11 began its journey home. Huntley and Brinkley had approached the lunar conquest with a "blasé attitude more appropriate to covering political conventions," Gould continued. "Major events have a way of shifting the balance of power in TV news; it may have happened again in the last two days ..."[9]

As for the television industry as a whole, the results were less clear. In mainstream publications, critics praised the telecasts from the moon as evidence that the medium's public affairs commitment to space had indeed moved television well beyond the "vast wasteland" decried by Newton Minow nearly a decade before. In *The Washington Post*, Lawrence Laurent proclaimed, "The cameras get the important pictures, the animation sequences are high quality and almost every commentator is at ease with the grammar of space exploration." Gould asserted that the array of visual aids and expert analysis gave viewers an "introduction to the intricacies of science that would take weeks, months or years to extract from textbooks."[10]

In parts of the media spectrum less traveled though, critics charged that television, often charged with sensationalizing the news, had somehow managed to turn the momentous into the trivial. Questions about the space program's necessity in a time of war and urban strife were addressed superficially, they argued, with pseudo debates between Kurt Vonnegut and Arthur C. Clarke, or seemingly mocked, as when Cronkite told viewers after the lunar landing, "I wonder what all those kids who pooh-poohed this program are saying now?" Prominent intellectuals with severe misgivings about the manned space program, such as Lewis Mumford, were noticeably absent from American network coverage; one had to go to Canada to hear the critical views of Manhattan Project veteran Ralph Lapp. "There was no one to answer questions like, can this feat yield any immediate benefits, and if not, how long will it be before any kind of return– other than a propaganda return–can be gained from this massive investment?" wrote one college student after watching CBS's coverage of Apollo 11.[11]

The staggering size and technical complexity of the manned space program were nearly impossible to convey through television, one critic concluded a few months after Apollo 11's return. "The breathtaking beauty of our world as seen from space (so reassuring at a time when hatred of the human condition seems to be becoming endemic),

weightless fun in the space capsule, and the spectacle of Old Glory planted on lunar soil–these are the elements of the adventure that television has handled superbly."[12]

The spectacle of lunar conquest would have a short-lived hold on the attention of the American public. Aside from a spike during the imperiled Apollo 13 mission, viewership waned throughout the remainder of the lunar program. The networks responded accordingly by allotting less and less time to space coverage. Each network devoted fifty-plus hours of airtime to Apollo 11; NBC's thirty-five hours of coverage of Apollo 12 far outdistanced that provided by its two competitors. And by the time Apollo 17 made the country's final moon voyage in December 1972, only one television station in the country–Houston's public television outlet–showed the entire twenty-plus hours worth of lunar surface excursions.[13]

The public, it seems, had made up its mind about the space program long before Armstrong's boot had hit lunar dust. A national survey on the eve of Apollo 11 indicated that Americans backed the moon landing by a 51-to-41 percent margin, essentially reversing the results of a similar survey months earlier. Beneath the surface though, the same poll showed that the country hadn't changed at all: More than half of the citizenry still thought the annual $4 billion price tag for the space program wasn't worth it, a percentage that had varied little since the mid-1960s. Given the amount of time and money they had invested toward the lunar conquest though, Americans made the decision to enjoy the resulting blockbuster when it was released over the country's airwaves. Most had little interest in the sequels.[14]

!

NOTES

Chapter 1

[1] This and the preceding paragraphs are from Wernher von Braun, "Crossing the Last Frontier," *Collier's*, March 22, 1952, 24-29, 72, 74.

[2] Jules Verne, *From the Earth to the Moon Direct in Ninety-Seven Hours and Twenty Minutes, and a Trip Round It* (New York: Scribner, Armstrong, 1874); H. G. Wells, *The First Men In the Moon* (London: G. Newnes, limited, 1901); Arthur C. Clarke, *Prelude to Space: A Compellingly Realistic Novel of Interplanetary Flight* (New York: World Editions, 1951).

[3] "What Are We Waiting For?" *Collier's*, March 22, 1952; Ron Miller, "To Boldly Paint What No Man Has Painted Before," *Invention and Technology* 18, no. 1 (Summer 2002), http://www.americanheritage.com/articles/magazine/it/2002/1/2002_1_14.shtml.

[4] Dennis Piszkiewicz, *Wernher Von Braun: The Man Who Sold the Moon* (Westport, Conn.: Praeger, 1998), 72; Randy Liebermann, "The *Collier's* and Disney Series," in *Blueprint for Space: Science Fiction to Science Fact*, ed. Frederick Ira Ordway III and Randy Liebermann (Washington: Smithsonian Institution Press, 1992), 135.

[5] Piszkiewicz, *Man Who Sold the Moon*, 72; Liebermann, "The *Collier's* and Disney Series," 135; Michael J. Neufeld, *Von Braun: Dreamer of Space, Engineer of War* (New York: Alfred A. Knopf in association with the National Air and Space Museum, Smithsonian Institution, 2007), 256.

[6] "The V-Rockets," http://www.stelzriede.com/ms/html/sub/marshwvr.htm.

[7] Andrew Walker, "Project Paperclip: Dark Side of the Moon," *BBC News*, November 21, 2005. http://news.bbc.co.uk/2/hi/uk_news/magazine/4443934.stm.

[8] Daniel Lang, "A Reporter at Large: A Romantic Urge," *The New Yorker*, April 21, 1951, 84.

[9] Neufeld, *Dreamer of Space*, 236-238.

[10] "The Seer of Space," *Life*, November 18, 1957, 136; Neufeld, *Dreamer of Space*, 277.

[11] Neufeld, *Dreamer of Space*, 240-241, 246.

[12] "Nazis Planned Rocket to Hit U.S.," *The New York Times*, December 4, 1946.

[13] Lang, "A Reporter at Large," 78.

[14] Lang, "A Reporter at Large," 79.

[15] Von Braun's FBI and Army dossiers were declassified in the mid-1980s and revealed the extent to which he was involved in the Nazi party and with recruiting slave labor. The most damning evidence came in the form of a letter written by von Braun stating that he had gone to the Buchenwald detention

camp to find more qualified workers and had arranged for their transfer to the Mittelwerk. Piszkiewicz, *Man Who Sold the Moon*, 202-203.

[16] *Dora*, Jean Michel's first-person account of his imprisonment in the concentration camp, was released in the United States in 1979 and criticized von Braun for not speaking out about the conditions the rocket engineer saw during a 1944 inspection of the camp. Piszkiewicz, *Man Who Sold the Moon*, 199-200.

[17] Lang, "A Reporter at Large," 79, 81, 87.

[18] Lang, "A Reporter at Large," 87.

[19] Neufeld, *Dreamer of Space*, 252-254.

[20] "Scientist Projects Journey to Mars," *The New York Times*, September 7, 1951.

[21] Fred L. Whipple, "Recollections of Pre-Sputnik Days," in *Blueprint for Space: Science Fiction to Science Fact*, ed. Frederick Ira Ordway III and Randy Liebermann (Washington: Smithsonian Institution Press, 1992), 129.

[22] Ernst Stuhlinger and Frederick Ira Ordway, *Wernher Von Braun, Crusader for Space: A Biographical Memoir* (Malabar, Fla.: Krieger Pub. Co., 1996), 113; Neufeld, *Dreamer of Space*, 256-257; Piszkiewicz, *Man Who Sold the Moon*, 72-73.

[23] Neufeld, *Dreamer of Space*, 257; Piszkiewicz, *Man Who Sold the Moon*, 73; Stuhlinger and Ordway, *Crusader for Space*, 115.

[24] Neufeld, *Dreamer of Space*, 257; David Smith, "They're Following Our Script: Walt Disney's Trip to Tomorrowland," *Future* 1, no. 2 (May 1978), 56; Piszkiewicz, *Man Who Sold the Moon*, 73.

[25] Neufeld, *Dreamer of Space*, 258; Liebermann, "The *Collier's* and Disney Series," 136.

[26] Piszkiewicz, *Man Who Sold the Moon*, 73; Liebermann, "The *Collier's* and Disney Series," 141; Neufeld, *Dreamer of Space*, 258-259; "Ad Drums Up Trade for Mars Tour, but Its Departure Is Rather Indefinite," *Christian Science Monitor*, April 24, 1952. The readership figures are derived from *Collier's* claim that four to five people read each of the 3 million circulated copies. Liebermann, "The *Collier's* and Disney Series," 137.

[27] Piszkiewicz, *Man Who Sold the Moon*, 73; Liebermann, "The *Collier's* and Disney Series," 141; Neufeld, *Dreamer of Space*, 258.

[28] "What Are We Waiting For?" *Collier's*, March 22, 1952, 23.

[29] Von Braun, "Crossing the Last Frontier," 74.

[30] Robert C. Cowan, "Satellite Space Ship Seen Possible Within 15 Years," *Christian Science Monitor*, March 14, 1952; "Too Constant Moon," *The Washington Post*, March 23, 1952.

[31] Neufeld, *Dreamer of Space*, 259-260, 265-266.

[32] Orval Hopkins, "Magazine Rack," *The New York Times*, October 12, 1952; Wernher von Braun, "The Journey," *Collier's*, October 18, 1952, 53-54.

[33] William C. Laurence, "2 Rocket Experts Argue 'Moon' Plan," *The New York Times*, October 14, 1952.

[34] Neufeld, *Dreamer of Space*, 268-270; "Journey into Space," *Time*, December 8, 1952, 62-64, 67-70, 73.

[35] Fred L. Whipple and Wernher von Braun, "The Exploration," *Collier's*, October 25, 1952, 38-40, 42, 44-48; Wernher von Braun with Cornelius Ryan, "Baby Space Station," *Collier's*, June 27, 1953, 33-35, 38, 40.

[36] Wernher von Braun with Cornelius Ryan, "Can We Get to Mars?" *Collier's*, April 30, 1954, 22-29; Neufeld, *Dreamer of Space*, 275-276.

[37] Neufeld, *Dreamer of Space,* 277; Dwayne A. Day, "Viewpoint: Paradigm Lost," *Space Policy* 11, no. 3 (1995): 153-154.

[38] Neufeld, *Dreamer of Space,* 285.

[39] Piszkiewicz, *Man Who Sold the Moon,* 84; Leonard Mosley, *Disney's World: A Biography* (New York: Stein and Day, 1985), 233; Bob Thomas, *Walt Disney: An American Original* (New York: Simon and Schuster, 1976), 213.

[40] Neufeld, *Dreamer of Space,* 285; Mosley, *Disney's World,* 215; Thomas, *Walt Disney,* 213; Smith, "They're Following Our Script," 55.

[41] Smith, "They're Following Our Script," 55-56.

[42] Smith, "They're Following Our Script," 56; Liebermann, "The *Collier's* and Disney Series," 145.

[43] Smith, "They're Following Our Script," 56 (emphasis added).

[44] Neufeld, *Dreamer of Space,* 285-286.

[45] Mosley, *Disney's World,* 265.

[46] Neufeld, *Dreamer of Space,* 286-288; Mike Wright, "The Disney-Von Braun Collaboration and Its Influence on Space Exploration," in *Inner Space, Outer Space: Humanities, Technology and the Postmodern World, Selected Papers from the 1993 Southern Humanities Conference,* ed. Daniel Schenker, Craig Hanks and Susan Kray (Huntsville, AL: Southern Humanities Press, 1993), 154; Smith, "They're Following Our Script," 57; Piszkiewicz, *Man Who Sold the Moon,* 85; Charles Shows, *Walt: Backstage Adventures with Walt Disney* (La Jolla, Calif.: Windsong Books International, 1980), 29-30.

[47] Neufeld, *Dreamer of Space,* 290; Smith, "They're Following Our Script," 57-58; Piszkiewicz, *Man Who Sold the Moon,* 87; Wright, "The Disney-Von Braun Collaboration," 153.

[48] Piszkiewicz, *Man Who Sold the Moon,* 87; Wright, "The Disney-Von Braun Collaboration," 153.

[49] Lawrence Laurent, "Annual Indoor Sport: The Ten Best Shows," *The Washington Post,* December 25, 1955.

[50] Wright, "The Disney-Von Braun Collaboration," 155-156; Piszkiewicz, *Man Who Sold the Moon,* 88.

[51] Piszkiewicz, *Man Who Sold the Moon,* 89; Wright, "The Disney-Von Braun Collaboration," 155.

[52] Smith, "They're Following Our Script," 60.

[53] J.P. Shanley, "TV: A Trip to the Moon," *The New York Times,* December 29, 1955.

[54] Shanley, "TV: A Trip to the Moon."

[55] Neufeld, *Dreamer of Space,* 277; Hanson W. Baldwin, "Rockets Tested in Army Center," *The New York Times,* December 8, 1955.

[56] Neufeld, *Dreamer of Space,* 281-284, 291-294.

[57] Neufeld, *Dreamer of Space,* 294.

[58] Neufeld, *Dreamer of Space,* 296-298; John G. Norris, "'Crash' Program Gave Russia Edge in Race to Launch Earth Satellite," *The Washington Post,* October 9, 1957.

[59] Neufeld, *Dreamer of Space,* 298.

[60] Hanson W. Baldwin, "The Missile Program: An Evaluation of U.S. Progress in Race Against Soviet for Supremacy," *The New York Times,* March 17, 1957.

[61] Richard Witkin, "Army's Missile Goes 1,500 Miles," *The New York Times,* June 6, 1957.

[62] "Army Has Best Long-Range Missile, Expert Says at Nickerson's Trial," *The Washington Post*, June 27, 1957; "The Nickerson Sentence," *Christian Science Monitor*, July 2, 1957.

[63] Gordon L. Harris, *Selling Uncle Sam* (Hicksville, N.Y.: Exposition Press, 1976), 63-64; "Atomic Missile on Display Here," *The New York Times*, July 7, 1957.

[64] Harris, *Selling Uncle Sam*, 64-65; "Atomic Missile on Display Here," *The New York Times*; "Missile Show Reflects Youths' Scientific Bent," *The New York Times*, July 24, 1957.

[65] Harris, *Selling Uncle Sam*, 64-65; "Missile Ends Its Grand Central Show," *The New York Times*, July 28, 1957.

[66] John Hillaby, "Soviet Planning Early Satellite," *The New York Times*, August 3, 1955; "Soviet Planning 'Moon' This Year," *The New York Times*, June 23, 1957; Hanson W. Baldwin, "The Ultimate Weapon: An Analysis of Soviet Announcement on Intercontinental Ballistic Missile," *The New York Times*, August 27, 1957.

[67] Roy Silver, "Satellite Signal Broadcast Here," *The New York Times*, October 5, 1957; "U.S. Radio Rebroadcasts Signals From Sphere," *The Washington Post*, October 5, 1957.

[68] William H. Stringer, "Space Era Advent Jolts Washington," *Christian Science Monitor*, October 5, 1957; "Reports on Soviet Artificial Satellite Sent to Eisenhower at Gettysburg Farm," *The New York Times*, October 6, 1957.

[69] Harris, *Selling Uncle Sam*, 81-82; "Redstone Experts Tell of Spurned 'Moon,' " *The Washington Post*, October 13, 1957.

[70] "Device is 8 Times Heavier Than One Planned by U.S.," *The New York Times*, October 5, 1957; Robert C. Cowen, "Made-in-U.S.S.R. 'Moon' Circles Earth," *Christian Science Monitor*, October 5, 1957; "U.S. Stupidity Seen," *The New York Times*, October 6, 1957.

[71] Jack Raymond, "Clash of Services on Missile Looms," *The New York Times*, February 24, 1957; Russell Porter, "Army Suspends Nickerson From Rank for One Year," *The New York Times*, June 30, 1957.

[72] "2 Generals Say Army Could Have Had Satellite 2 Years Ago," *New York Times*, October 9, 1957.

[73] "Avoid Satellite Row, Army Orders Experts," *The Washington Post*, October 10, 1957; "Redstone Experts Tell of Spurned 'Moon,' " *The Washington Post*, October 13, 1957; Drew Pearson, "6 U.S. Satellites Gathering Dust," *The Washington Post*, October 25, 1957.

[74] George Barrett, "Visit With a Prophet of the Space Age," *The New York Times Magazine*, October 20, 1957, SM-14, 86-87.

[75] Barrett, "Visit With a Prophet," SM-14, 86.

[76] John W. Finney, "Program Speeded: Launchings Would Be In Addition to Navy Plans for Six," *The New York Times*, November 6, 1957; Neufeld, *Dreamer of Space*, 314-316; "Von Braun Says Five Years Are Needed to Catch Soviet," *The New York Times*, Nov. 10, 1957.

[77] "Advertising: News from Magazine Industry," *The New York Times*, March 20, 1957; James L. Baughman, "Who Read *Life*? The Circulation of America's Favorite Magazine," in *Looking at Life Magazine*, ed. Erika Doss (Washington: Smithsonian Institution Press, 2001), 47-48.

[78] "The Looks and the Feel of the Hardware," *Life*, November 19, 1957, 134-135; "Flying Fun and a Family Tea," *Life*, November 19, 1957, 138-139.

[79] "The Seer of Space," *Life*, November 19, 1957, 133.

[80] "Plain Talk from Von Braun," *Life*, November 19, 1957, 136.

Chapter 2

[1] Because of the classified nature of some missile programs, a completely accurate count of early Cape Canaveral launches does not exist. A detailed estimate has been compiled in Cliff Lethbridge, "Painting By Numbers: A Statistical Analysis of Cape Canaveral Launches, The First 50 Years." http://spaceline.org/statistics/50-years.html.

[2] Gordon L. Harris, *Selling Uncle Sam* (Hicksville, N.Y.: Exposition Press, 1976), 79, 85; "Missiles: On the Firing Line," *Newsweek*, November 25, 1957, 39-40.

[3] "Missiles: On the Firing Line"; "Oral History: Remembering the Space Race," *Quest* 9, no. 3 (2002): 7; Walter Cronkite, *A Reporter's Life* (New York: Alfred A. Knopf, 1996), 273.

[4] Paul Lancaster, "Missiletown, Fla.: Cocoa Beach Booms as Test Base Speeds Missile, Satellite Work," *Wall Street Journal*, December 3, 1957.

[5] George Barrett, "Visit to 'Earthstrip No. 1'," *The New York Times Magazine*, September 8, 1957, SM106; Lancaster, "Missiletown, Fla."

[6] Lethbridge, "Painting By Numbers"; Lancaster, "Missiletown, Fla."

[7] W.H. Lawrence, "President Voices Concern on U.S. Missiles Program, but Not on the Satellite," *The New York Times*, October 10, 1957; "U.S. Satellite Plans Told," *Christian Science Monitor*, October 9, 1957; John W. Finney, "Secrecy Will Veil Satellite Launching," *The New York Times*, December 30, 1957.

[8] "On Refusing to Race," *The Washington Post*, October 10, 1957; William H. Stringer, "President Moves to Match Sputnik," *Christian Science Monitor*, October 14, 1957.

[9] "Satellites: The Calamity … Why," *Newsweek*, December 16, 1957, 66.

[10] "Security Curbs Shield Vanguard," *The New York Times*, December 5, 1957.

[11] "Periscoping the Nation: 'Bird Watchers' Diary," *Newsweek*, December 16, 1957, 25; Finney, "Secrecy Will Veil Satellite Launching"; "Satellites: The Calamity," 66.

[12] "U.S. Satellite Launching Now Scheduled for Dec. 4," *Christian Science Monitor*, November 26, 1957; "U.S. Baby Satellite Is Described," *The New York Times*, November 29, 1957; "U.S. Reported Set to Fire Big 'Moon'," *Christian Science Monitor*, November 29, 1957.

[13] "Capital Dismayed at Test's Failure," *The New York Times*, December 7, 1957; Robert C. Cowen, "Missile Fizzle: Normal Hazard?" *Christian Science Monitor*, December 7, 1957; "Advance Publicity Harmful Abroad, Democrats Say," *The Washington Post*, December 7, 1957; Milton Bracker, "U.S. Ready to Fire First Satellite Early This Week," *The New York Times*, December 2, 1957.

[14] "The Build-Up, the Letdown," *Newsweek*, December 16, 1957, 65; "Leaky Valve, Bad Weather Delay U.S. Satellite 'Shoot'," *Christian Science Monitor*, December 5, 1957.

[15] Harry Reasoner, *Before the Colors Fade* (New York: Knopf, Distributed by Random House, 1981), 39-40.

[16] Jay Barbree, *Live From Cape Canaveral: Covering the Space Race, From Sputnik to Today* (New York: Smithsonian Books/Collins, 2007), 11.

[17] "Advance Publicity Harmful Abroad."

[18] "Satellites: The Calamity ... Why," 65; "Flop: World Sober, Satirical," *Christian Science Monitor*, December 7, 1957.

[19] "Failure Reported Quickly in Russia," *The New York Times*, December 7, 1957; William J. Jorden, "Pravda Jubilant at U.S. Failure," *The New York Times*, December 9, 1957.

[20] "Rocket Failure Shocks Public; Many See World-Wide Ridicule," *The New York Times*, December 7, 1957.

[21] "Sputtering Spaetnik," *Christian Science Monitor*, December 7, 1957.

[22] "Failure and Its Lessons," *The New York Times*, December 7, 1957.

[23] "Advance Publicity Harmful Abroad."

[24] Finney, "Secrecy Will Veil Satellite Launching"; "Up There – At Last," *Newsweek*, February 10, 1958, 29; "Newsmen Agreed to Delay Reports," *The New York Times*, February 1, 1958.

[25] "End of the Vigil," *Newsweek*, February 10, 1958, 34; "Newsmen Agreed to Delay Reports"; Harris, *Selling Uncle Sam*, 79.

[26] "Up There – At Last," 29; "Newsmen Agreed to Delay Reports."

[27] Dennis Piszkiewicz, *Wernher von Braun: The Man Who Sold the Moon* (Westport, Conn.: Praeger, 1998), 119; "End of the Vigil," 34; Michael J. Neufeld, *Von Braun: Dreamer of Space, Engineer of War* (New York: Alfred A. Knopf in association with the National Air and Space Museum, Smithsonian Institution, 2007), 320.

[28] "End of the Vigil," 34; "Up There – At Last," 28; Robert Alden, "U.S. Satellite Heard Here and on Coast," *The New York Times*, February 1, 1958.

[29] "End of the Vigil," 34.

[30] Courtney Sheldon, "Triumph for Army," *The Christian Science Monitor*, February 1, 1958; Neufeld, *Dreamer of Space*, 323; John W. Finney, "U.S. Satellite Is 'Working Nicely'," *The New York Times*, February 2, 1958.

[31] "Up There – At Last," 31; "Reach for the Stars," *Time*, February 17, 1958, 25.

[32] "Space: Reaching for the Moon," *Newsweek*, December 16, 1957, 66-67; Harry C. Kenney, "Space Flight Agency Urged," *Christian Science Monitor*, December 5, 1957; "Eisenhower's Message on Space Agency," *The New York Times*, April 3, 1958; "Civil Space Group Starts Operation," *The New York Times*, October 2, 1958.

[33] The National Aeronautics and Space Act, Pub. L. No. 85-568 72 Stat. 426 (Jul. 29, 1958), Sec. 203. (a) (3). http://www.nasa.gov/offices/ogc/about/space_act1.html.

[34] Memorandum from Walter T. Bonney to Keith Glennan, September 9, 1958, NASA History Office, Washington, D.C.

[35] Memorandum from Walter T. Bonney to Keith Glennan, September 9, 1958.

[36] Memorandum from Walter T. Bonney to Keith Glennan, September 9, 1958.

[37] Memorandum from Walter T. Bonney to Keith Glennan, September 9, 1958; Richard Witkin, "Rocket Fails in Moon Shot, Blowing Up in 77 Seconds," *The New*

York Times, August 18, 1958; John P. Shanley, "TV and the Rocket," *The New York Times,* August 24, 1958.

[38] Memorandum from Walter T. Bonney to Keith Glennan, September 9, 1958.

[39] Col. John A. Powers, interview by Robert Merrifield, November 9, 1968, NASA History Office, Washington, D.C.; Memorandum from Herb Rosen to Walter T. Bonney, November 24, 1958, NASA History Office, Washington, D.C.

[40] Ginger Rudeseal Carter, "Public Relations Enters the Space Age: Walter S. Bonney and the Early Days of NASA P.R." (paper presented to the History Division of the Association for Education in Journalism and Mass Communication, Chicago, August 1997). https://listserv.cmich.edu/cgi-bin/wa.exe? A2=ind9709&L=aejmc&T=0&P=13505; Paul P. Haney, interview by Sandra Johnson, January 20, 2003, NASA Johnson Space Center Oral History Project, transcript at http://www.jsc.nasa.gov/history/oral_histories/ participants.htm.

[41] Carter, "Public Relations Enters the Space Age."

[42] "Rendezvous with Destiny," *Time,* April 20, 1959, 17, 19; Edward Gamarekian, "'7 Picked for 'Mercury' Called 'Cream of Crop'," *The Washington Post,* April 10, 1959; Loyd S. Swenson Jr., James M. Grimwood and Charles C. Alexander, *This New Ocean: A History of Project Mercury,* NASA Special Publication-4201 in the NASA History Series, 1989), 60-64. http://www.hq.nasa.gov/ office/pao/History/SP-4201/ch6-8.htm.

[43] Christopher C. Kraft, *Flight: My Life in Mission Control* (Waterville, ME: Thorndike Press, 2001), 90; John A. Powers Biography, MA-8/18, NASA History Office, Washington, D.C.; "Calm Voice From Space," *Time,* March 2, 1962, 39; Col. John A. Powers, interview by Robert Merrifield, November 9, 1968.

[44] Col. John A. Powers, interview by Robert Merrifield, November 9, 1968.

[45] Carter, "Public Relations Enters the Space Age"; Paul P. Haney, interview by Sandra Johnson, January 20, 2003.

[46] Col. John A. Powers, interview by Robert Merrifield, November 9, 1968.

[47] Col. John A. Powers, interview by Robert Merrifield, November 9, 1968; Roger D. Launius, "Heroes in a Vacuum: The Apollo Astronaut as Cultural Icon" (paper presented to the 43rd AIAA Aerospace Sciences Meeting and Exhibit, January 10-13, 2005, Reno, Nevada).

[48] The exchange between the two astronauts is recounted in Alan B. Shepard and Donald K. Slayton, *Moon Shot: The Inside Story of America's Race to the Moon* (Atlanta: Turner Pub., 1994), 62.

[49] Roger D. Launius and Bertram Ulrich, *NASA and the Exploration of Space: With Works from the NASA Art Collection* (New York: Stewart, Tabori and Chang, 1998), 40-41; Launius, "Heroes in a Vacuum."

[50] Launius and Ulrich, *NASA and the Exploration of Space,* 41; Shepard and Slayton, *Moon Shot,* 63; Donald K. Slayton and Michael Cassutt, *Deke! U.S. Manned Space: From Mercury to the Shuttle* (New York: Forge, 1994), 74.

[51] Launius and Ulrich, *NASA and the Exploration of Space,* 41.

[52] Shepard and Slayton, *Moon Shot,* 65.

[53] Neal Thompson, *Light This Candle: The Life and Times of Alan Shepard, America's First Spaceman* (New York: Crown Publishers, 2004), 169; John Catchpole, *Project Mercury: Nasa's First Manned Space Programme,* Springer-Praxis Books in Astronomy and Space Sciences (London: Springer, published in association

with Praxis Pub., 2001), 96; Tom Wolfe, *The Right Stuff* (New York: Farrar, Straus and Giroux, 1979), 89-90.

[54] Thompson, *Light This Candle*, 169-170.

[55] Thompson, *Light This Candle*, 170-171; John W. Finney, "7 Named as Pilots for Space Flights Scheduled in 1961," *The New York Times*, April 10, 1959; John G. Norris, "7 Vie to Be First Man in Space," *The Washington Post*, April 10, 1959; "The Seven Chosen," *Time*, April 20, 1959, 18; "Rendezvous with Destiny," *Time*, April 20, 1959, 17, 19; Paul P. Haney, interview by Sandra Johnson, January 20, 2003; Wolfe, *The Right Stuff*, 93-94.

[56] Catchpole, *Project Mercury*, 96; Wolfe, *The Right Stuff*, 90.

[57] James Reston, "Washington: The Sky's No Longer the Limit," *The New York Times*, April 12, 1959.

[58] Andrew Heiskell, "The Astronauts Own Stories Will Appear Only in *Life*," *Life*, August 24, 1959, 98-99; Robert Sherrod, "The Selling of the Astronauts," *Columbia Journalism Review* (May/June 1973): 17; Thompson, *Light This Candle*, 173-174.

[59] The astronauts' first exclusive stories appear in the September 14, 1959, issue of *Life*, pages 26-43.

[60] Published articles and photos about the astronauts' training that predate their first *Life* issue include C.B. Palmer, "The 'Supernormal' Seven," *The New York Times Magazine*, August 16, 1959, SM22; William G. Wearts, "Astronauts Try Take-Off Device," *The New York Times*, August 26, 1959; Roger Greene, "Astronauts Taking Exhausting Tests Without Qualms," *The Washington Post*, September 6, 1959. Criticism over the *Life* deal is discussed in detail in Sherrod's "The Selling of the Astronauts," 17-25.

[61] The wives' first exclusive stories appear in the September 21, 1959, issue of *Life*, pages 142-163.

[62] Trudy Cooper, "I Want to Watch It Go," *Life*, September 21, 1959, 157.

[63] Gordon Cooper and Bruce Henderson, *Leap of Faith: An Astronaut's Journey Into the Unknown* (New York: HarperTorch, 2002), 18-19; Thompson, *Light This Candle*, 174-175; "To the Astronauts!" *The Washington Post*, April 11, 1959.

[64] Memorandum from Walter T. Bonney to Keith Glennan, August 20, 1959, NASA History Office, Washington, D.C.

[65] Memorandum from Walter T. Bonney to Keith Glennan, August 20, 1959.

[66] Memorandum from Walter T. Bonney to Keith Glennan, August 20, 1959.

[67] Memorandum from Walter T. Bonney to Keith Glennan, August 20, 1959.

[68] Memorandum from Walter T. Bonney to Keith Glennan, August 20, 1959.

[69] Howard Benedict, "From Missiles to the Moonshot," *Air and Space Smithsonian*, June/July 1989, 83; "Information-Handling Procedures for East Coast Satellite and Space Vehicle Launchings," NASA Release No. 59-133, May 8, 1959, NASA History Office, Washington, D.C.

[70] A.M. Sperber, *Murrow: His Life and Times* (New York: Freundlich Books, 1986), 482-483, 529-535.

[71] "Murrow Says Stanton Criticism Shows Ignorance of TV Method," *The New York Times*, October 25, 1959; Jack Gould, "TV: Applause for Stanton," *The New York Times*, October 28, 1959.

[72] Frank Stanton, interview by Mary Marshall Clark, December 15, 1992, Notable New Yorkers, Columbia University Libraries Oral History Research Office, 433-

435, transcript at http://www.columbia.edu/cu/lweb/digital/collections/ nny/stantonf/transcripts/stantonf_1_10_433.html.

[73] Frank Stanton, interview by Mary Marshall Clark, December 15, 1992.

[74] The conversation with Fred Friendly is recounted by Frank Stanton in his interview by Mary Marshall Clark, December 15, 1992.

[75] John P. Shanley, "TV Reviews: Lucid Study," *The New York Times*, October 28, 1959; "Best Foot Forward," *Time*, November 9, 1959, 58.

[76] Shanley, "TV Reviews: Lucid Study"; Lawrence Laurent, "'Misalliance' Forecast as Major Test of Shaw on Playhouse 90 Performance," *The Washington Post*, October 29, 1959.

[77] Laurent, "'Misalliance' Forecast as Major Test"; Shanley, "TV Reviews: Lucid Study." Murrow's "wires and lights in a box" speech to the Radio and Television News Directors meeting and reaction to it is addressed in Joseph E. Persico, *Edward R. Murrow: An American Original* (New York: McGraw-Hill, 1988), 433-435 and Sperber, *Murrow: His Life and Times*, 539-542.

[78] Michael R. Beschloss, *Mayday: Eisenhower, Khrushchev, and the U-2 Affair* (New York: Harper & Row, 1986), 39-49.

[79] Beschloss, *Mayday*, 49-50; John W. Finney, "Space Unit Upset Over Repudiation," *The New York Times*, May 10, 1960.

[80] Beschloss, *Mayday*, 51-52; "Text of the U.S. Statement on Plane," *The New York Times*, May 6, 1960; Jack Raymond, "Capital Explains," *The New York Times*, May 6, 1960; Rose McDermott, "The U-2 Crisis," chapter in *Risk-Taking in International Politics: Prospect Theory in American Foreign Policy* (Ann Arbor, MI: University of Michigan Press, 1998), 114.

[81] Osgood Caruthers, "'Confession' Cited," *The New York Times*, May 8, 1960; Finney, "Space Unit Upset Over Repudiation."

[82] Russell Baker, "Space Aide Tells Why Agency Lied on U-2 Incident," *The New York Times*, June 2, 1960; Beschloss, *Mayday*, 110-111.

[83] "Space Aide Gets New Post," *The New York Times*, October 11, 1960; Memorandum for the Administrator from Joe Stein, October 14, 1960, NASA History Office, Washington, D.C.

Chapter 3

[1] Col. John A. Powers, interview by Robert Merrifield, November 9, 1968, NASA History Office, Washington, D.C.

[2] " 'We're All Asleep,' Says Space Aide," *The Washington Post*, April 13, 1961.

[3] Loyd S. Swenson, James M. Grimwood, and Charles C. Alexander, *This New Ocean: A History of Project Mercury* (Washington, D.C.: National Aeronautics and Space Administration, 1998), 332.

[4] Letter from Shorty Powers to Director, Office of Public Information, NASA, April 16, 1961, NASA History Office, Washington D.C.

[5] Letter from Shorty Powers to Director, Office of Public Information, NASA, April 16, 1961.

[6] John W. Finney, "Washington: U.S. Claims Scientific Lead Despite the Soviet Union's 'Spectaculars,' " *The New York Times*, April 16, 1961.

[7] "3 Chosen for Space Flight in Two or Three Months," *The New York Times*, February 22, 1961; Gene Kranz, *Failure is Not an Option* (New York: Simon and Schuster, 2000), 45.

[8] Billy Watkins, *Apollo Moon Missions: The Unsung Heroes* (Westport, Conn.: Praeger Publishers, 2006), 59; Swenson, Grimwood, and Alexander, *This New Ocean*, 349; Paul Haney, interview by Robert Merrifield, April 8, 1968, NASA History Office, Washington, D.C.; Scott Carpenter, "Al Just Left Us All Behind," *Newsweek*, August 3, 1998, 48-49; Neal Thompson, *Light This Candle: The Life and Times of Alan Shepard* (New York: Crown Publishers, 2004), 202.

[9] "Summary of Discussion on Question of Possible Avoidance of 'Vanguard-Type' Buildup on Project Mercury Experimental Launches," NASA History Office, Washington, D.C.

[10] "Avoidance of 'Vanguard-Type' Buildup."

[11] "Avoidance of 'Vanguard-Type' Buildup"; memorandum from Shelby Thompson to Keith Glennan, December 14, 1960, NASA History Office, Washington, D.C.; memorandum from Abe Silverstein to Keith Glennan, December 14, 1960, NASA History Office, Washington, D.C.; memorandum from Shelby Thompson to Joseph A. Stein, December 17, 1960, NASA History Office, Washington, D.C.; letter from T. Keith Glennan to Earl Ubell, December 23, 1960, NASA History Office, Washington, D.C.; "Space Agency Eases Information Policy," *The New York Times*, December 28, 1960.

[12] Letter from T. Keith Glennan to Leonard Goldenson, President, American Broadcasting Company, February 18, 1960, NASA History Office, Washington, D.C.

[13] Richard L. Lyons, "Confidence in TV Still High, Roper Tells FCC," *The Washington Post*, December 18, 1959.

[14] Lawrence K. Grossman, "Murrow Said It All In 1958," *Columbia Journalism Review*, May/June 2002, 53; Jack Gould, "1959 Off Camera," *The New York Times*, December 27, 1959.

[15] Gould, "1959 Off Camera"; James L. Baughman, *The Republic of Mass Culture*, Third Edition (Baltimore: Johns Hopkins University Press, 2006), 94-95; Lawrence Laurent, "TV Is Beginning to Show Signs of Growing Up," *The Washington Post*, December 6, 1959; John Crosby, "Creativity May Follow 'The Year of Scandal'," *The Washington Post*, December 28, 1959; Jack Gould, "TV: The Great Debate," *The New York Times*, September 27, 1960; Richard F. Shepard, "73,500,000 Viewers Estimated To Have Seen Television Debate," *The New York Times*, September 28, 1960.

[16] Lawrence Laurent, "Networks' 'Pool' Ready for Astronaut Launching," *The Washington Post*, May 2, 1961; "How Radio-TV Will Cover First U.S. Astronaut," *Broadcasting*, April 24, 1961, 52, 54.

[17] Paul Haney, interview by Robert Merrifield, April 8, 1968; "Astronaut's Protector: Walter Charles Williams," *The New York Times*, May 5, 1961.

[18] Paul Haney, interview by Robert Merrifield, April 8, 1968.

[19] Paul Haney, interview by Robert Merrifield, April 8, 1968; Paul P. Haney, interview by Sandra Johnson, January 20, 2003, NASA Johnson Space Center Oral History Project, transcript at http://www.jsc.nasa.gov/history/oral_histories/participants.htm.

[20] John W. Finney, "U.S. Acts to Stem Space Publicity," *The New York Times*, May 2, 1961; Walter Cronkite, *A Reporter's Life* (New York: Alfred A. Knopf, 1996), 274-275; "Senators Voice Fears," *The New York Times*, May 2, 1961; Lawrence Laurent, "Millions of Viewers Shot Into Space With Shepard," *The Washington Post*, May 6, 1961.

[21] Paul P. Haney, interview by Sandra Johnson, January 20, 2003.

[22] Paul P. Haney, interview by Sandra Johnson, January 20, 2003.

[23] Swenson, Grimwood, and Alexander, *This New Ocean*, 350; "How Radio-TV Will Cover First U.S. Astronaut," *Broadcasting*, April 24, 1961, 52, 54; John W. Finney, "U.S. Acts to Stem Space Publicity," *The New York Times*, May 2, 1961; Jay Barbree, *Live from Cape Canaveral: Covering the Space Race, from Sputnik to Today*, 1st ed. (New York: Smithsonian Books/Collins, 2007), 55.

[24] Lawrence Laurent, "Millions of Viewers Shot Into Space With Shepard," *The Washington Post*, May 6, 1961; John W. Finney, "Shepard Had Periscope: 'What a Beautiful View'," *The New York Times*, May 6, 1961; "Oral History: Remembering the Space Race," *Quest* 9, no. 3 (2002): 8; Christopher C. Kraft, *Flight: My Life in Mission Control* (Waterville, ME: Thorndike Press, 2001), 138; Thompson, *Light This Candle*, 248-251.

[25] Robert Conley, "Nation Exults Over Space Feat; City Plans to Honor Astronaut," *The New York Times*, May 6, 1961; Evelyn Lincoln, *My Twelve Years with John F. Kennedy* (New York: D. McKay Co., 1965), 258.

[26] "A Daughter at School Also Watches Father," *The New York Times*, May 6, 1961; "'Beautiful,' Says Wife of First Astronaut," *The Washington Post*, May 6, 1961.

[27] Jack Gould, "Radio-TV" Well Done!" *The New York Times*, May 6, 1961; Barbree, *Live from Cape Canaveral*, 59.

[28] Finney, "Shepard Had Periscope."

[29] Swenson, Grimwood, and Alexander, *This New Ocean*, 575; Kraft, *Flight*, 139-140.

[30] Laurent, "Millions of Viewers Shot Into Space"; Lawrence Laurent, "Networks' 'Pool' Ready for Astronaut Launching," *The Washington Post*, May 2, 1961; Gould, "Radio-TV: Well Done!"

[31] Laurent, "Millions of Viewers Shot Into Space"; Gould, "Radio-TV: Well Done!.

[32] Laurent, "Millions of Viewers Shot Into Space"; William H. Stringer, "Flight Publicity Upheld," *Christian Science Monitor*, May 6, 1961.

[33] John F. Kennedy news conference, May 5, 1961, John F. Kennedy Presidential Library and Museum, http://www.jfklibrary.org/Historical+Resources/ Archives/Reference+Desk/Press+Conferences/003POF05Pressconference 11_05051961.htm.

[34] Hugh Sidey, "The President's Voracious Reading Habits," *Life*, March 17, 1961, 56; "Text of Kennedy's Speech to Publishers," *The New York Times*, April 28, 1961; "Press Is Divided on Kennedy Talk," *The New York Times*, April 30, 1961.

[35] Baughman, *Republic of Mass Culture*, 96; Tom Wicker, "Kennedy Gives Shepard Medal," *The New York Times*, May 9, 1961; "… to hear, and to see and to listen," *Broadcasting*, May 15, 1961, 28-29.

[36] George Rosen, "Pub Affairs Role Redeems Medium," *Variety*, May 10, 1961.

[37] Val Adams, "F.C.C. Head Bids TV Men Reform 'Vast Wasteland'," *The New York Times*, May 10, 1961; Lawrence Laurent, "Broadcasting Industry Shaken by Blunt Talk," *The Washington Post*, May 11, 1961; Lawrence Laurent, "FCC

Chief Beards Broadcasters, Vows to Make Them Serve Public," *The Washington Post*, May 10, 1961; "FCC Head Seeks a Rein on TV Networks, Assails 'Mayhem' on Children's Shows," *The Wall Street Journal*, June 6, 1961; Louis G. Panos, "FCC Asks Networks Regulation," *The Washington Post*, June 20, 1961; "Minow Asks More TV News," *The Christian Science Monitor*, September 30, 1961; Frederick W. Roevekamp, "Network Chiefs Reject FCC Bid," *The Christian Science Monitor*, December 8, 1961; Phil Casey, "Most Letter Writers Support Minow In His Assault on Current TV Fare," *The Washington Post*, May 22, 1961.

[38] Jack Gould, "2 Networks Used Rehearsal Shots," *The New York Times*, July 22, 1961; Jack Gould, "Fakery in Space," *The New York Times*, June 30, 1961.

[39] Gould, "2 Networks Used Rehearsal Shots."

[40] Gould, "2 Networks Used Rehearsal Shots," Art Woodstone, "Hokum and Deceit, A Few Moments of Real Drama: Grissom's Flight," *Variety*, July 26, 1961; Gould, "Fakery in Space." The official Space Task Group report did not give a reason why the hatch blew on Liberty Bell 7, but many observers believed Grissom had inadvertently hit a button designed to open it. John Catchpole, *Project Mercury: Nasa's First Manned Space Programme*, Springer-Praxis Books in Astronomy and Space Sciences (London, New York: Springer, 2001), 304; Tom Wolfe, *The Right Stuff* (New York: Farrar, Straus, and Giroux, 1979), 230-233.

[41] "Kennedy Phones Salute to Pilot," *The New York Times*, July 22, 1961; Alvin Shuster, "Congress Wary on Cost, But Likes Kennedy Goals," *The New York Times*, May 26, 1961.

[42] Howard Benedict, " 'Shorty' Powers Loved the Rocket's Glare," *Florida Today*, January 3, 1980; "Calm Voice From Space," *Time*, March 2, 1962, 39; Col. John A. Powers, interview by Robert Merrifield, November 9, 1968.

[43] William Leavitt, "Speaking of Space: Cocoa Beach Blues," *Space Digest*, March 1962, 63-64.

[44] Neal Stanford, "U.S. Orbital Try Put Off to Feb. 13," *The Christian Science Monitor*, January 31, 1962.

[45] "Radio and TV Pool Will Cover Flight," *The New York Times*, January 26, 1962; Lawrence Laurent, "Networks Involved in Suspense Story," *The Washington Post*, January 26, 1962; "Pooling of Glenn Shoot Convinces TV Webs They Can Live Together," *Variety*, February 28, 1962; Joseph Arthur Angotti, "A Descriptive Analysis of NBC's Radio and Television Coverage of the First U.S. Manned Orbital Flight," unpublished M.A. thesis, Indiana University, 1965, 35-37.

[46] Angotti, "A Descriptive Analysis," 19-25.

[47] Art Woodstone, "Television's $1,000,000 (When & If) Manshoot; Lotsa Prestige & Intrigue," *Variety*, January 24, 1962; Richard F. Shepard, "2 Networks Show Astronaut Films," *The New York Times*, January 20, 1962; Angotti, "A Descriptive Analysis," 27, 45.

[48] "TV Spends Half Million To Cover Canceled Shot," *The New York Times*, January 28, 1962; "Networks' Space Shot Costs: $3 Million," *Broadcasting*, February 26, 1962, 50; "Shollenberger Injured at Orbital Site," *Broadcasting*, February 26, 1962, 50.

[49] "Eyewitness: A Flight Plan for Orbit," CBS broadcast January 19, 1962, transcript in Walter Cronkite Collection, Center for American History, Austin, Texas.

[50] "Eyewitness: A Flight Plan for Orbit," CBS broadcast January 19, 1962; Howard Benedict, "Relaxed Astronaut Attends Church," *The Washington Post*, January 22, 1962; "'Trust in the Lord,' Sings Glenn at Florida Church," *The Washington Post*, January 30, 1962; Tony Gieske, "Star Idea Stands Out As Glenns Worship," *The Washington Post*, February 5, 1962.

[51] Leavitt, "Speaking of Space"; John G. Norris, "Rocket Fails, Other Shots Wait," *The Washington Post*, January 25, 1962; Gladwin Hill, "Ranger Crosses Path of the Moon; TV Attempt Fails," *The New York Times*, January 29, 1962.

[52] Gay Talese, "75,000 On Beach Somber at News," *The New York Times*, January 28, 1962; James Reston, "Cape Canaveral: Half-Way to Heaven in Living Color," *The New York Times*, February 23, 1962; "Motel Waitress Slain," *The New York Times*, January 30, 1962; "Racket Boss Luciano Falls Dead in Italy," *The Washington Post*, January 27, 1962; Richard F. Shepard, "Carson May Take Paar's Post Oct. 1," *The New York Times*, January 31, 1962.

[53] Richard Witkin, "Glenn Orbit Shot Is Delayed Again," *The New York Times*, January 23, 1962; Richard Witkin, "Glenn's Orbiting Foiled By Clouds; 75,000 at Scene," *The New York Times*, January 28, 1962; Neal Stanford, "U.S. Orbital Try Put Off to Feb. 13," *The Christian Science Monitor*, January 31, 1962.

[54] Julian Scheer, "John Glenn's Lift-Off Into Politics," *The Washington Post*, February 20, 1975.

[55] "Networks' Space Shot Costs: $3 Million," *Broadcasting*, February 26, 1962, 50.

[56] Cronkite, *A Reporter's Life*, 280; "The Most Intimate Medium," *Time*, October 14, 1966, 63.

[57] "The Most Intimate Medium," *Time*, October 14, 1966, 63; "The 20th Century: Mission, Outer Space," CBS broadcast December 21, 1958, transcript in Walter Cronkite Papers, Center for American History, Austin, Texas; "Eyewitness: The Flight of the Saturn," CBS broadcast October 27, 1961, transcript in Walter Cronkite Papers, Center for American History, Austin, Texas; "The 20th Century: Reaching for the Moon," CBS broadcast September 20, 1959, transcript in Walter Cronkite Papers, Center for American History, Austin, Texas.

[58] Jack Iams, "TV Anchor Men Really in Orbit," *New York Herald-Tribune*, February 25, 1962.

[59] Angotti, "A Descriptive Analysis," 84-88.

[60] "Glenn Family to See Flight on Four TVs," *The Washington Post*, January 21, 1962; Sue Cronk, "Family Pride Orbited With Glenn," *The Washington Post*, February 21, 1962; "The High Price of History," *Television Magazine*, April 1962, 65; Nan Robertson, "New York Pauses to 'Watch' Glenn," *The New York Times*, February 21, 1962.

[61] Robertson, "New York Pauses to 'Watch' Glenn."

[62] "CBS News Extra: The Flight of John Glenn," broadcast February 20, 1962, transcript in Walter Cronkite Collection, Center for American History, Austin, Texas.

[63] Robertson, "New York Pauses to 'Watch' Glenn."

[64] Robertson, "New York Pauses to 'Watch' Glenn."

65 Angotti, "A Descriptive Analysis," 39-41; Chet Hagan, "Launch Day Working Routine MA-6 NBC News," appendix in Angotti, "A Descriptive Analysis."

66 Lawrence Laurent, "TV Took Nation Along With Glenn," *The Washington Post*, February 21, 1962; Angotti, "A Descriptive Analysis," 79-80.

67 Angotti, "A Descriptive Analysis," 73-75, 131-132; *It Was An Unprecedented Seven Days of Television*.

68 Bob Williams, "On the Air," *New York Post*, February 21, 1962; *It Was An Unprecedented Seven Days of Television: February 14-20, 1962* (New York: Columbia Broadcasting System, 1962).

69 *It Was An Unprecedented Seven Days of Television*; Hamish Lindsay, *Tracking Apollo to the Moon* (London, New York: Springer, 2001), 74; Jack O'Brian, "Co-Starring – Walter Cronkite," *New York Journal-American*, February 21, 1962; "Transcript of Colonel Glenn's Conversations With Ground on His 3 Circuits of Earth," *The New York Times*, February 21, 1962.

70 Iams, "TV Anchor Men Really in Orbit"; Isabella Taves, "Walter Cronkite: Why Won't He Be Himself on TV?" *Look*, August 25, 1964, 84.

71 *It Was An Unprecedented Seven Days of Television*; Iams, "TV Anchor Men Really in Orbit"; "O'Brian, "Co-Starring – Walter Cronkite"; Gay Talese, "Glenn Family Calm Amid Cheers and Confetti," *The New York Times*, February 24, 1962.

72 Bob Williams, "On the Air," *New York Post*, February 21, 1962; "Transcript of Colonel Glenn's Conversations."

73 Jack Gould, "TV: Astronaut Protected," *The New York Times*, February 22, 1962; *It Was An Unprecedented Seven Days of Television*.

74 *It Was An Unprecedented Seven Days of Television*; Gould, "TV: Astronaut Protected."

75 "Chronology of Glenn's Day, Beginning With His Awakening at 2:20 A.M. for Flight," *The New York Times*, February 21, 1962; Jack Gould, "Radio-TV: Networks Convey Drama of Glenn Feat," *The New York Times*, February 21, 1962; Angotti, "A Descriptive Analysis," 121; "TV Viewers 'In Orbit'," *The Christian Science Monitor*, February 21, 1962.

76 *It Was An Unprecedented Seven Days of Television*; Iams, "TV Anchor Men Really in Orbit"; Gould, "Radio-TV: Networks Convey Drama of Glenn Feat"; Jack Gould, "Miracle in Space," *The New York Times*, February 25, 1962; Marshall McLuhan, *The Gutenberg Galaxy: The Making of Typographic Man* (New York: Signet Books, 1969), 31.

77 Jack Gould, "TV: Glenn Comes Home," *The New York Times*, February 24, 1962; James Reston, "Cape Canaveral: Is the Moon Really Worth John Glenn?" *The New York Times*, February 25, 1962.

78 "Tuesday, Feb. 20, 1962," *Broadcasting*, February 26, 1962, 146; "The High Price of History," *Television Magazine*, April 1962, 65.

79 "The High Price of History," 65.

80 "The High Price of History," 65.

81 "Calm Voice From Space," *Time*, March 2, 1962, 39; "Col. Powers Is Earthlings' Link With Space Men," *The New York Times*, February 21, 1962.

82 "Aurora 7. Do You Read Me?" *Time*, June 1, 1962, 14-15; Swenson, Grimwood, and Alexander, *This New Ocean*, 449-450; "TV and Radio Into Fluid Drive With Bangup Coverage of Orbiting Carpenter," *Variety*, May 30, 1962.

[83] "Aurora 7. Do You Read Me?" 15-16; Richard Witkin, "On Ocean 3 Hours," *The New York Times*, May 25, 1962; Swenson, Grimwood, and Alexander, *This New Ocean*, 453.

[84] "Excerpts from the Description of Carpenter's Flight and His Rescue in the Atlantic," *The New York Times*, May 25, 1962.

[85] Kraft, *Flight*, 168.

[86] Col. John A. Powers, interview by Robert Merrifield, November 9, 1968.

[87] "Aurora 7. Do You Read Me?" 16; Richard Witkin, "Space Aides Knew Aurora Was Safe," *The New York Times*, May 26, 1962.

[88] "Entire Nation Gives Thanks When Astronaut Is Sighted," *The New York Times*, May 25, 1962; Cronkite, *A Reporter's Life*, 276; Dale L. Cressman, "Fighting for Access: ABC's 1965-66 Feud with NASA," *American Journalism* 24, no. 3 (2007): 135.

[89] Jack Gould, "Radio-TV: Painful Gap," *The New York Times*, May 25, 1962; "Oral History: Remembering the Space Race," *Quest* 9, no. 3 (2002): 16.

[90] Richard Witkin, "On Ocean 3 Hours," *The New York Times*, May 25, 1962; "Aurora 7. Do You Read Me?" 16; "Excerpts from the Description of Carpenter's Flight."

[91] CBS News Extra: "The Flight of Aurora 7," broadcast Thursday, May 24, 1962, transcript in Walter Cronkite Papers, Center for American History, Austin, Texas.

[92] Charles W. Corddry, "Capsule's 3d Orbit 'Troubles' Probed," *The Washington Post*, May 26, 1962; Kraft, *Flight*, 170.

[93] Col. John A. Powers, interview by Robert Merrifield, November 9, 1968; Gould, "Radio-TV: Painful Gap."

[94] Cronkite, *A Reporter's Life*, 276; Walter Cronkite, interview by Robert Sherrod, March 27, 1970, Robert Sherrod Collection, NASA History Office, Washington, D.C.

Chapter 4

[1] Graeme Zielinski, "Julian Scheer, NASA Publicist and N.Va. Conservationist, Dies," *The Washington Post*, September 4, 2001; Billy Watkins, *Apollo Moon Missions: The Unsung Heroes* (Westport, CT: Praeger, 2006), 53-54.

[2] Watkins, *Apollo Moon Missions*, 54-55.

[3] Watkins, *Apollo Moon Missions*, 54-55.

[4] Piers Bizony, *The Man Who Ran the Moon: James E. Webb, NASA, and the Secret History of Project Apollo* (New York: Thunder's Mouth Press, 2006), 15; Barton C. Hacker and James M. Grimwood, *On the Shoulders of Titans: A History of Project Gemini* (Washington, D.C.: National Aeronautics and Space Administration, 1977), 96-97 http://www.hq.nasa.gov/office/pao/History/SP-4203/ch5-2.htm; Courtney G. Brooks, James M. Grimwood and Loyd S. Swenson, *Chariots for Apollo: A History of Manned Lunar Spacecraft* (Washington, D.C.: National Aeronautics and Space Administration, 1979) http://www.hq.nasa.gov/office/pao/History/SP-4205/ch3-6.html.

[5] Bizony, *The Man Who Ran the Moon*, 11-13; Gay Talese, "Astronauts Investing in Motel Venture in Cape Canaveral," *The New York Times*, March 13, 1962; "Random Notes from Washington: A Word From the Chief Did It," *The New York Times*, June 4, 1962.

[6] John W. Finney, "Astronauts Decline Offer of Free Homes in Texas," *The New York Times*, April 4, 1962; Shorty Powers, interview by Robert Merrifield, November 9, 1968, NASA History Office, Washington, D.C.

[7] "Letters to the Times: Astronauts in Business," *The New York Times*, March 24, 1962; "Letters to the Editor: Feet of Clay," *The Washington Post*, March 18, 1962.

[8] "NASA Public Affairs Heads, 1958-1976," NASA History Office, Washington, D.C.; "November 1961-September 1963: Organizational and Key Personnel History, Office of Public Affairs," NASA History Office, Washington, D.C.; Julian Scheer, interview by Robert Merrifield, July 20, 1967, NASA History Office, Washington, D.C.

[9] Watkins, *Apollo Moon Missions*, 54-55.

[10] The conversation between Webb and Scheer is detailed in Watkins, *Apollo Moon Missions*, 54-55.

[11] Watkins, *Apollo Moon Missions*, 56-57; Michael Collins, interview by Robert Sherrod, September 9, 1974, NASA History Office, Washington, D.C.; Michael Collins, interview by Robert Sherrod, September 3, 1970, NASA History Office, Washington, D.C.; Robert Sherrod, "The Selling of the Astronauts," *Columbia Journalism Review* (May-June 1973), 18-19.

[12] Thomas Paine, interview by Robert Sherrod, August 14, 1970, NASA History Office, Washington, D.C.; Chris Kraft, interview by Robert Sherrod, July 27, 1972, NASA History Office, Washington, D.C.

[13] Robert R. Gilruth, interview by Robert Sherrod, August 26, 1969, NASA History Office, Washington, D.C.; "Flight Earns Glenn $245 Extra; He Anticipates It While in Orbit," *The New York Times*, February 21, 1962; Shorty Powers, interview by Robert Merrifield, November 9, 1968, NASA History Office, Washington, D.C.; Chris Kraft, *Flight: My Life in Mission Control* (Waterville, ME: Thorndike Press, 2001), 91; Walter Cunningham, *The All American Boys* (New York: Ibooks, 2003), 192-193; Paul Haney, interview by Robert Sherrod, June 17, 1971, NASA History Office, Washington, D.C.

[14] Neal Thompson, *Light This Candle: The Life and Times of Alan Shepard* (New York: Crown Publishers, 2004), 172-173; Shorty Powers, interview by Robert Merrifield, November 9, 1968.

[15] Donald K. Slayton and Michael Cassutt, *Deke!: U.S. Manned Space From Mercury to the Shuttle* (New York: Forge, 1994), 79-80; Shorty Powers, interview by Robert Merrifield, November 9, 1968; Wally Schirra and Richard N. Billings, *Schirra's Space* (Boston: Quinlan Press, 1988), 67-68; Ralph Morse, "Full-Court Press," *Air and Space Smithsonian*, June/July 1989, 87; Thompson, *Light This Candle*, 194-196.

[16] Morse, "Full-Court Press," 86-87.

[17] Sherrod, "The Selling of the Astronauts," 19-20; Robert R. Gilruth, interview by Robert Sherrod, August 26, 1969; Robert R. Gilruth, interview by Robert Sherrod, November 14, 1969, NASA History Office, Washington, D.C.

[18] Cunningham, *The All American Boys*, 194-195.

[19] Sherrod, "The Selling of the Astronauts," 20.

20 John W. Finney, "Kennedy Backs Sale of Space Memoirs," *The New York Times*, November 24, 1962; Sherrod, "The Selling of the Astronauts," 18.

21 Finney, "Kennedy Backs Sale of Space Memoirs"; Sherrod, "The Selling of the Astronauts," 20; "Policy Concerning Sale of Literary, Television and Radio Rights, and Endorsement of Commercial Products by Astronauts," NASA News Release No. 62-198, September 16, 1962, NASA History Office, Washington, D.C.; "NASA Outlines Astronaut Policy," NASA News Release No. 62-199, September 16, 1962, NASA History Office, Washington, D.C.

22 Richard Witkin, "Schirra Critical on Use of Glenn," *The New York Times*, September 14, 1962; Gilruth Rebuts Schirra Charge, *The New York Times*, September 15, 1962; "Glenn's Outside Activities Are Defended by Shepard," *The New York Times*, September 16, 1962; Walter Cronkite, "Walter Schirra: Our Next Man in Orbit," *Look*, September 11, 1962, 66-67; Walter Cronkite, interview by Robert Sherrod, March 27, 1970, NASA History Office, Washington, D.C.

23 Watkins, *Apollo Moon Missions*, 56-57.

24 Julian Scheer, interview by Robert Sherrod, June 30, 1969, NASA History Office, Washington, D.C.

25 Paul Haney, interview by Robert Sherrod, June 17, 1971, NASA History Office, Washington, D.C.; Mary Ann Watson, *The Expanding Vista: American Television in the Kennedy Years* (New York: Oxford University Press, 1990), 126-127.

26 Gordon Harris, *Selling Uncle Sam* (Hicksville, N.Y.: Exposition Press, 1976), 72; Jack Gould, "TV: An Astronaut's Day," *The New York Times*, October 4, 1962; Walter Cronkite, interview by Robert Sherrod, March 27, 1970.

27 Letter from Julian Scheer to James M. Grimwood, February 9, 1977, NASA History Office, Washington, D.C.; Thompson, *Light This Candle*, 313.

28 Watkins, *Apollo Moon Missions*, 55.

29 Brian Duff, interview by John Mauer, May 1, 1989, The Glennan-Webb-Seamans Project for Research in Space History, Smithsonian National Air and Space Museum, http://www.nasm.si.edu/research/dsh/TRANSCPT/DUFF3.HTM.

30 Watkins, *Apollo Moon Missions*, 55.

31 Julian Scheer, interview by Robert Sherrod, February 18, 1969, NASA History Office, Washington, D.C.

32 Julian Scheer, interview by Robert Merrifield, July 20, 1967.

33 Julian Scheer, interview by Robert Sherrod, February 18, 1969.

34 Julian Scheer, interview by Robert Sherrod, February 18, 1969; Julian Scheer, interview by Robert Sherrod, May 1, 1972, NASA History Office, Washington, D.C.

35 Julian Scheer, interview by Robert Sherrod, February 18, 1969.

36 Paul Haney, interview by Robert Sherrod, June 17, 1971; Art Woodstone, "Coop's Loops Get TV Whirl," *Variety*, May 22, 1963.

37 Bob Stahl, "Networks Blast Astronaut News Curb," *TV Guide*, June 1, 1963.

38 Stahl, "Networks Blast Astronaut News Curb."

39 Stahl, "Networks Blast Astronaut News Curb."

40 Robert C. Toth, "Col. Powers Is Losing His Post as Spokesman for Space Flights," *The New York Times*, July 20, 1963; "Powers Scores Idea of Women Astronauts," *Washington Evening Star*, July 11, 1963.

[41] "Haney Succeeds Lt. Col. Powers," NASA Release No. 63-167, July 31, 1963, NASA History Office, Washington, D.C.; Julian Scheer, interview by Robert Sherrod, May 1, 1972; "Powers Gets Space Job in District," *Washington Sunday Star*, August 18, 1963; Toth, "Col. Powers Is Losing His Post."

[42] Memorandum from James Webb to Dr. George Simpson, August 9, 1963, NASA History Office, Washington, D.C.; "Administrative History of Public Affairs (Ca. 1963-1967)," NASA History Office, Washington, D.C.; Caryl Rivers, "NASA: News Chief Respects Reporters," *Editor and Publisher*, April 4, 1964, 44.

[43] "NASA Information Plan," *Aviation Week*, March 3, 1962, 17; Walter Pennino, interview by Lee Saegesser and Steve Garber, February 19, 1997, NASA History Office, Washington, D.C.; Julian Scheer, interview by Robert Merrifield, July 20, 1967; Rivers, "NASA: News Chief Respects Reporters," 44.

[44] "Administrative History of Public Affairs (Ca. 1963-1967)."

[45] "Administrative History of Public Affairs (Ca. 1963-1967)"; Julian Scheer, interview by Robert Merrifield, July 20, 1967.

[46] Bizony, *The Man Who Ran the Moon*, 18; Brian Duff, interview by John Mauer, April 24, 1989, The Glennan-Webb-Seamans Project for Research in Space History, Smithsonian National Air and Space Museum, http://www.nasm.si.edu/research/dsh/TRANSCPT/DUFF1.HTM; Brian Duff, interview by John Mauer, May 1, 1989.

[47] Rivers, "NASA: News Chief Respects Reporters," 43.

[48] Rivers, "NASA: News Chief Respects Reporters," 43.

[49] Rivers, "NASA: News Chief Respects Reporters," 43.

[50] Sherrod, "The Selling of the Astronauts," 21-22.

[51] Watkins, *Apollo Moon Missions*, 56-57.

[52] Watkins, *Apollo Moon Missions*, 56.

[53] "Public Affairs Program Review Document," April 19, 1966, NASA History Office, Washington, D.C.

[54] Brian Duff, interview by John Mauer, April 24, 1989.

[55] Robert L. Heath, Gabriel M. Vasquez, *Handbook of Public Relations* (Thousand Oaks, CA: Sage Publications, 2001), 480-481; Brian Duff, interview by John Mauer, April 24, 1989; Edwin Diamond, "That Moon Trip: Debate Sharpens," *The New York Times*, July 28, 1963.

[56] Diamond, "That Moon Trip: Debate Sharpens."

[57] Brian Duff, interview by John Mauer, April 24, 1989; "Public Affairs Program Review Document."

[58] Rivers, "NASA: News Chief Respects Reporters," 43.

Chapter 5

[1] John Noble Wilford, "Gemini 8 Crew Is Forced Down in Pacific," *The New York Times*, March 17, 1966; "At 'The Limit,' Man Prevails," *Newsweek*, March 28, 1966, 60-61; "A 'Glitch' on Gemini 8 ...," *America*, April 2, 1966, 430-431.

[2] Martin Waldron, "Calm Shattered at Space Center," *The New York Times*, March 17, 1966; "Voice in Space: Gemini 'Is Tumbling and We Can't Turn Anything

Off'," *The Washington Post*, March 18, 1966; "A 'Glitch' on Gemini 8 ...," 430-431.

3 John G. Rogers, "Fans for Fiction," *New York Herald-Tribune*, March 18, 1966; "... and 'Lost in Space'," *America*, April 2, 1966, 431.

4 Rogers, "Fans for Fiction"; "... and 'Lost in Space'."

5 "CBS News Special Report: Gemini Preview," March 22, 1965, transcript in Walter Cronkite Papers, Center for American History, Austin, Texas.

6 "CBS and NBC: Walter vs. Chet and Dave," *Newsweek*, September 23, 1963, 62; Val Adams, "Networks Drop Regular Shows," *The New York Times*, November 23, 1963; Val Adams, "Back to Normal for Radio and TV," *The New York Times*, November 26, 1963; Lawrence Laurent, "Weekend Coverage Earns Great Praise," *The Washington Post*, November 28, 1963.

7 William Whitworth, "Profiles: An Accident in Casting," *The New Yorker*, August 3, 1968, 51; Jeff Alan and James Martin Lane, *Anchoring America: The Changing Face of Network News* (Chicago: Bonus Books, 2003), 101; Reuven Frank, *Out of Thin Air: The Brief Wonderful Life of Network News* (New York: Simon and Schuster, 1991), 111-112.

8 Whitworth, "Profiles: An Accident in Casting," 50; Alan, *Anchoring America*, 98; Hollis Alpert, "TV's Unique Tandem: Huntley-Brinkley," *Coronet*, February 1961, 163; Jack Gould, "Friendly Rival," *The New York Times*, March 8, 1964; Val Adams, "Cronkite Denies He Plans to Quit," *The New York Times*, August 4, 1964.

9 Dale L. Cressman, "Fighting for Access: ABC's 1965-66 Feud with NASA," *American Journalism* 24, no. 3 (2007): 144; "CBS and NBC: Walter vs. Chet and Dave," 62-63.

10 Jack Gould, "New Faces in Old Places," *The New York Times*, August 9, 1964; Gould, "Friendly Rival."

11 Barbara Matusow, *The Evening Stars: The Making of the Network News Anchor* (Boston: Houghton Mifflin, 1983), 117; Gould, "New Faces in Old Places"; Adams, "Cronkite Denies He Plans to Quit"; Jack Gould, "C.B.S. by a Landslide," *The New York Times*, November 4, 1964.

12 "The TV Teeter-Totter," *The New York Times*, March 14, 1965; Gould, "New Faces in Old Places"; Frank, *Out of Thin Air*, 133; Jack Gould, "Robert Edmonds Kintner: The Man From NBC," *The New York Times*, October 24, 1965.

13 Gould, "Friendly Rival"; Gould, "New Faces in Old Places"; Gould, "Robert Edmonds Kintner"; Jack Gould, "Peacock Preening Time," *The New York Times*, April 25, 1965.

14 Pad 19," *The New Yorker*, April 3, 1965, 38-39; Gay Talese, "Cocoa Beach: The Verve Fades, and a Yawn Replaces the Boom," *The New York Times*, March 23, 1965.

15 "Pad 19," 38.

16 John Horn, "G3 Liftoff Right Down TV's Alley," *New York Herald-Tribune*, March 24, 1965.

17 Evert Clark, "Gemini Is Ready for Flight Today," *The New York Times*, March 23, 1965; "Corned Beef Incidents Are Barred By NASA," *The New York Times*, May 6, 1965; Paul Gardner, "TV Review: Astronauts Escorted into Orbit and Back," *The New York Times*, March 24, 1965.

18 Walter Sullivan, "Astronauts Ready to Start 62-Orbit Space Trip Today," *The New York Times*, June 3, 1965; "Live From Space," *Newsweek*, June 14, 1965, 72.

[19] "And Now ... Over to Houston," *Newsweek*, June 14, 1965, 33; Evert Clark, "New NASA Center Making Its Debut," *The New York Times*, June 3, 1965.

[20] "Live From Space," 72.

[21] Louis Alexander, "Space Flight News: NASA's Press Relations and Media Reaction," *Journalism Quarterly* 43, no. 4 (Winter 1966), 722-23; CBS memorandum, May 12 plan for June 3, 1965, launch, Walter Cronkite papers, Center for American History, Austin, Texas; "Space Coverage Costs $4 Million," *Broadcasting*, June 7, 1965, 68.

[22] Alexander, "Space Flight News," 723-24.

[23] Alexander, "Space Flight News," 723-24.

[24] Alexander, "Space Flight News," 724.

[25] Alexander, "Space Flight News," 724-25.

[26] Gould, "Radio-TV: Gemini Flight's Drama Brought Home"; George Gent, "The Home Viewer's Gemini," *The New York Times*, May 30, 1965; Cressman, "Fighting for Access," 138.

[27] Gent, "The Home Viewer's Gemini"; "All Stops Pulled Out on Flight Promotion," *Broadcasting*, June 7, 1965, 68-69.

[28] "Space Coverage Costs $4 Million," *Broadcasting*, June 7, 1965, 68; Walter Carlson, "Advertising: Gulf Using Instant Sponsorship," *The New York Times*, June 9, 1965.

[29] Lawrence Laurent, "All Three Networks Now Pushing Color," *The Washington Post*, May 7, 1965; Kenneth G. Slocum, "Stampede to Color," *The Wall Street Journal*, March 3, 1965; Paul Molloy, "Froth Dominates Networks' Schedule for Coming Season," *The Washington Post*, August 5, 1964; "NBC Will Increase Color-TV Programming in the Coming Season," *The Wall Street Journal*, March 9, 1965; Jack Gould, "TV: Sarnoff Triumphant," *The New York Times*, March 10, 1965; Jack Gould, "Op (Color) Comes to TV Art," *The New York Times*, March 21, 1965.

[30] Gould, "Radio-TV: Gemini Flight's Drama Brought Home"; "If you followed the four-day Gemini IV flight on NBC-TV, you had plenty of company ..." advertisement, *The New York Times*, June 9, 1965; "Gemini Broadcast Times," *The New York Times*, June 3, 1965; Lawrence Laurent, " 'Simulation' Leaves a Trail of Confusion," *The Washington Post*, June 8, 1965.

[31] "The Great Adventure Moves Ahead," *Newsweek*, June 14, 1965, 30, 33; Cressman, "Fighting for Access," 138; Gould, "Radio-TV: Gemini Flight's Drama Brought Home."

[32] E.G. Sherburne, Jr., "Television Coverage of the Gemini Program," *Science*, September 17, 1965, 1329; "Live From Space," *Newsweek*, June 14, 1965, 72.

[33] "Live From Space," 72; Frank, *Out of Thin Air*, 234-235.

[34] Matusow, *The Evening Stars*, 127; "Live From Space," 72.

[35] Val Adams, "Networks Planning Coverage of Gemini Spacecraft Landing," *The New York Times*, June 5, 1965; Jack Gould, "Radio-TV: Space Victory," *The New York Times*, June 8, 1965; Laurent, " 'Simulation' Leaves a Trail of Confusion."

[36] Laurent, " 'Simulation' Leaves a Trail of Confusion."

[37] "$6 Million for Gemini 4 TV," *Broadcasting*, June 14, 1965, 66; "3 Networks Carry Films of Astronaut; Re-Runs on Today," *The New York Times*, June 9, 1965; Val Adams, "Space Excursion Goes on TV Today," *The New York Times*, June

8, 1965; "The Great Adventure Moves Ahead," *Newsweek*, June 14, 1965, 30; Lawrence Laurent, "Outer Space Comes Alive in Walk Film," *The Washington Post*, June 9, 1965.

38 "First Again ... And Again!" advertisement, *The New York Times*, June 9, 1965; "CBS Takes Gemini Ratings," *Broadcasting*, June 7, 1965, 9; "$6 Million for Gemini 4 TV," 66; Walter Carlson, "Advertising: Gemini 4, TV and a Big Ad," *The New York Times*, June 8, 1965.

39 "$6 Million for Gemini 4 TV," 66; Lawrence Laurent, "Networks Will Pool Efforts on Space Shot Coverage," *The Washington Post*, June 12, 1965; Val Adams, "TV Pool Proposed for Space Shots," *The New York Times*, June 9, 1965; Val Adams, "Networks Study Space News Pool," *The New York Times*, June 10, 1965.

40 "Extensive Pool for Gemini 5," *Broadcasting*, July 26, 1965, 62; "ITT Seeks Early Bird on Gemini TV," *The Washington Post*, July 20, 1965; "Comsat In Dispute Over Gemini 5 TV," *The New York Times*, July 23, 1965; "Thumbs Down on Live Pickup of Splashdown," *Broadcasting*, August 2, 1965, 9.

41 "Thumbs Down on Live Pickup of Splashdown," *Broadcasting*, August 2, 1965, 9; NBC advertisement, *The New York Times*, August 19, 1965; NBC advertisement, *The Washington Post*, August 19, 1965; NBC advertisement, *The New York Times*, August 21, 1965; Macy's advertisement, *The New York Times*, August 12, 1965.

42 "... and Protests From Sports Fans," *America*, September 4, 1965, 231.

43 Val Adams, "Friendly Assails Gemini Coverage," *The New York Times*, August 21, 1965; "GT-5 Shoots Down Friendly Memo With a Real Space Cliffhanger, As Arbitron Vindicates NBC 'Overkill'," *Variety*, August 25, 1965; Jack Gould, "Potshots Over TV Space," *The New York Times*, August 29, 1965; Rick DuBrow, "CBS Will Curtail Coverage of Flights," *The Washington Post*, August 24, 1965; "Network Chiefs Swap Snarls," *Broadcasting*, August 30, 1965, 52.

44 Frank, *Out of Thin Air*, 140; "Network Chiefs Swap Snarls," 52.

45 "Gemini Hottest Programming on Radio-TV," *Broadcasting*, August 30, 1965, 50; "GT-5 Shoots Down Friendly Memo"; NBC advertisement, *The New York Times*, August 25, 1965.

46 Gould, "Potshots Over TV Space"; Art Buchwald, "Capitol Punishment ... Countdown 1966," *The Washington Post*, August 26, 1965; "GT-5 Shoots Down Friendly Memo"; "Network Chiefs Swap Snarls," 52; Jack Gould, "Networks Rouse Sports Fans' Ire," *The New York Times*, August 22, 1965.

47 Sherburne, "Television Coverage of the Gemini Program," 1329; Jack Gould, "TV: Networks Cover Gemini Landing," *The New York Times*, August 30, 1965.

48 "TV Nets Ponder 'Advantages' of Pooling Gemini," *Variety*, August 25, 1965.

49 Millie Budd, "Has the Romance Gone Out of Covering Space Shots?" *The Houston Post*, December 2, 1965; Alexander, "Space Flight News," 723-24.

50 Jack Gould, "Live TV Coverage of Gemini 6 After Splashdown a Spectacle," *The New York Times*, December 17, 1965; John Horn, "Networks Protest on Control of Gemini," *New York Herald-Tribune*, December 1, 1965.

51 Lawrence Laurent, "TV Goes Into Orbit With Space Shots," *The Washington Post*, December 16, 1965; Gould, "Live TV Coverage of Gemini 6"; "Networks Protest ITT Space-Shot Rates," *Broadcasting*, November 29, 1965, 66-70.

[52] "Gemini 6 Pilots See Splashdown on TV," *The New York Times*, December 19, 1965; "Public Affairs Program Review Document," April 19, 1966, NASA History Office, Washington, D.C.; Budd, "Has the Romance Gone Out of Covering Space Shots?"; David Hoffman, "NASA's Mission: Sparking 'Dull' Flights as Interest Wanes," *The Boston Globe*, September 26, 1965.

[53] Frank, *Out of Thin Air*, 237-238; Jack Gould, "Kintner to Head N.B.C. 3 Months," *The New York Times*, December 14, 1965; "Adviser to the President: Robert Edmonds Kintner," *The New York Times*, April 1, 1966; Jack Gould, "Friendly Quits C.B.S. News Post In Dispute Over Vietnam Hearing," *The New York Times*, February 16, 1966.

[54] Cressman, "Fighting for Access," 139; Al Salerno, "'66's Biggest TV Drama Unscheduled," *New York World-Telegram*, March 17, 1966.

[55] Bob Williams, "On the Air," *New York Post*, March 17, 1966; "Oral History: Remembering the Space Race," *Quest* 9, no. 3 (2002): 14.

[56] Williams, "On the Air"; Martin Waldron, "Astronauts Calm as Craft Tumbled," *The New York Times*, March 18, 1966; Alexander, "Space Flight News," 727; Paul Haney, interview by Robert Merrifield, April 8, 1968, NASA History Office, Washington, D.C.

[57] Alexander, "Space Flight News," 727.

[58] Cressman, "Fighting for Access," 140-141.

[59] Walter Sullivan, "The Week in Science: A Russian Steps into Space," *The New York Times*, March 21, 1965; Cressman, "Fighting for Access," 141.

[60] Paul Haney, interview by Robert Merrifield, April 8, 1968, NASA History Office, Washington, D.C.

[61] Lawrence Laurent, "The Long Night Was Worth It!" *The Washington Post*, June 3, 1966; "Live Television From the Moon," *Broadcasting*, June 6, 1966, 54-55; Jack Gould, "From the Moon to the Living Room: A 22-Pound Camera Unit Delivers," *The New York Times*, June 3, 1966.

[62] "Nationwide TV Audience 'Sees' Space Maneuver," *The New York Times*, June 6, 1966; Jack Gould, "TV: Gemini 9's Return Is Viewed Live by Millions," *The New York Times*, June 7, 1966; Lawrence Laurent, "Cameras Catch Gemini Climax," *The Washington Post*, June 7, 1966.

[63] M.J. Arlen, "The Air: Peter Hackes Tells Us About the Hand-Over-Hand Restraining System, and Other Stories," *The New Yorker*, November 26, 1966, 219.

[64] "CBS News Special Report: Halfway to the Moon: Gemini-Apollo Report," broadcast November 15, 1966, transcript in Walter Cronkite Papers, Center for American History, Austin, Texas.

[65] Memorandum from James E. Webb to Bill Moyers, December 22, 1966, NASA History Office, Washington, D.C.

Chapter 6

[1] Evert Clark, "The Effect on the Space Race," *The New York Times*, April 16, 1967; Charles A. Murray and Catherine Bly Cox, *Apollo* (Burkittsville, MD: South Mountain Books, 2004), 186-187.

[2] Joseph Shea, interview by Robert Sherrod, May 16, 1971, NASA History Office, Washington, D.C.; Donald K. Slayton and Michael Cassutt, *Deke!: U.S. Manned Space, From Mercury to the Moon* (New York: Forge, 1994), 189; Clark, "The Effect on the Space Race."

[3] Murray and Cox, *Apollo*, 193.

[4] Francis French and Colin Burgess, *In the Shadow of the Moon: A Challenging Journey to Tranquility, 1965-1969* (Lincoln, NE: University of Nebraska Press, 2007), 161.

[5] French and Burgess, *In the Shadow of the Moon*, 161; Murray and Cox, *Apollo*, 193.

[6] Gordon Harris, *Selling Uncle Sam* (Hicksville, NY: Exposition Press, 1976), 37.

[7] Harris, *Selling Uncle Sam*, 38.

[8] French and Burgess, *In the Shadow of the Moon*, 159; Paul Haney, interview by Robert Sherrod, January 6, 1970, NASA History Office, Washington, D.C.

[9] Paul Haney, interview by Robert Sherrod, January 7, 1970, NASA History Office, Washington, D.C.

[10] Harris, *Selling Uncle Sam*, 38l; Frank Murray, "Reporters Off, Tight Security Held on Apollo Tragedy," *Editor and Publisher*, February 4, 1967, 9.

[11] Harris, *Selling Uncle Sam*, 38.

[12] Jack King, interview by Robert Sherrod, October 30, 1969, NASA History Office, Washington, D.C.; Julian Scheer, interview by Robert Sherrod, June 4, 1969, NASA History Office, Washington, D.C.; Erlend A. Kennan and Edmund Harvey, Jr., *Mission to the Moon: A Critical Examination of NASA and the Space Program* (New York: Morrow, 1969), 45-47.

[13] Murray, "Reporters Off, Tight Security," 9.

[14] Murray, "Reporters Off, Tight Security," 9; Harris, *Selling Uncle Sam*, 40; "NASA Criticized for News Handling on Apollo Deaths," *The Philadelphia Inquirer*, February 1, 1967; Kennan and Harvey, *Mission to the Moon*, 46.

[15] Paul Haney, interview by Robert Sherrod, January 6, 1970, NASA History Office, Washington, D.C.; Martin Waldron, "Fire on Spacecraft Captured on Film," *The New York Times*, January 28, 1967.

[16] Martin Waldron, "Fire on Spacecraft Captured on Film," *The New York Times*, January 28, 1967.

[17] Murray, "Reporters Off, Tight Security," 10.

[18] George Alexander, "It Looks Like the Inside of a Furnace," *The Washington Post*, January 30, 1967.

[19] Murray, "Reporters Off, Tight Security," 9-10.

[20] John Noble Wilford, "3 Astronauts' Tape Ends With 'Get Us Out of Here!'" *The New York Times*, January 31, 1967; Alexander, "Batteries May Hold Key to Apollo Fire"; "NASA Criticized for News Handling on Apollo Deaths."

[21] Murray, "Reporters Off, Tight Security," 9; George Alexander, "Batteries May Hold Key to Apollo Fire," *The Washington Post*, January 29, 1967; "NASA Criticized for News Handling on Apollo Deaths."

[22] John Noble Wilford, *We Reach the Moon:* The New York Times *Story of Man's Greatest Adventure* (New York: Bantam, 1969), 99; Chris Kraft, *Flight: My Life in Mission Control* (Waterville, ME: Thorndike Press, 2001), 179.

[23] Wilford, "3 Astronauts' Tape Ends With 'Get Us Out of Here!'"; "Did the 3 Astronauts Die Instantly?" *The Washington Evening Star*, January 31, 1967; Murray, "Reporters Off, Tight Security," 10.

[24] J.V. Reistrup, "Astronauts' Last Words Kept Secret," *The Washington Post*, February 1, 1967; Julian Scheer, interview by Robert Sherrod, June 4, 1969, NASA History Office, Washington, D.C.; Julian Scheer, interview by Robert Sherrod, September 11, 1969, NASA History Office, Washington, D.C.

[25] Paul Haney, interview by Robert Sherrod, January 6, 1970; Paul Haney, interview by Robert Sherrod, January 7, 1970.

[26] "Space Program Goes Underground," *Houston Chronicle*, February 3, 1967.

[27] William Hines, "Washington Close-Up: NASA Probe Value Doubtful," *The Washington Evening Star*, February 9, 1967.

[28] William J. Coughlin, "Editorial: On Tragedy," *Technology Week*, February 6, 1967, 50.

[29] "A Second Space Test Tragedy," *Chicago Tribune*, February 1, 1967.

[30] John Noble Wilford, "Preliminary Accounts of Apollo Accident Urged," *The New York Times*, February 1, 1967; Hines, "Washington Close-Up: NASA Probe Value Doubtful."

[31] John Noble Wilford, "Criticism Sharp: Faulty Wire Is Termed the Probable Cause of Blaze Fatal to 3," *The New York Times*, April 10, 1967; "Head of House Panel Says Report Is 'Indictment' of NASA and Contractors," *The New York Times*, April 10, 1967; Howard Simons, "NASA Still Faces Task to Regain Confidence," *The Washington Post*, April 10, 1967.

[32] William J. Coughlin, "The Apollo 204 Review," *Technology Week*, April 17, 1967, 50; "Incompetence and Negligence," *The New York Times*, April 11, 1967.

[33] David Schoumacher and Joan Richman, "The Apollo Accident," April 20, 1967, Walter Cronkite Papers, Center for American History, Austin, Texas.

[34] Schoumacher and Richman, "The Apollo Accident."

[35] Jules Bergman, "NASA and the Press: The Whole Truth," *Columbia Journalism Review*, Summer 1968, 59.

[36] Jay Barbree, *Live from Cape Canaveral: Covering the Space Race, From Sputnik to Today* (New York: Smithsonian Books/Collins, 2007), 124-126; James Skardon, "The Apollo Story: The Concealed Patterns," *Columbia Journalism Review*, Winter 1967/1968, 39.

[37] Skardon, "The Apollo Story: The Concealed Patterns," 36; Howard Benedict, "Full-Court Press: Apollo Meets the Media," *Air and Space Smithsonian*, July 1989, 84.

[38] Skardon, "The Apollo Story: The Concealed Patterns," 37.

[39] William Hines, "NASA: The Image Misfires," *The Nation*, April 24, 1967, 517.

[40] "Grissom … White … Chaffee …," *New York Times* advertisement, January 31, 1967; "Why Should Man Go to the Moon?" *Time*, February 10, 1967, 22.

[41] "The 21st Century: 'To the Moon'," CBS broadcast aired February 5, 1967, transcript in Walter Cronkite Papers, Center for American History, Austin, Texas.

[42] Piers Bizony, *The Man Who Ran the Moon: James E. Webb and the Secret History of Project Apollo* (New York: Thunder's Mouth Press, 2006), 147, 123.

[43] "Is NASA Covering Up?" *Christian Science Monitor*, May 2, 1967; Bizony, *The Man Who Ran the Moon*, 127.

[44] George Mueller, interview by Robert Sherrod, April 21, 1971, NASA History Office, Washington, D.C.

[45] Bizony, *The Man Who Ran the Moon*, 127.

[46] Bizony, *The Man Who Ran the Moon*, 127, 134; "Congress Scores NASA for Secrecy," *Technology Week*, May 15, 1967, 21; "The Apollo Disaster Reshapes NASA's Image," *The Washington Star*, May 14, 1967.

[47] "Reticent NASA," *The New York Times*, April 19, 1967; "Full Disclosure Is Imperative," *The Boston Globe*, April 19, 1967.

[48] "Ryan Asks Release of Apollo Report," *The New York Times*, April 27, 1967; "Report on Apollo Released by Ryan," *The New York Times*, April 30, 1967; "Suppressed Report," *The New York Times*, April 28, 1967.

[49] John Noble Wilford, "Top Apollo Aides Shifted by NASA," *The New York Times*, April 6, 1967.

[50] "The Apollo Disaster Reshapes NASA's Image," *The Washington Star*, May 14, 1967; Bizony, *The Man Who Ran the Moon*, 142-143; John Noble Wilford, "Apollo Decision Backed by Webb," *The New York Times*, May 12, 1967.

[51] Bizony, *The Man Who Ran the Moon*, 147; Paul Dembling, interview by Robert Sherrod, January 22, 1969, NASA History Office, Washington, D.C.; "Congress Scores NASA for Secrecy," *Technology Week*, May 15, 1967, 21; "Excerpts from Webb Statement to House Unit," *The New York Times*, April 11, 1967; Evert Clark, "Six Months After Tragedy, the Apollo Program Finds Itself Gaining but 'Still in a Time of Testing'," *The New York Times*, July 2, 1967.

[52] Paul Haney, interview by Robert Merrifield, April 8, 1968, NASA History Office, Washington, D.C.

[53] John Noble Wilford, "NASA Assailed for Secrecy on Apollo Problems," *The New York Times*, May 11, 1967; Gladwin Hill, "Apollo Astronauts Are Confident," *The New York Times*, May 11, 1967; "The Hoopla Begins Again," *The Boston Globe*, May 12, 1967.

[54] Thomas O'Toole, "… Economic," *The Washington Post*, October 1, 1967; *The Today Show Looks at Ten Years of Space Exploration* (Washington, D.C.: Aerospace Industries Association of America, 1968).

[55] "Some Representative Statements by Mr. Webb to Congress or the Press on the Soviet Space Program," NASA memorandum, November 2, 1967, NASA History Office, Washington, D.C.

[56] John Noble Wilford, "363-Foot Saturn Awaits Its Launching on Thursday," *The New York Times*, November 6, 1967; Jerry E. Bishop, "Saturn 5's Success Enhances the Odds of U.S. Landing Men on the Moon by 1970," *The Wall Street Journal*, November 10, 1967.

[57] William Hines, "NASA Sets the Stage for a Press Briefing," *The Washington Star*, November 9, 1967.

[58] Hines, "NASA Sets the Stage for a Press Briefing."

[59] Hines, "NASA Sets the Stage for a Press Briefing."

[60] Dr. Robert Seamans, interview by Martin Collins, December 8, 1987, The Glennan-Webb-Seamans Project for Research in Space History, Smithsonian National Air and Space Museum, http://www.nasm.si.edu/research/dsh/TRANSCPT/SEAMANS5.HTM.

[61] Murray and Cox, *Apollo*, 237-240; Bishop, "Saturn 5's Success"; "Moonward Bound," *Time*, November 17, 1967.

[62] Walter Cronkite, interview by Robert Sherrod, March 27, 1970, NASA History Office, Washington, D.C.

63 John Noble Wilford, "Goals Achieved," *The New York Times*, November 10, 1967; "The Success of Saturn 5," *The New York Times*, November 10, 1967.

64 "Saturn's Triumph," *The Washington Post*, November 10, 1967.

65 Thomas Paine, interview by Robert Sherrod, October 7, 1971, NASA History Office, Washington, D.C.

66 John Noble Wilford, "Unmanned Apollo Trip Marred; Further Rocket Tests Expected," *The New York Times*, April 5, 1968.

67 Neil Sheehan, "Webb Quits as Head of Space Agency; Notes Soviet Lead," *The New York Times*, September 17, 1968.

68 Rudy Ambramson, "NASA's Boss a Great Huckster," *The Washington Post*, September 26, 1968; "ABC Evening News," September 16, 1968, Vanderbilt Television News Archives.

69 "Huntley-Brinkley Report," September 16, 1968, Vanderbilt Television News Archives.

Chapter 7

1 Jack Gould, "Billion Could See Landing on Moon," *The New York Times*, July 18, 1969.

2 John Noble Wilford, "Orbiting Apollo Craft Transmits TV Show," *The New York Times*, October 15, 1968; Memorandum from Robert C. Seamans to George Mueller and Julian Scheer, March 30, 1966, NASA History Office, Washington, D.C.

3 Paul Haney, interview by Robert Merrifield, April 8, 1968, NASA History Office, Washington, D.C.

4 Thomas O'Toole, "Schirra Balks, Scrubs TV Broadcast," *The Washington Post*, October 13, 1968; Wally Schirra and Richard N. Billings, *Schirra's Space* (Boston: Quinlan Press, 1988), 202.

5 Letter from George Low to Robert Sherrod, March 18, 1974, NASA History Office, Washington, D.C.; "TV for Apollo," *Time*, April 26, 1968, 104.

6 Memorandum from Sam Phillips to George Low, "Apollo On-Board TV," April 10, 1968, quoted in Ivan D. Ertel and Roland W. Newkirk, *The Apollo Spacecraft – A Chronology*, Volume IV, Part 2 (K) (Washington, D.C.: NASA, 1974) http://www.hq.nasa.gov/office/pao/History/SP-4009/v4p2k.htm.

7 Thomas O'Toole, "Schirra Balks, Scrubs TV Broadcast," *The Washington Post*, October 13, 1968.

8 Memorandum from Gordon Manning and Walter Cronkite to Dick Salant, October 3, 1968, Walter Cronkite Papers, Center for American History, Austin, Texas.

9 Memorandum from Manning and Cronkite to Salant, October 3, 1968.

10 Memorandum from Manning and Cronkite to Salant, October 3, 1968; Robert Hotz, "Back in Business," *Aviation Week and Space Technology*, October 21, 1968, 21; "CBS Evening News With Walter Cronkite," October 9, 1968, Vanderbilt Television News Archives.

11 "CBS Evening News With Walter Cronkite," October 9, 1968.

12 John Noble Wilford, "Orbiting Apollo Craft Transmits TV Show," *The New York Times*, October 15, 1968; "First Live TV Space Show," *Christian Science Moni-*

tor, October 15, 1968; Neal Stanford, "Impressive Flight Plan for Apollo 7," *Christian Science Monitor*, October 10, 1968; O'Toole, "Schirra Balks, Scrubs TV Broadcast."

13 National Aeronautics and Space Administration, "Apollo 7 Air-to-Ground Voice Transcriptions," http://www.jsc.nasa.gov/history/mission_trans/ AS07_TEC.PDF; Richard D. Lyons, "Astronauts Move Apollo Closer to Booster Rocket in Test of Space Rescue," *The New York Times*, October 13, 1968.

14 Lyons, "Astronauts Move Apollo Closer"; William K. Stevens, "Schirra, Going Own Way as Usual, Balks at TV," *The New York Times*, October 13, 1968; Christopher C. Kraft, *Flight: My Life in Mission Control* (Waterville, ME: Thorndike Press, 2001), 290.

15 Julian Scheer, interview by Robert Sherrod, February 18, 1969, NASA History Office, Washington D.C.

16 "The Huntley-Brinkley Report," October 14, 1968, Vanderbilt Television News Archives; Thomas O'Toole, "15 Million Watch Astronauts at Work," *The Washington Post*, October 15, 1968.

17 "Apollo 7 Air-to-Ground Voice Transcriptions"; "CBS Evening News With Walter Cronkite," October 14, 1968, Vanderbilt Television News Archives.

18 Michael Kapp, interview by Robert Sherrod, September 30, 1971, NASA History Office, Washington, D.C.

19 "Apollo 7 Air-to-Ground Voice Transcriptions"; "CBS Evening News With Walter Cronkite," October 14, 1968.

20 "Apollo 7 Air-to-Ground Voice Transcriptions"; "CBS Evening News With Walter Cronkite," October 14, 1968.

21 Walter Cunningham, *The All-American Boys* (New York: Ibooks, 2003), 161; "Dino's High Wire Is Down to Earth," *The Washington Post*, October 16, 1968.

22 "CBS Evening News With Walter Cronkite," October 14, 1968.

23 "CBS Evening News With Walter Cronkite," October 14, 1968.

24 O'Toole, "15 Million Watch Astronauts at Work"; John Noble Wilford, "Orbiting Apollo Craft Transmits TV Show," *The New York Times*, October 15, 1968; "First Live TV Space Show"; "CBS Evening News With Walter Cronkite," October 14, 1968.

25 John Noble Wilford, "Moon Shot Hopes Raised by Apollo," *The New York Times*, October 16, 1968.

26 Wilford, "Moon Shot Hopes Raised by Apollo"; "Acrobats in Orbit," *Time*, October 25, 1968, 84.

27 Wilford, "Moon Shot Hopes Raised by Apollo."

28 Wilford, "Moon Shot Hopes Raised by Apollo"; John Noble Wilford, "Relaxed Astronauts on 2d Half of Flight," *The New York Times*, October 17, 1968; Cunningham, *The All-American Boys*, 147.

29 Kraft, *Flight*, 289.

30 Thomas O'Toole, "Apollo Crew, Still Griping, Sets Record," *The Washington Post*, October 21, 1968; "Apollo 7 Air-to-Ground Voice Transcriptions."

31 John Noble Wilford, "Schirra Nettled Over New Tests," *The New York Times*, October 21, 1968; "Apollo 7 Air-to-Ground Voice Transcriptions."

32 Wilford, "Schirra Nettled Over New Tests."

33 Cunningham, *The All-American Boys*, 148.

34 O'Toole, "Apollo Crew, Still Griping"; "Apollo 7 Throws Spotlight on Strains of Long Space Missions," *Christian Science Monitor*, October 23, 1968; Joan Richman, undated CBS internal memorandum, Walter Cronkite Papers, Center for American History, Austin, Texas.

35 Gerald Griffin, interview by Robert Sherrod, March 8, 1974, NASA History Office, Washington, D.C.

36 "CBS Evening News With Walter Cronkite," October 23, 1968, Vanderbilt Television News Archives, transcript in Walter Cronkite Papers, Center for American History, Austin, Texas.

37 "Apollo-TV Signs Off," *Christian Science Monitor*, October 22, 1968; "CBS Evening News With Walter Cronkite," October 21, 1968, Vanderbilt Television News Archives.

38 Richard D. Lyons, "TV From Space Likely to Have Military and Economic Value," *The New York Times*, October 15, 1968; Richard S. Lewis, "A Streetcar Named Apollo," *Bulletin of the Atomic Scientists*, November 1968, 24.

39 Donald K. Slayton and Michael Cassutt, *Deke!: U.S. Manned Space from Mercury to the Shuttle* (New York: Forge, 1994), 218-219; Joan Richman, undated CBS internal memorandum.

40 John Noble Wilford, "U.S. Prepares Moon Shot in December," *The New York Times*, October 23, 1968; Howard Benedict, "Full-Court Press: Apollo Meets the Media," *Air and Space Smithsonian* (June/July 1989), 84.

41 George Low, interview by James Burke, May 25, 1979, transcript for BBC television program "Project Apollo," NASA History Office, Washington, D.C.; Thomas Paine, interview by Robert Sherrod, January 23, 1969, NASA History Office, Washington, D.C.

42 Joseph Shea, interview by Robert Sherrod, May 16, 1971, NASA History Office, Washington, D.C.; "Lovell Finds Lack of Scientific Need for Lunar Voyage," *The New York Times*, November 21, 1968; John Noble Wilford, "Space: Concern That We Are Racing Too Fast For the Moon," *The New York Times*, December 15, 1968; "CBS Evening News With Walter Cronkite," November 20, 1968, Vanderbilt Television News Archives.

43 Neal Stanford, "Snapping Earth's Bands," *Christian Science Monitor*, December 24, 1968; "Columbuses of Space," *The New York Times*, December 22, 1968.

44 "CBS Evening News With Walter Cronkite," December 23, 1968, Vanderbilt Television News Archives; Stanford, "Snapping Earth's Bands"; David E. Kucharsky, "Open Letter to the Apollo 8 Spacemen," *Christianity Today*, December 20, 1968, 31.

45 William K. Stevens, "Live TV Pictures From Apollo 8 Received Clearly in Homes," *The New York Times*, December 23, 1968; John Noble Wilford, "Astronauts Give Television Show on Way to Moon," *The New York Times*, December 23, 1968; "Excerpts From Conversation With the Spacemen," *The New York Times*, December 23, 1968; Harry F. Rosenthal, "TV From Apollo Hits a Snag," *The Washington Post*, December 23, 1968.

46 Thomas O'Toole, "Kibitzers Found Moon Trio Laconic," *The Washington Post*, December 31, 1968.

47 John Noble Wilford, "Apollo Nears Moon on Course, Turns Around to Go Into Orbit; Crew Sends Pictures of Earth," *The New York Times*, December 24, 1968.

⁴⁸ Neal Stanford, "Apollo 8 Flight Plan Calls for Six TV Appearances En Route," *Christian Science Monitor*, December 21, 1968; William K. Stevens, "Live TV Pictures From Apollo 8 Received Clearly in Homes," *The New York Times*, December 23, 1968.

⁴⁹ John Noble Wilford, "Apollo Nears Moon on Course"; "Excerpts From Talks on TV With Crew of Apollo 8," *The New York Times*, December 24, 1968; Courtney G. Brooks, James M. Grimwood and Loyd S. Swenson, *Chariots for Apollo: A History of Manned Lunar Spacecraft* (Washington, D.C.: NASA, 1979) http://history.nasa.gov/SP-4205/ch11-6.html.

⁵⁰ "CBS Evening News With Walter Cronkite," December 23, 1968.

⁵¹ Jack Gould, "TV: N.B.C. Up All Night With Apollo 8," *The New York Times*, December 25, 1968.

⁵² "Huntley-Brinkley Report," December 24, 1968, Vanderbilt Television News Archives; "Chronology of Crucial Portions of Spacecraft Trip Behind Moon," *The Washington Post*, December 25, 1968.

⁵³ National Aeronautics and Space Administration, "Apollo 8 Public Affairs Office Mission Commentary Transcript," http://www.jsc.nasa.gov/history/ mission_trans/AS08_PAO.PDF; "John Noble Wilford, "3 Men Fly Around the Moon Only 70 Miles From Surface," *The New York Times*, December 25, 1968.

⁵⁴ "Apollo 8 Public Affairs Office Mission Commentary Transcript"; "Prayer for Christmas From Borman in Orbit," *The New York Times*, December 25, 1968.

⁵⁵ National Aeronautics and Space Administration, "Apollo 8 Onboard Voice Transcription," http://www.jsc.nasa.gov/history/mission_trans/ AS08_CM.PDF.

⁵⁶ "Apollo 8 Public Affairs Office Mission Commentary Transcript"; Wilford, "3 Men Fly Around the Moon."

⁵⁷ "Message From the Moon," *The Washington Post*, December 26, 1968.

⁵⁸ "Apollo 8 Onboard Voice Transcription."

⁵⁹ Billy Watkins, *Apollo Moon Missions: The Unsung Heroes* (Westport, CT: Praeger, 2006), 69-73.

⁶⁰ "The Apollo 8 Christmas Eve Broadcast," http://nssdc.gsfc.nasa.gov/ planetary/lunar/apollo8_xmas.html; "Apollo 8 Onboard Voice Transcription"; Watkins, *Apollo Moon Missions*, 73, [emphasis added].

⁶¹ "Apollo 8 Onboard Voice Transcription"; Joesph Laitin, interview by Robert Sherrod, March 25, 1969, NASA History Office, Washington, D.C.; Paul Haney, interview by Robert Sherrod, January 6, 1970, NASA History Office, Washington, D.C. "Apollo 8 Public Affairs Office Mission Commentary Transcript."

⁶² Robert Zimmerman, *Genesis: The Story of Apollo 8* (New York: Dell Publishing, 1999), 293; Francis French and Colin Burgess, *In the Shadow of the Moon: A Challenging Journey to Tranquility, 1965-1969* (Lincoln, NE: University of Nebraska Press, 2007), 315.

⁶³ "Excerpts From Radio Talks With Apollo 8 Crew," *The New York Times*, December 26, 1968; "Apollo Workers Display Rare Emotion After Feat," *The New York Times*, December 28, 1968.

⁶⁴ "'It's Like Buck Rogers,' Says Chicago Man, Reflecting Reaction of an Awed World," *The New York Times*, December 28, 1968.

65 "'It's Like Buck Rogers'"; "CBS News Special Report: Man at the Moon," broadcast December 27, 1968, transcript in Walter Cronkite Papers, Center for American History, Austin, Texas; "Huntley-Brinkley Report," December 27, 1968, Vanderbilt Television News Archives; "ABC Evening News," December 27, 1968, Vanderbilt Television News Archives.

66 "'It's Like Buck Rogers'"; "ABC Evening News," December 27, 1968; "ABC Evening News," December 24, 1968, Vanderbilt Television News Archives.

67 Homer Bigart, "New-Breed Astronauts: Scientists, Not Daredevils," *The New York Times*, December 20, 1968; "The Flight of Apollo 8," *America*, January 11, 1969, 31.

68 "'Modern Magi' Put Moon Flight Into Scriptural Perspective," *Christianity Today*, January 17, 1969, 36; "Churches Mirror Apollo's Verses," *The New York Times*, December 26, 1968; Gordon Harris, *Selling Uncle Sam* (Hicksville, N.Y.: Exposition Press, 1976), 61; Joesph Laitin, interview by Robert Sherrod, March 25, 1969, NASA History Office, Washington, D.C.

69 Archibald MacLeish, "A Reflection: Riders on Earth Together, Brothers in Eternal Cold," *The New York Times*, December 25, 1968; "ABC Evening News," December 27, 1968; "Huntley-Brinkley Report," December 28, 1968, Vanderbilt Television News Archives.

70 "Huntley-Brinkley Report," December 30, 1968, Vanderbilt Television News Archives.

71 French and Burgess, *In the Shadow of the Moon*, 312; Zimmerman, *Genesis*, 284-285.

72 French and Burgess, *In the Shadow of the Moon*, 312.

Chapter 8

1 Billy Watkins, *Apollo Moon Missions: The Unsung Heroes* (Westport, Conn.: Praeger, 2006), 51.

2 Christoper C. Kraft, *Flight: My Life in Mission Control* (Waterville, ME: Thorndike Press, 2001), 307-308.

3 Kraft, *Flight*, 308.

4 Kraft, *Flight*, 308.

5 Arthur Hill, "The Downfall of Paul Haney, Why and How It Came About," *The Houston Chronicle*, April 27, 1969; Paul P. Haney, interview by Sandra Johnson, January 20, 2003, NASA Johnson Space Center Oral History Project, http://www.jsc.nasa.gov/history/oral_histories/participants.htm.

6 Brian Duff, interview by John Mauer, April 26, 1989, The Glennan-Webb-Seamans Project for Research in Space History, Smithsonian National Air and Space Museum, http://www.nasm.si.edu/research/dsh/TRANSCPT/DUFF2.HTM; Hill, "The Downfall of Paul Haney."

7 Brian Duff, interview by John Mauer, April 26, 1989; Jim Maloney, "Haney Deal Raw, Cruel," *The Houston Post*, April 28, 1969; Jim Maloney, "Haney Gets Powers' Sympathy," *The Houston Post*, April 24, 1969.

8 Thomas O'Toole, "Space Flights' 'Voice' Quits NASA," *The Washington Post*, April 26, 1969; "Duff, Haney Appointments," NASA Release No. 69-59, April 22,

1969, NASA History Office, Washington, D.C.; Brian Duff, interview by John Mauer, April 26, 1989.

9 Brian Duff, interview by John Mauer, April 26, 1989.

10 Brian Duff, interview by John Mauer, April 26, 1989.

11 Brian Duff, interview by John Mauer, April 26, 1989.

12 Warren C. Wetmore, "Docking Transmitted Live in First Color TV From Space," *Aviation Week and Space Technology*, May 26, 1969, 18; Jack Gould, "U.S. Outline Seen on TV From Space," *The New York Times*, May 19, 1969.

13 Letter from George Low to Robert Sherrod, March 18, 1974, NASA History Office, Washington, D.C.

14 Wetmore, "Docking Transmitted Live," 18; Gould, "U.S. Outline Seen."

15 Wetmore, "Docking Transmitted Live," 18.

16 Gould, "U.S. Outline Seen."

17 John Noble Wilford, "Astronauts Orbit Moon and Prepare to Go Close Today," *The New York Times*, May 22, 1969; Thomas O'Toole, "Lem Skims Near Moon, Rejoins Command Ship," *The Washington Post*, May 23, 1969; Richard Witkin, "Apollo Astronauts Belie Shyness on Television," *The New York Times*, May 26, 1969; Laurence Laurent, "Apollo 10: TV's Finest Hours," *The Washington Post*, May 27, 1969.

18 "An Uncluttered Path to the Moon," *Time*, June 6, 1969, 64; Gene Cernan, interview by James Burke for BBC television program "Project Apollo," May 19, 1979, unedited transcript, NASA History Office, Washington, D.C.

19 John Noble Wilford, "Apollo 10 Ends Eight-Day Flight; NASA Gives a Go-Ahead to Plans for Summer Landing on the Moon," *The New York Times*, May 27, 1969.

20 Gordon Harris, *Selling Uncle Sam* (Hicksville, N.Y.: Exposition Press, 1976), 29; letter from Julian Scheer to James M. Grimwood, February 9, 1977, NASA History Office, Washington, D.C.; Jonathan Spivak, "NASA Goes All Out In Planning Publicity For the Moon Landing," *The Wall Street Journal*, July 8, 1969.

21 Spivak, "NASA Goes All Out"; Michael Collins, *Carrying the Fire: An Astronaut's Journeys* (New York: Cooper Square Press, 2001), 332-333; James R. Hansen, *First Man: The Life of Neil A. Armstrong* (New York: Simon and Schuster, 2005), 395.

22 Scheer tells of the exchange with the Nixon aide in "What About God?" *The Orlando Sentinel*, July 20, 1989.

23 Henry Raymont, "Publishers Hitching Star To the Moon Expedition," *The New York Times*, July 16, 1969; Richard D. Lyons, "Astronauts to Get a Million in Year for Their Stories," *The New York Times*, June 22, 1969.

24 Thomas Griffith, interview by Robert Sherrod, October 7, 1971, NASA History Office, Washington, D.C.; Chris Kraft, interview by Robert Sherrod, July 23, 1972, NASA History Office, Washington, D.C.

25 Julian Scheer, interview by Robert Sherrod, September 11, 1969, NASA History Office, Washington, D.C.; Julian Scheer, interview by Robert Sherrod, April 26, 1973, NASA History Office, Washington, D.C.; Hansen, *First Man*, 397-399.

26 The exchanges between Armstrong and reporters are chronicled in Norman Mailer's *Of a Fire on the Moon: A Work in Three Parts* (Boston: Little, Brown, 1970), 38-39, 45; Hansen, *First Man*, 399.

27 Mailer, *Of a Fire on the Moon*, 22, 29; Hansen, *First Man*, 399.

28 Hansen, *First Man*, 228.

[29] Mailer, *Of a Fire on the Moon*, 44-45; Hansen, *First Man*, 399; French and Burgess, 392.

[30] William Greider, "Protesters, Viewers Flood Cape Area," *The Washington Post*, July 16, 1969.

[31] Victor Cohn, "Plans for Mars Vs. Money Pinch," *The Washington Post*, July 13, 1969; "Cleaver Scores Apollo 11 as Circus," *The New York Times*, July 18, 1969.

[32] Thomas Paine, interview by Gene Emme, September 3, 1970, NASA History Office, Washington, D.C.

[33] Julian Scheer, "The 'Sunday of the Space Age,'" *The Washington Post*, December 6, 1972.

[34] Scheer, "The 'Sunday of the Space Age.'"

[35] Thomas Paine, interview by Eugene Emme, September 3, 1970.

[36] "The Scene at the Cape: Prometheus and a Carnival," *Time*, July 25, 1969, 13; William Greider, "A Moment of Majesty, Then Banter," *The Washington Post*, July 17, 1969.

[37] Greider, "A Moment of Majesty"; Jack Gould, "25 Million Watch the Lift-Off on TV," *The New York Times*, July 17, 1969.

[38] The final moments of King's countdown and his reaction are chronicled in Watkins, *Apollo Moon Missions*, 117-119.

[39] Harris, *Selling Uncle Sam*, 62; Greider, "A Moment of Majesty."

[40] "The Scene at the Cape," 13.

[41] "ABC Evening News," July 16, 1969, Vanderbilt Television News Archives.

[42] Herblock, "Transported," *The Washington Post*, July 18, 1969.

[43] Fred Ferretti, "Apollo 11 TV Coverage to Engage Many Earthlings," *The New York Times*, July 14, 1969.

[44] Ferretti, "TV Coverage Proves Expensive."

[45] Ferretti, "TV Coverage Proves Expensive"; "You'll Be There When Men Land on Moon," *Broadcasting*, July 14, 1969, 45; "TV Coverage Soars Aloft With Apollo 11," *Broadcasting*, July 21, 1969, 39; Lawrence Laurent, "Greatest Show Off Earth," *The Washington Post*, July 22, 1969.

[46] "The Moon Hours," *The New Yorker*, July 26, 1969, 26-27.

[47] CBS News and CBS Television Network, *10:56:20 PM EDT, 7/20/69: The Historic Conquest of the Moon as Reported to the American People* (New York: Columbia Broadcasting System, 1970), 31-32.

[48] CBS advertisement, *The New York Times*, July 16, 1969; "TV Coverage Soars Aloft With Apollo 11," 39; Ferretti, "TV Coverage Proves Expensive."

[49] John Noble Wilford, "Live Television to Show First Footsteps on Moon," *The New York Times*, June 17, 1969; Thomas Paine, interview by Robert Sherrod, October 7, 1971, NASA History Office, Washington, D.C.

[50] Fred Ferretti, "Cronkite on Endurance: 'You Don't Think of That,'" *The New York Times*, July 24, 1969.

[51] Broadcast rundown, "Man on the Moon: The Epic Journey of Apollo 11," July 20, 1969, CBS News Daily News Broadcasts, Original Series Volume 7, Walter Cronkite Papers, Center for American History, Austin, Texas.

[52] Broadcast rundown, "Man on the Moon."

[53] *10:56:20 PM EDT*, 31-32.

[54] *10:56:20 PM EDT*, 64.

[55] *10:56:20 PM EDT*, 64-65.

56 "Miracle in Sound" *Time*, August 1, 1969, 22.

57 "Oral History: Remembering the Space Race," *Quest* 9, no. 3 (2002), 18; *CBS News Correspondent Walter Cronkite on CBS News Coverage of U.S. Manned Space Flight, 1961-1972 [Walter Cronkite. A Space Odyssey]*, DVD, Peabody Awards Collection, University of Georgia.

58 "Oral History: Remembering the Space Race," 18; *CBS News Correspondent Walter Cronkite.*

59 "Oral History: Remembering the Space Race," 19.

60 *10:56:20 PM EDT*, 78.

61 *10:56:20 PM EDT*, 78; George Mueller, interview by Robert Sherrod, November 19, 1969, NASA History Office, Washington, D.C.; Andrew Chaikin, *A Man On the Moon: The Voyages Of the Apollo Astronauts* (New York: Viking, 1994), 194-197.

62 Broadcast rundown, "Man on the Moon"; *10:56:20 PM EDT*, 81; Chaikin, *A Man On the Moon*, 220; Edwin Diamond, "The Dark Side of Moonshot Coverage," *Columbia Journalism Review*, Autumn 1969, 16.

63 Diamond, "The Dark Side of Moonshot Coverage," 16.

64 Diamond, "The Dark Side of Moonshot Coverage," 14.

65 Diamond, "The Dark Side of Moonshot Coverage," 14; Richard Witkin, "Alarm Preceded Landing on Moon," *The New York Times*, July 25, 1969.

66 Ferretti, "Apollo 11 TV Coverage."

67 Bob Williams, "On the Air," *New York Post*, July 22, 1969; Jack Gould, "TV: Lunar Scenes Top Admirable Apollo Coverage," *The New York Times*, July 22, 1969.

68 Lawrence Van Gelder, "For Most in U.S., a Day of Joy and Reverence," *The New York Times*, July 22, 1969; "Cathedrals in the Sky," *Time*, August 1, 1969, 20; Judith Martin, "N.Y. Happening Honors Apollo," *The Washington Post*, July 21, 1969.

69 *10:56:20 PM EDT*, 94-95; Lawrence Laurent, "Greatest Show Off Earth," *The Washington Post*, July 22, 1969; "The Moon Hours," 28.

70 "The Moon Hours," 26.

71 Wilford, "Live Television to Show First Footsteps on Moon"; Dick Darcey, "Moon TV Can't Be in Color," *The Washington Post*, July 20, 1969.

72 "TV From the Moon," Honeysuckle Creek Tracking Station, http://www.honeysucklecreek.net/Apollo_11/TV_from_Moon.html.

73 "Parkes and Honeysuckle," Honeysuckle Creek Tracking Station, http://www.honeysucklecreek.net/Apollo_11/PKS_and_HSK.html.

74 "The Moon Hours," 27; Robert G. Kaiser, "The Whole World Was Watching 3 Men in Space," *The Washington Post*, July 22, 1969; Lawrence Van Gelder, "For Most in U.S., a Day of Joy and Reverence," *The New York Times*, July 22, 1969; James F. Clarity, "Soviet Shows Moon-Walk 3 Times," *The New York Times*, July 22, 1969; William Borders, "Even in Hostile Nations, the Feat Inspires Awe," *The New York Times*, July 22, 1969; National Aeronautics and Space Administration, "Apollo 11 Mission Report," http://history.nasa.gov/alsj/a11/A11_PAOMissionReport.html.

75 The exchange in the NBC control room is chronicled in "The Moon Hours," 26-27.

76 "Voice From Moon: 'Eagle Has Landed'," *The New York Times*, July 21, 1969.

77 "TV From the Moon"; "You'll Be There When Men Land on Moon," 44; "Parkes and Honeysuckle."

[78] "Voice From Moon"; "The Moon Hours," 27.

[79] "Voice From Moon." Later, Armstrong would say that he intended the line to be, "... one small step for *a* man," but the voice recordings from the mission indicate that Armstrong failed to say the article. Chaikin, *A Man On the Moon*, 209.

[80] "Voice From Moon"; "The Moon Hours," 26-27.

[81] "A Giant Leap for Mankind," *Time*, July 25, 1969, 12; "Voice From Moon."

[82] "TV Puts Moon Walk Before Eyes of Millions Around World," *Aviation Week and Space Technology*, July 28, 1968, 38-39; "A Giant Leap for Mankind," 12.

[83] National Aeronautics and Space Administration, "Apollo 11 Mission Commentary," July 20, 1969, http://www.hq.nasa.gov/alsj/a11/a11transcript_pao.htm.

[84] "A Remote That Broke All the Records," *Broadcasting*, July 28, 1969, 28; "Apollo 11 Mission Commentary."

[85] "Apollo 11 Mission Commentary."

[86] Wilford, "Live Television to Show First Footsteps on Moon"; "A Giant Leap for Mankind," 10, 12; "Back From the Moon," *Newsweek*, August 4, 1969; Chaikin, *A Man On the Moon*, 213.

[87] "The Moon Hours," 26-27.

[88] "The Moon Hours," 29-30.

[89] "Oral History: Remembering the Space Race," 19.

[90] Chaikin, *A Man On the Moon*, 222-223; Collins, *Carrying the Fire*, 411-412.

[91] Watkins, *Apollo Moon Missions*, 58-59.

[92] "TV Transmission Became a Luxury Once the Walk Was Over," *The New York Times*, July 22, 1969; Ferretti, "TV Coverage Proves Expensive and Complex."

[93] *10:56:20 PM EDT*, 125.

[94] Neil Compton, "Moon Watching," *Commentary* (October 1969), 86; *10:56:20 PM EDT*, 125.

[95] "The Huntley-Brinkley Report," July 24, 1969, Vanderbilt Television News Archives; "You'll Be There When Men Land on Moon," 45; "CBS Evening News," July 24, 1969, Vanderbilt Television News Archives.

[96] "ABC Evening News," July 24, 1969, Vanderbilt Television News Archives; The Moon and 'Middle America'," *Time*, August 1, 1969, 10A.

[97] Chaikin, *A Man On the Moon*, 227.

Epilogue

[1] Michael J. Neufeld, *Von Braun: Dreamer of Space, Engineer of War* (New York: Alfred A. Knopf in association with the National Air and Space Museum, Smithsonian Institution, 2007), 433.

[2] Wernher von Braun (introduction by Ron Miller), "Now That Man Has Reached the Moon, What Next?" in *Blueprint for Space: Science Fiction to Science Fact*, edited by Frederick Ira Ordway III and Randy Liebermann (Washington: Smithsonian Institution Press, 1992), 167.

³ Letter from Cornelius Ryan to Hobart Lewis, February 27, 1970, quoted in von Braun, "Now That Man Has Reached the Moon," 167.

⁴ James Clayton, "Apollo 11: Public Relations Dream," *The Washington Post*, July 27, 1969.

⁵ James Kauffman, "A Successful Failure: NASA's Crisis Communications Regarding Apollo 13," *Public Relations Review* 27 (2001): 439; Brian Duff, interview by John Mauer, April 24, 1989, The Glennan-Webb-Seamans Project for Research in Space History, Smithsonian National Air and Space Museum, http://www.nasm.si.edu/research/dsh/TRANSCPT/DUFF1.HTM.

⁶ George Mueller, interview by Martin Collins, June 22, 1988, The Glennan-Webb-Seamans Project for Research in Space History, Smithsonian National Air and Space Museum, http://www.nasm.si.edu/research/dsh/TRANSCPT/MUELLER6.HTM; Brian Duff, interview by John Mauer, April 24, 1989; Julian Scheer, interview by Robert Sherrod, February 22, 1973, NASA History Office, Washington, D.C.

⁷ "NASA's Captain Video," *Time*, August 9, 1971, 12; Tom Shales, "Columbia, Gem of the Sky," *The Washington Post*, April 15, 1981; Ryan M. Martin and Lois A. Boynton, "From Liftoff to Landing: NASA's Crisis Communications and Resulting Media Coverage Following the Challenger and Columbia Tragedies," *Public Relations Review* 31 (2005): 256.

⁸ Lawrence Laurent, "Moon Mission Ratings Race," *The Washington Post*, July 25, 1969.

⁹ Jack Gould, "TV: Lunar Scenes Top Admirable Apollo Coverage," *The New York Times*, July 22, 1969.

¹⁰ Jack Gould, "TV Has Involved and Educated Millions in Mysteries of Space," *The New York Times*, July 17, 1969; Lawrence Laurent, "TV Apollo Coverage: Expert," *The Washington Post*, July 17, 1969.

¹¹ Edwin Diamond, "The Dark Side of Moonshot Coverage," *Columbia Journalism Review*, Autumn 1969, 16; Neil Compton, "Moon Watching," *Commentary* (October 1969), 85.

¹² Neil Compton, "Moon Watching," *Commentary* (October 1969), 84.

¹³ "Apollo 17 Marks End of Space-Age TV Series," *Broadcasting*, December 11, 1972, 16.

¹⁴ Louis Harris, "Public, in Reversal, Now Backs Landing on Moon, 51 to 41 Pct.," *The Washington Post*, July 14, 1969; Louis Harris, "Space Programs Losing Support," *The Washington Post*, July 31, 1967.

SELECTED BIBLIOGRAPHY

Archival Sources

Center for American History, Austin, Texas. Walter Cronkite Papers, including CBS News memoranda, broadcast transcripts, notes, periodical clipping files; *New York Herald-Tribune* morgue files.

The Glennan-Webb-Seamans Project for Research in Space History, Smithsonian National Air and Space Museum, Washington, D.C. Online at http://www.nasm.si.edu/research/dsh/gwspi-p1.html. Transcripts of oral history interviews with key figures in NASA's public affairs efforts.

Johnson Space Center Oral History Project, Houston, Texas, online at http://www.jsc.nasa.gov/history/oral_histories/participants.htm. Transcripts of oral history interviews with key figures in NASA's public affairs efforts.

NASA History Office, Washington, D.C. Internal agency memoranda, reports, press releases, media kits, periodical clipping files, and oral history transcripts including the Robert Sherrod Collection.

Notable New Yorkers, Columbia University Libraries Oral History Research Office, New York, N.Y., online at http://www.columbia.edu/cu/lweb/digital/collections/nny/. Transcript of oral history interview with former CBS president Frank Stanton.

Peabody Awards Collection, University of Georgia, Athens, Ga. Video entries for the Peabody Awards, including a compilation of clips from Walter Cronkite space broadcasts, 1961-1972.

Vanderbilt Television News Archive, Nashville, Tenn. Video clips from network television evening news broadcasts, 1968-1970.

Books and Journal Articles

Alan, Jeff, and James Martin Lane. *Anchoring America: The Changing Face of Network News*. Chicago: Bonus Books, 2003.

Alexander, Louis. "Space Flight News: NASA's Press Relations and Media Reaction." *Journalism Quarterly* 43, no. 4 (Winter 1966), 722-728.

Angotti, Joseph Arthur. "A Descriptive Analysis of NBC's Radio and Television Coverage of the First U.S. Manned Orbital Flight." M.A. Thesis, Indiana University, 1965.

Barbree, Jay. *Live from Cape Canaveral: Covering the Space Race, from Sputnik to Today*. New York: Smithsonian Books/Collins, 2007.

Baughman, James L. "Who Read *Life*? The Circulation of America's Favorite Magazine." In *Looking at Life Magazine*, edited by Erika Doss, 41-51. Washington, D.C.: Smithsonian Institution Press, 2001.

————. *The Republic of Mass Culture: Journalism, Filmmaking, and Broadcasting in America since 1941*. 3rd ed., The American Moment. Baltimore: Johns Hopkins University Press, 2006.

Benedict, Howard. "Full-Court Press: Apollo Meets the Media." *Air and Space Smithsonian*, June/July 1989, 84.

Bergman, Jules. "NASA and the Press: The Whole Truth." *Columbia Journalism Review*, Summer 1968, 58-61.

Beschloss, Michael R. *Mayday: Eisenhower, Khrushchev, and the U-2 Affair*. New York: Harper & Row, 1986.

Bizony, Piers. *The Man Who Ran the Moon: James E. Webb and the Secret History of Project Apollo*. New York: Thunder's Mouth Press, 2006.

Brooks, Courtney G., James M. Grimwood, and Loyd S. Swenson. *Chariots for Apollo: A History of Manned Lunar Spacecraft*. Washington, D.C.: NASA, 1979. http://www.hq.nasa.gov/office/pao/History/SP-4205.

Byrnes, Mark Eaton. *Politics and Space: Image Making by NASA*. Westport, Conn.: Praeger, 1994.

Carter, Ginger Rudeseal. "Public Relations Enters the Space Age: Walter S. Bonney and the Early Days of NASA P.R." Paper presented to the History Division of the Association for

Education in Journalism and Mass Communication, August 1997, in Chicago. https://listserv.cmich.edu/cgi-bin/wa.exe?A2=ind9709&L=aejmc&T=0&P=13505.

Catchpole, John. *Project Mercury: NASA's First Manned Space Programme*, Springer-Praxis Books in Astronomy and Space Sciences. London: Springer, published in association with Praxis, 2001.

CBS News and CBS Television Network. *10:56:20 PM EDT, 7/20/69: The Historic Conquest of the Moon as Reported to the American People*. New York: Columbia Broadcasting System, 1970.

Chaikin, Andrew. *A Man on the Moon: The Voyages of the Apollo Astronauts*. New York: Viking, 1994.

Collins, Michael. *Carrying the Fire: An Astronaut's Journeys*. New York: Cooper Square Press, 2001.

Cooper, Gordon, and Bruce Henderson. *Leap of Faith: An Astronaut's Journey into the Unknown*. New York: HarperTorch, an imprint of HarperCollins, 2002.

Cressman, Dale L. "Fighting for Access: ABC's 1965-66 Feud with NASA." *American Journalism* 24, no. 3 (2007): 133-151.

Cronkite, Walter. *A Reporter's Life*. New York: Alfred A. Knopf, 1996.

Cunningham, Walter. *The All-American Boys*. New York: Ibooks, 2003.

Day, Dwayne A. "Viewpoint: Paradigm Lost." *Space Policy* 11, no. 3 (1995): 153-159.

Ertel, Ivan D. and Roland W. Newkirk, with Courtney G. Brooks. *The Apollo Spacecraft: A Chronology*. 4 vols. Washington, D.C.: National Aeronautics and Space Administration, 1974. http://www.hq.nasa.gov/office/pao/History/SP-4009.

Fowler, Eugene. *One Small Step: Apollo 11 and the Legacy of the Space Age*. New York: Smithmark Pub., 1999.

Frank, Reuven. *Out of Thin Air: The Brief Wonderful Life of Network News*. New York: Simon & Schuster, 1991.

French, Francis and Colin Burgess. *In the Shadow of the Moon: A Challenging Journey to Tranquility, 1965-1969*, Outward Odyssey. Lincoln, Neb.: University of Nebraska Press, 2007.

Grossman, Lawrence K. "Murrow Said It All In 1958." *Columbia Journalism Review*, May/June 2002, 53.

Hacker, Barton C., and James M. Grimwood. *On the Shoulders of Titans: A History of Project Gemini.* Washington, D.C.: National Aeronautics and Space Administration, 1977. http://www.hq.nasa.gov/office/pao/History/SP-4203.

Hansen, James R. *First Man: The Life of Neil A. Armstrong.* New York: Simon & Schuster, 2005.

Harris, Gordon L. *Selling Uncle Sam.* Hicksville, N.Y.: Exposition Press, 1976.

Heath, Robert L., and Gabriel Vasquez. *Handbook of Public Relations.* Thousand Oaks, Calif.: Sage Publications, 2001.

It Was an Unprecedented Seven Days of Television: February 14-20, 1962. New York: Columbia Broadcasting System, Inc., 1962.

Kauffman, James. "A Successful Failure: NASA's Crisis Communications Regarding Apollo 13." *Public Relations Review* 27 (2001): 437-448.

Kennan, Erlend A., and Edmund H. Harvey. *Mission to the Moon: A Critical Examination of NASA and the Space Program.* New York: Morrow, 1969.

Kraft, Christopher C. *Flight: My Life in Mission Control.* Waterville, Maine: Thorndike Press, 2001.

Kranz, Gene. *Failure Is Not an Option: Mission Control from Mercury to Apollo 13 and Beyond.* New York: Simon & Schuster, 2000.

Launius, Roger D. *Frontiers of Space Exploration.* Westport, Conn.: Greenwood Press, 1998.

———. "Heroes in a Vacuum: The Apollo Astronaut as Cultural Icon." Paper presented to the 43rd AIAA Aerospace Sciences Meeting and Exhibit, January 10-13, 2005, in Reno, Nevada.

Launius, Roger D., and Bertram Ulrich. *NASA & the Exploration of Space: With Works from the NASA Art Collection.* New York: Stewart, Tabori & Chang, 1998.

Lethbridge, Cliff. "Painting By Numbers: A Statistical Analysis of Cape Canaveral Launches, The First 50 Years." http://spaceline.org/statistics/50-years.html.

Lewis, Richard S. "A Streetcar Named Apollo." *Bulletin of the Atomic Scientists,* November 1968, 24.

Liebermann, Randy. "The *Collier's* and Disney Series." In *Blueprint for Space: Science Fiction to Science Fact,* edited by Frederick Ira

Ordway and Randy Leibermann, 135-46. Washington, D.C.: Smithsonian Institution Press, 1992.

Lincoln, Evelyn. *My Twelve Years with John F. Kennedy.* New York: D. McKay Co., 1965.

Mailer, Norman. *Of a Fire on the Moon: A Work in Three Parts.* Boston: Little, Brown, 1970.

Martin, Ryan M., and Lois A. Boynton. "From Liftoff to Landing: NASA's Crisis Communications and Resulting Media Coverage Following the Challenger and Columbia Tragedies." *Public Relations Review* 31 (2005): 253-261.

Matusow, Barbara. *The Evening Stars: The Making of the Network News Anchor.* Boston: Houghton Mifflin, 1983.

McDermott, Rose. "The U-2 Crisis." In *Risk-Taking in International Politics: Prospect Theory in American Foreign Policy,* 107-133. Ann Arbor, Mich.: University of Michigan Press, 1998.

McLuhan, Marshall. *The Gutenberg Galaxy: The Making of Typographic Man.* New York: Signet Books, 1969.

Miller, Ron. "To Boldly Paint What No Man Has Painted Before." *Invention and Technology* 18, no. 1 (Summer 2002), http://www.americanheritage.com/articles/magazine/it/20 02/1/2002_1_14.shtml.

Morse, Ralph. "Assignment Apollo." *Air and Space Smithsonian,* June/July 1989, 84-87.

Mosley, Leonard. *Disney's World: A Biography.* New York: Stein and Day, 1985.

Murray, Charles A., and Catherine Bly Cox. *Apollo.* Burkittsville, Md.: South Mountain Books, 2004.

Neufeld, Michael J. *Von Braun: Dreamer of Space, Engineer of War.* New York: Alfred A. Knopf in association with the National Air and Space Museum, Smithsonian Institution, 2007.

"Oral History: Remembering the Space Race." *Quest* 9, no. 3 (2002): 4-20.

Persico, Joseph E. *Edward R. Murrow: An American Original.* New York: McGraw-Hill, 1988.

Piszkiewicz, Dennis. *Wernher Von Braun: The Man Who Sold the Moon.* Westport, Conn.: Praeger, 1998.

Reasoner, Harry. *Before the Colors Fade*. New York: Knopf, distributed by Random House, 1981.

Schirra, Wally, and Richard N. Billings. *Schirra's Space*. Boston: Quinlan Press, 1988.

Shepard, Alan B., and Donald K. Slayton. *Moon Shot: The Inside Story of America's Race to the Moon*. Atlanta: Turner Publishing, 1994.

Sherburne, E.G., Jr. "Television Coverage of the Gemini Program." *Science*, September 17, 1965, 1329.

Sherrod, Robert. "The Selling of the Astronauts." *Columbia Journalism Review* (May/June 1973): 17-25.

Shows, Charles. *Walt: Backstage Adventures with Walt Disney*. La Jolla, Calif.: Windsong Books International, 1980.

Skardon, James. "The Apollo Story: The Concealed Patterns." *Columbia Journalism Review* (Winter 1967/1968): 34-39.

Slayton, Donald K., and Michael Cassutt. *Deke!: U.S. Manned Space, From Mercury to the Shuttle*. New York: Forge, 1994.

Smith, David. "They're Following Our Script: Walt Disney's Trip to Tomorrowland." *Future* 1, no. 2 (May 1978), 54-63.

Sperber, A. M. *Murrow, His Life and Times*. New York: Freundlich Books, 1986.

Stuhlinger, Ernst, and Frederick Ira Ordway. *Wernher Von Braun, Crusader for Space: A Biographical Memoir*. Original ed. Malabar, Fla.: Krieger Publishing, 1996.

Swenson, Loyd S., James M. Grimwood, and Charles C. Alexander. *This New Ocean: A History of Project Mercury*. Washington, D.C.: National Aeronautics and Space Administration, 1998. http://www.hq.nasa.gov/office/pao/History/SP-4201.

Thomas, Bob. *Walt Disney: An American Original*. New York: Simon and Schuster, 1976.

Thompson, Neal. *Light This Candle: The Life and Times of Alan Shepard, America's First Spaceman*. New York: Crown Publishers, 2004.

The Today Show Looks at Ten Years of Space Exploration. Washington, D.C.: Aerospace Industries Association of America, 1968.

Von Braun, Wernher (Introduction by Ron Miller). "Now That Man Has Reached the Moon, What Next?" In *Blueprint for Space: Science Fiction to Science Fact*, edited by Frederick Ira Ordway and Randy Leibermann, 166-75. Washington: Smithsonian

Institution Press, 1992.

Watkins, Billy. *Apollo Moon Missions: The Unsung Heroes*. Westport, Conn.: Praeger Publishers, 2006.

Watson, Mary Ann. *The Expanding Vista: American Television in the Kennedy Years*. New York: Oxford University Press, 1990.

Whipple, Fred L. "Recollections of Pre-Sputnik Days." In *Blueprint for Space: Science Fiction to Science Fact*, edited by Frederick I. Ordway III and Randy Liebermann, 127-34. Washington, D.C.: Smithsonian Institution Press, 1992.

Wilford, John Noble. *We Reach the Moon:* The New York Times *Story of Man's Greatest Adventure*. New York: Bantam Books, 1969.

Wolfe, Tom. *The Right Stuff*. New York: Farrar, Straus, and Giroux, 1979.

Wright, Mike. "The Disney-Von Braun Collaboration and Its Influence on Space Exploration." In *Inner Space, Outer Space: Humanities, Technology and the Postmodern World. Selected Papers from the 1993 Southern Humanities Conference*, edited by Daniel Schenker; Craig Hanks and Susan Kray, 151-60. Huntsville, Ala.: Southern Humanities Press, 1993.

Zimmerman, Robert. *Genesis: The Story of Apollo 8: The First Manned Flight to Another World*. New York: Dell Publishing, 1999.

INDEX

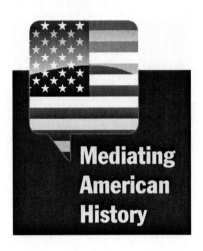

Mediating American History

SERIES EDITOR: DAVID COPELAND

Realizing the important role that the media have played in American history, this series provides a venue for a diverse range of works that deal with the mass media and its relationship to society. This new series is aimed at both scholars and students. New book proposals are welcomed.

For additional information about this series or for the submission of manuscripts, please contact:

Mary Savigar, Acquisitions Editor
Peter Lang Publishing, Inc.
29 Broadway, 18th floor
New York, New York 10006
Mary.Savigar@plang.com

To order other books in this series, please contact our Customer Service Department:

(800) 770-LANG (within the U.S.)
(212) 647-7706 (outside the U.S.)
(212) 647-7707 FAX

Or browse by series:

WWW.PETERLANG.COM